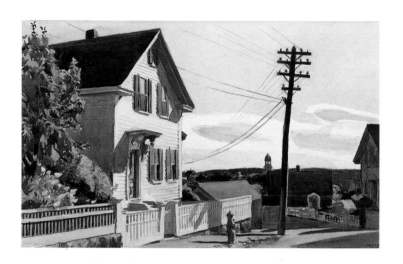

TOWARD AN AMERICAN IDENTITY

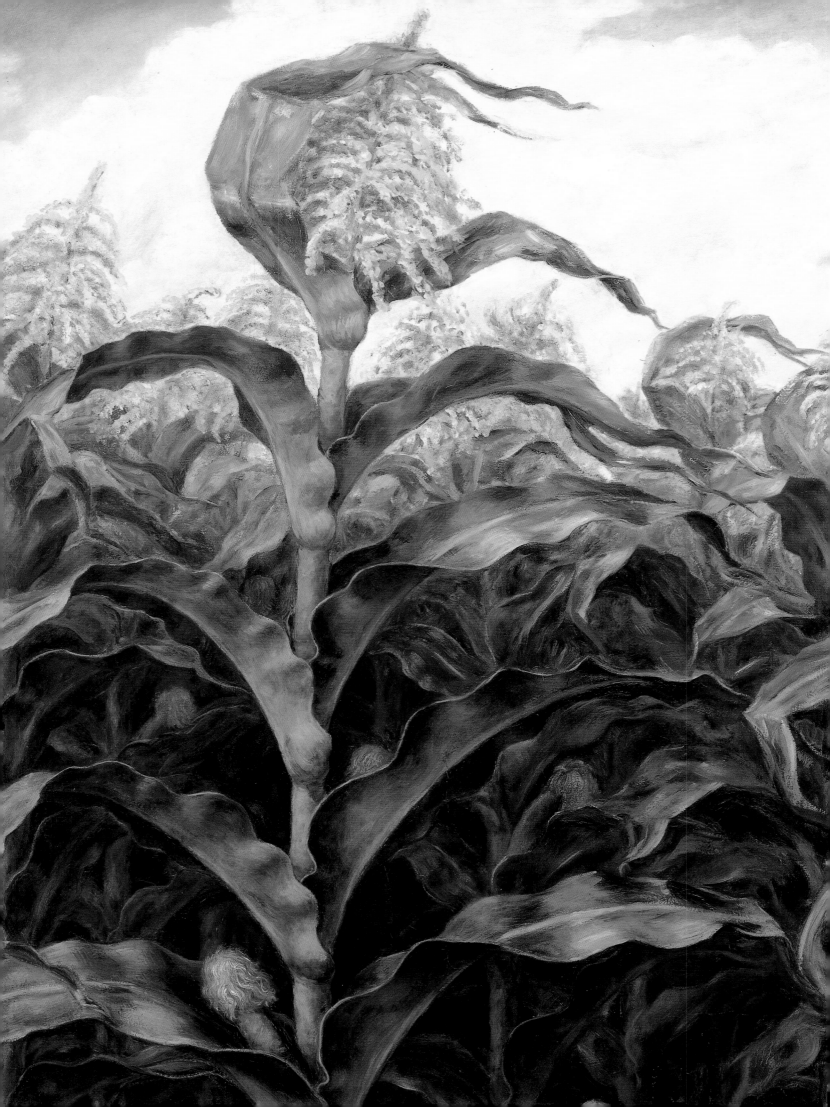

TOWARD AN
AMERICAN
IDENTITY

SELECTIONS FROM THE WICHITA ART MUSEUM
COLLECTION OF AMERICAN ART

NOVELENE ROSS

WITH AN ESSAY BY DAVID CATEFORIS

CATALOGUE EDITED BY DAVID CATEFORIS

ENTRIES CONTRIBUTED BY BRIAN J. BACH, ALISA PALMER BRANHAM, MARIA-ELENA BUSZEK,

DAVID CATEFORIS, JANE COMSTOCK, DIANA L. DANIELS, LISA DORRILL, MICHAEL P. GAUDIO,

SARA HOHN, KERRY A. MORGAN, MELISSA RIAZ, JOHN A. SCHWARTZ, SCOTT A. SHIELDS,

STACEY SKOLD, MARK ANDREW WHITE, DEBORAH J. WILK, AND MIKE WILLIS

WICHITA ART MUSEUM, WICHITA, KANSAS

TOWARD AN AMERICAN IDENTITY:

SELECTIONS FROM THE WICHITA ART MUSEUM

The exhibition is organized by the Wichita Art Museum in association with The American Federation of Arts. It is supported in part by the National Endowment for the Arts and the Kansas Arts Commission. Additional funding was provided by the Henry Luce Foundation and the Estate of Louise C. Murdock. The exhibition is a project of ART ACCESS II, a program of the AFA with major support from the Lila Wallace-Reader's Digest Fund.

EXHIBITION ITINERARY

Wichita Art Museum

Wichita, Kansas

October 12, 1997 - January 25, 1998

Mississippi Museum of Art

Jackson, Mississippi

March 6 - July 26, 1998

Orlando Museum of Art

Orlando, Florida

August 21 - October 18, 1998

Davenport Museum of Art

Davenport, Iowa

November 13, 1998 - January 10, 1999

Tacoma Art Museum

Tacoma, Washington

January 29 - March 28, 1999

The catalogue *Toward An American Identity: Selections from the Wichita Art Museum Collection of American Art* was supported in part by generous grants from the Henry Luce Foundation, Inc., the National Endowment for the Arts, a Federal agency, and the Kansas Arts Commission, a State agency. Additional funding was provided by the Estate of Louise Caldwell Murdock and the City of Wichita.

Published by The Wichita Art Museum

619 Stackman Drive

Wichita, Kansas 67203-3296

Library of Congress Card Catalog Number 97-60437

ISBN 0-939324-51-2

DESIGNER Carol Haralson

PHOTOGRAPHER Dimitris Skliris

Printed and bound in Hong Kong by ColorPrint Offset

COVER: Edward Hopper, *Sunlight on Brownstones,* 1956, oil on canvas, 30⅜ x 40⅛ in., Wichita Art Museum, Roland P. Murdock Collection, detail (catalogue entry, page 159); back cover: Oscar E. Berninghaus, *Aspens, Early Autumn, Taos,* n.d., oil on canvas, 25¼ x 30¼ in., Wichita Art Museum, Gift of Mrs. George M. Brown Estate, detail (catalogue entry, page 97).

HALFTITLE AND PAGE 5: Edward Hopper, *Adam's House,* 1928, watercolor on paper, 16 x 25 in., Wichita Art Museum, Roland P. Murdock Collection, full view and detail (catalogue entry, page 155).

FRONTISPIECE AND TITLE PAGE: John Steuart Curry, *Kansas Cornfield,* 1933, oil on canvas, 60⅜ x 38½ in., Wichita Art Museum, Roland P. Murdock Collection, detail and full view (catalogue entry, page 115).

CONTENTS PAGE: Edward Hopper, *Sunlight on Brownstones,* 1956, oil on canvas, 30⅜ x 40⅛ in., Wichita Art Museum, Roland P. Murdock Collection, detail (catalogue entry, page 159)

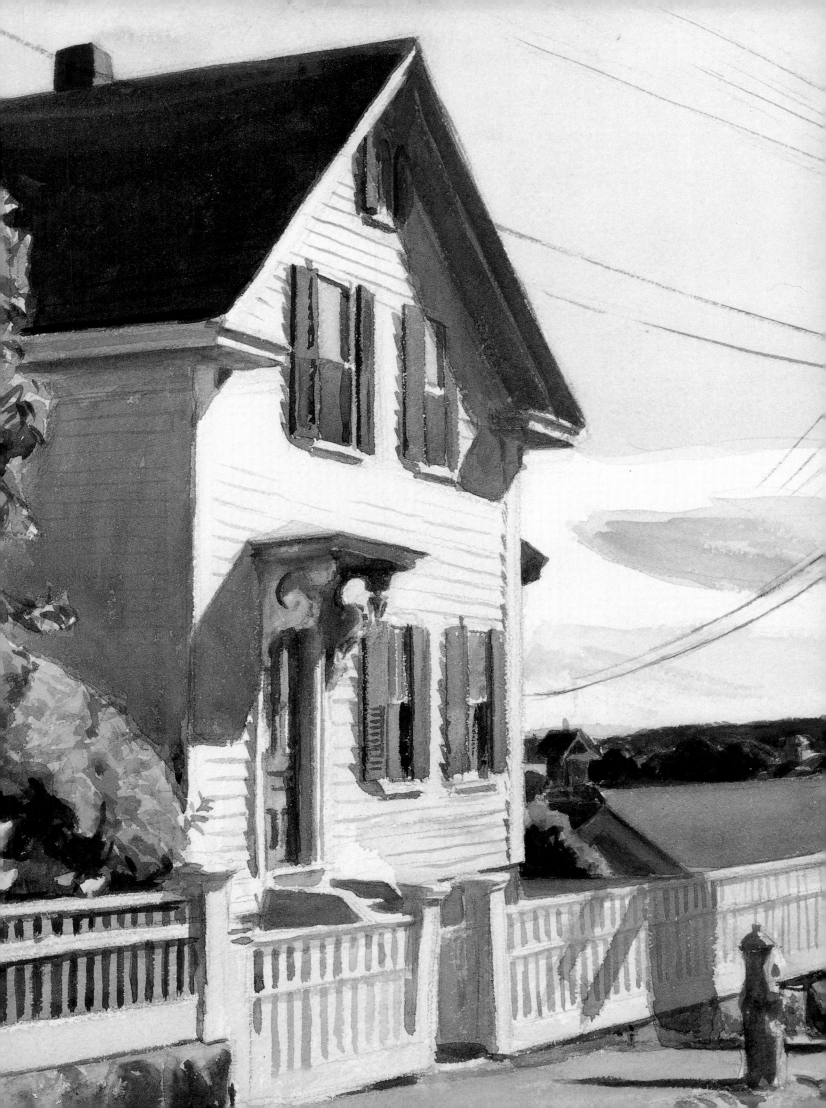

CONTENTS

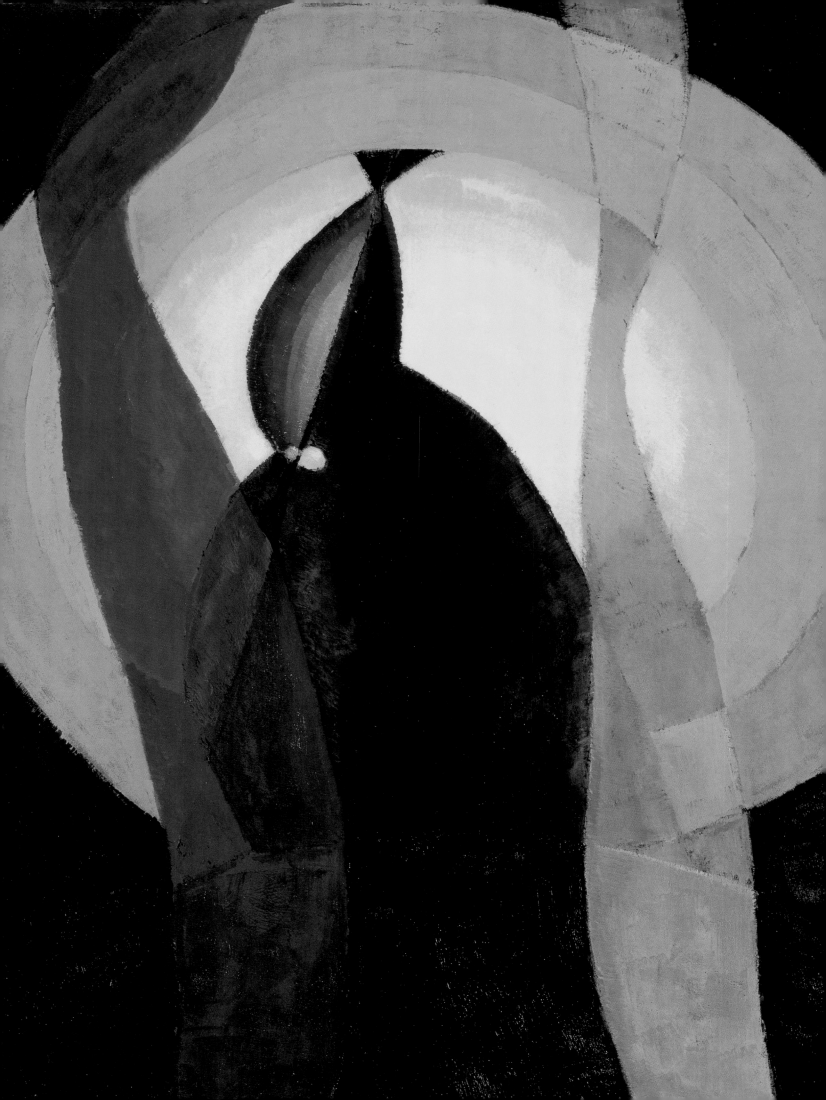

Many American art museums founded between 1900 and 1935 began with works of art owned by families or civic leaders. Those who chose for their private collections to have public homes gave rare gifts to their communities and such museums proliferated across the country. Yet, sometimes the simple act of possessing a good idea can make great things happen, as was the case in Wichita, Kansas. Louise Caldwell Murdock left an amazing legacy: not a collection, but an idea to create a collection of museum-quality American objects in her husband Roland's name for the people of her community. In the years since its founding, the Wichita Art Museum has grown to house one of the most important American art collections, which has never before been shared outside of Wichita in an exhibition of this magnitude.

We aimed to bring together some of its most important works of art to give museum visitors and catalogue readers the opportunity to examine the meaning of a masterwork in our culture and celebrate the history and foundation of its extraordinary, yet under-recognized collections.

The Wichita Art Museum was established in 1915, when Louise Murdock's will created a trust for the acquisition of works by "American painters, potters, sculptors, and textile weavers." Her foresight made the Wichita Art Museum one of the earliest in the country to concentrate on the art of America. Now the largest art museum in Kansas, the Wichita Art Museum is a major cultural center serving the state's largest city, the surrounding rural region, and the Great Plains. Its purpose is to collect, preserve, and exhibit American art, and educate the public about America's artistic heritage and evolving cultural identity.

In 1925 energized civic leaders met the requirements of the Murdock will which stated that the city must provide a building to house a prospective public art collection. They purchased 7.65 acres of land for the museum in Riverside near the bend of the Arkansas River as the site for a public art museum. Despite the burdens of the Depression, city leaders engaged New York architect Clarence Stein to design the museum building, a portion of which was completed and opened in 1935.

The Murdock will charged Elizabeth Stubblefield Navas, a friend and former assistant to Mrs. Murdock, with the task of assembling an American art collection for the people of Wichita. From 1938 to 1962 Mrs. Navas purchased 167 outstanding American paintings and sculpture. Artists represented included Dove, Marin, Ryder, Cassatt, Eakins, Henri, Hopper, Sheeler, Prendergast, Homer, Harnett, De Creeft, Lachaise, and Zorach. This strong collection eventually attracted additional gifts to the museum, particularly the L.S. and Ida L. Naftzger Collection of prints and drawings (1943–1951), the Naftzger Collection of C.M. Russell's Art, and the John W. and Mildred L. Graves Collection of American Impressionism.

In 1955 the city hired the first professional director and appointed a governing board of citizens. As agents for the city, the Wichita Art Museum Board is augmented by advisory and support groups (the Friends of the Wichita Art Museum, Inc., and the Wichita Art Museum Foundation, Inc.) and through community committees to the Board in the areas of development, volunteerism, membership, building and grounds, collections, education, marketing, finance, and special events.

OPPOSITE:
ARTHUR G. DOVE
(1880-1946)
Forms Against the Sun, ca. 1926
Oil on metal, 29 x 21 in.
Roland P. Murdock
Collection, M76.48,
detail (catalogue entry,
page 127)

Community interest and support grew rapidly in the early 1960s, leading to the expansion of the original 11,750 square foot building with the addition of gallery and support wings totaling 10,000 square feet, designed by the Wichita firm of Schaefer, Johnson, Cox and Frey. By 1975 museum and city leaders agreed that a major expansion was needed to serve growing art audiences and to house the collections. Nationally known architect Edward Larrabee Barnes, who had just completed the Walker Art Center's new museum, was selected for the project. Inspired by the 1935 Stein plan, he incorporated the original building into the new museum which included a sculpture deck and extensive window views of the river and park district. Completed in 1977, the contemporary brick and glass structure totaling 78,115 square feet provided new spaces for larger permanent and temporary exhibitions, educational programs, support services, collections storage, and public areas.

Earnings from the Burneta Adair Endowment Fund, created in 1987, made possible acquisition of major additions to the collection, including works by Wendell Castle, Sidney Goodman, Jacob Lawrence, Fritz Scholder, Steve Kestrel, Benny Andrews, David Salle, Tom Otterness, Joan Snyder, and Berta Margoulies. Recent gifts to the museum include major works by Albert Bloch, Ernest Lawson, Theodore Robinson, William Glackens, Eric Fischl, Jane Piper, and John Twachtman.

Today the Wichita Art Museum pioneers cooperative ventures with other cultural providers, including neighboring institutions now known as "Museums on the River." Together with our colleagues from the Mid-America All Indian Center Museum, Old Cowtown Museum, Botanica—the Wichita Gardens, the Wichita Boathouse, and Exploration Place scheduled to open in 1999, we demonstrate that the vitality of downtown cultural institutions keeps economic growth and development healthy in this great community. This is why we are particularly pleased with the development of this traveling exhibition which shares important works of art from the collection with a national audience.

Among the many uncommon individuals who enriched and shaped this exhibition, we owe thanks to Robert Workman, formerly of the American Federation of Arts, for his input in the early stages of exhibition development and for helping to introduce the court-appointed Murdock Trustees to the value and importance of this collection tour; Roger Turner and Garner Shriver read, discussed, scrutinized, questioned, called for further examination, and upheld their roles with graciousness and concern. They are remarkable care-takers and helped us be excellent stewards of a collection held in public trust and we owe them our gratitude. Likewise, Eugene G. Coombs, attorney for the Murdock Trust, and Dana Winkler, assistant city attorney, spent countless hours over many years to ensure that the collection was properly maintained. We are also appreciative of the City of Wichita, and its manager Chris Cherches and mayor Bob Knight and the members of City Council for providing the generous financial support worthy of a collection of this stature.

The cooperation and participation of a large team of individuals have been essential to both the exhibition and the catalogue. Chief among them is the devotion of the Museum's curator, Novelene Ross, who embarked upon this project with delight. From its inception, she was eager to investigate the history of the collection and establish its place in the context of American art history and the history of American art museums. Her research permanently places Elizabeth Stubblefield Navas as the central connoisseur and this catalogue is testimony of her aesthetic. Dr. Ross's work is unparalleled in the history of this institution and we are indebted to her for bringing the project to fruition. It is the Museum's good fortune

to have connected, through former staff member Diane Koeppel-Horn, with David Cateforis, professor of art history at the University of Kansas. His spark and enthusiasm guided much of our early selections as we conceptualized the exhibition and we are grateful to him for his scholarly essay in this publication. Additionally, his students have contributed the catalogue entries cementing an ideal relationship between a public art museum and a leading university in our state.

This venture has been carried forward with consummate skill, not only by Novelene and David, but the Wichita Art Museum's permanent and contract staff. Deserving of thanks for their outstanding contributions are Lois Crane, Kim Curry Design, Donna Bridges, Lathi de Silva, Debbie Deuser, Deb Donahue, Elly Fitzig, Zachary Lamb, Nancy Lucas, Barbara Odevseff, Leslie Servantez, Dimitris Skliris, and Marian Thiessen. This project simply would not be successful without them, their commitment, and their uniquely creative vision of what a museum can become in the life of a community. Thanks are also due to Elly Fitzig, Elizabeth Willis Pearce, and Lisa Ashe for the help with related research and educational materials, and to Carol Haralson for the exquisite design of the catalogue. WAM's installation was ably designed by members of the Wichita chapter of the American Institute of Architects. We are extremely honored by their participation.

This project would and could not have been realized without the American Federation of Arts, under the able direction of Serena Rattazzi. She and her staff have enhanced our efforts to bring these paintings before new audiences through the national tour. We recognize the AFA's curator, Donna Gustafson, for her invaluable contributions throughout the process. The exhibition will be seen in four regions of the country. We acknowledge R. Andrew Maas, director of the Mississippi Museum of Art, Marena

Grant Morrisey, director of the Orlando Museum of Art, Stephen Bradley, director of the Davenport Museum of Art, and Chase Rynd, director of the Tacoma Art Museum, for recognizing the significance of this exhibition and joining the national tour. We are delighted by their participation.

This project would not have been possible without planning and catalogue support from the National Endowment for the Arts and the Kansas Arts Commission. This project is an example of the best of what happens when federal and state monies leverage private support for the benefit of many Americans. The Wichita Art Museum is especially grateful to the Henry Luce Foundation which awarded funding to support the full range of exhibition activities through its new American Collections Enhancement initiative. Thanks are extended to Ellen Holtzman from the Foundation whose guidance and encouragement extended over the many years of planning this event.

This volume is dedicated to the memory of Roland P. and Louise C. Murdock for providing the museum's greatest assets and establishing the strong foundation for continuing development. We hope that this ambitious project sufficiently honors Elizabeth S. Navas. We pay special tribute to the boards, members, and volunteers who have contributed both service and funds to support operations and acquisitions, to John and Elsie Naftzger for their many years of support, and to our friend Mildred Graves Weir, who is now living in Hawaii, for having the vision to advance the collection which bring us so much pleasure.

INEZ S. WOLINS
Wichita Art Museum Director

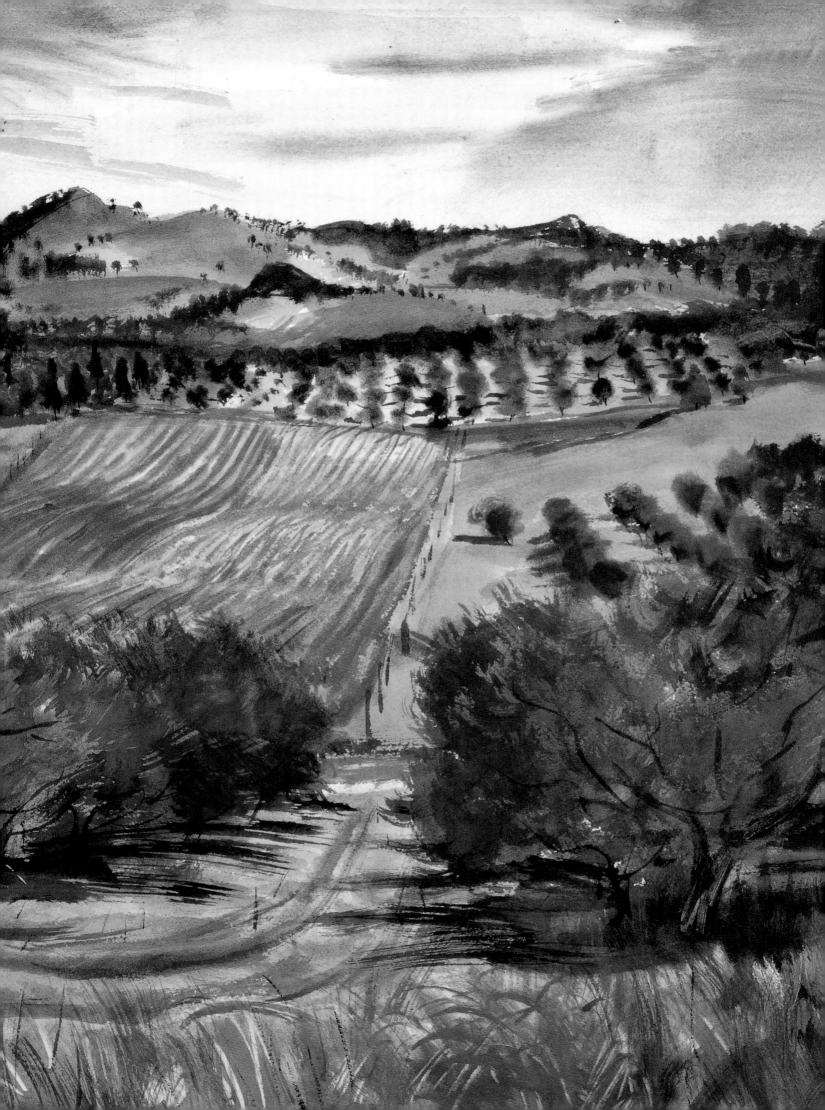

Throughout the nineteenth century, America looked to Europe for training and expertise in art, architecture, fashion, and music. In the twentieth century American artists, critics, and cultural historians began to search for a uniquely American style or point of view that accurately reflected the growing cultural independence of the maturing nation. The Wichita Art Museum, renowned for its collection of twentieth-century American art, was founded in the midst of these discussions. This catalogue and the exhibition that it accompanies describe the early history of the museum and provide new insight into the critical debates that helped define "what was American about American art."

It is our pleasure to have worked with the Wichita Art Museum to organize the first national tour of highlights from this remarkable collection. We are most grateful to Inez S. Wolins, director, Novelene Ross, chief curator, Barbara Odevseff, registrar, and the Museum's Murdock Trustees, Garner E. Shriver and Roger P. Turner, for their generous and good-humored cooperation.

At The American Federation of Arts, we acknowledge the efforts of the individuals who contributed most to the project: Rachel Granholm, curator of education, Donna Gustafson, curator of exhibitions, Corinne Maloney, exhibitions assistant, Michaelyn Mitchell, head of publications, Thomas Padon, director of exhibitions, Jennifer Rittner, assistant curator of education, Diane Rosenblum, registrar, Sara Rosenfeld, exhibitions coordinator, Jillian W. Slonim, director of communications, and Jennifer Smith, communications associate.

We would also like to acknowledge the institutions that have joined us in the presentation of the exhibition. We extend our appreciation to the Mississippi Museum of Art; Orlando Museum of Art; Davenport Museum of Art; and the Tacoma Art Museum.

Finally, we thank the Lila Wallace-Reader's Digest Fund for its support of the AFA's ART ACCESS II project.

SERENA RATTAZZI
Director, The American Federation of Arts

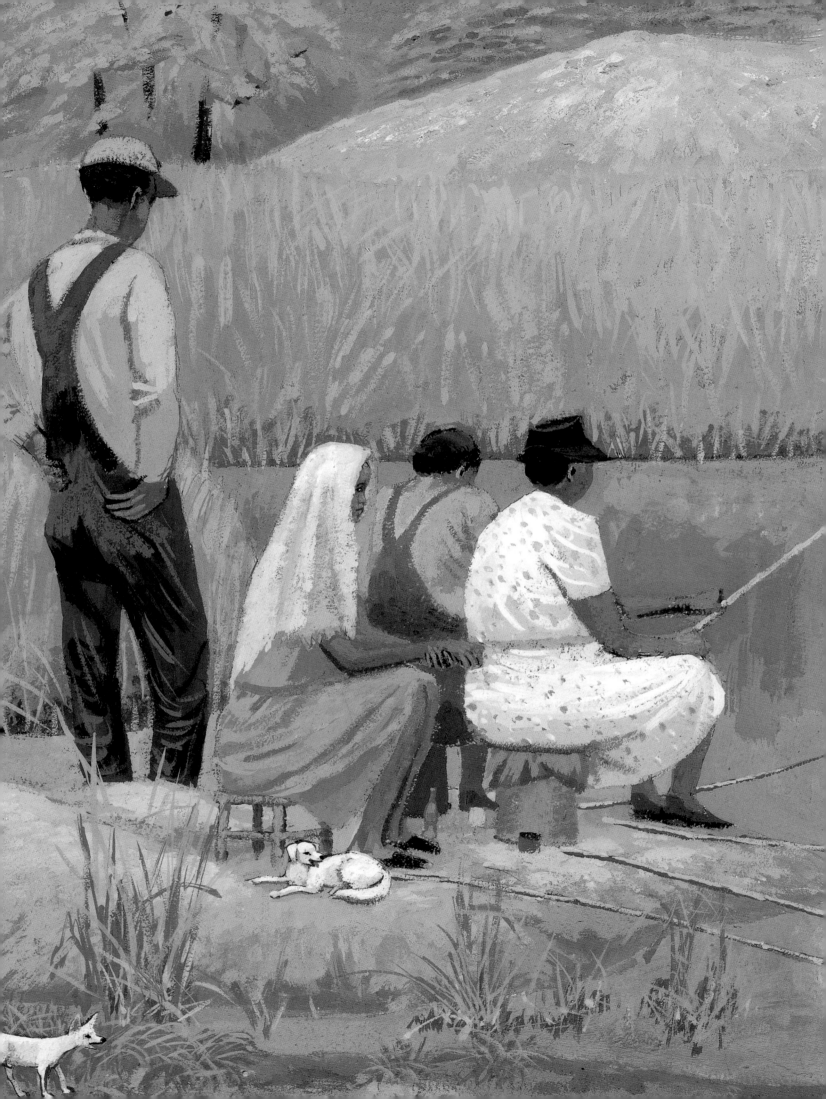

The development of the exhibition and catalogue *Toward An American Identity: Selections from the Wichita Art Museum Collection of American Art* incorporated the contributions of numerous individuals and institutions. It required the vision and resolve of WAM Director Inez S. Wolins to initiate what is the first national tour of works from the permanent collection to be undertaken by the Wichita Art Museum. The project could not have come into being or to fruition without her leadership in all administrative and funding areas or without her steadfast support of the staff.

In the conceptualization of this project I received invaluable suggestions from American art scholars Daphne Anderson Deeds, Elizabeth Milroy, E. Bruce Robertson, and, in particular, David Cateforis. The research and writing of the catalogue was a collaborative effort. I give special appreciation to David Cateforis, assistant professor, Kress Foundation Department of Art History, University of Kansas, for his substantial contributions, including the direction of the graduate seminar which produced all ninety-one catalogue entries, the editing of the entries, the insights of his scholarship and writing, and his editorial advice to me. The University of Kansas graduate students expanded our knowledge of the collection in their provision of new data and critical perceptions of the works. For the negotiation and development of all of the curatorial aspects of the exhibition tour, I am especially indebted to the experienced and patient direction of my colleague, Donna Gustafson, curator of exhibitions, American Federation of Arts.

My thanks to research assistant Elly Fitzig for her excellent work in compiling the primary data on Louise Caldwell Murdock, Elizabeth Navas, and the New York gallery dealers with whom Mrs. Navas collaborated, through her review of the Navas correspondence, her survey of pertinent documentation in the Archives of American Art, and

her interviews with various individuals who remembered Mrs. Navas. Additional information about Mrs. Murdock came from the research of Elizabeth Hicks. During my writing of the catalogue essays I received important suggestions and editorial input from Donna Gustafson, Elly Fitzig, and Elizabeth Milroy. The research and writing of the catalogue was advanced at all critical points by the generous, diligent, and indispensable assistance of WAM librarian Lois Crane who also served as research assistant, secretary, and editor, and performed other duties too varied and tedious to name. Carol Haralson not only created the catalogue's handsome design but also guided the staff throughout the production process.

Libraries and staff consulted for research and assistance included Judy Throm, Archives of American Art; Susan Craig, Head, Art and Architecture Library, University of Kansas; Gavin Thomas, interlibrary loan librarian, and Martha Gregg, librarian in charge of genealogy and local history, Wichita Public Library; and Jami Frazier Tracy, curator, Wichita-Sedgwick County Historical Museum. Members of the WAM curatorial staff, registrar Barbara Odevseff, head preparator Leslie Servantez, and photographer Dimitris Skliris committed long hours and a high degree of professional care to the preparation of the objects, data, and photographs for this exhibition and publication. For their expert counsel and treatment of the individual works of art, I gratefully acknowledge the services of fine arts conservators Forrest R. Bailey, Harriet K. Stratis, and Cynthia Kuniej Berry.

NOVELENE ROSS
Chief Curator, Wichita Art Museum

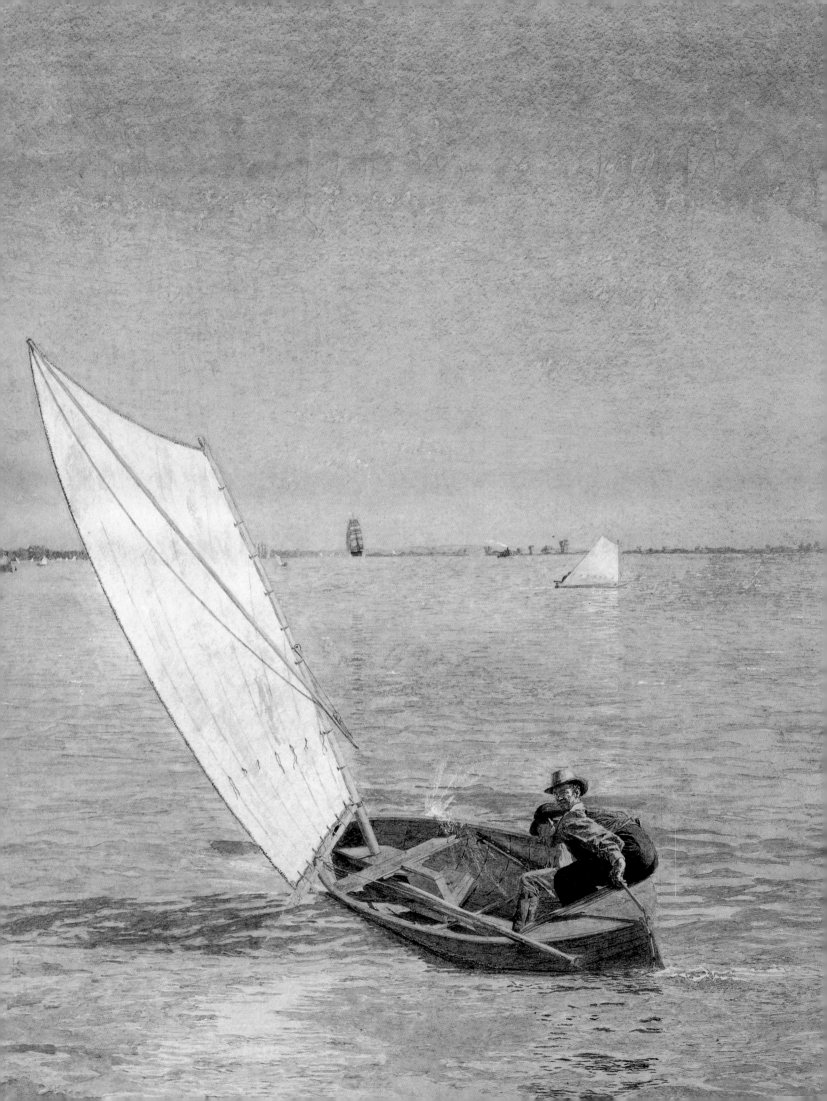

TOWARD AN AMERICAN IDENTITY

The Formulation of the Wichita Art Museum Collection

of American Art in an Era of Aesthetic Nationalism

NOVELENE ROSS

The question of what is expressly "American" in American art has engaged American artists and intellectuals from the colonial period of our nation's history to the present day. The founding of the Wichita Art Museum (WAM) and the formation of its core collection of American art, known as the Roland P. Murdock Collection, is intimately bound to the foment of nativist issues which preoccupied progressive American artists and their advocates from the turn of the century through the end of the 1940s. The individual who assembled the Murdock Collection and who acted as WAM's first curator, Elizabeth Stubblefield Navas (1885-1979), aligned herself fully with what was a major enterprise of American art in the first half of this century, the identification and vitalization of a uniquely American tradition in art past and present.

Navas purchased the 167 paintings, graphics, sculpture, and decorative objects which comprise the Murdock Collection between the years 1939 and 1962. However, she had begun formulating her ideas about what was quality and what was distinctively native in American art as early as 1916 when she organized an exhibition of American art for the City of Wichita from the Macbeth Gallery in New York. By the time Navas undertook her role as

creator and chief trustee of the Murdock Collection she had formed close associations with the most progressive advocates of American art of her time, among them Lloyd Goodrich, Edith Halpert, Holger Cahill, Juliana Force, Forbes Watson, William and Robert Macbeth, Alfred Barr, Antoinette Kraushaar, Eloise Spaeth, and Maynard Walker.

The generation of American art specialists to which Navas belonged conceived of art, not exclusively, but nonetheless in explicitly cultural terms. In their judgments about the work of contemporary American artists these progressive critics gave more weight to what they deemed native authenticity of style than to formal innovation. They could appreciate the new modes of perception proposed by modernism and still value older representational approaches because, in their minds, the overriding commonality of American art was its affirmation of the American ideals of democracy, individualism, and free expression. This exhibition and catalogue examine the ways in which the Navas circle of advocates and the artists whom they supported affirmed these values in their critical statements and in their interpretation of "American" subject matter.

Although Navas witnessed the emergence of Abstract Expressionism and was later able to appreciate the importance of

1 In 1977 Elizabeth Navas expressed her regret at not having purchased a work by abstract expressionist Willem de Kooning: "I had a chance to buy one of those gross women De Kooning painted, but I thought, if I send that back to Wichita, they will tear me limb from limb. So I didn't buy it. There were only a couple of them and now they are in private collections. The women were ugly, gross, and a lot of people wouldn't have liked them. But De Kooning wasn't saying women were like that, he was communicating his feeling about some evil in the world. If I could do it over, I would buy that painting." Elizabeth Navas quoted by Dorothy Belden, "She Knew What Art Was Good," *The Wichita Eagle and Beacon,* 6 November 1977.

2 Ninety-one works were selected for the catalogue and for presentation at the Wichita Art Museum. In deference to considerations of conservation, seventy-six works will tour.

3 Elizabeth Galland quoted by Susan Hund-Milne, "Louise Caldwell Murdock: A Great Benefactor of the Wichita Arts," *Family Ties* (December 1991), 12.

4 Program book, Twentieth Century Club, Wichita. Louise was president of the Twentieth Century Club from 1899 to 1906 and served thereafter on numerous committees.

an artist like Willem de Kooning,[1] she basically concluded her portrayal of the American vision prior to the triumph of the New York School. The ninety-one works[2] selected for inclusion and review in *Toward an American Identity: Selections from the Wichita Art Museum Collection of American Art* incorporate a majority of the finest pieces from the Murdock Collection as well as complementary works acquired through WAM's subsequent collection efforts. These paintings, watercolors, and graphics, whether representational or semi-abstract, assert a common allegiance to the themes of the land and the people. As a consequence of both the era which produced the art and of WAM's dominant curatorial temperament, the collection yields a fascinating glimpse into the psyche of a society searching for ways to amend its traditional national values of democracy and individualism to comprehend the new realities of the machine, the skyscraper, massive foreign immigration, relocation of a rural populace to the cities, the emergence of the "New Woman," the Great Depression, grand-scale consumerism, and world power.

HISTORY OF THE WICHITA ART MUSEUM'S FOUNDERS

THE REALIZATION of Wichita's need for an art museum originated in the mind of a woman from the generation which transformed Wichita from a cowtown to a "civilized" cultural center at the turn of the century. At age fourteen, Louise Caldwell Murdock (1858-1915) had moved with her family to the Wichita of 1872 where her father opened a store selling china and pottery. In 1877, Louise married Roland Pierpont Murdock, business manager and co-owner with his brother of Wichita's first major newspaper, *The Wichita Eagle.*

Although Louise was to request that the Wichita Art Museum's core collection be named in his honor, it was she who pioneered art appreciation in the Midwestern community.

Louise believed firmly in the Victorian ideals of progress, self-improvement, and civic duty. She had initiated her self-education in the arts while accompanying her husband on business trips to Chicago and New York. Seeking ideas to improve her efforts at home decoration, Louise started touring museums and galleries. Her discovery of the old masters awakened in her a sense of intellectual need far more profound than the desire for a graciously appointed home. As a Wichita friend later explained, "Having the privilege of seeing this art caused [Louise] to be aware of the narrow horizons of the women of her own community and the lack of climate for any creative effort."[3] She fostered the Chautauqua movement in Wichita, and in 1899 Louise founded the Twentieth Century Club for women devoted to "the support of literary, educational, scientific, and benevolent undertakings and the promotion of the fine arts." Louise contributed substantially to that enterprise with her lectures on great names in Western art such as Jean François Millet, Anthony Van Dyck, Paolo Veronese, J. M. W. Turner, and Michelangelo.[4]

What began as a genteel excursion into the arts matured into a professional career. In 1908, two years after her husband's death, Louise traveled east to study interior decoration and home furnishing at the New York School of Fine and Applied Arts. Later known as the Parsons School of Design, this institution played an historic role in promoting the modernist concept of beauty as an integral component of functional objects and the environment of everyday life. Encouraged by the school's director, Frank Alvah Parsons, Louise

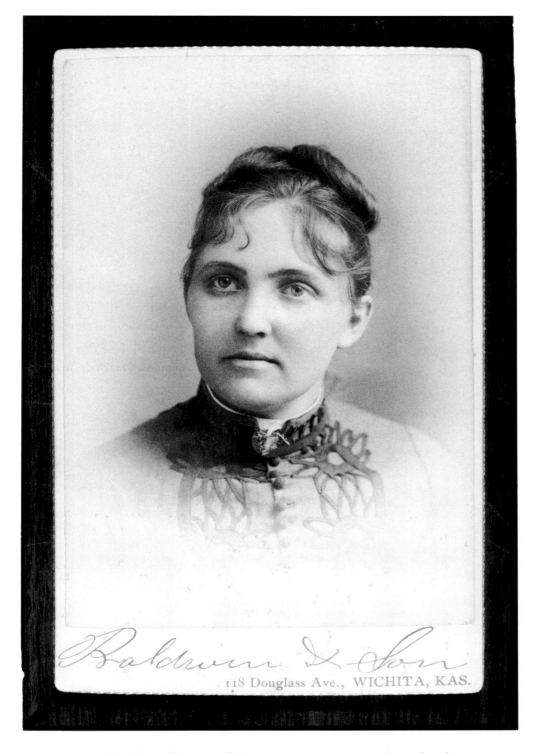

1 Baldwin & Son, photographers, Louise Caldwell Murdock, ca. late 1880s, Courtesy of Wichita-Sedgwick County Historical Museum

118 Douglass Ave., WICHITA, KAS.

returned to establish herself as one of the first professional interior decorators in Kansas. With her father's financial backing, she designed and built Wichita's first "skyscraper," a seven-story, fire-proof office building. This business, and the Caldwell-Murdock Building, which she named in honor of her father and late husband, would eventually provide the income to create a public art collection.

Even as an independent businesswoman, Louise devoted a considerable amount of time to proselytizing her faith in the spiritual benefits of the arts in daily life. She lectured to women's groups throughout the Kansas region. While she earned her income from middle class clients, business and civic commissions, Murdock always felt a personal mission to democratize the arts. She was most proud

2 Caldwell-Murdock Building, 111 E. Douglas, Wichita, ca. 1916, Courtesy of the Wichita Public Library Local History Collection.

[5] Louise Caldwell Murdock, quoted in obituary, *The Wichita Beacon* 23 April 1915.

[6] Navas, from the text of an untitled lecture she presented to a Wichita PEO chapter, ca. 1954, p. 3. Navas Papers, WAM.

[7] Ibid., 2-3.

of research which she undertook to create interior decoration for farm homes, a model project sponsored by the General Council of the Federation of Women's Clubs for the Panama-Pacific Exposition. However, perhaps the most telling index to the depth of her commitment to bringing beauty into the lives of women without ready access to the nation's art centers came in her response to a journalistic blunder. Toward the end of her life when she was desperately ill from cancer, the *Kansas City Star* published a feature in their Sunday supplement about Louise Murdock's distinguished career. In the

course of its adulatory comment, the article mistakenly stated that Mrs. Murdock offered free instruction in home decoration to women who could not afford to pay for such services. Before the error could be corrected, Louise received hundreds of letters from around the country. Requests for advice came from women of incredibly varied circumstances living "in the hills of Virginia, in New England, in the most Southern states, in the Middle West, North and West." Working in great pain, she carefully answered each correspondent. When asked later why she imposed such an ordeal upon herself, Murdock responded that "These women are needy and have come to me in good faith and I wouldn't turn them down for anything in the world. . . . I have destroyed every letter carefully, in order that no one ever can know the heartfelt appeals that came from some of those mothers and wives. . . . Some of those poor women have only one room, but they cherish that artistic taste that is in every woman's heart."[5]

Murdock was as understanding of the pragmatic limitations of the housewife's situation as she was sympathetic to their desires. Acting as vice-chairman of the Art Committee of the National Federation of Women's Clubs, she created trunk exhibits of fabrics and samples of other goods to provide a practical aid to farm women interested in improving the aesthetic character of their homes.[6] Between approximately 1910 and 1915 Louise also introduced fine arts exhibitions to Wichita. She organized, often at her own expense, loan exhibitions from New York galleries. These exhibits began modestly, the first featuring "prints of old masters, another time, etchings, and finally valuable paintings."[7] A series of articles in October 1912 issues of *The Wichita Beacon* extolled Mrs. Murdock's bringing of an exhibition of American paintings from the Macbeth-Folsom galleries of New York City for the

occasion of Wichita's annual "Fair and Exposition." The fair was Wichita's version of the international expositions then in vogue celebrating progress in science, the practical arts, and the fine arts. The effort begun by Louise Murdock, to place American art in a community showcase, would be continued by her young associate Elizabeth Stubblefield.

Murdock bequeathed her wealth to the care of her surviving family members, her mother, sister, and an errant son.[8] She designated that after their demise the estate could then be used for the betterment of the community. In her interpretation of the latter Louise exhibited a decidedly modern spirit. She specified that a trust be established to create a public collection of contemporary artworks by "American painters, potters, sculptors, and weavers." She challenged the city to become an active partner in her mission to make her fellow citizens cognizant of their unique artistic heritage. In order to receive the trust, the city first had to provide a facility to house and display an art collection.

In the 1920s a group of local artists and civic leaders joined forces to stimulate public support for an art museum and to position the city to receive Louise Murdock's generous bequest when the time came. Under the leadership of Park Board commissioner L. W. Clapp, the city purchased 7.65 acres of farmland situated at a bend of the Little Arkansas River on which to site the museum. Then in the early 1930s Clapp, at his own expense, studied architectural plans and traveled to museums around the nation in order to develop a knowledgeable proposal for a museum facility and for an architect. Complementing the progressive spirit of benefactor Louise Murdock, Clapp recommended Clarence Stein, a nationally respected architect who worked in a modern Art Deco vein. Stein and Clapp con-

curred in the need for Wichita's art museum to reflect its particular geographic and cultural heritage. Observing Wichita's regional association with the prairie and with ancient Indian settlements, Stein submitted a design for an elegantly simple Art Deco structure to be ornamented with polychromed tiles inspired by Mayan-Aztec patterns. Using grant funds from the federal government, the city erected the central unit of Stein's design. However, without additional monies to complete the construction of the two symmetrical wings, the city was forced to accept a truncated version of the longed-for facility. Nonetheless the Wichita Art Museum proudly opened its doors in 1935 with a gala inaugural loan exhibition of major European and American paintings borrowed from regional and national museums including the Corcoran Gallery of Art, the Brooklyn Museum of Art, the Minneapolis Institute of Arts, and the Nelson-Atkins Museum of Art.[9] By September 1937 the perpetual trust from the Murdock estate had been established and the work of creating a public art collection of American art could begin.

Louise Murdock had chosen Elizabeth Stubblefield Navas for this task. Like her employer and mentor, Navas personified the confidence and ingenuity of the so-called "New Woman," and she fit the American mold of the self-made authority. There is no doubt that Louise Murdock harbored the deepest respect and affection for her young assistant and personal confidante. Murdock had left Navas her interior design business as well as the responsibility of actually selecting the objects to constitute her proposed American art collection. According to Navas these momentous responsibilities came as a complete surprise.[10] Suffering in the last stages of her cancer and hoping for a miracle, Murdock had traveled to Chicago for additional medical consulta-

[8] Roland P. Murdock, Jr. (1884-1935) caused his mother endless grief with his history of prodigal spending, alcoholism, check forgery, and imprisonment.

[9] Lack of documentation leaves it unclear as to who was most responsible for the organization of this exhibition. It may have represented the combined efforts of Elizabeth Navas and the officers of the Wichita Art Association. From 1935 to 1943 the City of Wichita leased the Wichita Art Museum building to the Wichita Art Association (now the Wichita Center for the Arts). The Association conducted studio art classes in the museum and organized the loan of works from local and regional artists. The Association also engaged exhibitions toured by regional and national museums, galleries, and tour agencies. Space in the museum was reserved by court order for the Roland P. Murdock Collection. However, once Navas began to install her purchases, tensions arose from the competing concerns of the Association and Navas. In 1942 the Association purchased its own property and moved out a year later. The City Park Board then assumed its period of directing the affairs of the museum.

[10] Navas quoted by Belden. When the courts formally established the Murdock Trust in 1937, Elizabeth Navas and a Kansas City accountant, John A. Parkinson, were appointed co-trustees. Navas, however, was entrusted with the selection and management of the art collection. Parkinson's role was essentially to focus upon the financial growth of the trust from the income generated by the rental of Murdock's business property, the Caldwell-Murdock Building.

11 Elizabeth McCausland, quoted by Elizabeth Navas in an untitled essay (28 August 28 1965), 2, about the legacy of Louise Caldwell Murdock and the scope of the Murdock Collection which Navas mailed to Richard R. Crocker, Sunday editor, *The Wichita Eagle.* Navas Papers, WAM.

12 Navas quoted by Belden.

13 Navas, unpublished lecture written for presentation to a Wichita PEO chapter, ca. 1954, 2.

3 Elizabeth Stubblefield Navas, ca. 1960s, Navas Papers, WAM.

tion. Returning home resigned to her fate, she immediately sat down to the task of drafting her will. Navas, who was at work at her own desk across the room, did not learn until after Murdock's death that she was the one called to create "what may be called a water hole of art in the dry lands."

Navas used that phrase in 1965 in a tribute to Louise Murdock which she hoped to have published in the hometown press. The sly dig at the cultural aridity of Wichita was typical of Navas's style. Throughout her career as Murdock trustee, she maintained a defensive, adversarial posture with the community from which she sprang. In her letter to the *Wichita Beacon*'s Sunday editor, Navas didn't say that Wichita or Kansas was a cultural desert, but she gleefully quoted friend and fellow Wichita expatriate in the New York art world, Elizabeth McCausland, as the outside expert to speak for her. As Navas would have been quick to charge, how

could one, without the reminder of the provincial context, fully appreciate the fact that it had been "banner headline news. . . in 1915 when a Kansas woman left her estate for the endowment of an art collection," and "the Middle West had begun to feel stirrings of the creative life."11

Because Navas maintained a cool reticence about the facts of her personal history, documentation is scant, fragmentary, and sometimes contradictory. Although she always claimed her birth date as 1895, she was actually born ten years earlier in the small town of Coffeyville, Kansas. She grew up in Independence, another small Kansas town, where she graduated from high school in 1902. In 1910 the Stubblefield family moved to Wichita. A defining moment in Navas's life occurred sometime between 1904 and 1910 when she left the Midwest for the first time to travel east. She stopped first in Ohio to visit with her younger sister, Josephine, whom the family had been able to send to Oberlin College to study music. From there she traveled on to New York to visit one of her mother's relatives, an art teacher who lived in Brooklyn. Her hostess took her on tour of art classes and probably to museums and galleries as well. Elizabeth must have been dazzled by the city's cultural attractions because she returned home determined to find a way to study art in New York. As she remembered the experience later, she exulted, "I stepped off the train, and I said, this is where I belong. I'm getting back to New York."12

Navas said that she worked for Louise Murdock during the last five years of Murdock's life, 1910 to 1915. Speaking of this period of her life, Navas related that her first meeting with Murdock occurred shortly after her family's settlement in Wichita and came at her own initiative.13 Interested in pursuing a career in the visual arts and having heard of Murdock's leader-

ship in this area, she requested an interview with the distinguished lady in the latter's interior decoration offices in the Caldwell-Murdock Building.

The two women seem to have immediately recognized themselves as kindred spirits. There were some interesting parallels in their personal lives which may have lent psychological resilience to their professional relationship. Both women had been cheated by family obligations of higher education and came to resent the loss. Murdock, the eldest of three daughters, left school at fourteen to stay home and care for her invalided younger sister. Navas too was the oldest of three female children. Enigmatic as usual, she would only say that "I never did know why my father didn't want me to go to college; we never talked about it." Perhaps the family had been in difficult financial straits when Navas came out of high school and could not afford to send a daughter to college until Josephine was old enough to attend Oberlin. Or with resources for the education of only one child had Elizabeth been judged the lesser prospect? Whatever the reason, Navas, like Murdock, would act independently to remedy this deficiency, and both would turn to art as a means to enter the masculine worlds of business success and intellectual stimulation. Murdock took Navas into her employ and treated this young assistant like a partner. Navas returned Murdock's trust with a fierce loyalty which included disapproval of Murdock's decision to give the art collection her husband's name. Navas's correspondence contains frequent complaints that the Murdocks contributed nothing to the origin or support of an art collection in Wichita; it was all the doing of a Caldwell woman and, by rights, should have borne her name.

At about the same time she met Louise Murdock, Navas undertook formal training in the arts. According to universi-

ty records, Elizabeth Stubblefield enrolled in summer courses in interior design and fine arts at Teacher's College of Columbia in 1911. She apparently established a routine of winter work in Wichita and summer classes at Columbia in 1912, 1913, and 1916. Working for Murdock, Navas organized the logistical details of the trunk exhibits for the National Federation of Women's Clubs, and assisted in the execution of important public commissions for the decoration of the Wichita Club, the Wichita Country Club, the Carnegie building for the Wichita Public Library, and the Crawford Theater building in Wichita.[14] This work, particularly the design of interior decoration for the Public Library, brought the young Navas into contact with accomplished artists and craftsmen who practiced the Parsons School philosophy of integrating fine art into the fabric of practical life.

Through her work with Murdock in developing an annual fine arts exhibition for the Wichita Fair, Navas no doubt made the acquaintance of William Macbeth, one of the few dealers at the time to specialize in contemporary American art. In 1916, within a year of being named co-trustee of the Murdock Estate, Navas re-established her working relationship with Macbeth and continued the Murdock tradition.[15] She borrowed a group of paintings of urban genre scenes and tonalist landscape subjects from the Macbeth Gallery for a Wichita exhibit titled *The Famous All-American Art Loan Collection of Masterpieces of Oil and Water Color Painting*. Sponsored by the Wichita Equal Suffrage Association, the exhibition was presented at the *International Wheat Show, Wichita Fair and Exposition*.[16]

In 1917 Elizabeth married Spanish-born Raphael Navas, an accomplished pianist who had moved to Wichita around 1908.[17] That same year Navas established residence in New York from where she

[14] Navas, untitled essay about Louise Murdock and the Murdock Collection written for publication in *The Wichita Beacon* (1965).

[15] An unsigned letter to Elizabeth S. Navas from the Macbeth Gallery, dated 26 February 1917, refers to the fact that "your Art Society was credited with a commission of 5% on a picture which was sold soon after the exhibition in Wichita." Navas sent a reply to William Macbeth, dated 1 March 1917, in which she expressed anticipation of "the pleasure of future business relations." Navas Papers, WAM.

[16] The checklist with prices for "The Famous All-American Art Loan Collection of Masterpieces of Oil and Water Color Painting" was printed in the *Official Guide, Program and Souvenir of International Wheat Show, Wichita Fair and Exposition* (2-14 October 1916), 43. Navas Papers, WAM. Thirty-two works were listed, and although the *Guide* did not identify the Macbeth Gallery as the source of the loans, most of the artists listed, and perhaps all, were being shown at Macbeth.

4 The Murdock Studio, business interior, Caldwell-Murdock Building, ca. 1928-1930, Courtesy of the Wichita-Sedgwick County Historical Museum.

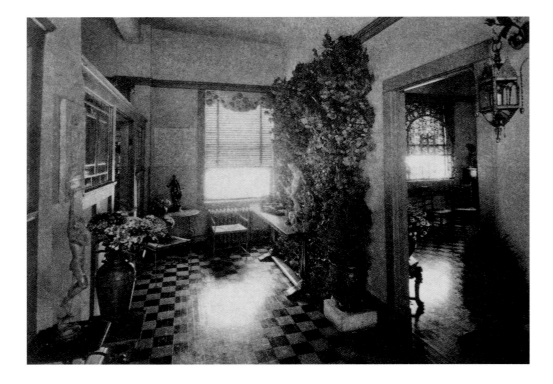

17 Raphael Navas's history is even more incomplete than that of Elizabeth. He is known to have taught in Wichita at the Power-Myers Conservatory of Music located at 340 N. Market. He had received his professional training in Europe at the National Conservatory of Madrid and at the Paris Conservatory where he is said to have studied with noted European teachers.

18 The interior decoration business, called The Murdock Studio, closed in 1964. An auction notice from December 1964 announces the private sale of the contents of the Murdock Studio in the Caldwell Building. Navas is listed as owner and Mrs. F. L. Hetrick is listed as "Charge." Navas Papers, WAM.

19 Interview conducted with Elizabeth Navas by Avis Berman, *Rebels on Eighth Street, Juliana Force and the Whitney Museum of American Art* (New York: Athenaeum, 1990), 410-11. The interview also confirmed that Navas became well enough acquainted with Force to be invited to parties at Force's home.

20 Documentation in the Navas Papers, WAM, provides evidence of Elizabeth Navas's active service on the Board of Trustees of The American Federation of Arts from 1948 through 1970. Among the exhibitions which Navas helped to organize were *Landmarks in American Art,* Wildenstein Gallery, N.Y., 1953; *The American Vision,* Wildenstein Gallery, N.Y., 1957; *Teen-Age Paintings from Israel,* 1959; *As Artists See Artists,* 1963, which included the Wichita Art Museum on its tour itinerary; and *Realism and Reality,* 1965, which concluded its tour at the Wichita Art Museum.

managed her affairs in Wichita through correspondence and annual trips to the city. Navas maintained Murdock's interior decoration business through supervision by a local manager[18] and supported certain of Murdock's Wichita projects for public art education. In New York Navas devoted herself to self-instruction in American art, visiting galleries and museums, reading criticism in journals, exhibition catalogues, and books, and seeking the advice and acquaintance of the most progressive and important advocates of American art of the day. In 1938, ready to begin purchasing work for the Murdock Collection, she wrote to Juliana Force, the founding director of the Whitney Museum of American Art and the individual who could justly be considered the authority on the creation of a collection centered upon contemporary American artists, to explain her mission and to request advice. Force responded by inviting Navas to lunch and treating her to a comprehensive assessment of each of the New York dealers in American art.[19]

When Raphael Navas died in 1939, the Murdock Collection became Navas's

life work. Her early purchases from the Downtown Gallery, Kraushaar Galleries, the Frank Rehn Gallery, Maynard Walker Gallery, and the Macbeth Gallery demonstrate that she quickly acquainted herself with the principal galleries showing contemporary American artists. During the late 1940s through the 1960s Navas expanded her advocacy of American art appreciation to a national arena through service on the Board of Trustees of The American Federation of Arts. She was particularly active in the organization of touring exhibitions of American art for the AFA.[20]

During 1939 to 1962, when Navas made her Murdock Collection purchases, the governance of the Wichita Art Museum evolved from the control of the City of Wichita's Board of Park Commissioners to administration by the chair of the Wichita University (now Wichita State University) art department and then to supervision by a city commission-appointed board over a professional museum director. Norman Geske, a friend of Navas's who was director of the Sheldon Memorial Art Gallery, University of

Nebraska, Lincoln, and was also building an American art collection, said that Elizabeth Navas was "the envy of the art world" in her day.[21] Limited only by available funds, Navas could make her purchases without having to answer to the co-trustee of the Murdock Estate, a museum board of trustees, or to a museum director. Throughout this time, but especially in the early days, Navas acted as *de facto* curator of the Murdock Collection. She made annual trips to Wichita to supervise the installation of the collection and she jealously guarded this privilege. In one of her many epistles to Wichita to clarify curatorial authority, she wrote, "For the record, President Corbin and Doctor McFarland do not install any work of art belonging to the Roland P. Murdock Collection. I rearrange the galleries each October, incorporating the new acquisitions. Always a plan is conceived to present different aspects of American art; in other words, to tell a story."[22]

Navas made all decisions about loans and conservation. As in all such matters, she sought the most authoritative advice of the day from Sheldon and Caroline K. Keck, who pioneered the development of professional fine arts conservation service in the United States and who published several books on the care and preservation of art objects. She had her local sources, some called them her spies, who kept her apprised of the care of paintings at WAM. When she thought something amiss she responded quickly as in this letter to a Wichita attorney, "There have been complaints in the last two months, that paintings in the Murdock Collection were . . . being subjected to procedures that are damaging. . . . The two University employees accused denied ever touching the pictures. At this time I accept their statements as true, but I shall make my own investigation."[23] Navas wanted the court to give her official status as curator and did not hesitate to contrast the ignorance of others with her own expertise. From her New York apartment she fired a steady and scathing barrage of admonishment to whichever hapless individual was in charge. In a typical dispatch to yet another director of the Wichita Board of Park Commissioners she raged that she had received reports that the Murdock paintings had been removed to accommodate a loan exhibition. "I regret very much that it is necessary to complain of the housing of the Murdock Collection, but it is my duty as a trustee to see that it is cared for properly," she wrote. "It seems to me that a more realistic understanding of the possibilities of the Wichita Art Museum is to be had by all who are interested in it."[24] She offered further instructions about suitable educational programs such as films, concerts, and lectures which could be offered instead of "so many loan shows" to attract the public. However, if Navas reacted sharply to perceived threats to her status, she felt just as keenly her old employer's sense of an educational mission with national import:

My greatest worldly interest is this Wichita Art Museum. It offers a unique opportunity for educational work. Never in the history of our country, has understanding been so necessary. That could be enhanced through a broad program of education, offered democratically by municipalities. It is my hope that the gift of Mrs. Murdock may be an inspiration toward such a program.[25]

Navas's correspondence throughout her career as Murdock Trustee, as well as the reports of the people who admired her and of those who feared her, attest to her knowledge of American art and of the museum profession, to her fierce vigilance over the welfare of the Murdock Collection, and to her defensive animosity toward the Wichita caretakers of the col-

[21] Norman Geske interviewed by Novelene Ross, 15 July 1994.

[22] Navas, letter of 9 December 1953 to Emory L. Cox, director, Board of Park Commissioners, Wichita, Kansas. Navas Papers, WAM.

[23] Navas, in a letter of 23 June 1952, to Vincent Hiebsch, attorney, Wichita, Kansas. Navas Papers, WAM.

[24] Navas, in a letter to Alfred MacDonald, Board of Park Commissioners, City of Wichita, 12 March 1946, 1. Navas was never officially appointed curator by either the court or the museum's governing body. Navas Papers, WAM.

[25] Ibid., 2.

26 Navas, unpublished lecture, "Art in Wartime: Wichita Art Museum, A Leading Patron of American Art," ca. 1942, p. 2. Navas Papers, WAM. Navas was apparently rendering to her own advantage observations made by Howard Devree in his regular column for the *New York Times:* "The Realm of Art: Current Activities," and "Art in Use, Events That Stress Practical Issues," 5 July 1942, Section 8.

Too often our artists have felt cut off from their museums as well as from the public. Yet the museums as educators, with programs constantly becoming more alive and of greater interest to the public, are in a highly advantageous position as mediators, and in the position to be of incalculable service to the contemporary artist.

When one remembers the work of the Whitney Museum; such exhibitions as that arranged by Dorothy Miller at the Museum of Modern Art last season, showing work by eighteen contemporary American painters and sculptors from nine states; the collections formed by the Nebraska Art Association under the direction of Dwight Kirsch [The collection is now that of the Sheldon Memorial Art Gallery, University of Nebraska, Lincoln. Dwight Kirsch and Elizabeth Navas were intimate friends who advised and supported one another in the task of building quality American art collections for Midwestern communities.]; and for the Wichita Museum through the Murdock Fund by Elizabeth Navas…then the artist even in wartime, may look ahead with considerable courage.

27 Walt Kuhn, interviewed by Alonzo Lansford, *Art Digest* 23, no. 3 (1 November 1948): 15.

28 Navas, letter to Richard Grove, director, WAM, 28 November 1960. Navas Papers, WAM.

lection. As the professionalism of the Wichita Art Museum increased in the late 1960s, Navas exercised less control over the day-to-day business of the museum. However, she was never to believe that the city understood what a treasure they had in the Murdock Collection and she made no secret of the fact that, over the years, she considered a number of city officials and directors to be fools and charlatans.

At the same time, Navas shrewdly cultivated public support in Wichita for the enterprise of building an American art collection and for her leadership in that endeavor. Whenever praise, especially praise from the national media or from an acknowledged expert, accrued to the Murdock Collection, she fired off press releases to the editors of the local Wichita papers. When called upon for lectures to a Wichita Art Museum audience or to a local civic group, she trumpeted the high esteem in which the Murdock Collection was held by leading cultural authorities:

To stimulate and to encourage American art we must patronize it. . . . Wichita is making a recognized contribution toward the development of art in this country. Recently the *New York Times* on its art page made a survey of such encouragement and published a list of museums which it deemed as the best supporters of the art of the United States. Third on the list was the Murdock Art Fund as administered by Elizabeth S. Navas for the Wichita Art Museum. The first and second names were the Whitney Museum of American Art in New York City and the Fine Arts department of Nebraska State University. . . . 26

Likewise, Navas carefully saved for the collection archives the numerous letters from her New York colleagues praising her efforts. Among those who registered respect for Navas's organizational abilities and for her curatorial acumen were Lester B. Bridaham, secretary, Art Institute of Chicago; Francis Henry Taylor, director,

Metropolitan Museum of Art; Alfred H. Barr, Jr., director, Museum of Modern Art; Edith Halpert, director of the Downtown Gallery and a major proselytizer of collecting contemporary American art; and Lloyd Goodrich, curator and later director of the Whitney Museum of American Art. When she wanted to test and validate her judgment on the purchase of Eakins pieces, of a Mary Cassatt painting or a Hopper painting, she talked to Goodrich. Navas followed all of Halpert's enthusiasms, particularly American folk art and the interest in minority artists and the early modernists. The artists she collected also reflect her attention to major American shows in the 1930s and 1940s at the Metropolitan Museum of Art, the Museum of Modern Art, and the Whitney. In 1948, artist Walt Kuhn, who had played a major role in the organization of the 1913 Armory Show which had introduced modernism to the U.S., was asked by an interviewer to comment on the museum scene in America. Kuhn included Wichita in his survey with this compliment to Navas's informed "eye": "Wichita? Mrs. Navas is a careful shopper. Result—she collects good pictures."27

THE FORMULATION OF AN AMERICAN AESTHETIC

IN 1968, six years after she had completed her purchases, Navas declared to the director of WAM that her motive in assembling the Roland P. Murdock Collection had been to "present visually a history of the culture of the United States."28 She was not claiming comprehensive coverage, but was instead advancing a judgment about the communal significance of a collection of national art. Like others who inaugurated American art collections in the 1930s and 1940s, Navas believed she had witnessed the coming of age of art in America. She exulted in the

idea that the living artists whom they championed, and the historic artists whom they "rediscovered," had firmly imprinted Western tradition with the stamp of an "American spirit."

Navas's acquisition program and artist preferences very closely resembled the conception of *American Painting and Sculpture, 1862-1932,* advanced by Holger Cahill and Alfred Barr in 1932 in one of the early exhibitions of the fledgling Museum of Modern Art, New York.[29] Barr and Cahill identified the realist schools generated by The Eight and the individualistic experiments in expression fostered by the early modernists as the two central currents of contemporary American art. They believed these movements to be authentic voices of a robust native school of art whose vital connection with American life signaled that American art "had definitely arrived" after a long history of provincial subservience to European leadership. As for the important historical antecedents of the contemporary American school, they nominated the great individualists of the late 19th century, according greatest respect to Thomas Eakins, Winslow Homer, and Albert Pinkham Ryder. In the opinion of the period, these artists could justly be called "American ancestors." Each had unavoidably been dependent upon European models. Yet, the writers explained, instead of succumbing to easy imitation, each had taken what he wanted from Europe in idea or technique and, through force of personality, made it his own.

According to all records, Navas's first purchase was *Kansas Cornfield,* a heroically-scaled Midwestern landscape by Kansas native son John Steuart Curry. In a rare act of deference to an opinion from Wichita, Navas took the advice of Mrs. Henry J. Allen, wife of a former Kansas governor and an early patron of American architect Frank Lloyd Wright. In a press interview

given late in her life, Navas acknowledged to a reporter for the *Wichita Eagle and Beacon* that Mrs. Allen had made the politic suggestion that she buy a Curry because he had been born in Kansas. Although Navas admitted that she didn't much like Curry herself, she had thought the purchase appropriate and popular at the time. Navas explained to the reporter that her first objective as a collector had been to acquire representation of the members of The Eight. She recalled proudly, "There were sixteen paintings in that first group, and I had seven of the Eight."[30]

The Eight, of whom Navas spoke so reverentially, referred to a group of eight American painters led by Robert Henri who sought exhibition and market alternatives to the conservative National Academy of Design by mounting an independent show in the Macbeth Gallery, New York, in 1908. The official taste of the Academy favored sentimental paraphrases of the antique, picturesque Old World genre scenes, elegant drawing-room portraits, and genteel studio and garden images of an impressionist character. Following its French prototype, the National Academy strove to enforce its taste through a system of hierarchical membership, juried exhibitions, and prizes. In opposition to this narrow regime, The Eight proposed an inclusive democratic program of artist-oriented exhibits which would presumably encourage individual expression and engage the public more directly as an arbiter of taste.[31]

The event of the exhibition titled "The Eight" caused a sensation in the contemporary press, and, by the 1930s, achieved mythic status as a revolutionary moment in the history of American art. It wasn't exactly a revolution, but it was perceived to be, and it was that perception which critically influenced definitions of an American aesthetic in the 1930s and

[29] This reference is not to be taken as Navas's sole model of an American collection, but as a representative of the thinking of the period, and one of many exhibitions which she attended.

[30] Navas quoted by Belden. The sixteen paintings were: Thomas Eakins, *Billy Smith,* 1898; John Sloan, *Hudson Sky,* 1908; Maurice Prendergast, *As Ships Go Sailing By,* 1910-13; George Luks, *Mike McTeague,* 1921; William Glackens, *Luxembourg Gardens,* 1906; Charles Burchfield, *December Twilight,* 1932-38; John Steuart Curry, *Kansas Cornfield,* 1933; Reginald Marsh, *Sandwiches,* 1938; Henry Varnum Poor, *In Western Garb,* 1937; Guy Pène du Bois, *Fog, Amagansett,* 1938; Alexander James, *Portrait of the Artist's Wife,* 1939; Louis Bouché, *Promised Land, Long Island,* 1939; Henry Mattson, *Sea Ways,* 1939; George Grosz, *The Blue Chair,* 1938; Peggy Bacon, *Hecate's Court,* n.d.; Edward Hopper, *5 A.M.,* 1937.

[31] Painter and teacher Robert Henri and his four young protégés, John Sloan, William J. Glackens, Everett Shinn, and George Luks, comprised the nucleus of the Eight. Henri, who had inspired Sloan, Glackens, Shinn, and Luks to advance from their careers as newspaper illustrators to serious painters, had also influenced their adoption of realist styles and had encouraged them to continue portraying contemporary urban life. The three remaining members of the Eight joined the realists in friendship and in sympathy with the idea that individual freedom of expression was the first principle of a vital art. These three were: painter of romantic fantasy Arthur B. Davies, tonalist interpreter of rural and urban American landscape Ernest Lawson, and post-impressionist celebrant of parks and beaches Maurice Prendergast.

32 For an analysis of the facts and myths of the revolution wrought by Robert Henri and The Eight see Elizabeth Milroy, *Painters of a New Century: The Eight and American Art* (Milwaukee Art Museum, 1991) and Virginia M. Mecklenburg, "Manufacturing Rebellion: The Ashcan Artists and the Press," *Metropolitan Lives, The Ashcan Artists and Their New York* (Washington, D. C.: National Museum of American Art in association with W. W. Norton, 1995), 191-213.

33 Joseph J. Kwiat, "Robert Henri and the Emerson-Whitman Tradition," in Joseph J. Kwiat and Mary C. Turpie, eds., *Studies in American Culture, Dominant Ideas and Images* (Minneapolis: University of Minnesota Press, 1960), 155-56.

34 Peter Conn, *The Divided Mind: Ideology and Imagination in America 1898-1907* (Cambridge and New York: Cambridge University Press, 1983), 251-91, examines the period's perception of the arts as effete and frivolous and the defensive postures and strategies adopted by American artists to assert their manhood.

1940s.[32] The showing of The Eight was neither the first independent artist group exhibition nor was it the first exhibit to issue a challenge to the stodgy rules and standards of the academy. The styles and subjects posed by The Eight, while they may not have all won entry to an academy exhibition, presented no departure from the known. The Eight were not universally reviled by the critics and they certainly did not suffer neglect. Some press reviews did castigate The Eight for the offense of rude subjects and technical drivel, but there were just as many flags hoisted in praise of the group's honesty and daring. After the exhibit closed in New York it traveled to eight different museums in the East and in the Midwest. Gertrude Vanderbilt Whitney purchased seven paintings from the show which eventually entered the collection of the Whitney Museum of American Art.

The Eight never showed together again as a group, but their exhibition triumphed as the manifesto of a new realist focus in American art upon ordinary citizens and the experiences of contemporary life. In the 1930s the critics Holger Cahill and Alfred Barr gave the name "Ashcan School" to the realist painters who were associated with the aesthetic proclaimed in the exhibition of The Eight and who devoted themselves to portrayals of the bohemian and lower class aspects of the urban scene. Cahill and Barr intended the epithet "Ashcan" as a tribute to what they saw as an American rebellion against an effete, disengaged, and essentially European cult of beauty.

Using the issue of nationalism to promote his own group, Henri had cast the dialogue about contemporary art in emotionalized cultural terms. Echoing the ideas and attitudes of the 19th-century American writer Ralph Waldo Emerson and the poet Walt Whitman, who had in their times issued calls for the nation to find its own pure voice in the arts, Henri prescribed a militant cultivation of a native aesthetic.[33] He defined the American art spirit as a freedom from foreign influences, a passion for life, direct expression, and the personal assertion of integrity and virility.[34] Following upon the dramatic coverage of the exhibition of The Eight, Henri effectively popularized his sentiments and the realist agenda through his teaching and writings. In 1923 one of Henri's admiring pupils compiled and published a compendium of his lectures, documenting the artist's vibrant humanist philosophy of making art, in a book called *The Art Spirit*. Artists, writers, art people, and the general public, including Elizabeth Navas, read the Henri book as the bible of progressivism.

The issues raised in the 1908 exhibition of The Eight—opposition to the academic canon of painting, a nationalistic definition of the American aesthetic, and exhibit support for contemporary American art—were destined to resonate in the 1930s and 1940s. The emerging focus upon an explicitly American artistic vision and heritage found expression in the 1930s in the opening of the Whitney Museum of American Art, New York, the presentation of shows of contemporary American art at established and newly opened museums around the country, and the expansion in the nation's art capital, New York, of the number of private galleries willing to show emerging American talent. The statements of Holger Cahill, who was one of the era's most influential proselytizers of American art, articulated the perceptions of this burgeoning American art establishment. In his introduction to the catalogue accompanying the *Exhibition of Contemporary American Art*, shown in mid-1929 at the Atlantic City (N.J.) Art Association, Cahill declared the institution's "belief in the vital significance of the artists' contribution to our civilization," and exhorted museums and collec-

tors to free themselves from their veneration of foreign cultures and to collect so as "to acquaint Americans with their own civilization."[35]

The works shown in Cahill's Atlantic City exhibition typified what would become the period's definition of progressive American art. Cahill's show featured a large group of realist interpreters of American life, including George Bellows, Charles Burchfield, Guy Pène du Bois, Robert Henri, Edward Hopper, and Kenneth Hayes Miller. He joined to this list members of the small group of artists who could be called the American avant-garde. These were the artists who in the first two decades of the century had been receptive to European modernism and who had returned from travels abroad to adapt aspects of the modernist stylistic vocabulary to explicitly American landscape, architectural, and figurative subjects. This group which included Charles Demuth, Marsden Hartley, John Marin, Alfred H. Maurer, Georgia O'Keeffe, Abraham Walkowitz, and Max Weber, had been nurtured and exhibited in the first two decades of the century almost exclusively by avant-garde photographer and dealer Alfred Stieglitz. Cahill filled out his picture of vital contemporary American expression with examples of works by artists whose imagery evolved from a realist vein into personalized composites of realism and modernism. The latter included Andrew Dasburg, Stuart Davis, Preston Dickinson, Yasuo Kuniyoshi, Charles Sheeler, Niles Spencer, Joseph Stella, Marguerite Zorach and William Zorach.

These artists and their associates constituted the category of independents from among whom Navas and her peers would build their contemporary American collections. Navas's characterization of her first purchases to the *Eagle* reporter was correct in spirit if not in fact. She did present four works by some of the artists who belonged to The Eight—John Sloan, George Luks, William Glackens, and Maurice Prendergast—in that inaugural group of sixteen paintings which went on view for the first time at WAM in November 1940. Navas introduced these artists and their respective paintings to her Wichita audience as fellows of "The Eight," a stout-hearted rebel group which had "opened the eyes of other artists to the life around them, to contemporary and local subject matter."[36] Contrasting the program of Sloan and the realists with the academic, decorative approach to painting, Navas related of Sloan that "Any dishonesty, any affectation, is unbearable to him." She pronounced that "Beauty is in honesty," and reiterated the mantra of current American art criticism that truly great art "sprang from life rather than from art."[37]

On this same occasion Navas gave additional proof of what she and her peers recognized as American art made from the stuff of life. She offered examples of images by Charles Burchfield and John Steuart Curry depicting landscape scenes of Midwestern small towns and farms; Reginald Marsh's portrayal of "human derelicts" on the urban beach of Coney Island; Guy Pène du Bois's contrasting view of the beautiful people at play on an exclusive stretch of Long Island's sandy coast; Peggy Bacon's humorous commentary on lowlife urban dwellers from the animal kingdom—two alley cats exercising dominion over the nocturnal precincts of Manhattan's tenement backyards, garbage cans, and cellars; Edward Hopper's study of early morning light raking the smokestacks of a factory situated on the New England coastline; and Thomas Eakins's portrait of a rough-edged professional boxer who had entertained fight-fans in the Philadelphia Arena in the late 1890s.

Navas took particular pride in brandishing such a prestigious name as Eakins among the trophies from her maiden

[35] Holger Cahill, "Introduction," *Exhibition of Contemporary Art* (Atlantic City, N.J.: The Atlantic City Art Association, 1929), Archives of American Art, microfilm reel ND/56. Holger Cahill played a central role in the promotion of American art. In the 1920s he served as assistant to the director of the Newark Museum and edited the art magazine *Space*. In the 1930s he organized exhibitions of American art and wrote catalogues for the Museum of Modern Art, New York. Cahill was one of the first to appreciate the connection of folk art to the modern aesthetic. He encouraged and advised early 20th-century collectors of Americana and American folk art. During the mid-1920s he formed a close association with Edith Halpert, who opened her Downtown Gallery in 1926. From then until the early 1950s, Cahill advised Halpert's selection and support of artists and collaborated with her upon important exhibition projects. Cahill also exercised considerable influence on artists' and public perception of the cultural significance of American art through his directorship of the WPA Federal Art Project (1935-1943). Throughout his career Cahill published commentary on American art for *The Nation, The New Republic,* and *The American Mercury.* Elizabeth Navas respected Cahill and emulated his opinions, often using quotes from Cahill's writings in her lectures in Wichita and in the gallery labels she wrote for the Murdock Collection paintings.

[36] Navas, untitled address delivered at the Wichita Art Museum on 8 November 1940, on the occasion of the installation of the first sixteen paintings purchased for the Murdock Collection, p. 6. Navas Papers, WAM.

[37] Ibid.

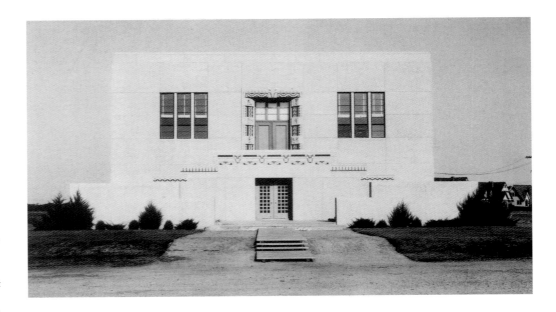

38 In a letter of 27 August 1948 complimenting Elizabeth Navas upon the fine work she had done in assembling the Murdock Collection, Aline B. Louchheim, *New York Times,* wrote "And I am very pleased to hear of your policy of going backwards. I had remarked to someone only a day or two before I got your letter that I thought all the museums which were interested only in the present were making a mistake because their communities needed the background roots." The initial letter from Elizabeth Navas to Aline Louchheim has been lost. About two years later Navas wrote to Margit Vargas, art editor for *Life* magazine, hoping to stimulate a story about her purchases of paintings by 18th-century American artist Robert Feke and 19th-century American folk artists. She explained, "While my particular interest is in the contemporary field, I am trying to include in the Collection a few examples of the best work of the past. By presenting the background of American Art, I hope that a better understanding and appreciation of the present may result." (28 February 1950) Navas Papers, WAM.

39 Navas, Murdock Collection inaugural address (8 November 1940), 3, 6.

40 Ibid., 4.

41 "Four Unusual Exhibitions of American Art," a review supplied to Edith Halpert, Downtown Gallery, by the American Art News clipping service, dated 7 June 1930, Archives of American Art, microfilm reel ND/56.

hunt. Although she did not, in her 1940 address, elaborate her motives for acquiring works by American artists of the past, Navas would later boast to an art editor at the *New York Times* that she had acquired pieces like the Eakins in order to provide the proper context and history for works of contemporary American artists.38 She characterized Eakins as "one of the most profound minds in American painting of the last generation," and as a strong-minded independent who had stood above the sentimentality of his period.39 By 1940, the currents of artistic and social thought which had conferred momentum upon the Ashcan artists' realist crusade had also lionized Eakins as not only worthy to enter the pantheon of the great painters in Western art of the 19th century, but also as a painter of preeminent American credentials. As Navas observed in presenting her purchase of Eakins's portrait of *Billy Smith,* "critical opinion today favors three men as the greatest painters this country has produced, and Thomas Eakins is one of them."40 Although Navas left that pronouncement dangling without further elucidation, she was undoubtedly referring to the focus of American art criticism created by a retrospective exhibition of three 19th-century American masters, *Winslow*

Homer, Albert Pinkham Ryder, Thomas Eakins, in 1930 at the Museum of Modern Art. An art critic observed at the time that the MOMA exhibition made a convincing case for "a really national school" and expressed the hope that "some contemporary American may be able to interpret the present with as great clarity as these men did their day."41

The MOMA exhibit constituted one of the early landmarks in the progressive campaign to nurture and validate a national school of painting. The artists themselves, both the realists and the modernists, reexamined past American art production to find reenforcement and guidance in their present concerns.42 Likewise the advocates of the independents strove to identify and authenticate their contemporary artists' American roots. Edith Halpert, director of the Downtown Gallery and a force to whom Elizabeth paid close attention, played a major role in forging links between the non-academics of the present and their "ancestors." Halpert coined the catchy phrase "American Ancestors" to comprehend a class of indigenous American art production from the 18th and 19th centuries which might be called "folk." In this category she included craft, the work of self-taught and itinerant

painters called limners, and the imagery of 19th-century "primitives" like Edward Hicks, who applied a flat, stylized mode of description to his fantasy *The Peaceable Kingdom*.[43] While Halpert waged the fight in the arena of the marketplace, art specialists of more scholarly intent such as Lloyd Goodrich, curator at the Whitney Museum of American Art, gleaned America's artistic past for its yield of an indigenous aesthetic which resonated with the cultural imperatives of the time. During the 1930s and continuing through the 1940s, the search for and celebration of America's true artistic ancestors blossomed in exhibitions, lectures, and publications.

Lloyd Goodrich, who produced the first major monographs on Eakins, Homer, and Ryder, elucidated what was, for his generation, the quintessential American qualities expressed in the work of these men. In Eakins and Homer the scholar detected a Whitmanesque pictorial program to sing of America's people and of the land. Goodrich ascertained a deeply felt, robust affirmation of community in

Eakins's thoughtful portrayal of non-aesthetic subjects from the popular culture of his own Philadelphia. He saw Eakins's disdain for the genteel conventions of portraiture, his relentless pursuit of his sitter's "nucleus of character," and the artist's perseverance in the face of critical neglect and financial failure as signs of artistic and moral integrity.[44]

In his 1936 catalogue essay on Winslow Homer for the centenary exhibition of the artist at the Whitney, Goodrich introduced his perception of Homer as the Yankee artist "primeval" who forged his own vision from instinct and direct experience.[45] By 1944, Goodrich had amplified this appraisal to define Homer as the "epitome of our national artistic development," that is, the archetype of a "self-taught" artist who crafted "art out of the raw material of American life."[46] Goodrich explained that while Homer possessed little more than a good illustrator's command of formal means, he "painted certain elemental things. . . with. . . power and utter authenticity."[47]Goodrich argued that the distinction of this American genius lay

[42] See Theodore E. Stebbins, Jr., "The Memory and the Present: Romantic American Painting in the Lane Collection," in Theodore E. Stebbins, Jr., and Carol Troyen, *The Lane Collection, 20th Century Paintings in the American Tradition* (Boston: Museum of Fine Arts, 1983), 11-13, for a discussion of the acute consciousness of American tradition and the need for a national school among the American modernists in the Stieglitz circle. Stebbins writes "The Stieglitz painters thought not only about Picasso and Cézanne, but also about Ryder and Copley and their American predecessors," 17.

[43] See Diane Tepfer, "American Ancestors and American Folk Art," *Edith Gregor Halpert and the Downtown Gallery, Downtown 1926-1940; A Study in American Art Patronage,* Ph.D. dissertation (Ann Arbor: U.M.I. Press, 1989), 163-87, for a discussion of Edith Halpert's pioneering role both in promoting the appreciation of American folk art, Americana, 19th-century American painters such as Edward Hicks and William Michael Harnett, and in making the connection between these earlier traditions and American modernism.

[44] Lloyd Goodrich, *Thomas Eakins, His Life and Work* (New York: Whitney Museum of American Art, 1933), 111-12, 114, 154-55.

[45] Lloyd Goodrich, *Winslow Homer Centenary Exhibition* (New York: Whitney Museum of American Art, 1936), 5, 12-13.

[46] Lloyd Goodrich, *Winslow Homer (*New York: Whitney Museum of American Art and Macmillan Company, 1944), 203.

6 School children viewing paintings from the Roland P. Murdock Collection and selections from the Mrs. Cyrus M. Beachy Doll Collection, Wichita Art Museum, spring 1947, Courtesy of the Wichita Public Library Local History Collection.

47 Ibid., 204

48 Ibid.

49 Holger Cahill, "Ryder, the Solitary," *Art in America in Modern Times* (New York: Reynal and Hitchcock, 1934), 15. This commentary was prepared for "a series of radio broadcasts over Station WJZ and a coast-to-coast network, through the facilities of the National Broadcasting Company, on Saturday nights from October 6th, 1934 through January 26th, 1935...," frontispage.

50 Lloyd Goodrich, *Albert P. Ryder Centenary Exhibition,* (New York: Whitney Museum of American Art, 1947), 39.

51 Maurice Sterne-Alexander Brook, "Albert P. Ryder," *The Index of Twentieth Century Artists* 1, no. 5 (February 1934), 66.

52 Goodrich, *Albert P. Ryder Centenary Exhibition,* 20, 33.

53 Lloyd Goodrich, *Albert P. Ryder* (New York: George Braziller, 1959), 11.

54 Roger Fry, "Art in America, the Art of Albert Pinkham Ryder," *The Burlington Magazine* 13, no. 61 (15 April 1908): 63. In an undated letter of the early 1970s, Navas wrote to WAM curator George P. Tomko to tell him that as a part of her self-education in the arts she began reading all of Roger Fry's criticism in the early 1940s. She explained that when she learned that Fry had written an article on Ryder in a 1908 edition of *The Burlington Magazine,* she "wrote to London for a copy." In that article she took note of a reproduction of the painting titled *Moonlight on the Sea.* Navas linked Ryder to Eakins in the opening sentence of a gallery label which she wrote for the painting *Moonlight on the Sea:* "Virgil Barker, eminent American critic, has spoken of the twin peaks in painting of the American mind, namely, the lofty realistic probity of Thomas Eakins and the epic imaginative authenticity of Albert Pinkham Ryder." Navas Papers, WAM.

not so much in his formal inventiveness as in the intangible character assets of instinct, virility, and candor.[48]

The artist in this trio of ancestors who did rate recognition for his prescient invention of abstract formal means was Albert Pinkham Ryder. Ryder's imagery, as can be seen in *Moonlight on the Sea,* the painting which Navas purchased for the Murdock Collection in 1947, distilled the basics of sea, sail, cloud, and moon into a romantic metaphor of human mortality and cosmic mystery. Ryder appealed enormously to American moderns because his style provided an independent native precedent for the modernist tenet that imaginative form reveals the truth of the spirit while representational form merely describes appearances. In his commentary for a series of 1934 radio broadcasts about American art, Holger Cahill characterized Ryder as a proto-modernist who "had a feeling as keen as any Cubist for what is vital and interesting in shapes."[49] In his 1947 catalogue essay for the *Albert P. Ryder Centenary Exhibition* at the Whitney, Lloyd Goodrich declared that Ryder "had anticipated certain tendencies of modern art— its freedom from bondage to literal naturalism, its sense of plastic design, its discovery of the subconscious mind."[50]

Most importantly, however, the progressives could make the case that Ryder had been an artistic pioneer in a thoroughgoing American mold. Writing in 1934, Maurice Sterne and Alexander Brook described Ryder's fidelity to his own inner vision as an invincible stand for principle "comparable to that of Emerson and Thoreau.... He was as American as they...."[51] Goodrich also emphasized that Ryder's distortions of natural form were instinctive rather than calculated, and grounded in his love for the seacoast and fields of his New Bedford, Massachusetts, home. Even when he lived in New York, the scholar related, Ryder kept nature as a

direct touchstone for his imagination in nightly walks through parks and around the wharves.[52] As Goodrich elaborated in a later publication, Ryder was just as American as Eakins and Homer. While the latter represented the best of a long-standing American tendency toward naturalism in the arts, Ryder represented the equally prominent strain of romanticism in American art, a disposition for creative exploration of the inner life exemplified by the literary heritage of Poe, Hawthorne, Melville, Emily Dickinson, and by the grandiose wilderness landscapes produced by Frederic Church and Albert Bierstadt.[53]

However, according to contemporary judgment, Ryder had achieved a vision more enduring than that of romantic painters of conventional academic means, precisely because he had embodied more of the pure American spirit of individualism. Ryder the man had been largely indifferent to worldly rewards in everything from his personal comforts to his professional prestige. He formed warm friendships with his fellows in the New York artist community, but gave no pursuit to prizes or sales. After some initial professional training in painting, Ryder chose to embark upon a very private voyage of experimentation with the materials, the composition, and the content of painting. As Roger Fry, the Ryder-admirer that Navas most liked to quote, put it:

> Ryder... belongs quite definitely to his age, and, though not quite so obviously, to his country; but it is partly by virtue of this very exaggeration of individualism in his art that he does so.[54]

In the period formulation of the American aesthetic, artists and critics alike cherished Eakins, Homer, and Ryder for the approved cultural virtues of self-reliance, candor, and intuitive embrace of life. In addition Eakins and Homer provided explicit precedent for the democratic

subject agenda of the urban realists and the Regionalists. However, it took more educational effort on the part of the advocates of the modernist and the experimental to make the case that these descendants of Ryder who were advancing more subjective, idiosyncratic pictorial interpretations of the American experience also spoke to the people.

Holger Cahill and Edith Halpert forwarded the issue of the American modernist's populist credentials in their promotion of American folk art as America's indigenous artistic legacy. Beginning in 1929, Cahill and Halpert collaborated in the organization of numerous gallery and museum exhibitions to demonstrate a cultural and aesthetic foundation for contemporary American modernism in America's historic folk traditions. They examined examples of craft, architecture, and painting which might be variously termed primitive, naive, popular, vernacular, untutored, provincial, anonymous, or outsider.[55] Among the most exciting and comprehensive of these exhibitions was *American Folk Art: The Art of the Common Man in America 1750-1900* which opened at the Museum of Modern Art in 1932. The exhibition title emphasized the preeminence of the democratic component in the valuation of folk art and its aesthetic kin. When Halpert issued press releases and gave lectures on the subject, she stressed the idea that "folk art developed logically as an authentic expression of the community for the community...in contradistinction to the established art of the few for the few."[56] Halpert and Cahill suggested that while the European modernists had had to look beyond their own cultural borders to the arts of Africa, Oceania, and Pre-Columbian America for instruction in artistic alternatives to academic conceptions of pictorial form, American artists had found inspiration in their own backyards. In actuality, the Americans' exposure

to modernism had sensitized them to an appreciation of the so-called "primitive" or non-representational artistic traditions. Yet, once armed with that sensitivity, American artists did respond enthusiastically to the stylistic qualities of reductive simplicity and to the emotive properties of wit, candor and faith inherent in the best of American folk art. Charles Sheeler and Yasuo Kuniyoshi, two of the modernists represented by Halpert and respected by Navas, were among those most vocal in acknowledging their respective debts to the precise clarity of folk style and the surrealist realization of primal feeling in folk content. Halpert summarized the native continuity of modern and folk by explaining that contemporary American artists had recognized in the art of the people their own quest for an "honest, direct and imaginative expression of life as they knew it."[57]

Elizabeth Navas carefully filled in her representation of the "American Ancestors" in the Murdock Collection with representation of the American folk tradition. During the 1940s and 1950s she purchased from the Downtown Gallery an anonymous wood carving of an eagle with outspread wings from the Federalist period and three early 19th-century examples of folk portraits executed by itinerant, self-taught painters of the limner tradition. In this same period she purchased examples of works by 20th-century American practitioners of the folk style, Horace Pippin and John Kane. The latter were among those singled out by Halpert, Cahill, and Barr as the representatives of a pure intuitive strain of modernism in native art.[58]

The incorporation of a folk aesthetic into the definition of modern American art coincided with and encouraged kindred democratization of the concept of a national artistic character. The inclusion of African American Horace Pippin in the 1938 MOMA exhibition *Masters of*

[55] See Tepfer, 132-156, for a discussion of the historic partnership of Edith Halpert, Downtown Gallery, with pioneer collector of American folk art, Abby Aldrich Rockefeller.

[56] Edith Halpert, unpublished lecture presented to an Antiques Forum at Colonial Williamsburg, Virginia, 2 February 1951, p. 3, in which Halpert reiterated the arguments which she and Cahill had first advanced in the 1930s. Archives of American Art, microfilm reel ND/20.

[57] Ibid.

[58] In 1938 the Museum of Modern Art featured Kane and Pippin, among others, in its exhibition of *Masters of Popular Painting: Modern Primitives of Europe and America*. The exhibit compared the art of self-taught American painters to that of European naives such as French artist Henri Rousseau, who had earned the respect of his European modernist contemporaries for his intuitive abstraction of form. Both the French and the American contributors to the catalogue eulogized the "popular painters" for the expression of simple feeling in simple form, an exercise of the human touch which they believed contemporary artists would do well to emulate: "Despite the complicated machinery of these [modern] forces, the common people have preserved their integrity, their fecundity and their genuineness: taking pleasure near at hand, taking their inspiration in the actual universe, in all that lies about them, in reality and nature. . . [The masters of popular painting] are painters of all week, of every week, of eternity." Jean Cassou, "Preface," *Masters of Popular Painting: Modern Primitives of Europe and America* with text also by Holger Cahill, Maximilian Gauthier, Dorothy C. Miller, and others, (1938; reprint, New York: Arno Press, 1966), 16.

59 The 1920s effervescence of African American creativity in arts and letters, which became known as the Harlem Renaissance, awakened white America's awareness of blacks as both ethnic artists of distinctive character and as original contributors to the mainstream culture. African American art continued to excite support from progressive white cultural leaders through the Depression era and the administration of Franklin Roosevelt. Roosevelt's federal arts grants and programming encouraged focus upon the diversity of the ethnic and regional identities to be encompassed by the term "American." Among the projects created by the WPA Writer's Project administered by Roosevelt aide Harry Hopkins was the *American Guide Series* and the *Life in America Series* which emphasized the positive strengths to be derived from cultural diversity in the United States. These projects devoted considerable effort to the gathering and recording of folklore, particularly black folklore, but also a myriad of other ethnic customs and popular literature. See Marcus Klein, *Foreigners: The Making of American Literature 1900-1940* (Chicago: University of Chicago Press, 1981), for documentation of the period's federal and individual efforts to expand the definition of "American" to encompass the cultures of new immigrants and of long-established non-Anglo groups.

60 Tepfer, 235-39, documents Halpert's leadership in giving recognition to the cultural contributions of the African American artist.

61 Letter [name withheld] to Elizabeth Navas, dated 31 July 1944. Navas Papers, WAM.

62 Letter from Beatrice von Keller, acting director of fine arts, Virginia Museum of Fine Arts, Richmond, to Elizabeth Navas, dated 21 August 1944. Navas Papers, WAM.

Popular Painting: Modern Primitives of Europe and America not only asserted the fine arts status of an unlearned intuitive vision, it also proclaimed the significance of art produced by hitherto ignored racial minorities.[59]

Edith Halpert and Elizabeth Navas both belonged to that circle of New York intellectual and civic leaders whose progressive artistic and social agendas often overlapped. As a part of her personal mission to teach Americans to appreciate and buy American art, Halpert aggressively promoted recognition of the contribution made by African Americans to the enrichment of American art.[60] In December 1941, Halpert opened the *American Negro Art* exhibition of approximately seventy-five 19th- and 20th-century examples of painting, sculpture, and graphics at the Downtown Gallery. Just as she had insisted upon an indigenous foundation for American modernism in the example of American folk art, Halpert also contended that the black artist was not a contemporary novelty, but a native son who had a long, albeit little acknowledged, history in America. Her show incorporated not only examples of "primitives" but also works by professionally trained African American artists such as Edward M. Bannister, Robert S. Duncanson, William Simpson, and Henry Ossawa Tanner.

Navas understood very clearly that when she purchased Horace Pippin's *West Chester, Pennsylvania* from the artist's 1944 one-man show at the Downtown Gallery she was expanding the Murdock Collection's racial definition of "American" artist. Not long after the acquisition had been announced, Navas received a letter from Wichita expressing qualms about the wisdom of showing a work by a "Negro artist" in the Wichita Art Museum. The writer, the wife of a prominent city official, feared that the showing of the Pippin painting might entice "colored people" to

come to the museum, and that such patronage would likely scare away white patrons and thus end support for WAM. Suggesting that she had uncovered some reports of relevant problematic situations elsewhere in the nation, the would-be advisor concluded that she had written to "*Public* art museums around the country," and that the "replies were very interesting."[61]

Given this challenge, Navas fired off a letter to the director of the Virginia Museum of Fine Arts, Richmond, to inquire about that museum's policy of collecting works by black artists. She had already determined her course but was no doubt pleased to receive vindication from Beatrice von Keller, acting director of fine arts, that "colored artists and institutions" had been participants in the Virginia Museum of Fine Arts since its founding as a state institution in 1936.[62] Navas later acquired works by other artists who were valued for their distinctively American pluralism of lineage, such as African American Jacob Lawrence and Japanese American Yasuo Kuniyoshi.[63] That she shared in her era's pluralistic conception of American civilization is revealed in an introductory text which she prepared for the installation of the Roland P. Murdock Collection in 1960. She declared, "American heritage derives from many ancestral sources. . . [and] geographically, [from] various sections of the country."[64]

She would have concurred, as always, with her good friend and mentor, Lloyd Goodrich, who reflected that the pluralism of American art was "fitting expression of a democratic society, free and fluid, allowing wide scope to individualism."[65]

Navas and her contemporaries spoke confidently to the existence and triumph of an American art spirit. Artists and critics alike embraced the idea that the American spirit resided in the common particulars of the people and the land. The

realist interpreted this ideal as a moral imperative to register the human pulse of the nation in portrayals of ordinary life in every precinct from the big city streets to the primitive villages in remote corners of the continent. The American modernist "kept the faith," as Navas herself once phrased it,[66] by reaching down within the self, as the American folk artist had done, for intuitive responses to nature and to the human condition.

The exhibition *Toward An American Identity: Selections from the Wichita Art Museum* and this book honor the vision of Louise Caldwell Murdock and Elizabeth Stubblefield Navas, who acted upon the conviction that art may teach us where we have been and who we are. Their concep- tion of what defined an American suffered, as do all such efforts at universal character- ization, from the limitations of their time. Yet we cannot help but admire them for the courage to believe that art mattered and for the generosity to see the making of American identity as an ongoing enter- prise.

[63] In 1949, when Navas pur- chased the first of four works by Kuniyoshi in the Murdock Collection, she did so in the con- text of critical appreciation of the artist's "fortuitous union of American folk art, modernism, and Oriental sensitivity." Lloyd Goodrich, *Yasuo Kuniyoshi* (New York: Whitney Museum of American Art, 1948), 47.

[64] Navas, draft of "Installation Gallery, Wichita Art Museum," ca. December 1960. Navas Papers, WAM.

[65] Lloyd Goodrich, "What is American in American Art, Common Denominators from the Pilgrims to Pollock," *Art in America* 51, no. 4 (August 1963): 39.

[66] Navas, inaugural address to Wichita Art Museum audience, 8 November 1940, p. 2. "Nationality is *not only* a matter of birth and politics, in Art it is primarily a matter of environment. The artist is required only to *keep faith* with the *American spirit* for it is this alone which shall brand his art as American." Navas Papers, WAM.

"THAT OUR SOIL WILL PRODUCE THE ARTIST"

American Landscape Painting and National Identity, ca. 1890-1950

DAVID CATEFORIS

The permanent collection of the Wichita Art Museum offers a rich array of American landscape painting from the late 19th century to the middle of the 20th century. No sweeping account of the stylistic and thematic development of American art during that period can hope to encompass the broad range of individual expression seen in the Wichita collection, which spans the stylistic spectrum from the highly illusionistic to the completely non-representational, while embracing a wide range of subjects, from the rocky shores of New England to the soaring skyscrapers of Manhattan, the fertile fields of Kansas, and the rugged mountains of New Mexico. If there is an essential commonality among these works it is to be found not in style or in subject matter but in the artists' generally shared attitude toward the creation of national identity in art. Most of these artists believed that their work was fundamentally rooted in the American land, and that this connection to the land provided their art with its distinctly American qualities.

The belief in the American land's capacity to shape the national character has long been cherished in American cultural history. It was eloquently expressed in the middle of the 19th century by the minister E. L. Magoon, who observed:

The diversified landscapes of our country exert no slight influence in creating our character as individuals, and in confirming our destiny as a nation. Oceans, mountains, rivers, cataracts, wild woods, fragrant prairies, and melodious winds, are elements and exemplifications of that general harmony which subsists throughout the universe. . . . Grand natural scenery tends permanently to affect the character of those cradled in its bosom, is the nursery of patriotism the most firm and eloquence the most thrilling.[1]

During the middle decades of the 19th century, this belief found powerful expression in the work of American landscape painters, who celebrated American nature as the repository of the moral, religious, and political ideals of the young American nation. Hudson River School painters such as Thomas Cole, Asher B. Durand, Jasper Francis Cropsey, and Frederic Edwin Church exalted the Edenic beauty of the wild forests, streams, rivers, and mountains of the Northeastern United States, as well as the pastoral harmony of lands newly settled and cultivated by white homesteaders (Cole, *View of Schroon Mountain, Essex County, New York, After a Storm*, 1838, Cleveland Museum of Art, fig. 1). Nature was for the Hudson River School painters not only a source of spiritual inspiration, but also a wellspring of

For their helpful comments on earlier drafts of this essay, I am grateful to Novelene Ross, Donna Gustafson, and Charles Eldredge. I also wish to thank my students at the University of Kansas, whose names appear at the front of this volume, for their research and writing on the Wichita collection, which has done much to stimulate and inform my own understanding of the pictures under discussion here.

DAVID CATEFORIS
Assistant Professor, Kress Foundation Department of Art History, University of Kansas

OPPOSITE
CHILDE HASSAM
(1859-1935)
The Birches, 1891
Pastel on board, 22 x 18 in.
John W. and Mildred L. Graves
Collection, 1993.1, detail
(catalogue entry, page 147)

1 Thomas Cole, (1801-1848) *View Of Schroon Mountain, Essex County, New York, After a Storm*, oil on canvas, 1838, 39⅜ x 63 in., ©The Cleveland Museum of Art, 1997, Hinman B. Hurlbut Collection, 1335.1917.

[1] E. L. Magoon, "Scenery and Mind," in *The Home Book of the Picturesque; or American Scenery, Art, and Literature* (1852; reprint, Gainesville, Fla.: Scholars' Facsimiles and Reprints, 1967), 3, quoted in Angela Miller, *The Empire of the Eye: Landscape Representation and American Cultural Politics, 1825-1875* (Ithaca: Cornell University Press, 1993), 8.

[2] For a classic expression of these sentiments, see Thomas Cole, "Essay on American Scenery," *American Monthly Magazine,* New Series, I (January, 1836): 1-12, reprinted in John McCoubrey, ed., *American Art 1700-1960: Sources and Documents* (Englewood Cliffs, N.J.: Prentice-Hall, 1965), 98-110.

[3] For this and the following, see Doreen Bolger Burke and Catherine Hoover Voorsanger, "The Hudson River School in Eclipse," in *American Paradise: The World of the Hudson River School* (New York: Metropolitan Museum of Art, 1987), 71-90.

national pride; they found the fresh, raw beauty of the American wilderness implicitly superior to the long-inhabited landscapes of Europe, and invested unimproved American nature with hopes for future national greatness.[2] As settlement expanded toward the Pacific artists such as Albert Bierstadt and Thomas Moran traveled west to depict the stirring scenery of the Rocky Mountains and Sierra Nevadas, endorsing through their heroically-scaled canvases the ideology of Manifest Destiny, which justified the creation of an American empire stretching "from sea to shining sea." (Bierstadt, *The Domes of the Yosemite,* 1867, St. Johnsbury Athenaeum, St. Johnsbury, Vermont, fig. 2)

With the closing of the frontier in the late 19th century, wild nature lost its power to symbolize the nation's future, and the Hudson River and Rocky Mountain Schools fell rapidly into decline.[3] Artistic nationalism gave way to an increasingly cosmopolitan orientation, as American patrons began avidly to collect European art, and increasing numbers of American artists went abroad to seek academic training in such centers as London, Paris, and Munich. Many remained in Europe for several years, painting European subjects and exhibiting in the European salons.

And when they came home to the United States, they brought their European training and perspective with them.

Many American painters who studied in France in the 1880s came into contact with the work of the French Impressionists, and quite a few Americans adopted the Impressionist style themselves. Upon returning from France American Impressionists such as Theodore Robinson, J. Alden Weir, John Twachtman, Childe Hassam, and Willard Leroy Metcalf painted American scenery in the manner of the French *plein air* painters Monet, Renoir, and Pissarro. Working directly from nature, they employed high-keyed color, broken brushstrokes, and informal compositions to capture the fleeting effects of light and atmosphere in the open air.

Eschewing the dramatic wilderness scenes favored by the painters of the Hudson River and Rocky Mountain Schools, these American Impressionists rendered modest views of the towns, countryside, and coastline of New England. Each of their canvases recorded a specific place, known intimately through personal experience. Among the most distinguished American Impressionist images are John Twachtman's subtle winter landscapes, painted in the 1890s on his farm in

Greenwich, Connecticut (e.g., *Falls in January,* ca. 1895, page 253), and Childe Hassam's serene, sun-lit coastal scenes, painted on the Isles of Shoals off the shores of New Hampshire (e.g., *Jelly Fish,* 1912, page 148). Hassam also produced numerous views of New York City, captured under a variety of seasonal and atmospheric conditions (e.g., *Union Square in Spring,* 1896, Smith College Museum of Art, Northampton, Massachusetts, fig. 3), establishing an American Impressionist cityscape tradition carried on well into the 20th century by his followers such as Guy Carlton Wiggins (e.g., *Looking Down Fifth Avenue,* ca. 1947, page 257).

Despite the foreign origin of the American Impressionists' aesthetic, many American critics recognized a distinctive national note in their work. Among the earliest to find in American Impressionism an authentically native form of artistic expression was Hamlin Garland, whose 1894 essay, "Impressionism," praised the rise of Impressionism in the art of numer-ous nations, including the United States, which Garland saw in the international art exhibition at the 1893 World's Columbian Exposition in Chicago. Garland, a Midwestern author, advocated a form of literary naturalism he called veritism, which held that writers should describe the people, places, and social conditions they knew best. Adapting this literary principle to painting, Garland lauded the American Impressionists' commitment to painting familiar and directly observed local scenes, rather than imported ones. It was Garland's conviction that "art, to be vital, must be local in its subject; its universal appeal must be in its working out, in the way it is done. Dependence upon the English or French groups is alike fatal to fresh, individual art."[4]

Here Garland sounded a theme that would be repeated continually over the next several decades by American artists and critics—namely, that a national art could only be produced by American artists responding directly to specific

[4] Hamlin Garland, "Impressionism," in Garland, *Crumbling Idols: Twelve Essays on Art Dealing Chiefly with Literature, Painting, and the Drama,* ed. Jane Johnson (Cambridge, Mass.: Harvard University Press, 1960), 104.

2 Albert Bierstadt, (1830-1920) *The Domes Of The Yosemite,* oil on canvas, 1867, St. Johnsbury Athenaeum, St. Johnsbury, Vermont. Photograph ©Jenks Studio of Photography, 1997.

3 Childe Hassam, *Union Square In Spring*, oil on canvas, 1896, 21½ x 21 in., Smith College Museum of Art, Northampton, Massachusetts.

5 Hippolyte Taine, *Lectures on Art,* first series, trans. John Durand (New York: Henry Holt, 1875), 34.

6 Ibid., 89.

7 Garland, 104.

8 Childe Hassam quoted in A.E. Ives, "Talks with Artists: Mr. Childe Hassam on Painting Street Scenes," *Art Amateur* 27 (October 1892): 116-17, reprinted in Ulrich W. Hiesinger, *Childe Hassam: American Impressionist* (Munich: Prestel-Verlag, 1994), 180. I am grateful to Raechell Smith for her help in obtaining this reference.

American locales, while avoiding European influences. Garland's belief that authentic and vigorous art grew out of direct contact with the local environment was influenced by the French philosopher Hippolyte Taine, who viewed art as the organic product of *race, milieu,* and *moment.* Taine held that the "productions of the human mind, like those of animated nature, can only be explained by their *milieu.*"[5] He went on to compare works of art to plants and flowers "developed and propagated in a certain soil."[6] Taine's organic theory of art exerted a powerful influence on many American artists and critics of the late 19th and early 20th centuries, including not only Garland but also Robert Henri, Thomas Hart Benton, and Thomas Craven.

Garland praised the American Impressionists not only for painting local places but also for painting the present, rather than the past. "The Impressionist is not an historical painter, he takes little interest in the monks and brigands of the Middle Ages," wrote Garland. "He does not feel that America is without subjects to paint because she has no castles and donjon keeps. He loves nature, not history."[7] In another context, Childe Hassam observed that by recording the present and the local, he and the other American Impressionists were, in effect, painting history: "I believe the man who will go down to posterity is the man who paints his own time and the scenes of everyday life around him. . . . A true historical painter. . . paints the life he sees about him, and so makes a record of his own epoch."[8]

Robert Henri, the leader of a rebellious group of young urban realists, agreed completely with Hassam's viewpoint, declaring: "If you want to be a historical painter, let your history be of your own time, of what you can get to know personally—of manners and customs within your own experience."[9] Henri's experience encompassed the everyday life of New York City, which he and his colleagues George Bellows, William Glackens, George Luks, Everett Shinn, and John Sloan began to record enthusiastically in the opening years of the 20th century. Unlike Hassam and other American Impressionists, who sought primarily to capture aesthetic effects of light and atmosphere, Henri and his friends focused on the daily activities of the urban populace (Henri, *Street Scene with Snow [57th Street, NYC]*, 1902, Yale University Art Gallery, Mabel Brady Garvan Collection, fig. 4). Instead of the flickering brushwork and bright colors of Impressionism, they painted with a dark palette and bold stroke inspired by the art of Hals, Velázquez, and Manet. By these means they sought to express the democratic vitality they sensed in New York's teeming streets and parks, markets and harbors, bars and beaches. Their refusal of the genteel conventions of both academic and Impressionist art and their predilection for lower class subject matter eventually earned for Henri and his followers the nickname of the "Ashcan School."

Because their art was based in their personal experience of the American life

[9] Robert Henri, *The Art Spirit* (Philadelphia: J.B. Lippincott, 1960), 218.

4 Robert Henri, *Street Scene With Snow (57th Street, NYC)*, oil on canvas, 1902, 26 x 32 in., Yale University Art Gallery, Mabel Brady Garvan Collection.

surrounding them, the Ashcan artists believed that they were producing an indigenous American art. Like Hamlin Garland, Henri held that a national art would inevitably arise from the artist's interaction with his or her local environment. In this view Henri followed such 19th-century thinkers as Ralph Waldo Emerson, Walt Whitman, and Leo Tolstoy, who called on artists to respond to the societies in which they lived, and Taine, who understood art as a product of the social and environmental conditions in which it was created.[10] Evoking an organic metaphor clearly derived from his reading of Taine, Henri declared:

it is not possible to create an American art from the outside in. For successful flowering it requires deep roots, stretching far down into the soil of the nation, gathering sustenance from the conditions in the soil of the nation, and in its growth showing, with whatever variation, inevitably the result of these conditions. And the most showy artificial achievement, the most elaborate imitation of art grown in France or Germany, are valueless to a nation compared with this product that starts in the soil and blooms over it.[11]

Notwithstanding his invocation of the indigenous soil as the source of national character in art, Henri was after 1902 primarily committed to painting American people rather than the American landscape (e.g., *Eva Green,* page 151). Meanwhile, the other Ashcan painters were attracted to a new kind of landscape—that of the modern metropolis, which provided an architectural setting for contemporary human drama. John Sloan, a self-described "spectator of life," took long walks around New York City and recorded in his diary the memorable scenes of human interest he witnessed. These impressions then served as the basis for paintings, drawings, and etchings of urban genre subjects (e.g., *Indians on Broadway,* page 240).

Sloan typically executed his urban images in the studio, working from memory or from sketches, but between 1906 and 1910 he also painted about fifty small oil studies directly from nature.[12] In these he sought to record spontaneously his experience of a particular place at a particular moment, much as the American Impressionists had done. *Hudson Sky* (1908, page 238) was likely based on an oil sketch Sloan made at Coytesville, New Jersey, from a high point on the banks of the Hudson River. The scene looks east over the Palisades towards the dark green hills of northern Manhattan, surmounted by an impressive sky filled with banks of white stratus clouds. Sloan provides little indication that this is in fact a suburban location; the diminutive ship moving up the river is unobtrusive, and the visible section of Manhattan displays surprisingly few hints of urban development. Sloan's interest clearly lies in the fresh and open atmosphere of the landscape itself.

Like his friend Sloan, George Bellows sought to convey a specific sense of place in his paintings of New York City and of the New England coast. *The Skeleton* (1916, page 95) depicts a stretch of the rocky shore of Camden, Maine, surveyed from a point out on the water. The focal point of the composition is the enormous wooden hull of a ship under construction, which dwarfs the small manned rowboat in the foreground. Looming behind the ship's skeleton are massive green-brown hills, surmounted by a dramatic, dark blue sky. Bold colors and vigorous brushwork charge the scene with robust physical power.

Eulogizing Bellows in 1925, Frank Crowninshield noted approvingly that this quintessentially American artist had never traveled to Europe. Crowninshield suggested that the power of Bellows's work came from its rootedness in the American environment: "All of his reactions, all of his

[10] Matthew Baigell, "American Art and National Identity: The 1920s," *Arts Magazine* 61 (February 1987): 48. See also Joseph J. Kwiat, "Robert Henri and the Emerson-Whitman Tradition," *PMLA* 71 (September 1956): 617-36.

[11] Robert Henri, "Progress in Our National Art Must Spring from the Development of Individuality of Ideas and Freedom of Expression: A Suggestion for a New Art School," *Craftsman* 15 (January 1909): 388.

[12] Rowland Elzea and Elizabeth Hawkes, *John Sloan: Spectator of Life* (Wilmington: Delaware Art Museum, 1988), 108.

emotional qualities, were derived from America; from the soil, sky, wind and water which he knew and observed so well."[13] As further evidence of the painter's uncorrupted Americanism, Crowninshield pointed to Bellows's "imperviousness" to the influences of Post-Impressionism, Fauvism, Cubism, Futurism and other modern European movements which had "descended like a thunderclap upon American art" at the 1913 Armory Show.[14] A watershed event in the history of American art, the Armory Show was the first large-scale introduction of European modernism to the United States. Even though the Armory Show was organized by American artists, and despite the fact that three quarters of the approximately 1300 works on view were by Americans, the lion's share of attention was captured by the work of European innovators such as Cézanne, Gauguin, van Gogh, Matisse, Picasso, Braque, Léger, Delaunay, Duchamp, Picabia, Kandinsky, Lehmbruck, and Brancusi.

The Armory Show culminated efforts to foster modernism in the United States that had already been undertaken by Alfred Stieglitz, the avant-garde photographer who since 1905 had operated the Little Galleries of the Photo-Secession, known as 291 for their Fifth Avenue address. Beginning in 1908, Stieglitz exhibited at 291 the work of European modernists such as Rodin, Cézanne, Matisse, Rousseau, and Picasso. In 1909, Stieglitz also started to exhibit the work of the emerging American modernists, most of whom had traveled to Paris to gain first-hand exposure to the new European work. Among the American modernists to have their first exhibitions at 291 in the years before the Armory Show were Arthur B. Carles, Arthur G. Dove, Marsden Hartley, John Marin, Alfred Maurer, and Max Weber. The last show held at 291 before Stieglitz closed the gallery in 1917 featured the work of Georgia O'Keeffe, who in 1924 would become Stieglitz's wife.

Stieglitz hoped that the advanced European work he displayed at 291 would stimulate the development of a vital and independent American art. The principal organizers of the Armory Show, Walt Kuhn, Walter Pach, and Arthur B. Davies, held similar hopes, but in the eyes of many observers, the Armory Show had a different effect—it showed how tame and timid the work of the Americans was compared with the radical innovations of the European modernists. Critic Randolph Bourne, for example, viewed the exhibition as an appalling example of "our cultural humility before the civilizations of Europe," staged "with the frankly avowed purpose of showing American artists how bad they were in comparison with the modern French."[15] Bourne called for an end to such "groveling" and for the recognition of "a national spirit" in American art, "as superbly clear and gripping as anything the culture of Europe has to offer us, and immensely more stimulating, because of the very body and soul of to-day's interests and aspirations."[16]

As the decade progressed, calls for an American cultural awakening resounded in the pages of journals such as *The New Republic, The Dial,* and *The Seven Arts.* Van Wyck Brooks, an influential literary critic, spoke for many when he expressed the belief that the renewal of American culture could be brought about only through the forging of an organic relationship between the American artist and his environment. Influenced, as Robert Henri had been, by Emerson and Whitman, Brooks believed that a great national art would be created by artists working within American communities and instinctively communicating through their art the spirit of those communities. And, also like Henri, Brooks employed organic metaphors in support of this view, as, for

[13] Frank Crowninshield, "Introduction," *Memorial Exhibition of the Work of George Bellows* (New York: Metropolitan Museum of Art, 1925), 13.

[14] Ibid., 14.

[15] Randolph S. Bourne, "Our Cultural Humility," *Atlantic Monthly* 114 (October 1914): 506.

[16] Ibid., 507.

17 For this particular organic metaphor see Van Wyck Brooks, "Toward a National Culture," *Seven Arts* 2 (March 1917): 535-47. In the opening paragraph (535), Brooks writes of the "pallid and wizened" American Rhodes scholars he encounters at Oxford: "It is a barren soil these men have sprung from, plainly they have never known a day of good growing weather." A bit later on (539), the author laments the absence of a "sympathetic soil" for the sustenance of American artists. Brooks's imagery recalls Henry James's lament: "The soil of American perception is a poor little barren artificial deposit!" James, "The Madonna of the Future" (1874), in *The Complete Tales of Henry James,* ed. Leon Edel (Philadelphia: J.B. Lippincott, 1962), 3:15.

18 R. J. Coady, "American Art," *Soil* 1 (December 1916): 3, 4.

19 *Contact* 1 (December 1920): 1.

20. Alfred Stieglitz, letter to Paul Rosenfeld, 5 September 1923, quoted in Matthew Baigell, "American Landscape Painting and National Identity: The Stieglitz Circle and Emerson," *Art Criticism* 4 (1987): 32.

21 See William Innes Homer, *Alfred Stieglitz and the American Avant-Garde* (Boston: New York Graphic Society, 1977), 262.

example, when he likened artists to plants that could thrive only if nurtured by a rich soil.[17] Through its name alone, *The Soil,* a short-lived avant-garde magazine founded in 1916 by Robert Coady, confirmed the currency of the organic view of American art. In his first editorial, Coady proclaimed:

> There is an American Art. Young, robust, energetic, naive, daring and big-spirited. . . . it is an expression of life—a complicated life—American life. The isms have crowded it out of "the art world" and it has grown naturally, healthfully, beautifully. It has grown out of the soil and through the race and will continue to grow.[18]

William Carlos Williams and Robert McAlmon, the editors of another little magazine, *Contact,* also espoused an organic point of view in announcing their "conviction that art which attains is indigenous of experience and relations. . . . We will be American, because we are of America."[19]

In this atmosphere of rising cultural nationalism, Alfred Stieglitz exchanged his earlier internationalist orientation for an exclusive commitment to the work of American artists. Stieglitz voiced his strong support for authentic native expression in a 1923 letter to the critic Paul Rosenfeld, wherein he argued against American art with a "French flavor."

> That's why I continued my fight single handed at 291—That's why I'm really fighting for Georgia [O'Keeffe]. She *is* American. So is Marin. So am I. Of course the world must be considered as a whole in the final analysis. That's really a platitude—so self understood. But there is America. —Or isn't there an America. Are we only a marked down bargain day remnant of Europe? —Haven't we any of our own courage in matters aesthetic?[20]

Stieglitz dedicated the Intimate Gallery, which he ran from 1925 to 1929,

to the work of "Seven Americans" including Dove, Hartley, Marin, O'Keeffe, the photographer Paul Strand, Stieglitz himself, and an unknown "X."[21] And Stieglitz announced explicitly his devotion to American art in the name of his last gallery, An American Place, which he operated from 1929 until his death in 1946.

From the beginning of their association with him, the American painters supported by Stieglitz faced the challenge of assimilating European vanguard influences without sacrificing their sense of American identity. John Marin drew stylistic sustenance from Cézanne, the Cubists, and the Futurists, but predicated his work not on the art of other painters but on a direct response to the American land. Like Walt Whitman, with whom he was often compared, Marin was enamored equally of the city and country, taking as his two great subjects the wind-swept coast of Maine and the towering skyscrapers of Manhattan.

While his realist contemporaries like Sloan and Bellows recorded incidents in the lives of New York City's inhabitants, Marin sought through more abstract, formally dynamic means to express the "great forces" he felt surging through the city's architectural fabric. "The whole city is alive," declared Marin in a 1913 statement,

> buildings, people, are all alive; and the more they move me the more I feel them to be alive. . . . I see great forces at work; great movements; the large buildings and the small buildings; the warring of the great and the small; influences of one mass on another greater or smaller mass. Feelings are aroused which give me the desire to express the reaction of these "pull forces," those influences which play with one another; great masses pulling smaller masses, each subject in some degree to the other's power. . . . And so I try to express graphically what a great city is doing. Within the frames there must be a balance,

controlling of these warring, pushing, pulling forces. This is what I am trying to realize.[22]

In the watercolor *Region, Trinity Church, NYC* (1926-36, page 194), with its teetering composition animated by tumbling diagonal lines and bursts of bold color, Marin gives exhilarating expression to the dynamic forces of the metropolitan environment.

Marin was equally captivated by the Maine coast, where he spent most of his summers from 1914 to the end of his life. There he painted pictures which he hoped would be "seething with the whole atmosphere of Maine."[23] Marin's *Cape Split* (1939-42, page 195), painted in cool hues of blue, white, grey, and tan, exudes an aura of invigorating freshness. Buoyancy and excitement are conveyed through spontaneous brushstrokes and the asymmetrical composition, which juxtaposes the highly abstracted forms of beach houses along the shore with the single white sailboat on the water. Slicing across the surface of the composition are several dark "ray lines"—stylistic devices derived by Marin from Futurism and intended to communicate a sense of vibrant energy coursing through matter.

American critics located the source of Marin's greatness in his organic connection to the American landscape. Writing of Marin's Maine watercolors in 1921, Paul Strand proclaimed:

His work attests frankly to a conscious recognition on his part that he is rooted in this American continent. The rocks and hills of Maine, its turbulent icy seas, its vast skies, claim his love inevitably. . . . This is Maine and nowhere else. It is America and nowhere else. We are made to experience something which is our own, as nothing which has grown in Europe can be our own. We are taken up bodily . . . and are shoved into the core of our own world— made to look at it.[24]

Strand's characterization of Marin as organically rooted in the American land was often repeated. Paul Rosenfeld, for example, described Marin as "fast in American life like a tough and fibrous apple tree lodged and rooted in good ground."[25] Stieglitz said of Marin: "He does not set out consciously to paint things American but he does so necessarily, because he himself is of the soil."[26] Marin himself used the image of soil in a broadly nationalistic manner: "It is a legitimate hope," he declared, "that our soil will produce the artist."[27] He also observed: "When we grow potatoes in this country we use American soil and when we paint pictures I guess we use something like it."[28]

Marsden Hartley came as well to emphasize the need for an organic connection between the American painter and his environment. After experimenting with abstraction in the mid-1910s under the influence of the Cubists and Kandinsky, whose work he had encountered during a three-year European sojourn, Hartley returned to a more realistic mode of painting during a trip to New Mexico in 1918-19 (e.g., *New Mexico Landscape,* 1919, Frederick R. Weisman Art Museum, University of Minnesota, Minneapolis, fig. 5). In an essay he wrote at this time Hartley called for "a sturdier kind of realism, a something that shall approach the solidity of the landscape itself, and for the American painter the reality of his own America as Landscape."[29] Contact with the environment was, for Hartley, essential for the creation of a vital and authentic American art. "The painters will somehow have to acquaint themselves with the idea of America as landscape, as a native productive space before they can come to conclusions which will have any worth whatsoever among artists of America and the world."[30]

Notwithstanding this nativist declara-

22 John Marin, statement written for his 1913 exhibition at 291, published as "Water-colors by John Marin," *Camera Work* 42-43 (April-July 1913): 18.

23 John Marin, letter to Alfred Stieglitz, October 1919, in *The Selected Writings of John Marin,* ed. Dorothy Norman (New York: Pellegrini and Cudahy, 1949), 51.

24 Paul Strand, "American Watercolors at the Brooklyn Museum," *Arts* 2 (December 1921): 151, 152.

25 Paul Rosenfeld, *Port of New York: Essays on Fourteen American Moderns* (New York: Harcourt, Brace and Company, 1924), 153.

26 Alfred Stieglitz, conversation of 27 January 1926, in Herbert J. Seligmann, *Alfred Stieglitz Talking: Notes on Some of His Conversations, 1925-1931* (New Haven: Yale University Library, 1966), 28.

27 John Marin, "Guest Editorial," *The Palisadian,* 15 November 1940, reprinted in *The Selected Writings of John Marin,* 196.

28 John Marin, art column in the *New York Herald Tribune,* 18 October 1936, quoted in *John Marin on John Marin,* ed. Cleve Gray (New York: Holt, Rinehart, and Winston, 1970), 128.

29 Marsden Hartley, "America as Landscape," *El Palacio* 7 (December 1918): 340.

30 Ibid., 342.

5 Marsden Hartley, *New Mexico Landscape*, oil on canvas, 1919, 18⅛ x 24⅛ in., Collection Frederick R. Weisman Art Museum at the University of Minnesota, Minneapolis, Bequest of Hudson Walker from the Ione and Hudson Walker Collection.

31 Hartley's return to Maine was predicted by Paul Rosenfeld, who wrote in 1924: "Some day, perhaps some day not so far distant, Hartley will have to go back to Maine. For it seems that flight from Maine is in part flight from his deep feelings. It was down east that he was born and grew and lived a great many of his years. There dwell the people to whom he is closest akin; there is the particular landscape among which his decisive experiences were gotten; there every tree and mountain wall is reminiscent of some terrible or wonderful day. And when he has to make his peace with life, it is to this soil, so it would appear, that he must return." *Port of New York,* 99-100.

32 Marsden Hartley, "On the Subject of Nativeness—A Tribute to Maine," in Hartley, *On Art,* ed. Gail R. Scott (New York: Horizon Press, 1982), 114.

33 Ibid., 115.

34 On the importance of Homer's Prout's Neck paintings for Hartley's late work, see Bruce Robertson, *Reckoning with Winslow Homer: His Late Paintings and Their Influence* (Cleveland: Cleveland Museum of Art, 1990), 153-64.

tion, the restless Hartley spent much of the remainder of his life outside of the United States, working in France, Germany, Mexico, Bermuda, and Nova Scotia, with intermittent periods of residence in New York, New Hampshire, and Massachusetts. Always seeking but failing to maintain the sense of organic connection to a place, Hartley at last resolved to return to his native state of Maine, encouraged to do so in part by Marin's Maine pictures.[31] In a statement written for his 1937 exhibition at An American Place, Hartley lauded Maine's painters, composers, and poets, and identified the state's geography and wildlife as enduring sources of artistic inspiration:

> The Androscoggin, the Kennebec, and the Penobscot flow down to the sea as solemnly as ever, and the numberless inland lakes harbor the loon, and give rest to the angles of geese making south or north according to season, and the black bears roam over the mountaintops as usual. . . . the gulls remain the same and the rocks, pines, and thrashing sea never lose their power and their native tang.

Nativeness is built of such primitive things, and whatever is one's nativeness, one holds and never loses no matter how far afield the traveling may be. [32]

Concluding on a Tainean note, Hartley proclaimed: "This quality of nativeness is coloured by heritage, birth, and environment, and it is therefore for this reason that I wish to declare myself the painter from Maine."[33]

Among the earlier Maine artists Hartley singled out for praise was Winslow Homer, a Bostonian by birth who spent the last twenty-four years of his life at Prout's Neck on the Maine coast, painting powerful images of the rugged shoreline.[34] Homer's influence is felt in Hartley's *End of the Hurricane* (1938, page 145), which pictures surging waves pounding jagged rocks in the aftermath of a storm—a theme frequently depicted by Homer, but treated by Hartley with greater simplicity and forcefulness. Employing a bold pictorial style appropriate to the subject of "the thrashing sea," Hartley paints with rough brushstrokes and stark light and dark contrasts, setting somber blacks and browns

against brighter whites and blue-grays. As the dark, toothy diagonals of the shoreline rocks climb from the lower left, the wall of white sea spray rises above them, obscuring much of the sky and flattening out the pictorial space. At the lower right, a battered lobster trap, tossed upon the rocks by the swelling waves, reminds us, as Homer's work often does, of nature's power to overwhelm helpless humanity.

In contrast to the peripatetic Hartley, Arthur Dove went abroad only once, for an eighteen-month period of study in France in 1908-9; the rest of his life he resided in rural areas of Connecticut and New York State, living close to nature and supporting himself and his family by farming or tending yachts. Dove's French sojourn provided him with exposure to the work of Cézanne and Matisse, and his involvement with the Stieglitz circle gave him an awareness of Cubism. But Dove developed a distinctive mode of abstraction that owed little to European sources, basing his work on a personal response to nature and intuitively transforming natural motifs into simplified, organic shapes. While some of Dove's pictures, such as *Sunrise in Northport Harbor* (1929, page 128), communicate a tangible sense of place, his work more typically symbolizes celestial rhythms and biotic processes through abstract compositions of line, plane, and color, as in *Forms Against the Sun* (ca. 1926, page 127), and *High Noon* (1944, page 131).

Critics routinely invoked organic images of land and soil to praise Dove's work. Paul Rosenfeld, in characteristic fashion, observed that "there is not a pastel or drawing or painting of Dove's that does not communicate some love and direct sensuous feeling of the earth."[35] Georgia O'Keeffe called Dove "the only American painter who is of the earth," and suggested that his art grew directly out of intimate contact with his environment: "Dove comes from the Finger Lakes region. He was up there painting, doing abstractions that looked just like that country, which could not have been done anywhere else."[36] Dove himself employed a farming metaphor in explanation of his art, writing, "it is the growing of ideas into facts that is the sort of agriculture that interests me most. . . . That goes toward what is meant by modern painting. It is the human laboratory making research into life and all human thought and emotion to find young healthy plants that can stand the test of growing among the things that are lasting through the ages."[37]

Like Dove, Hartley, and Marin, Georgia O'Keeffe found her primary artistic inspiration in nature. She expressed her passion for natural forms and energies in her innovative organic abstractions, close-up images of flowers, leaves, shells and bones, and landscapes of the Texas Panhandle, Lake George, and New Mexico. Notwithstanding her love of nature, O'Keeffe also devoted herself to painting that most inorganic of subjects, New York City, during a four-year period beginning in 1925. In that year, O'Keeffe moved with Stieglitz into an apartment on the twenty-eighth floor of the Shelton Hotel, New York's first set-back skyscraper. She became fascinated by the towering new buildings of Manhattan, which she and others of her generation recognized as symbols of native invention and productive energy. Architect Claude Bragdon, for example, in 1925 called the skyscaper "a symbol of the American Spirit—restless, centrifugal, perilously poised" and "the only truly original development in the field of architecture to which we can lay unchallenged claim."[38]

O'Keeffe often would paint the skyscrapers from a low vantage point, so that they appear to soar heavenwards and loom over the viewer (e.g., *The Shelton with Sunspots*, 1926, The Art Institute of

[35] Rosenfeld, *Port of New York,* 168.

[36] Quoted in Barbara Haskell, *Arthur Dove* (Boston: New York Graphic Society, 1974), 118, 77.

[37] Arthur Dove, letter to Elizabeth McCausland, 1933, quoted in *The Artist in America* (New York: W.W. Norton and Company, 1967), 160, 169.

[38] Claude Bragdon, "The Shelton Hotel, New York," *Architectural Record* 58 (July 1925): 1.

6 Georgia O'Keeffe, *The Shelton With Sunspots*, oil on canvas, 1926, 49 x 31 in., The Art Institute of Chicago, gift of Leigh B. Block, 1985.206. Photograph ©1996, The Art Institute of Chicago. All rights reserved.

Chicago, fig. 6). These canvases evoke the vertiginous sensation of the pedestrian who looks up to find herself dwarfed by the towering urban monoliths. O'Keeffe's *East River No. 1* (1926, page 215) offers the opposing sensation of lofty detachment available to one who observes the city from above. Painted from the window of her apartment in the Shelton, O'Keeffe's oil surveys a long horizontal strip of the industrial shore of Manhattan, the East River beyond it, and the smog-shrouded shore of Queens in the distance. The diminutive factories and warehouses are mute and inaccessible; the monochrome palette of white, black, and gray provides no warmth or comfort. A subtle mood of melancholy permeates this cityscape, in contrast to the exuberance of O'Keeffe's celebrated leaf and flower paintings of the same decade.

While O'Keeffe would shortly turn away from the city as an artistic subject, many of her contemporaries in the 1920s and 1930s embraced urban architecture and industrial machinery as dynamic expressions of the new American spirit. Their generally shared attitude was announced in a 1927 statement by the artist Louis Lozowick, "The Americanization of Art." "The history of America," declared Lozowick, "is a history of gigantic engineering feats and colossal mechanical construction." With Whitmanesque zeal, Lozowick proclaimed: "The skyscrapers of New York, the grain elevators of Minneapolis, the steel mills of Pittsburgh, the oil wells of Oklahoma, the copper mines of Butte, the lumber yards of Seattle give the American industrial epic in its diapason." But Lozowick recognized that the American environment "is not in itself art but only raw material which becomes art when reconstructed by the artist according to the requirement of aesthetic form." He warned artists not to "attempt a literal soulless transcription of the American scene," but called on them to "give a penetrating creative interpretation of it, which, while including everything relevant to the subject depicted, would exclude everything irrelevant to the plastic possibilities of that subject."[39]

Lozowick's words found their visual expression in his own paintings and prints (e.g. *New York,* ca. 1925-26, Walker Art Center, fig. 7) and in the works of numerous other American artists of the 1920s and 1930s such as Charles Sheeler, Charles Demuth, Niles Spencer, and Ralston Crawford. Because of their tendency to work with simplified forms, crisply defined edges, smooth brushwork, and unmodulated colors, these painters became known as Precisionists. Eagerly responding to the realities of the new American machine age, the Precisionists devoted much of their effort to the depiction of urban and industrial landscapes. In their canvases, the skyscraper and the factory replaced the mountain and the forest as emblems of national pride and identity. The leading Precisionist artist, Charles Sheeler, for example, celebrated modern American industry's power and productivity in a well-known series of photographs and paintings of the Ford Motor Company's River Rouge plant in Dearborn, Michigan. Sheeler's *American Landscape* (1930, Museum of Modern Art, New York, fig. 8), based on one of his photographs of the River Rouge complex, envisions the new national landscape—not without a touch of irony—as a clean and efficient environment of factory buildings and machinery, depicted in a crisp style of quasi-photographic objectivity.

The palpable sense of place created in *American Landscape* and other Sheeler canvases confirmed the artist's commitment to maintaining contact with American materials and the American environment. In the mid-1930s, Sheeler observed:

39 "The Americanization of Art," statement for catalogue of the Machine Age Exposition of May 1927, reprinted in Janet Flint, *The Prints of Louis Lozowick: A Catalogue Raisonné.* (New York: Hudson Hills Press, 1982), 18.

[40] Charles Sheeler papers, Archives of American Art, Smithsonian Institution, microfilm roll NSH 1, frame 102, quoted in Baigell, "American Art and National Identity: The 1920s," 51.

I have found that quite unconsciously the things which have to do with indigenous social necessities have for the most part claimed my interest For this reason, and despite the enjoyment of European visits, a prolonged residence abroad has never seemed desirable. It remains a persistent necessity that I should feel a sense of derivation from the country in which I live and work.[40]

While seeking always to maintain that feeling of contact with his native environment, in later pictures such as *Skyline* (1950, page 235), Sheeler exchanged photographic realism for a more abstract formal design based on planar geometry. Though *Skyline* still conveys Sheeler's admiration for a distinctive American locality—in this case, Manhattan, with its impressive profile of skyscrapers—its high degree of stylization generates less a sense of place and a greater emphasis on what Lozowick termed a "penetrating creative interpretation" of the American scene.

7 Louis Lozowick, (1892-1973) *New York,* oil on canvas, ca. 1925-26, 30⅜ x 22 in., Collection Walker Art Center, Minneapolis, Gift of Hudson D. Walker, 1961.

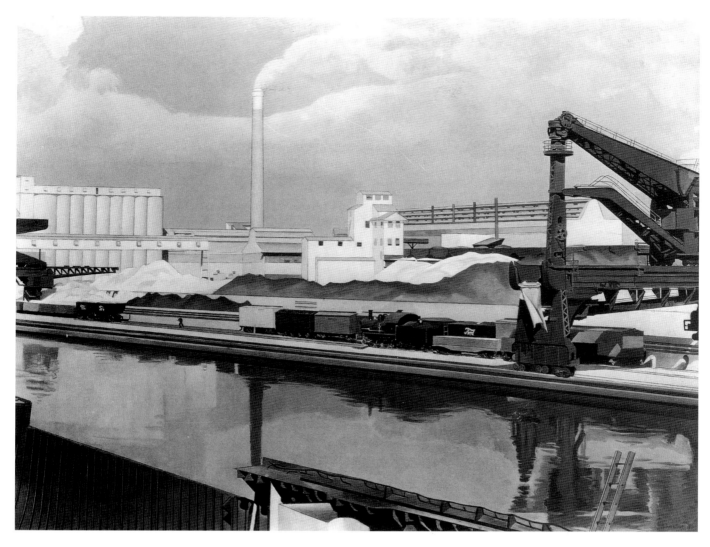

A great deal of Precisionist work shares this tendency towards abstraction from local source materials to achieve a more generalized pictorial statement. Charles Demuth's *Rise of the Prism* (1919, page 125), for example, transforms the particular atmosphere and scenery of Provincetown harbor into a refined cubist play of fractured space and transparent planes of color. Likewise, Ralston Crawford's *Section of a Steel Plant* (ca. 1936-37, page 113), a carefully engineered composition of crisp planes of color in a shallow, airless space, is derived from an actual steel plant in Coatesville, Pennsylvania, but more readily understood as a generic and idealized image of the American industrial landscape.

Charles Burchfield and Edward Hopper shared with their Precisionist con-temporaries a commitment to representing the American environment, but diverged from them in their choices of subject matter and style. While the Precisionists favored dynamic machine age subjects such as soaring skyscrapers and sprawling factories, Burchfield and Hopper were drawn to more modest and homely archi-tectural motifs such as anonymous, turn-of-the-century houses and nondescript urban storefronts. And while the Precisionists actively employed cubist-inspired methods of abstraction to produce stylized compositions, Burchfield and Hopper remained largely indifferent to European modernist developments and painted in more traditional realist modes.

In the latter half of the 1910s the young Burchfield painted romantic images of haunted houses and enchanted forests,

8 Charles Sheeler, *American Landscape,* oil on canvas, 1930, 24 x 31 in., The Museum of Modern Art, New York, Gift of Abby Aldrich Rockefeller. Photograph ©1997 The Museum of Modern Art, New York.

41 Edward Hopper, "Charles Burchfield: American," *Arts* 14 (July 1928): 5, 10.

42 Ibid., 6-7.

inspired by recollections of childhood fears and fantasies. He also painted bleak images of the scarred industrial landscape around his hometown of Salem, Ohio, such as *Abandoned Coke Ovens* (1918, page 98), whose eerie atmosphere of desolation contrasts sharply with the optimistic view of industry offered by the Precisionists in the 1920s and 1930s.

Around the time he moved to suburban Buffalo, New York in 1921, Burchfield began to produce more objective depictions of the drab streets of midwestern towns and cities, with their shops and houses huddled together under cheerless, cloud-filled skies (e.g., *Edge of Town,* 1921-41, Nelson-Atkins Museum of Art, Kansas City, Missouri, fig. 9). Animated by Burchfield's love-hate relationship with his native environment, these pictures exposed the depressing ugliness and banality of the midwestern urban landscape, while at the same time revealing the painter's powerful physical and emotional attachment to it.

In a 1928 appreciation, Edward Hopper praised Burchfield's "intensely emotional and personal vision of the American scene," and noted that Burchfield, who had never been to Europe,

produced an art that was "firmly rooted in the land."[41] Hopper was particularly impressed by Burchfield's rendition of "all the sweltering tawdry life of the American small town," and his images of "Our native architecture, with its hideous beauty, its fantastic roofs, pseudo-Gothic, French Mansard, Colonial, mongrel, or what not, with eye-searing color or delicate harmonies of faded paint, shouldering one another along interminable streets that taper off into swamps or dump heaps. . . "[42] Hopper was himself powerfully attracted to American vernacular architecture, and devoted much of his effort to representing the ordinary buildings of New York City, where he spent his winters, and the Victorian houses of the New England coastal towns where he spent his summers. Even more dispassionate than Burchfield in his response to the built environment, Hopper painted his buildings with a cold, clear light that banished all hints of romanticism.

A fine example of Hopper's mature style is the watercolor *Adam's House* (1928, page 155), painted in Gloucester, Massachusetts. Consciously avoiding the picturesque and the anecdotal, Hopper rendered the quiet corner of this small

9 Charles Burchfield, *Edge Of Town,* watercolor with touches of gouache over graphite on paper, 1921-41, 26¹⁵⁄₁₆ x 39¹³⁄₁₆ in., The Nelson-Atkins Museum of Art, Kansas City, Missouri, gift of the Friends of Art.

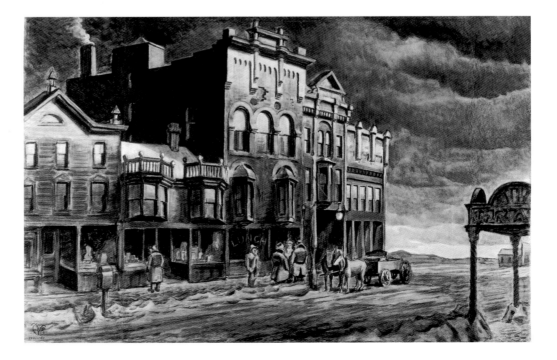

town street in all of its everyday banality, capturing, with characteristic directness, the effect of strong sunlight striking individual objects and defining their forms through light and shade. Each individual motif, from the telephone pole and fire hydrant to the tree, picket fence, and house, is treated as a discrete visual fact. The blank, silent face of the house and the marked absence of people on the street inject into the otherwise bright image an ineffable aura of loneliness, reinforced by the painter's evident emotional detachment from the subject.

Critics of the 1920s and 1930s recognized a distinctly indigenous quality in Hopper's clear-eyed vision of the everyday American environment. Lloyd Goodrich, for example, wrote in 1927: "It is hard to think of another painter today who is getting more of the quality of America in his canvases than Edward Hopper. In all his work one feels the transparent brilliancy of our skies, our strong sunlight, the clearness of our atmosphere—natural qualities which find their echo in the stark angularity and hardness of American architecture."[43] In his own writings of the late 1920s and early 1930s, Hopper associated himself with those quintessentially American painters who had maintained their independence from European modernism and found inspiration in the indigenous environment. "The home-staying painter," wrote Hopper, "is beginning to be looked upon with a new and envious respect by his colleague who has unwittingly exchanged his birthright for a cultural equipment that he begins to find of doubtful value."[44] Revealing the likely influence of Taine's environmentalist theories, and the views of his own teacher, Robert Henri, Hopper went on to note that the "native qualities" in American art, while "elusive and not easily defined. . . are in part due to the artist's visual reaction to the land, directed and shaped by the more

fundamental heritage of race."[45] Hopper was encouraged to note the emergence of certain artists of originality and intelligence who are no longer content to be citizens of the world of art, but believe that now or in the near future American art should be weaned from its French mother. These men in their work are giving concrete expression to their belief. The "tang of the soil" is becoming evident more and more in their painting.[46]

By the early 1930s, critics were identifying Hopper and Burchfield as pioneers of the American Scene movement, the dominant artistic tendency in the United States during the Great Depression. As the country struggled through a grim period of economic distress following the 1929 stock market crash and contended with the agricultural catastrophe of the Dust Bowl, a majority of Americans turned their attention inward to seek solutions to the nation's problems and to build hope for the future. Art critics such as Thomas Craven exhorted American painters to join in this process by abandoning experiments with Parisian modernism and devoting themselves to the portrayal of indigenous subjects in an accessible realist idiom. In a characteristic passage, strongly reminiscent of Emerson and Whitman, Craven urged American painters to "grasp the immensity of New York . . .; to experience the Renaissance banditry and racketeering of Chicago; to explore the cotton belt and hillbillies of the South; to observe the tractors in the Kansas wheat fields; the cow gentlemen of the Southwest; the Rockies; and the proud breed of Californians—an epic in itself!"[47]

The trend toward American Scene painting was encouraged by New Deal art programs such as the Public Works of Art Project (1933-34), the Section of Fine Arts of the Treasury Department (1934-43), and the Federal Art Project of the Works

[43] Lloyd Goodrich, "The Paintings of Edward Hopper," *Arts* 11 (March 1927): 136.

[44] Edward Hopper, "John Sloan and the Philadelphians," *Arts* 11 (April 1927): 169.

[45] Ibid., 170.

[46] Ibid., 177.

[47] Thomas Craven, *Men of Art* (New York: Simon and Schuster, 1931), 508.

48 Peyton Boswell, Sr., in *The Americana Annual,* 1932 (New York: Americana Corporation, 1932), 72, quoted in Matthew Baigell, *The American Scene: American Painting of the 1930's* (New York: Praeger, 1974), 18.

49 Thomas Craven, *Modern Art: The Men, The Movements, The Meaning* (New York: Simon and Schuster, 1934), 318-19.

10 Grant Wood, (1891-1942) *Near Sundown,* oil on canvas, 1933, 15 x 26½ in., Spencer Museum of Art, University of Kansas, gift of Mr. George Cukor.

Progress Administration (1935-43), which gave financial support to American artists, and generally promoted American subject matter. Whether paid by the government or working independently, American Scene painters energetically documented the lives and circumstances of the American people and the American land. While some produced images that confronted the depressed conditions of the present, others celebrated the myths and traditions of the American past, or crafted optimistic images to provide hope for the future.

Peyton Boswell, Sr., editor of the *Art Digest* and a champion of the American Scene, called it "a movement looking forward to the production of works of art that, avoiding foreign influences, actually expressed the spirit of the land."[48] Implicit in Boswell's formulation was a belief that an authentic national art would be rooted in and sustained by the native soil. Thomas Craven agreed, and insisted also that American soil was unsuited to the cul-

tivation of European styles. Employing an organic metaphor doubtless derived from his reading of Taine and redolent as well of his own Salina, Kansas, upbringing, Craven declared:

Art cannot mature in an environment which grants it no cultivation; and the indigenous plant which might be strong and lusty in natural soil, is vitiated into an exotic growth when transferred to the collector's hot-house. There are in America many cultivated men and women who express a desire to encourage a native school of painting, but to win their approval, American art must conform, in subject and style, to the imported variety: "Art is art," they blandly tell you, "existing beyond the boundaries of nationalities." This is true in the abstract; but particular works of art are produced within nationalities, and in their most flourishing state, are conditioned by local influences.[49]

Agrarian subject matter, expressing almost by definition "the spirit of the

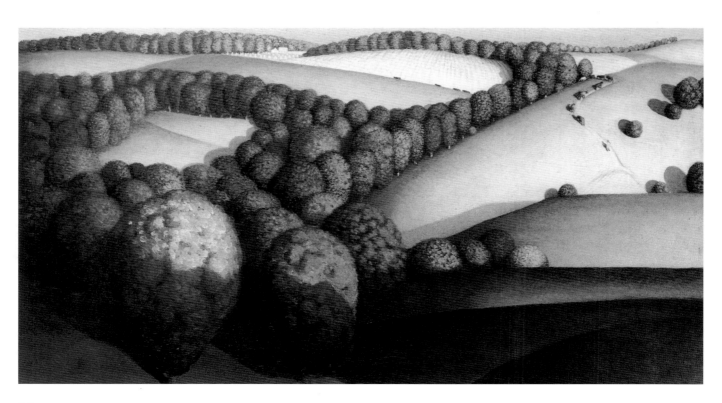

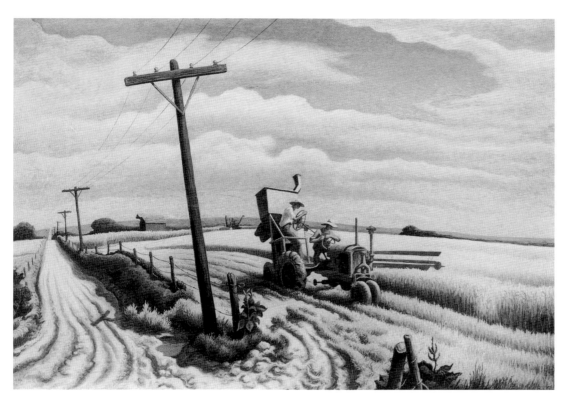

11 Thomas Hart Benton, (1889-1975) *Kansas Wheat Scene,* oil on canvas mounted over plywood, 1953, 21 x 28¾ in., Spencer Museum of Art, University of Kansas, gift of Dr. and Mrs. Franklin D. Murphy.

12 John Steuart Curry, *Tornado Over Kansas,* oil on canvas, 1929, 46¼ x 60½ in., Muskegon Museum of Art, Muskegon, Michigan.

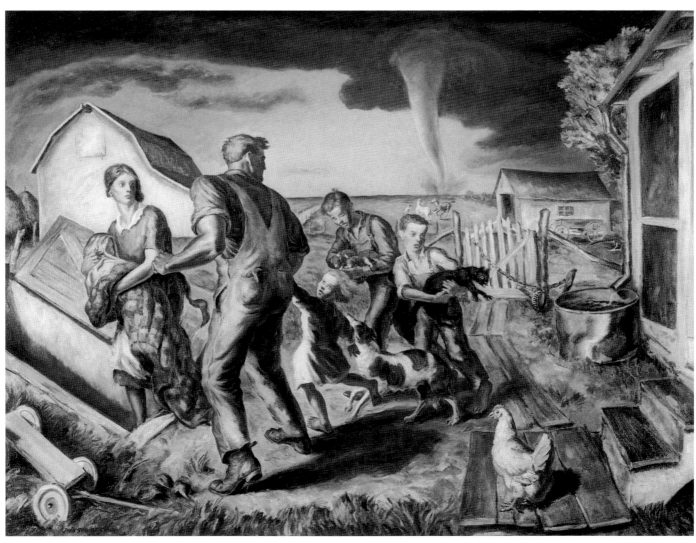

50 John Steuart Curry in *The Capital Times* (Madison, Wisconsin), 4 December 1936, quoted in Baigell, *The American Scene,* 128.

51 Thomas Craven, "John Steuart Curry," in *Catalogue of a Loan Exhibition of Drawings and Paintings by John Steuart Curry* (Chicago: The Lakeside Press Galleries, 1939), 8.

52 Ibid., 8.

53 Stuart Davis, "The New York American Scene in Art," *Art Front* (February 1935), reprinted in Diane Kelder, ed., *Stuart Davis* (New York: Praeger, 1971), 152. Davis penned this essay in response to an article, "Art: U.S. Scene," *Time Magazine* 24 (24 December 1934): 24-27, which reported on the work of Benton, Curry, Wood, Reginald Marsh, Charles Burchfield, and other American Scene painters, who, by offering "direct representation in place of introspective abstractions" were "destined to turn the tide of artistic taste in the U.S." (24).

land," was popular throughout the decade of 1930s, and the Regionalist painters of the Midwest, led by Thomas Hart Benton of Missouri, Grant Wood of Iowa, and John Steuart Curry of Kansas, gained special prominence as painters of the farmlands. Among the three painters, Wood's images of the cultivated landscape were the gentlest and most idealized. He pictured the fertile Iowa fields as smooth, flowing expanses, traversed by lines of cotton-ball trees, patterned by neat rows of crops, and dotted with toy-like farm houses (e.g., *Near Sundown,* 1933, Spencer Museum of Art, University of Kansas, Lawrence, fig. 10). Omitting modern farm equipment and motorized vehicles from his pictures, Wood created a strongly sentimental and backward-looking vision of farm life. Benton, by contrast, did not shy away from painting tractors and other modern realities, and invested his compositions with a rhythmic force that conveyed the energy and abundance of Midwestern agricultural production (e.g., *Kansas Wheat Scene,* 1953, Spencer Museum of Art, University of Kansas, Lawrence, fig. 11). Curry painted the most dramatic and violent images of farm life, rendering tornadoes, storms, floods, and frightened animals (e.g., *Tornado Over Kansas,* 1929, Muskegon Museum of Art, Muskegon, Michigan, fig. 12) in an effort "to depict the American farmer's incessant struggle against the forces of nature."[50]

Curry also painted more benign agrarian scenes, such as *Kansas Cornfield* (1933, page 115). Departing from the long-range, horizontal view of the landscape that he normally employed, Curry presented the cornfield at close range, in a vertical format that emphasizes the impressive stature of the thriving stalks. So vivid is Curry's image that we can almost smell the earthy richness of the soil and the sweet, green aroma of the plants themselves; likewise, we can almost feel the hot summer wind and hear the rustling of the corn's leaves and swaying tassels. The foremost corn plant, rising near the center of the composition, assumes a fascinating anthropomorphic presence. With its lower leaves extending outward like arms and its topmost leaves and tassel resembling a human head, it seems even to possess human intelligence.

Curry based *Kansas Cornfield* on studies made at his parents' farm in Kansas, to which he would return during summers in the 1930s while maintaining a residence and studio in Westport, Connecticut. Thomas Craven, himself a native Kansan, praised Curry's art as an authentic outgrowth of the painter's experience of Kansas farm life, noting with approval that Curry, despite a year spent in Paris in 1926-27, had resisted the lures of Cubism, geometric abstraction, and other modernist styles of foreign origin, and had remained committed to portraying "the intimate facts of farm life" in a plainspoken realist mode.[51] "There are fewer influences at work in Curry's paintings than in the canvases of any other artist of the first rank," Craven proudly declared; "he proceeds from realities, from things directly observed and experienced, or in the case of historical subjects, from events and phenomena related to the background of his people."[52]

Curry was not without his detractors, however. The Kansan's fame infuriated the New York modernist Stuart Davis, who asked:

> How can a man who paints as though no laboratory work had ever been done in painting, who willfully or through ignorance ignores the discoveries of Monet, Seurat, Cézanne and Picasso and proceeds as though painting were a jolly lark for amateurs, to be exhibited in county fairs, how can a man with this mental attitude be considered an asset to the development of American painting?[53]

Davis, a cosmopolitan artist who had absorbed the influences of European innovators like Picasso, Léger, and Miró, found the work of Curry, Benton, Wood, and other American Scene painters to be stylistically reactionary, provincial and sentimental. He also abhorred what he called "the vicious and windy chauvinistic ballyhoo carried on in their defense by a writer like Thomas Craven."[54]

Davis did seek to define himself as an American painter, but disagreed with the notion that his American identity was in any way compromised by the influence of European modernism on his art. Davis doubted, in fact, that it was even possible to isolate a uniquely "American" aesthetic uninflected by European influences, since American art had always drawn crucial sustenance from European art. "Over here," Davis wrote in 1930, "we are racially English-American, Irish-American, German-American, French, Italian, Russian or Jewish-American and artistically we are Rembrandt-American, Renoir-American and Picasso-American. But since we live here and paint here we are first of all, American."[55]

In a later essay, Davis noted that his work in fact always referred to the American environment, declaring: "I have enjoyed the dynamic American scene for many years past, and all of my pictures. . . . have their originating impulse in the impact of the contemporary American environment."[56] Among the paintings that Davis created around this time in response to the American landscape is *Bass Rocks #1* (1939, page 123), whose highly abstracted composition is based on drawings made from nature on Cape Ann, Massachusetts.[57] While cryptic indications of rocks, waves, and dockside architecture persist in the finished painting, the overall image reads as a tight, abstract arrangement of large color cutouts in bold primary and secondary hues, over-

laid and interspersed with quirky linear marks. The lively relationships between the picture's shapes, lines, and colors pulsate marvelously with the seaside's jaunty rhythms, and also suggest the syncopations of the jazz that Davis loved so well.

While Davis enthusiastically embraced the modern American environment and found in it great inspiration for his painting, his younger New York contemporaries, who became known as the Abstract Expressionists, rejected entirely the depiction of the American Scene. "To us, art is an adventure into an unknown world, which can be explored only by those willing to take the risks," declared Adolph Gottlieb and Mark Rothko in their famous 1943 letter to the *New York Times*.[58] Announcing their commitment to "tragic and timeless" subject matter, and professing their "spiritual kinship with primitive and archaic art," Gottlieb and Rothko explicitly rejected American Scene painting and other types of art designed to appeal to popular taste:

if our work embodies these beliefs it must insult anyone who is spiritually attuned to interior decoration; pictures for the home; pictures for over the mantel; pictures of the American Scene; social pictures; purity in art; prize-winning potboilers; the National Academy; the Whitney Academy; the Corn Belt Academy; buckeyes; trite tripe, and so forth.[59]

Gottlieb, Rothko, and their Abstract Expressionist colleagues sought to transcend national concerns in their art and achieve through abstraction a universal form of expression, capable of communicating across geographical and historical boundaries. As Jackson Pollock declared in 1944, "The idea of an isolated American painting, so popular in this country during the 'thirties, seems absurd to me, just as the idea of creating a purely American mathematics or physics would seem

54 Ibid., 153.

55 Stuart Davis, "The Place of Abstract Painting in America" (Letter to Henry McBride), *Creative Art* 6 (February 1930), reprinted in Kelder, ed., *Stuart Davis,* 110.

56 Stuart Davis, "The Cube Root," *Art News* 41 (1-14 February 1943): 22-23, 33-34. Davis listed, in Whitmanesque fashion, his variegated sources of inspiration: "Some of the things which have made me want to paint, outside of other paintings, are: American wood and iron work of the past; Civil War and skyscraper architecture; the brilliant colors on gasoline stations; chain-store fronts, and taxi-cabs; the music of Bach; synthetic chemistry; the poetry of Rimbaud; fast travel by train, auto, and aeroplane which brought new and multiple perspectives; electric signs; the landscape and boats of Gloucester, Mass.; 5 & 10 cent store kitchen utensils; movies and radio; Earl Hines hot piano and Negro jazz music in general, etc." Davis went to explain that these things determined the character of his paintings, not "in the sense of describing them in graphic images, but by predetermining an analogous dynamics in the design, which becomes a new part of the American environment." (33-34).

57 Stuart Davis, letter to Elizabeth S. Navas, 16 August 1944, quoted in *Catalogue of the Roland P. Murdock Collection* (Wichita: Wichita Art Museum, 1972), 36.

58 Mark Rothko and Adolph Gottlieb, letter to the *New York Times,* 13 June 1943, reprinted in McCoubrey, ed., *American Art 1700-1960,* 211. Barnett Newman, another Abstract Expressionist painter, helped his friends Rothko and Gottlieb draft the letter, but did not sign it.

59 Ibid., 211-12.

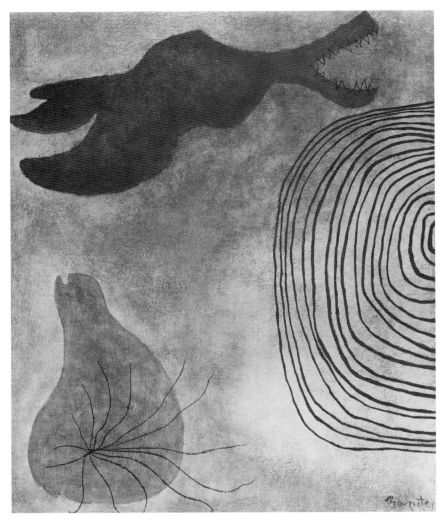

absurd. . . . the basic problems of contemporary painting are independent of any one country."[60] Pollock believed that the modern artist should not look to his outward environment for inspiration but rather should look within, to the unconscious—an idea popularized by the Surrealists and attractive not only to Pollock but to many of his colleagues including Gottlieb, Rothko, Theodoros Stamos, and William Baziotes. These artists did not paint American landscapes but psychological "inscapes," evoking subterranean or aqueous realms that stood metaphorically for the enigmatic recesses of the psyche (e.g., William Baziotes, *Whirlpool,* 1953, Wichita Art Museum, fig. 13).[61]

Standing somewhat apart from the other Abstract Expressionists in this regard was Willem de Kooning, who, like Stuart Davis, frankly acknowledged the contemporary American environment as an important stimulus for his own art. De Kooning was particularly fascinated by the

13 William Baziotes, (1912-1963) *Whirlpool,* oil on canvas, 1953, 24⅛ x 20¼ in., Wichita Art Museum, Art Purchase Fund, Friends of the Wichita Art Museum, Inc., 1982.11.

14 Willem de Kooning, (1904-1997) *Backyard On Tenth Street,* oil on canvas, 1956, 48 x 58½ in., The Baltimore Museum of Art, Frederic W. Cone Fund, BMA 1956.158.

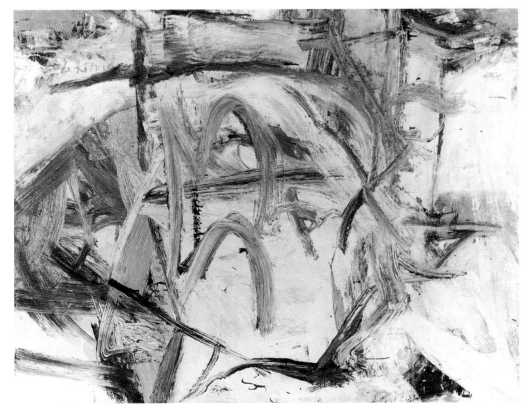

gritty urban atmosphere of lower Manhattan, which provided the inspiration for a group of urban abstractions he painted in the mid-1950s (e.g., *Backyard on Tenth Street,* 1956, Baltimore Museum of Art, fig. 14). In these energetic paintings de Kooning sought through the non-representational means of gestural brushwork, harsh colors, and hectic compositions to conjure up the dirt, noise, and dynamism of the big city streets.

A host of younger New York painters in the 1950s shared de Kooning's enthusiasm for the urban scene and emulated his exuberant gestural style, which came to be called "action painting." One of the most talented of these younger artists was Grace Hartigan, whose *East River Drive* (1957, page 142) is comparable to de Kooning's work of the same period. Painting impulsively on a large canvas, Hartigan laid down bold colors in thick strokes and patches that jostle and collide with one another, evoking the rushing energy of the titular thoroughfare, which bordered her neighborhood on the lower east side of Manhattan. "I have found my 'subject,' " declared Hartigan in 1956, "it concerns that which is vulgar and vital in American modern life, and the possibilities of its transcendence into the beautiful. I do not wish to *describe* my subject matter, or reflect upon it—I want to distill it until I have its essence."[62]

Whereas Hartigan sought to capture the essence of her subject through an exploratory process of gestural painting, Allan D'Arcangelo, like many Pop painters of the 1960s, rejected the spontaneity and emotionalism of "action painting" and distilled his experience of the American landscape through a calculated process of abstraction. D'Arcangelo's *Landscape* (1965, page 119) presents a streamlined image of the American highway as a flat black field, halved by a knife-edged white median line that speeds vertiginously

toward the horizon. While D'Arcangelo's geometric abstraction of the environment recalls the earlier work of Precisionists such as Sheeler and Crawford, his imagery is not inspired by any specific locale, as theirs often was, but derived from a generic and ubiquitous American experience—the experience of highway travel, which belongs to no one particular place. D'Arcangelo's work thus speaks to a condition of transition and movement, not one of organic connection to the earth. The soil, invoked as a source of national identity in art by Henri, Coady, Crowninshield, Rosenfeld, Marin, Hopper, Craven and so many others, has been paved over by blacktop.

D'Arcangelo's painting stands at the chronological terminus of the present exhibition, and marks the historical rejection of the almost mystical belief, dominant for much of our nation's history, in American identity as an organic product of contact with the native environment. Today, most artists and critics understand identity not as an organic essence but as an unstable construct, based as much on difference as on shared experience, and shaped not only by environment but also by age, race, ethnicity, class, gender, sexual orientation, and myriad other social factors. Few American artists would today agree with John Marin that it is a legitimate hope that our soil will produce the artist. That fact does not lessen, however, the importance this idea had in shaping the earlier history of our art.

60 Jackson Pollock, [Answers to a questionnaire], *Arts and Architecture* 61 (February 1944): 14, reprinted in Francis V. O'Connor, *Jackson Pollock* (New York: Museum of Modern Art, 1967), 33.

61 See Robert Carleton Hobbs, "Early Abstract Expressionism: A Concern with the Unknown Within," in Robert Carleton Hobbs and Gail Levin, *Abstract Expressionism: The Formative Years* (Ithaca: Cornell University Press, 1978), 8-26.

62 Grace Hartigan, statement in Dorothy C. Miller, ed., *Twelve Americans* (New York: Museum of Modern Art, 1956), 53.

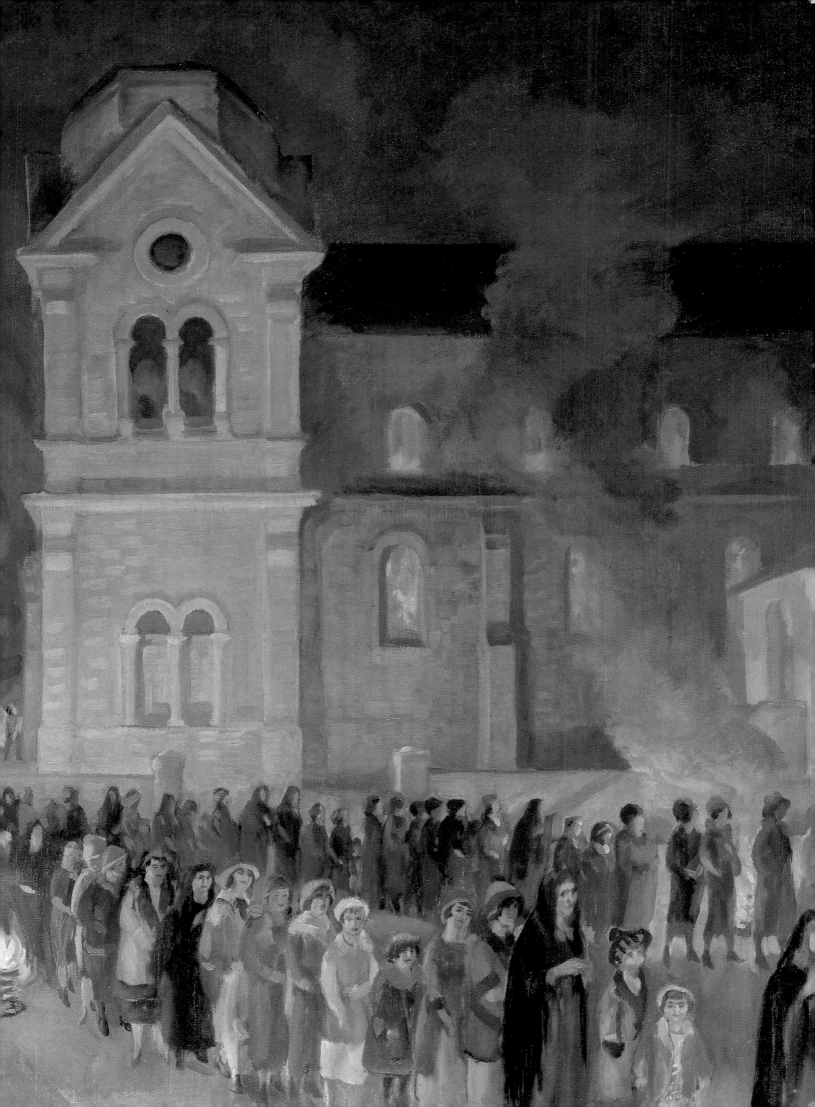

"AN ART OF THE FOLK FOR THE FOLK"

Images of the People in American Painting from the Wichita Art Museum Collection, ca. 1890-1950

NOVELENE ROSS

During the formative years of the Wichita Art Museum in the first half of the 20th century, the makers and interpreters of American art turned their gaze upon the American public as a source of inspiration for the creation of a national art. From about 1900 through the 1940s American artists preoccupied themselves with the identification of the values which set America apart from Europe. This cultural emphasis upon national identity coincided with an era of strong social consciousness in the arts. Like society at large, artists responded to the economic, political, and social upheavals of the period including massive waves of foreign immigration, progressive reform movements, the conflict of corporate business and big labor, isolationist reaction to World War I, and the widespread deprivation generated by the Great Depression. Within this social context artists conceived of the *common people* as a symbol, not only of democracy and individualism, but also of artistic integrity. This selection of 19th- and 20th-century portraits, character studies, urban views, regional genre scenes, and imaginative figural compositions from the Wichita Art Museum provides insight into some of the ways in which artists translated these nationalistic abstractions into the faces and stories of popular experience.

In the early 20th century the New York realists known as the Ashcan School investigated ethnic neighborhoods, public entertainments, and the daily commerce of the city's crowded streets, realizing their philosophy of making art from life by translating the themes and subjects associated with topical events and popular media into high art. However, curiosity about the ways of the people was not limited to discovery of new modes of life conditioned by the dynamics of the modern metropolis. During the same period artists settled in the primitive village of Taos in New Mexico territory or sojourned in fishing villages on remote islands off the coast of Maine yearning to make contact with isolated populations whom they believed represented the enduring moral core of the nation. By the end of the 1920s artistic movements predicated upon the idea of defining the American character, including the American Scene movement, the Regionalists, and the Social Realists, expanded the search for American identity to the mores, occupations, and hardships of the populace located across the country in small towns, on farms, and in distinctive geographic and cultural regions.

Artists came to view the process of portraying the people as a process of self-realization, a means of recovering and asserting their own claim to a tradition of

Edith Halpert used the phrase "an art of the folk for the folk" to describe the democratic origins of indigenous American art in a lecture presented to an Antiques Forum at Colonial Williamsburg, Virginia (2 February 1951), 3. Archives of American Art, microfilm reel ND/20.

OPPOSITE
JOHN SLOAN
(1871-1951)
*Eve of St. Francis,
Santa Fe,* 1925
Oil on canvas, 30⅛ x 40⅛ in.
Signed lower left: *John Sloan*
Roland P. Murdock Collection,
M83.50, detail (catalogue entry,
page 243)

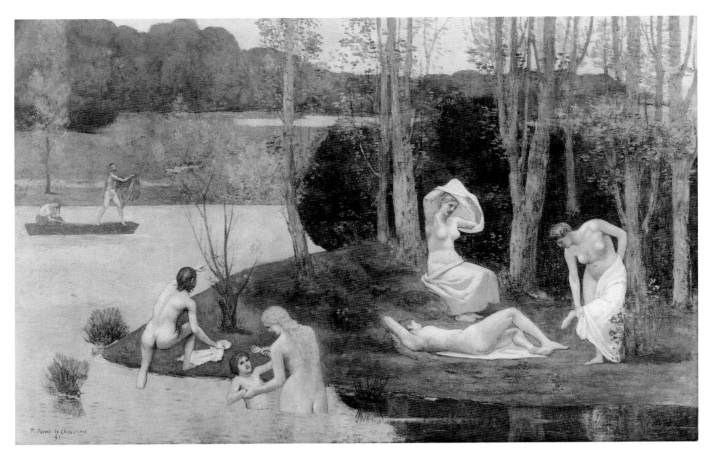

1 The decorative, classicizing style and allegorical subjects of French muralist Pierre Puvis de Chavannes (1824-1898) exerted considerable influence upon European and American artists in the late 19th century. *Summer,* oil on canvas, 1891, 50 x 91½ in., © Cleveland Museum of Art, 1997, gift of Mr. and Mrs. J. H. Wade, 1916.1056.

native originality. As artists and critics reviewed past American artistic production in search of useful examples of authentic national character and invention, they rejected modes of expression which seemed tainted by an elitist and hence foreign sensibility. Two WAM portraits of women created by important American painters of the late 19th century—J. Alden Weir's *The Connoisseur,*[1] 1889 (page 254), and Thomas Eakins's *Mrs. Mary Hallock Greenewalt,* 1903 (page 138)—serve as an instructive contrast of artistic motives which the advocates of a national style came to interpret as a revelation of personal artistic integrity. Weir and Eakins were contemporaries who in their own day represented alternative reactions to their common experience of European training and exposure to European styles. Weir's image reflects a cosmopolitan art-for-art's-sake aesthetic which dominated international taste from the 1880s through the early 20th century. His porcelain maiden, her gaze averted from the viewer and absorbed

in serene meditation, breathes a rarified air of untroubled ease. The kimono-style robe which she wears and the fine print executed on creamy handmade paper which she lifts with such delicate care signify not only the means to travel and to collect art but more importantly to exercise an educated and refined taste. In these details the artist declared his own study abroad and his participation in the then relatively new enthusiasms for Japanese prints and fine art etching. Weir's portrayal of his upper-class female subject as a generalized type characterized by slender grace also asserted the artist's acquaintance with the European sources of the aesthetic movement in the predominantly feminine and decorative figurative types of Puvis de Chavannes and the Pre-Raphaelites.[2] Serving the idea that art elevated one above the commonplace, Weir deliberately erased all reference to narrative and to the vulgar accents of daily life.[3] In its day *The Connoisseur*'s aspiration to a more universal standard of beauty represented the vanguard in American art.

By contrast, the realistic style, which Eakins developed in the years following his return to his native Philadelphia after completing four years of academic training abroad at the École des Beaux Arts, had seemed to his peers old-fashioned and provincial. In his portrait of *Mrs. Greenewalt,* Eakins advanced an image of woman which not only clashed with the triumphant hothouse-flower ideal of the day, but which also posed art itself as an aggressive and gritty persona. Like so many of the other individual achievers who fascinated Eakins, concert pianist Mary Hallock Greenewalt had earned acclaim for pressing the limits of her craft, for seeking an expanded arena of intellectual experience. She combined the talents of theoretician, musician, and inventor to develop concert performances which synchronized sound, color and light on an instrument of her own design.[4] In his portrait of the pianist, Eakins probed the tough qualities of character which he believed necessary to attain a creative level of expression. Although clad in an evening gown, the woman faces the viewer not like a star receiving her applause, but like a workman facing his task. By all physical clues, Mrs. Greenewalt would appear to be a laborer. Face and hands, the principal features of this composition, are strong, lean, and muscular.[5] In contrast to her stark white shoulders her face is ruddy as from too much sun, and the hands show a darker tint; strands of hair have escaped from the severe, functional coiffure; she sits with shoulders slightly slumped as if tired from long exertion and composes her hands, the well-honed tools of her art, in careful repose; the formal pink gown trimmed with gauze literally collapses in

[1] In 1978 the Museum purchased J. Alden Weir's *The Connoisseur* as a tribute to the collecting acumen of Elizabeth Stubblefield Navas and to provide greater representation of the aesthetic movement in the WAM collection. Acting on the biases of her time, Navas deliberately neglected the aesthetic movement as too European in flavor. However, the political climate of artistic criticism has shifted, and Navas would no doubt join contemporary critics in admiration of the achievements of the best of American artists in any era.

[2] See Doreen Bolger Burke et al., *In Pursuit of Beauty: Americans and the Aesthetic Movement* (New York: Metropolitan Museum of Art, 1986) for a comprehensive examination of the philosophy, sources and expression of the aesthetic movement in the U.S.

[3] Bailey Van Hook, "Decorative Images of American Women, The Aristocratic Aesthetic of the Late Nineteenth Century," *Smithsonian Studies in American Art* 4, no. 1 (Winter 1990): 45-69, summarizes recent scholarship on the prominence and sociological connotations of the subject of the upper-class woman engaged in meditative, artful pastimes in the American Impressionist and aesthetic movements. As Hook notes, the observations made by economist Thorstein Veblen in his major work *The Theory of the Leisure Class: An Economic Study of Institutions* (published in 1889, the same date of Weir's *Connoisseur*) reveal the currents of liberal political thought which informed the Ashcan artist's condemnation of the decorative academic style. Veblen argued that the pampered upper-class wife functioned primarily as a symbol of her husband's financial and political success. Hook and others also make the case that American culture, more than any other Western culture, made a fetish of the virginal woman unsullied by the moral, intellectual, or physical realities of the world. It is argued further that this particular idealization of woman and the assignment of art to her province symbolized the marginalization of both women and culture in the American power establishment. With hindsight it has become possible to say that, contrary to the artist's conscious conceptual motive to deny the workaday world, the subject of *The Connoisseur* did possess allusions to the political and cultural issues of its day.

[4] Mary Hallock Greenewalt also published her theories and toured the country giving lectures. As a pianist she soloed with the Pittsburgh and Philadelphia orchestras and earned international recognition for her interpretations of Chopin.

[5] Elizabeth Navas cited the feature of the hands as the reason for her particular attraction to this painting. Writing on 19 August 1965 to WAM curator William Stevens, Navas said that *"The hands* sold me the picture, for very personal reasons." Navas Papers, WAM. Navas's husband, Raphael Navas, was a pianist and it may have been this personal history which made the powerful character of the Greenewalt hands especially meaningful to her. Several years later in a 14 April 1971 letter to WAM curator George P. Tomko, Navas explained, in reference to several paintings, that she always paid attention "to the way hands are painted as indication of character as well as part of the design. . . . Mrs. Greenewalt's hands — the pianist. I acquired the painting because of the hands, there were other Eakins available at the time." Navas Papers, WAM. Although we have no correspondence between Lloyd Goodrich and Navas on the Greenewalt painting which Navas purchased in 1945 (offering her own personal credit to Knoedler and Co. in order to secure the painting and hold it until funds from the Murdock Trust became available), it is probable that she had taken careful note of the particular praise which Goodrich accorded to Eakins's treatment of a subject's hands. A good example is this comment: "Confined to portraiture, he [Eakins] attained a new mastery in this more limited field. His emphasis was above all on character, on the traits that made the individual different from any other person in the world — the architecture and bony structure of the head, the form and life of the hands." Lloyd Goodrich, "Thomas Eakins Today," *Magazine of Art* 37 (May 1944): 162-66.

2 Although Thomas Eakins did not depict the most brutal aspects of boxing, he documented the sport's coarse physical context. The fighter "Turkey Point" Billy Smith is featured in Eakins's *Between Rounds*, oil on canvas, 1899, 50⅛ x 39⅞ in., Philadelphia Museum of Art, gift of Mrs. Thomas Eakins and Miss Mary Adeline Williams.

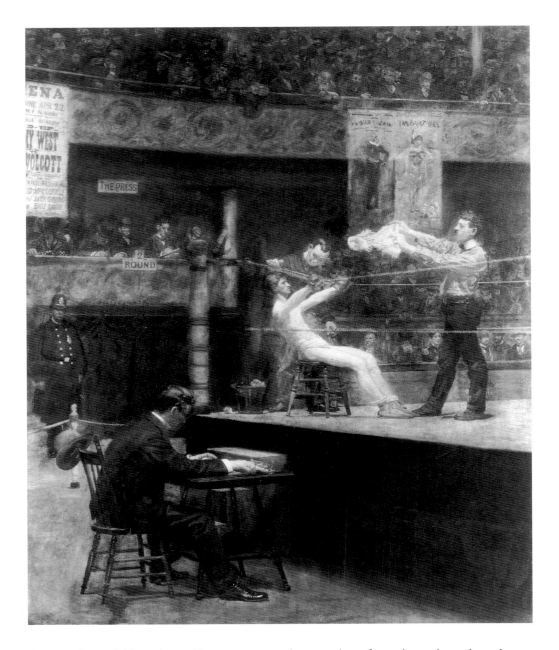

dozens of tiny folds and wrinkles, a metaphor of the gravity-laden frailties and sorrows of the flesh which bear upon the spirit. A strongly directed light sculpts the mass and the planes of the body while highlights in the corners of the sitter's eyes evoke the actual moisture of the eye's membrane and fix the viewer with a piercing gaze.

During his own lifetime Eakins received more criticism than praise from the American art establishment. In the post of director of the Pennsylvania Academy of the Fine Arts he introduced teaching methods which proved too radical for the period. Allowing female stu-

dents to draw from the male nude and insisting upon rigorous anatomical instruction at local surgical clinics eventually earned him dismissal from the Pennsylvania Academy. Few of his contemporaries appreciated Eakins's idea of extracting the heroic qualities of Rembrandt and Velázquez from the coarse material of modern existence.[6] Referenced against the prevailing ideas of cosmopolitan refinement, the psychological intensity of the Greenewalt portrait or the ringside meditations of a rough-edged professional boxer nicknamed "Turkey Point" *Billy Smith,* 1898 (page 137), seemed an affront to the aims of high art.

However, the critical reputation of Eakins soared in the 1920s when American artists turned against the National Academy and sought to establish a canon of American painting which could be claimed as independent of Europe. In the new era of artistic nationalism Weir's image of *The Connoisseur* represented the dominion of an effete sensibility deemed alien to American soil. Eakins's persona as a loner as well as his style made him a hero to the American artist in search of a native antidote to the decorative aesthetic. When the Metropolitan Museum of Art presented a memorial exhibition of the art of Thomas Eakins in 1917, Robert Henri extolled Eakins as a model of vital originality to his classes at the Art Students League. He praised Eakins as "a man of great character. . . iron will. . . big mind" whose quest for artistic independence "cost him heavily." Henri urged his students to pay close attention to the honesty and strength of Eakins's portraiture, "Look at these portraits well. Forget for the moment your school, forget the fashion. . . [and] you will find yourself, through the works, in close contact with a man who was a man, strong, profound, and honest. . . ."[7]

The same qualities of independence and forthrightness which now elevated Thomas Eakins to the status of American archetype were emphasized in the critical reevaluation of Mary Cassatt which occurred after her death.[8] Cassatt had not only pursued her career abroad, but enjoyed the distinction of having been the only American artist to participate in the original French Impressionist movement. However, in order to claim this innovative artist as one of their own, the American critics depreciated the contributions of the French experience to the lasting authority of her art. In 1926, Lloyd Goodrich wrote that although Cassatt had been influenced early in her career by Manet and Degas, she had later asserted a native "independence of viewpoint" and a clarity of design which he judged to be inherently American, a recurrence of the strain of the old American limner.[9] The models for Mary Cassatt's *Mother and Child,* ca. 1890 (page 107), may have been French, but as late as the 1950s writers would still cite the artist's unsentimental portrayal of ordinary people as prime evidence of her native individualism: "Mary Cassatt's most telling device was her own: she painted plain and sometimes charmless people in classically noble poses, with the same care the earlier artists lavished on saints and goddesses."[10]

[6] If Eakins's artistic means and his particular subjects didn't fulfill cultural expectations, the artist's selection of the character traits worthy of homage did. Elizabeth Johns argued this thesis in her contextual study of *Thomas Eakins: The Heroism of Modern Life* (Princeton, N.J.: Princeton University Press, 1983). She explains that Eakins "sought the person who in his full intellectual, aesthetic, and athletic power was definitive of the best of his times. In choosing his sitters, Eakins consistently paid tribute to such persons and to their achievements. In these choices, he drew on, explored, and celebrated cultural ideals prominent among his fellow citizens in the larger world beyond art," 3.

[7] Robert Henri, *The Art Spirit* (Philadelphia and New York: J. B. Lippincott, 1923), 86-87.

[8] See Nancy Mowll Mathews, "The Historical Cassatt," *Mary Cassatt: A Life* (New York: Villard Books, 1994), 321-33, for a description of the changing historical evaluations of Cassatt's art and career.

[9] Lloyd Goodrich, "New York Exhibitions," *Arts* 10, no. 6 (December 1926): 348-49, reported on an exhibition of paintings by Mary Cassatt at the Durand-Ruel Galleries and observed that despite her involvement in the French Impressionist movement, Cassatt exhibited her American heritage: "Influenced as she was in the beginning by Manet and Degas, her own individuality soon asserted itself, and in the work of her later years she was absolutely herself, and if one may say it without seeming to wave the flag, quite American. Looking at this group of pictures it was impossible to miss the American tang in the sharp, clear lines of her later work, in its bright and slightly hard color and its immediate technique. By this independence of viewpoint she proved her right to be remembered as one of the most original and brilliant American painters of her generation."

[10] This critical description was addressed specifically to WAM's new purchase of Mary Cassatt's *Mother and Child,* ca. 1890, "Best U.S. Woman Painter," *Time* 62, no. 15 (12 October 1953): 92.

3 An exuberant spirit of adventure permeates Winslow Homer's image of three boys and their adult companion sailing a catboat on the open sea. *Breezing Up* (*A Fair Wind*), oil on canvas, 1876, 24⅛ x 38⅛ in., ©1997 National Gallery of Art, Washington, gift of the W.L. and May T. Mellon Foundation.

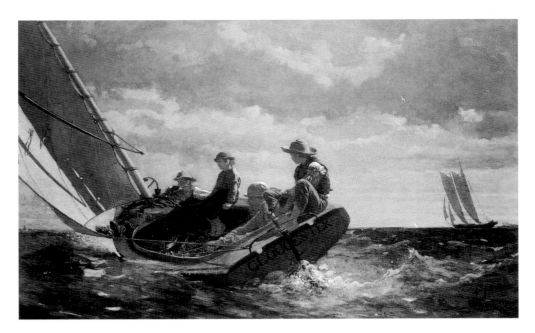

4 The two barefoot youths pictured in Winslow Homer's *Boys in a Pasture* manifest a robust health and serenity of spirit in harmony with the prosperous countryside which surrounds them. Oil on canvas, 1874, 15⅞ x 22⅞ in, The Hayden Collection, Courtesy, Museum of Fine Arts, Boston.

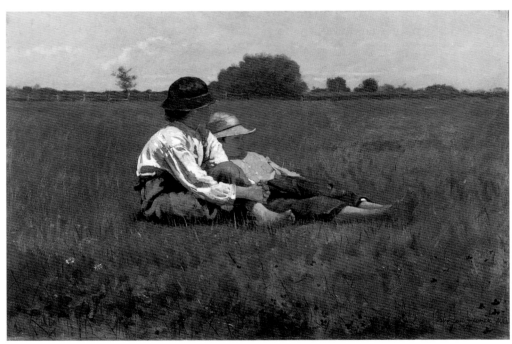

Of all the 19th-century painters to be hailed as models of American individualism, Winslow Homer provided the most fertile index to the nation's ideal of itself as a people. According to his own carefully cultivated self-image, Homer was a loner, a virile outdoorsman, a self-made man with little formal training who spurned the worldly allure of European-inspired fashions. Although he profitably absorbed stylistic lessons from *japonisme,* Impressionism, and Symbolism, Homer applied this knowledge to self-consciously American subjects of farming, hunting, and fishing in New England and on the rugged Maine coast, creating images which linked the common man to the moral circumference of the land.[11]

WAM's painting, *In the Mowing,* 1874 (page 153), depicts three country boys coming home to the call of dinner after a day spent outdoors amid flowering fields and sunshine. In this and similar images of rural childhood which he exe-

cuted in the 1870s Homer referred to a specific American iconography of the "rustic barefoot boy" which had emerged in art and literature before the Civil War and which, in the 1870s, had assumed a major presence in both popular and fine art.[12] The popular equation of a country childhood with goodness was exemplified by John Greenleaf Whittier's poem "The Barefoot Boy" (1856) which exalted the joy and freedom of a state of nature above the "prison cells" of adulthood, labor, and civilized society. Homer appropriated the symbol of the barefoot boy, divested it of an anecdotal sweetness, and charged it with a spare and solemn dignity.

Winslow Homer, like the writer Mark Twain in his portrayal of the "natural" boy Huckleberry Finn, depicted the barefoot boy of rural America as an individual in his own right. Sometimes a maiden schoolteacher struggled ineffectually to claim center stage or a parent waved from a distance as in WAM's *In the Mowing.* However, more often than not, boys appeared on their own as players of games, apprentice hunters, protectors of females and smaller children, solemn thinkers, and adventurous voyagers exulting in the freedom of the sea and in the glory of the open fields bathed in liquid sunlight.

Historians have argued with justification that nostalgia and a national denial of the social cataclysms of the Civil War and the industrial revolution motivated the creation in American art and literature of the rural idyll of the barefoot boy.[13] Yet, however deficient their service as historic documentation, the sturdy boys of *In the Mowing* summoned an image of an American type whose mythic dimensions held particular validity for 20th-century artists in search of an American identity. The scene bears strong affinity to Whitman's theme of "man in the open air" which celebrated the luxuriant adventuring of limbs and spirit in nature's sanctuary. As children the three protagonists lacked worldly status and served as a foil to the hypocrisy and corruption of their elders and, by extension, of "society" as did Huck Finn in Mark Twain's novel. As country boys the children represented Jefferson's yeoman stock, deemed by scholars in the 1920s as America's unique contribution to

[11] Bruce Robertson, *Reckoning with Winslow Homer: His Late Paintings and Their Influence* (Cleveland: Cleveland Museum of Art in cooperation with the Indiana University Press, 1990) presents a compelling argument for Winslow Homer's cultivation of an American identity and explains the cultural implications of Homer's particular definition of Americanism: "The terms contemporaries used most often to describe Winslow Homer were *big, virile, American,* and *real.* He had assumed a mythic character, becoming as it were the John Wayne of American Painting. We have already seen how far from actuality this myth is, in so far as we are able to see Homer's paintings without preconceptions. . . . We can gain a clearer picture by examining the associations that condensed around these terms,

defining them as much by what they rejected as by what they proposed about the nature of Homer's art. *Big* was opposed to *decorative, virile* was associated with the great outdoors, and both were balanced against *feminine,* the domestic, and interior spaces. *American* was set against *European,* of course, and the *real* was opposed to the *ideal* and the abstract. The oppositions could be, and were, extended further: power versus art, or strength versus refinement. Finally, moral virtue might stand against culture, and democracy must stand up against aristocracy," 63. Robertson also presents persuasive arguments for the influence of Homer's late art and for the corresponding influence of Homer's promotion of the persona of the rugged, instinctive outdoorsman as the authentic American character upon Henri and the urban realists.

[12] See Sarah Burns, "Barefoot Boys and Other Country Children: Sentiment and Ideology in Nineteenth-Century American Art," *The American Art Journal* 20, no. 1 (1988): 25-50.

[13] Ibid. Historians have long held the general character of post-Civil War genre imagery describing rural life in America to be a nostalgic paean to an idealized past. However, Linda J. Docherty has advanced the thesis that Winslow Homer, unlike the majority of his contemporaries, was not only attuned to topical social issues in his depiction of rural children but also that the artist, at least in certain instances, asserted a progressive point of view. In "A Problem of Perspective: Winslow Homer, John H. Sherwood, and *Weaning the Calf,*" *North Carolina Museum of Art Bulletin* 16 (Raleigh, 1993): 31-

48, Docherty analyzed Homer's 1875 painting *Weaning the Calf,* which depicts two white children watching a black child pull a calf away from its mother, as a commentary upon the determined struggle of the newly freed African American to establish his independence and self-sufficiency during the period of Reconstruction.

the model of a democratic citizen.[14] Homer's subject and his treatment of the composition seemed to fit Henry David Thoreau's prescription for "simple, cheap, and homely themes," fashioned in emulation of nature's methods, which according to Thoreau and to the later enthusiasts of American "primitivism" would yield an art of quality and of native authenticity.

In actuality Homer exercised an artful economy of means typical of his best work in the design of *In the Mowing.* Dividing the picture plane into two bands of earth and sky, he opposed the dominant horizon line to the centered verticals of the figures, and vitiated this spare geometric structure with the biomorphic silhouette of the tree

break, the thin slanting layers of cloud, and boldly brushed impasto highlights. Yet the artist himself claimed, and his admirers among the 20th-century realists chose to believe, that Homer had extracted his blunt abstractions from the inherent knowledge of his tough "Yankee race."

In the WAM collection, the faces of two city children, Robert Henri's *Eva Green,* 1907 (page 151), and George Luks's *Mike McTeague,* 1921 (page 191), announce the grafting of mythic Yankee virtues to new stock undertaken by American artists determined to find the spirit of that barefoot boy alive and well in their own urban haunts of the common-place.[15] The African American *Eva Green*

14 Vernon Louis Parrington advanced this interpretation of American ideals in *Main Currents in American Thought: An Interpretation of American Literature From the Beginnings to 1920,* 3 vols. (New York: Harcourt, Brace, 1930). In his introduction Parrington summarized the French romantic Physiocratic school of thought which influenced Thomas Jefferson's political philosophy: "Since the great desideratum is man in a state of nature, it follows, according to the Physiocratic school, that the farmer is the ideal citizen, and agriculture the common and single source of wealth; and that in consequence the state should hold the tillers of the soil in special regard, shaping the public policy with a primary view to their interests. And since social custom is anterior to statutory laws, since the individual precedes the state, government must be circumscribed in its powers and scope by common agreement, and held strictly to its sole concern, the care of the social well-being," vol. 1, v.

Written in the 1920s and published in various formats in the 1930s, Parrington's monumental analysis of the philosophic sources and content of 300 years of American letters stands as a landmark of American liberalism. It was symp-

tomatic of its era not only in its liberal social and economic perspective but also in its stated mission to account for the genesis of "ideals and institutions as have come to be regarded as traditionally American" through a cultural analysis of an artform, in this case literature.

15 Contemporary audiences would have recognized *Eva Green* and *Mike McTeague* as "relatives" of the stereotypical ethnic types already well established in popular and reform literature of the period. See Rebecca Zurier, Robert W. Snyder, Virginia M. Mecklenburg, *Metropolitan Lives: The Ashcan Artists and Their New York* (Washington, D.C.: National Museum of American Art in association with W.W. Norton, 1995), essay by Zurier and Snyder, 115-30, for exposition of the development of ethnic stereotypes in the press, theater, fiction, and social science reports and the relationship of this material to Ashcan imagery.

A good example of the kind of popular literature which advanced and affirmed the interests of the realist painters is Hutchins Hapgood, *Types from City Streets* (New York: Funk and Wagnalls, 1910). Hapgood stated a variation upon the Ashcan School philosophy when he argued that America's true artistic and intellectual aristo-

crats would be artists and writers who came "close to life,... who, like the lowly of the streets, gave frank and open expression to their thoughts and feelings," 15-20.

16 Henry James, *The American Scene, Together with Essays from "Portraits of Places,"* ed. W. H. Auden (New York: Scribner, 1946), 123-29. In 1906 when the expatriate James recorded his observations of the American scene after an absence of 25 years, he expressed profound shock at what he perceived as the alien face of the country. Wherever he traveled, but especially on the streets of New York, James could not shake his "horrified fascination" with the question of who and what is an American. James sensed the imminence and profundity of a change in American life whose outcome was beyond even his fertile imagining. That these aliens were already at home in America he had no doubt. He reflected upon the idea that all Americans were immigrants and described his native country "as the hugest thinkable organism for successful 'assimilation'," 124. Yet, "The operation of the immense machine (assimilation), identical after all with the total of American life, trembles away into mysteries that are beyond our present notation and that reduce us in many a mood to renouncing analysis," 124.

See Peter Conn, *The Divided Mind: Ideology and Imagination in America 1898-1917* (Cambridge and New York: Cambridge University Press, 1983), 21-48, for discussion of James's *American Scene* and of other striking examples in American literature, visual arts, music, and architecture, of the complex interplay of Victorian values with the radical forces of social and technological change which characterized the struggle of early 20th-century progressives to shape and define a modern American identity.

17 William Innes Homer, "Robert Henri as a Portrait Painter: An Introduction," in Valerie Ann Leeds, *My People, The Portraits of Robert Henri* (Orlando, Fla.: Orlando Museum of Art, 1994) argued that Henri's conscious program of depicting the spectrum of humanity reflected Henri's internationalism and his reaction to the horrors of World War I: "His outlook was clearly international, as witnessed by the diverse backgrounds of his sitters. His constant attention to these types speaks of his reaction to the evils of nationalism and 'patriotism' that impelled Europeans, with help from the United States later on, through four years of war between 1914 and 1918," 13.

and the Irish American *Mike McTeague* reflect the radical transformation of the ethnic face of America, particularly in the eastern cities, which occurred between 1900 and 1917 when Southern blacks came North and 15 million foreign-born people of varied national extraction immigrated to the U.S. It was impossible, as expatriate Henry James declared in 1906, to walk the streets of New York and not be shocked by the predominance of "alien" faces into bewildered contemplation of who and what is an American.[16]

If ever there was a face to vanquish the trembling epithets of *alien, exotic, strange,* or *hostile,* it is the ebullient countenance of *Eva Green.* Glancing toward the viewer as if a friend had spoken her name, Eva flashes her welcoming recognition in a warm, straightforward gaze. Composed of multiple touches of varied colors, the lighted orb of her face shines forth against the dark but subtly vibrant black clothing and background. The immediacy of her

glance echoes in the splash of the red hair ribbon and the spark of the pearl hatpin.

Henri derived his stylistic strategies from the 17th-century European precedents of Velázquez and Frans Hals. However, in *Eva Green* the artist fixed his appropriated pictorial qualities of candor and spontaneity firmly within a contemporary American context. By choosing to portray a distinctively American and urban ethnic type, Henri offered the most startling antithesis possible to the cultural biases of academic painting. *Eva Green* also alluded to the exuberant public sphere of life on the streets rather than to the genteel private sphere of the parlor. Henri was eventually to devote much of his career to painting portraits of children and of ethnic representatives of world cultures.[17] In his essay "My People," in which he describes the motivation of his ethnic portraits, Henri argued that every great artist had been "a rebel" who eschewed the prejudices of institutions and who learned to

5 Ashcan painter Everett Shinn's scene of a *Bar Room Brawl (Old Bowery, New York)*, pastel and watercolor, 1900, 8 x 12 in., typified the interest of many early 20th-century American artists and writers in the gritty realities of life among the working classes and in poor ethnic neighborhoods. Courtesy of Owen Gallery, New York.

follow the example of Nature in respecting the freedom of the individual to grow and live in his own way.[18] Nonetheless, it is remarkable that in 1907, at the beginning of the Harlem Renaissance and long before African Americans could be viewed as individuals by most whites, Henri deliberately sought out an African American child who, in the artist's most felicitous rendering of flesh and light, could embody the progressive American artist's ideal of spiritual health.[19]

George Luks's portrait of *Mike McTeague* speaks explicitly, in the manner of most of Henri's ethnic portraits, of the artist's equation of ethnic diversity, outsider class status, and defiant individualism with high moral and artistic ground. Mike McTeague, clad in garish orange togs, eyes narrowed to a glare and mouth drawn up into a defiant pout, epitomizes the stereotypical pugnacity of the Irish. Luks, who styled himself the barroom brawler and the blunt oracle of *real life,* must have identified personally with Mike McTeague.[20]

The romantic belief that art arose out of life lived close to the edge of existence where every pain and joy registered most keenly had been established among Henri's disciples well before the exhibition of The Eight in 1908. John Sloan's diary entries from 1906 to early 1908 testify to his early adoption, through the influence of Henri and through his own exposure to 19th-century French journal illustration, of the idea that the recording of life on the streets provided the vital antidote to "Kenyon Cox, W.H. Low and the other pink and white idiots."[21] On one occasion he wrote that he was "thinking how necessary it is for an artist of any creative sort to go among common people—not waste his time among his fellows, for it must be from the other class—not creators, nor Bohemians nor dilettantes that he will get his knowledge of life."[22]

John Sloan, who called his beloved New York "this great life full city," practiced this philosophy assiduously. His diary from the years 1906-13 provides a rich

6 Painter and art critic Kenyon Cox (1856-1919) led the forces of American academicism in the early 20th century. His advocacy of noble subjects cast in a Renaissance mold is aptly represented in *Tradition*, oil on canvas, 1916, 41¾ x 65⅛ in., © The Cleveland Museum of Art, 1997, gift of J.D. Cox, 1917.9.

catalogue of the sights, smells, the joys, and the sorrows of the streets. Sloan walked miles every day recording in memory observations of all kinds. He observed the glamour of theater-goers in an elevated station on a rainy night and took sympathetic note of a pathetically destitute and drunken woman who wandered distractedly through the shops.[23] Because of his own experience as a newspaper illustrator and his admiration for the 19th-century French tradition of popular journal illustration, Sloan had early on embraced the idea that the artist who wanted to create a vital contemporary art must immerse himself in the transitory episodes of life glimpsed on the city streets.[24]

WAM's drawing, titled *Indians on Broadway,* 1914 (page 240), like so many of Sloan's early urban scenes, derived from a happenstance encounter during a walk.

On 29 January 1907, Sloan recorded in his diary that he was on his way with a friend to see the Monet pieces on exhibit at the Durand-Ruel Galleries when he saw some "foolishly, brazenly, modernly dressed women laughing at the costumes of squaws who passed the 5th Avenue corner at 34th Street." Sloan sympathized with the ethnic dress of the Native Americans, commenting that "the squaws seemed the more rationally rigged."[25] Sloan apparently filed this scene away in his mind to retrieve it later for the WAM piece which he published in the July 1914 issue of the socialist journal *The Masses.* In the actual drawing the "squaws" have been transmuted into Indian chiefs with feathered headdresses. Without resort to a caption, Sloan advanced his humorous comparison of the dignified appearance of the Native Americans with the barbarism of

[18] Robert Henri, "My People," *Craftsman* 26, no. 5 (February 1915): 461.

[19] An illustration of Robert Henri's *Eva Green* served as the frontispiece of his article "Progress In Our National Art Must Spring From the Development of Individuality of Ideas and Freedom of Expression: A Suggestion For a New Art School," *Craftsman* 15, no. 4 (January 1909): 386-401. In this essay Henri declared his faith in the American ability to reform its art according to the legacy of Walt Whitman, Winslow Homer, and John Twachtman. In this same piece Henri cited a foreigner, French Barbizon artist Jean François Millet, as an exemplar of democratic values for the new American art. Henri praised Millet for seeking his subjects "in the humblest life of the nation," and for "finding in the muck and dirt of the miserable peasant existence the tremendous significance of life," 389. Throughout the article, Henri defined "the virile ideas of the country," 388, and "the great ideals native to the country," 387, as individualism, free expression, and democratic empathy with the people.

[20] Much has been written about George Luks's obsessive machismo, his false claims of heroics as a reporter during the Spanish-American War, his alcoholism, and eventual death in a barroom. An entry from the diary of fellow Ashcan school painter John Sloan makes explicit reference to the connection between Luks's macho behavior and his realist aesthetic. In his diary, Sloan reported that on 8 January 1908 he and Dolly went around to visit Luks and his wife only to find that George had "gone off on a 'jag.' " Sloan commented that Luks "justifies this behavior saying that an artist has to 'see life.' " *John Sloan's New York Scene, From the Diaries, Notes and Correspondence 1906-1913,* ed. Bruce St. John with an introduction by Helen Farr Sloan (New York: Harper & Row, 1965), 181.

[21] George Luks quoted by Sloan, from a conversation recorded in a diary entry dated 11 January 1908 in which Luks explained that he wanted to send his painting of the *Wrestlers* to a big exhibition so that he can show the academics "that we know what anatomy is." Ibid., 183. Other disparaging references to the practitioners of the decorative aes-

thetic include a 30 April 1907 reference to a conversation with Henri in which Henri despairs of becoming a fashionable painter because "he won't do the five o'clock tea drinking that is necessary for portrait work in this country today," 125. Sloan experienced the same kind of depression attending a preview of the Pennsylvania Academy of the Fine Arts annual exhibition, 19 January 1907, where he noted that "Whistler was still the idol," 99. Earlier Sloan had sneered at a "snobbish" art critic's admiring commentary upon the way in which Whistler declared his aesthetic intentions to the viewers in explanatory titles such as *Nocturne in Green and Gold.* Sloan ridiculed this art for art's sake posture with the thought that his *Girl in Studio* "should then be called 'Effect of Light on Stout Healthy Wench.' " October 1906, 75.

[22] Ibid., diary entry of 16 January 1908, 185.

[23] Ibid., incidents of 18 November 1906, 80, and 4 May 1907, 131, respectively.

[24] Ibid. Sloan collected volumes of the Parisian journal *Charivari;* was introduced to the illustrations of

Gil Blas, Courier Français, and other similar illustrated popular magazines devoted to manners, entertainments, and personalities of contemporary Paris, 25, 69-70. Between 1901 and 1905 Sloan executed a commission to produce 53 etchings and 54 drawings to illustrate special editions of the fashionable 19th-century Parisian writer Charles Paul de Kock, whose fictional and journalistic work depended upon his keen descriptions of daily life of various Parisian types and popular passions, 9.

[25] Ibid., 101.

7 In 1905 John Sloan began a print series of richly descriptive and humorous scenes of life in the crowded New York City streets and apartments. These images introduced numerous subjects which were to become prominent themes in American painting. John Sloan, *Roofs, Summer Night*, 1906, "New York City Life" series, etching, 5¼ x 7 in., Delaware Art Museum, gift of Mrs. Helen Farr Sloan.

8 In John Sloan's etching of *Sixth Avenue, Greenwich Village*, 1923, 5 x 7 in., men and women visit with friends, flirt, and socialize in the street against the backdrop of the utilitarian architecture of elevated train and subway. Delaware Art Museum, gift of Mrs. Helen Farr Sloan.

the young ladies parading in their high fashion finery.[26]

Sloan's depiction of *Indians on Broadway* typifies the non-dogmatic radicalism of the imagery published in *The Masses,* 1911 to 1917.[27] While it ridiculed fashion and conspicuous consumption, the drawing functioned not as an indictment of the evils of capitalism so much as a revel in the spectacle of the city streets where people of all kinds rubbed shoulders amid a ceaseless flow of sensation. Sloan's emphasis upon the inherent vitality of a pluralistic society reflected the optimism of the progressive artists and writers of the day, especially those associated with *The Masses.*[28] Liberal political attitudes formed an important component of many artists' conception of modernism. Yet their "socialist" principles embraced less of economic theory and more of a romantic iconoclasm. In the place of brooding propaganda about the desperateness of the class struggle, Sloan and the Ashcan School artists tended to express their sympathy for the laborer, the poor, and the outsider through a celebration of everyday life in the diverse ethnic neighborhoods and on the streets of New York.[29]

John Sloan's pioneering images of the intimate living spaces of the poor, those cramped and humble tenement bedrooms, rooftops, and iron fire escapes—drab corners vitalized by their inhabitants' joyful embrace of life's essentials—reverberate in Lawrence Beall Smith's *Ring Around the Chimney,* 1939 (page 245). In this lighthearted image of two amused young women watching a toddler in a baggy diaper dodge gleefully out of sight around the chimney, the central fixture of their dilapidated rooftop "playground" and "laundry room," the artist underscores vivacity and resilience as the people's virtues. Smith asserted, as had Sloan and many of their contemporaries, that the poor, who were also often the most recent immigrants, expressed humanity's noblest qualities. According to the conventional wisdom of the progressive, it was easy for the wellborn to enjoy life. Fortitude of the all-American pioneer variety, however, was to be found among the plain folk personified by the trio of tenement dwellers in *Ring Around the Chimney* whose mean circumstances could not deter them from laughter and neighborliness. Smith's emphasis upon the strength of *community* in the urban "ethnic village" is almost as great as his glorification of the sturdiness of the common people. By the end of the 1930s when Smith executed this image, the idea of *community* had assumed in the popular mind the function of a talisman against the fears generated by radical social change and economic instability.[30]

[26] Lloyd Goodrich, *John Sloan, 1871-1951* (New York: Whitney Museum of American Art, 1952), 44, identified Sloan's illustrations for *The Masses* as the work most directly expressive of the artist's individuality because the artist executed the illustrations to please himself. Following the exhibition of *Indians on Broadway* in this retrospective and upon Goodrich's praise of Sloan's illustrations for *The Masses* as "the best illustrations he ever did," 44, Elizabeth Navas purchased the piece for the Murdock Collection.

[27] Ibid., Goodrich credited the artistic strengths and innovations of *The Masses* to John Sloan's leadership and example.

[28] Rebecca Zurier, *Art For The Masses, A Radical Magazine and Its Graphics, 1911-1917* (Philadelphia: Temple University Press, 1988), provides a comprehensive history and interpretation of the political and artistic content of *The Masses.* See pages xv-xviii, 3-6, for a discussion of the philosophical character of the journal, a character which Zurier described as "irreverent, jocular," and "buoyant" in its activism.

[29] In their exhibition catalogue, H. Barbara Weinberg, Doreen Bolger, and David Park Curry, "Passionate Spectators," *American Impressionism and Realism, The Painting of Modern Life, 1885-1915* (New York: The Metropolitan Museum of Art, 1994), argue that both the American Impressionists and the American Realists of this period "tempered a commitment to portraying turn-of-the-century life with a tendency toward euphemism, optimism, nationalism, and nostalgia," 8.

[30] Warren Susman, editor and author of the introduction and notes, *Culture And Commitment 1929-1945* (New York: George Braziller, 1973), 19-23. Susman analyzed the collective psychology of the age in terms of the large themes expressed in popular culture. Chief among these themes are the importance of community life in a democracy, the reverential identification with "the folk" or "the people," the belief in the American unity of "all races and all creeds," and the mythic stature of New York as the "Promised Land" where even such home-spun natural folk as Gershwin's *Porgy and Bess* can make a new life.

One of the New York neighborhoods which proved most attractive to American artists intent upon divining the modern American spirit is represented in Kenneth Hayes Miller's *Show Window #2,* 1938 (page 210). The locale referenced featured a popular lower-to-middle class shopping district centered around 14th Street and Union Square where Miller's studio was located. Miller, who exercised considerable influence as a teacher and painter during the 1920s and 1930s, promoted the ordinary business traffic to be viewed from around his 14th Street and Union Square studio as the appropriate currency of a vital national art.[31]

Like Thomas Eakins before him, Miller taught the application of classical composition to subjects distinctively modern and explicitly American. As seen in *Show Window #2,* Miller cast the stuff of the nation's burgeoning consumer economy in the heroic formal idiom of the Renaissance so that Klein's department store bargain annex took on the majesty of temple architecture depicted by Masaccio while the stylish female shoppers and female service workers assumed the stately rhetorical poses and ample proportions of Renaissance goddesses. In Miller's vision, the American woman moved out of the private rooms of the home to play a prominent role in the public sphere of business and pleasure.[32]

Henri, Miller, and the painters whom they influenced conceived of the authentic New York experience, and, by extension, the authentic American experience, as a life lived in public. They repudiated the decorative artists' portrayal of refined and reticent private existence as tainted by aristocratic, European elitism, and contrary to the American ideal of a rugged, adventurous outdoor life. The tumult of the streets, whether genial or agitated, provided the self-consciously American artist of New York with a modern corollary to the 19th-century construct of frontier settlement as the quintessential American experience. Raphael Soyer's *The Crowd,* 1932 (page 246), a closeup view of working-class men and women knotted together as spectators around a speaker at a political rally in Union Square, exemplified the 14th Street School's perception of the city's greater press of peoples as a signifier of America's open, democratic mode of life.[33] In what is actually a cropped section of a larger painting, titled *Union Square,* showing a speaker addressing a group of demonstrators, Soyer took care to personalize and to dignify the gathered crowd. It is a trio of individuals who occupy the foreground of the abbreviated canvas. A soft golden light illuminates their upturned faces as if the artist wished to sanctify these countenances marked by care, hope, and patient forbearance.[34]

[31] Kenneth Hayes Miller and the artists influenced by him, including Reginald Marsh, Isabel Bishop, Raphael Soyer, and Edward Laning, were dubbed the "14th Street School" by John Baur in 1951 because of the location of Miller's studio on 14th Street near Union Square. The younger artists also took studios in this area and drew their subject matter from the activities in and around Union Square. Miller taught at the New York Art School and at the Art Students League. See Ellen Wiley Todd, *The "New Woman" Revised: Painting and Gender Politics on Fourteenth Street* (Berkeley, Los Angeles: University of California Press, 1993), who has examined the so-called 14th Street School of American Realism in rich historical detail with attention to the history, topography, politics, business, and culture of the 14th Street neighborhood; attention to the preoccupations and philosophy of the various artists active in this movement between the two world wars; and for particular analysis of the cultural context and implications of the 14th Street School's depiction of contemporary women.

[32] Todd, ibid., credits the 14th Street School with recognition in the 1920s and 1930s of both the expanded role of women in the urban workplace and of the emergence of an aggressive consumer economy which targeted women as prime customers, xxvi. Todd also argues that these artistic celebrants of the "new woman" reflected the contradictions inherent in the period's social construct of the feminine ideal, an ideal which joined the enhanced public visibility of women in modern commerce, recreation, and politics to traditional conceptions of feminine virtue and fulfillment.

[33] Ibid. Todd demonstrated that Union Square was not only a center of commercial traffic, but also, during the thirties, a center for political radicalism—the locale of May Day rallies, unemployment demonstrations, and protests against police brutality. However, as Todd asserts, the artists' portrayal of political rallies in the square seldom reflected upon the violence, rage, and desperation which attended some of these demonstrations, 122. Todd

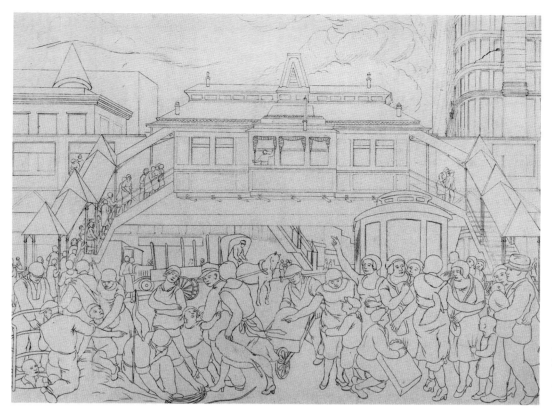

9 As a member of the 14th Street School, Edward Laning adopted Kenneth Hayes Miller's application of classical design to contemporary subjects. Laning's imposition of a frieze-like composition and linear clarity upon the traffic of construction workers, shoppers, and office workers endowed the busy commercial district of 14th Street and Union Square with dignity, measure, and order. *Fourteenth Street*, graphite on paper, 1931, 18 x 24¼ in., Wichita Art Museum, gift of Mrs. Alan Gruskin.

Jack Levine's *Medicine Show IV* (page 189), which was painted much later, in 1958, initially appears to be an indictment of the venality and gullibility of the masses. Levine depicted a carnival huckster, backed by the tantalizing distraction of near-naked showgirls, hawking his snake oil to a crowd of hard-faced, flabby, and gaudily dressed spectators. However, the sparkle and glamour of Levine's technique overpowers the censorious intent of his narrative homily. Splashed throughout the surface of limpid glazes and loosely brushed impasto highlights, a vibrant palette of reds—from orange to violet—makes the eye dance across the dense effusion of limbs, faces, and bare midriffs.

In the artist's commentary upon his 1950s' medicine show imagery, Levine himself admitted that he hadn't brought off his intended critique of the Madison Avenue hucksterism. Instead he had conjured up a nostalgic memory of the raucous ebullience of his old South Boston

argues throughout her study that the 14th Street School, especially in its adoption of a classicizing realism, deliberately projected an "upbeat" view of all Union Square gatherings in which "groups interact cordially and democratically," 90. Among the crowd subjects favored and repeated by the 14th Street School painters Miller, Soyer, Bishop, Laning and Marsh were shoppers in front of department stores, shoppers and office commuters on the subway stairs, crowds gathered in Union Square to hear street orators, the unemployed sitting on park benches on Union Square, and people queued up for entry to the movie house, the bowling alley, or other entertainments.

34 Howard E. Wooden, "Raphael Soyer," *Collected Essays on 101 Art Works From the Permanent Collections of the Wichita Art Museum* (Wichita: Wichita Art Museum, 1988), 106. Howard E. Wooden, who directed WAM from 1975-89, visited Soyer in his studio in February 1982 and conversed with Soyer about *The Crowd*. Soyer explained then that the image was a fragment of a larger painting. Later that summer, Soyer wrote to Wooden to say that he had cut down the painting because he had been dissatisfied with the big composition. At that time Soyer also identified the four people who had modeled for these individualized representatives of "the masses": the woman on the left was an art student, the young man to her right was an artist named Danny Cohen who died prematurely at age 24, and the older man to his right was the superintendent of the 14th Street neighborhood building where Soyer had his studio. The partial face of a young woman seen in the gap between the two men belonged to a dancer named Sylvia. Drawing with written identifications by the artist, WAM. See also Todd, *"New Woman,"* who reports that in a December 1982 interview with Soyer the artist identified *The Crowd* (Union Square) as "one of only two works he made under the 'direct influence' of the John Reed Club," 127.

neighborhood as he remembered it from the 1930s.[35]

Among the most devout celebrants of New York as the cornucopia of sensation, Reginald Marsh began to practice his creed in the early 1920s producing illustrations and a daily column on such city subjects as vaudeville, night clubs, and trials. Marsh, like Sloan, haunted the city's streets and entertainments, wherever a crowd would gather, to record ideas first for his illustrations and then later for his paintings. After a trip to Europe where he had absorbed lessons from Rembrandt and Rubens which he would later apply to his own imagery, Marsh declared himself blessed to return to New York: "I felt fortunate indeed to be a citizen of New York, the greatest and most magnificent of all cities in a new and vital country whose history had scarcely been recorded in art."[36]

WAM's 1947 tempera painting titled *Red Curtain* (page 202) provides explicit representation not only of one of Marsh's favorite subjects but also of the artist's persistent use of the fantastically voluptuous young woman as a metaphor for the coarse energy of the American populace.[37] In this particular image, a blond stripper strides confidently on stage, parading her physical abundance before a motley audience of males who register varied shades of emotion from excited voyeurism to nodding

slumber. This same stereotype of exuberant sexuality permeates the artist's imagery, injecting a surge of animal vitality into his oft-repeated scenes of shop girls strolling, dime-a-dance halls, public beaches, subways, amusement park rides, movie theaters, and burlesque shows. In these images, featuring, as they most often did, a compositional massing of overripe bodies in scant or skin-tight clothing, Marsh combined the high drama of a peasant Kermesse by Rubens with the ribaldry of a Thomas Rowlandson caricature.[38] Marsh asserted his democratic sympathies—and his artistic virility—not only in his subject preference for lower class diversions but also in the popular idiom of his style.

Following the dictum of Winslow Homer, and after him, of Robert Henri, that the manly American artist frankly addressed the rougher side of life, Reginald Marsh portrayed New York's "mean streets" in scenes of hobo "jungles" and the aimless, drunken desperation of the unemployed gathered beneath the El. Although the drawing of *The Bowery*, 1952-53 (page 205), in the WAM collection dates from the latter part of the artist's career, the inventory of derelicts includes the artist's typically egalitarian mix of ages and racial types, as well as the ubiquitous figure of the "beautiful doll" in the far left middle ground.[39]

[35] Stephen Robert Frankel, comp. and ed., *Jack Levine* (New York: Rizzoli, 1989), 70-71.

[36] Reginald Marsh, quoted in Lloyd Goodrich, *Reginald Marsh* (New York: Whitney Museum of American Art, 1955), 8.

[37] Edward Laning, "Through the Eyes of Marsh," *Art News* 54, no. 5 (September 1955): 22-24. In this review of the memorial exhibition of Reginald Marsh's art organized by Lloyd Goodrich for the Whitney Museum of American Art Laning characterized "Marsh's girl" not as an individual but as a mythic

American prototype. Laning explained that this "erotic apparition" functioned in Marsh's imagery as "catalyst" of creation and of destruction: "She is the great white whale of Reginald Marsh's myth of America," 24.

[38] Goodrich, *Reginald Marsh,* reported that Marsh, during his study in Europe in 1925, made a copy of Rubens's *Kermesse*, 7. Goodrich also pointed out the similarities between the themes and style of 18th-century English caricaturists Hogarth and Rowlandson and those of Reginald Marsh, 9.

[39] Navas purchased this piece following its inclusion in the 1955 memorial exhibition of Reginald Marsh's work organized by his friend and admirer Lloyd Goodrich for the Whitney Museum of American Art.

[40] Robert Henri, "Progress In Our National Art, "389. Henri extolled the independence and originality of the French Barbizon painter Jean François Millet because, in Henri's interpretation, Millet "had a vision of the greatness of life all about him whereas to the public he [Millet] seemed to be debasing his

mode of expression to low purposes, in reality he was finding in the muck and dirt. . .the tremendous significance of all life."

In a much earlier WAM piece titled *Sandwiches,* 1938 (page 200), Marsh presented one of his most somber expositions of life reduced to the base level of animal appetite. The scene's protagonist, a young African American male who is presumably destitute and/or homeless, grubs in a trash container on a public beach in search of discarded bits of food. Just a few feet beyond him and oblivious to the scavenger's presence a beefy and half naked couple embrace while in the distance a trio of buxom young women runs in the surf. Despite the melancholy gloom cast by the overall brown tones of the tempera glaze, the classically proportioned and muscular figures project an aura of defiant stamina. Marsh portrayed the masses' capacity for vulgarity just as he recognized the modern city's potential to engender and tolerate human degradation.

However, in Marsh's untitled ink wash of the New York skyline, 1950 (page 203), the city is seen from across the East River, its towering spires softened by the mist of the sea and the clouds of industry, suggesting that the artist's metaphorical "muck and dirt"[40] formed an essential part of his conception of this larger romantic whole. Like poet Carl Sandburg in his 1914 paean *Chicago,* Marsh gloried in the extravagance of the coarse primal energy which animated New York.[41]

Since the 19th century American artists intent upon denying and subverting the cultural hegemony of Europe had claimed coarse power as the quality which most distinguished the American character from the constitution of artifice bred by Old World civilizations. In 1909 Henri declared that the artist could still find this blunt and forceful character alive in the American people: "Why, here in America we have a country filled with energetic people. We are a distinct race; we have tremendous ideas to express, and often it seems to me that I cannot wait to hear the voice of these people."[42] Hearkening to the "fine and strong notes" of the people's voice which had been sounded in the work of Whitman and Homer, Henri had early on sought inspiration in the rugged environs of Monhegan Island, Maine.[43] He was attracted to this place not only by the wild fierceness of the sea and terrain but also by the simplicity of the island inhabitants.[44] Likewise, the artists who followed Henri to Monhegan Island identified the fishermen and their families who had inhabited the island and plied their grandfathers' trade as authentic American stock.

George Bellows's painting of *The Skeleton,* 1916 (page 95), paid tribute to the stalwart breed of the American worker in combined references to the fishermen of Monhegan Island and to the shipbuilders

41 Edward Laning, "Through the Eyes of Marsh," *Art News* 54, no. 5 (September 1955): 22-24. Marsh's fellow 14th Street School painter Edward Laning, argued that Marsh's oeuvre projected a surface energy which masked his true despair, described by Laning as "the black abyss" or "the blackness ten times black," which he saw at the heart of Marsh's work, 23. However, the visual evidence, together with the extensive documentation of the American realists' adherence to the romantic nationalism of Walt Whitman, supports Lloyd Goodrich's assertion in

Reginald Marsh, 1955, that ". . . fundamentally his [Marsh's] art was more affirmative than negative. His exposure of the ugly in humanity was the reverse side of a love of physical vitality and beauty," 9.

42 Henri, "Progress in Our National Art," 391.

43 Ibid. Henri specifically cited Whitman, Homer, and Twachtman as artists who had sounded the "strong and fine notes" of the people's voice. Bruce Robertson, in *Reckoning with Winslow Homer,* 86-88, 95, cited Homer, particularly

Homer's late paintings of the sea and Maine fishermen, as a critical influence upon the formation of Henri's conception of the American style and subjects. Robertson demonstrates that Henri's (and Henri's circle of artists) painting trips to Monhegan Island, Maine, was a specific pursuit of, as Henri said, Homer's "big, strong, American painting." Both contemporary critics and Robert Henri identified Homer's forcefulness of execution and the ruggedness of his human and landscape subjects with the quintessence of American character and experience.

44 Jessica F. Nicoll, *The Allure of the Maine Coast: Robert Henri and His Circle, 1903-1918* (Portland, Me.: Portland Museum of Art, 1995), 8, documents Robert Henri's attraction to Monhegan Island and its people in a letter of 12 July 1903 written by the artist to his parents, a letter in which he rhapsodized about the wildness of the sea, the cliffs, and the pine forests, and about the goodness of the people.

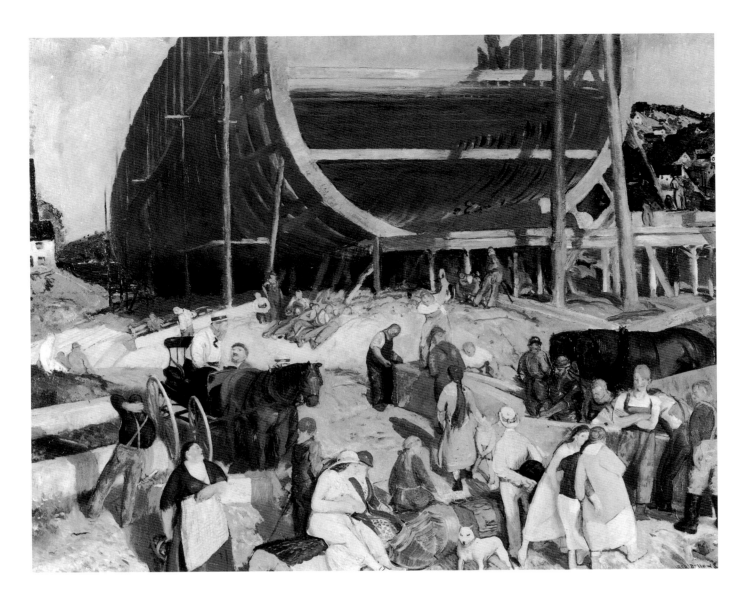

10 In *Shipyard Society* George Bellows portrayed the construction of a great vessel as a communal enterprise engaging men, women, and children of various classes. Oil on panel, 1916, 30 x 38 in., Virginia Museum of Fine Arts, Richmond, Va., The Adolph D. and Wilkins C. Williams Fund.

of Camden, Maine. When Bellows first joined Henri on Monhegan Island in 1911 he devoted his attention strictly to the melancholy desolation of rock and sea. However, during the summer of 1913 Bellows changed his Monhegan subject focus to the routine heroism of the fishermen who launched their small boats and hauled in their hard-won catch against the dramatic backdrop of "the ocean's boundless, primal energy."[45] In 1916 Bellows extended his study of the relationship of man to the sea in a series of major paintings, of which *The Skeleton* is one, about the workers in the Camden shipyard. That summer Bellows became fascinated by the construction of a huge wooden sailing ship. He selected the unfinished hull of the

ship as the emblematic center of an epic creative enterprise undertaken by the people—an American epic similar in grandeur of purpose and community to a medieval European town's construction of a great cathedral. Bellows later described the heroic intent of these images: "When I paint the great beginning of a ship at Camden, I feel the reverence the ship builder has for his handiwork. He is creating something splendid, to master wind and wave, something as fine and powerful as Nature's own forces."[46]

In WAM's painting of *The Skeleton,* Bellows combined the majestic feature of the grand ship's hull with the awesome and ominous power of nature as context for the rugged fishermen in their tiny open

boat.[47] The painter implied that the boldness of those original challengers of the American wilderness survived in the example of these Maine fishermen. WAM's *Skeleton,* taken in context with Bellows's series of 1914-16 depictions of the fishermen and shipbuilders, paid homage to an archetype of the American folk as a simple hardy breed who comprised the basic unit of all that was good in America: family, community, pragmatism, industry, and daring.

The same respect for the hardiness and courage of the mass of working people is evidenced in Harry Gottlieb's *Dixie Cups,* 1936-37 (page 140) and Vincent La Gambina's *Coal Mine Disaster,* 1941 (page 178). In the Gottlieb, it is the anonymous rank of men, the factory workers, who ensure the nation's progress by their competent and fearless command of the great roaring dynamo of modern industry. Recalling Renaissance iconography of Christ's entombment, La Gambina's image of half-naked miners lifting up one of their injured fellows admonished the viewer to remember that America's industrial might was purchased by the sacrifices of labor.

The apotheosis of the common man in American art peaked in the 1930s under the aegis of Regionalism and of government-sponsored art projects. Regionalist leaders Thomas Hart Benton, Grant Wood, and John Steuart Curry repudiated modernism as a kind of effete artifice which was inconsistent with the plain honest nature of *real* Americans. The people the Regionalists had in mind were those epitomized in Carl Wuermer's 1930 genre portrait titled *American Farmer* (page 258). Wuermer's close foreground and slightly below-eye-level view of the single erect figure set against a verdant landscape gives physical dimension to the heroic American virtues of self-reliance and rugged, independent existence upon the land. Whereas the Ashcan School had grafted the Jeffersonian ideal of the noble yeoman farmer onto the city dwellers, the Regionalists undertook a more literal resurrection of frontier values through their focus upon rural and small town America.

Russell Cowles was but one of many American artists exposed in training and in travel to a cosmopolitan comprehension of artistic expression, including European modernism, to seek renewal in the plain and sturdy existence of rural America. In a letter of 1941 written upon the occasion of a trip back to his native Iowa, Cowles confessed that seeing the familiar countryside summoned a "flood of nostalgic recollections" of times spent in concord with nature and in the companionship of people who lived in daily exchange with nature.[48] In the WAM painting titled *County Fair,* 1944 (page 111), which had been inspired by the artist's recent attendance at the Iowa State Fair in Des Moines, Cowles deliberately altered the grand proportions of Des Moines's live-

[45] Franklin Kelly, " 'So Clean and Cold': Bellows and the Sea," in Michael Quick et al., *The Paintings of George Bellows* (New York: Harry N. Abrams, 1992), 155.

[46] George Bellows, "The Big Idea: George Bellows Talks About Patriotism For Beauty," *Touchstone* 1 (July 1917): 270.

[47] Kelly, "Bellows and the Sea," discusses the thematic connections of Bellows's images of 1916 of the rowboat on the choppy sea to Winslow Homer's earlier use of the same subject to evoke man's epochal contest with nature in *The Fog Warning,* 1885, and to Stephen Crane's story "The Open Boat," in which four men in a rowboat struggle to stay afloat in the face of waves "barbarously abrupt and tall," 161.

[48] Russell Cowles, quoted in Donald Bear, *Russell Cowles* (Los Angeles: Dalzell Hatfield, 1946), 36.

11 John Steuart Curry's image of the Kansas wheat farmer standing strong and upright against the prairie wind exemplifies the Regionalist's glorification of the virtues of an older American ideal of the yeoman farmer. *Our Good Earth*, lithograph, 1942, 12¾ x 10⅛ in., Wichita Art Museum, The John W. and Mildred L. Graves Collection.

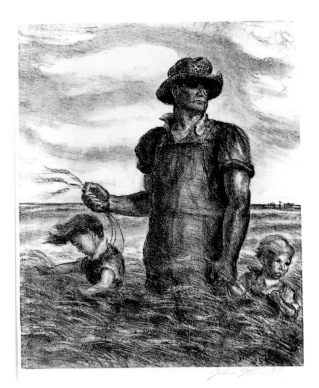

stock pavilion in order to evoke the more intimate and homely scene of a county fair.[49] From the grace and bounty embodied in the line of lithe young men leading their glossy-coated champion cows in parade before the judges, one might imagine that the noble lineage of ancient Crete had found reincarnation in the Iowa heartland.

However, the Regionalists' designation of the self-sufficient Midwestern farmer as the 20th-century standard-bearer of America's pioneer virtues did not trans-

late into blanket approbation of all facets of agrarian society. Like so many of Grant Wood's portrayals of small-town archetypes,[50] Edward Laning's *Camp Meeting*, 1937 (page 181), satirized the qualities of prudery, intolerance, and gullibility often associated with provincial life in general, and, in particular, with the emotional atmosphere of the tent revival.[51] However, Laning's disparagement of certain aspects of rural life did not reflect his general perceptions of the people as a symbol of national vigor. The artist's many murals and paintings of the 1930s expressed overwhelming empathy with the struggles and triumphs of the common man in such subjects as the arrival of immigrants at Ellis Island, destitute and homeless families begging on the streets, participants in a street rally being routed by the police, and Chinese American laborers laying the track for the transcontinental railroad.

Henry Koerner's gouache titled *Pond*, 1949 (page 165), is a Regionalist image which subtly insinuates its criticism of social injustice. The region in this case was a rural area around Chattanooga,

[49] Ibid., 32.

[50] James M. Dennis, "The Cosmopolitan Satirist," *Grant Wood, A Study in American Art and Culture* (Columbia: University of Missouri Press, 1986), 107-39, examines the satire directed by Wood at various popular American institutions and rituals.

[51] Robert L. Gambone, *Art and Popular Religion in Evangelical America, 1915-1940* (Knoxville: University of Tennessee Press, 1989), 83-6, explicates the iconography and content of Laning's satire in reference to the artist's personal experience, and to literary and

political associations of the period. Gambone's exploration of the Regionalists' fascination with the subject of evangelical religious experience revealed a general ambivalence, shared by artists and critics, about this particular predilection of the American folk.

[52] See catalogue entry for *Pond*, by Alisa Branham, 164.

[53] Marcus Klein, *Foreigners: The Making of American Literature, 1900-1940* (Chicago: University of Chicago Press, 1981), 154. Klein explained that the 1930s spawned a genre of "road books" in which the writers typically set out from New York traveling through the

Midwest, on to the Far West, and back to New York across the South, in search of that which was traditional and enduring and at the same time that which was quaint and individualistic. Among the writers and works in this genre cited by Klein were Edmund Wilson's *The American Jitters,* 1932; Sherwood Anderson's *Puzzled America*, 1935; Erskine Caldwell's *Some American People*, 1935; Nathan Asch's *The Road: In Search of America*, 1937; Louis Adamic's *My America*, 1938; and Benjamin Appel's *The People Talk*, 1940, 155-157.

[54] J. S. Balch, quoted in Klein, ibid., 168.

[55] Harry Hopkins, quoted from his preface to the *Massachusetts Guide* in Klein, ibid., 168. From 1933-40 Hopkins administered the *American Guide Series,* a writers' project to document the history and characteristics of each of the states.

Tennessee. As a Jewish immigrant whose parents and brother had perished in the Holocaust, Koerner was especially sensitive to racial bigotry.[52] He expressed his desire to see a more equitable treatment of African Americans in the U.S. by portraying them at leisure apart from the white culture which humiliated them, and by rendering them in a style identified with folk taste. To appreciate the significance of Koerner's choice of context one has only to compare the self-confident humanity of the figures in *Pond* with the stereotypical downcast African American stable cleaner in Cowles's *County Fair*. Although Cowles may have intended the figure of the stable hand scraping up cow manure as testimony to the earthy authenticity of his scene rather than as comment upon race and social class, his presentation of the African American's servile attitude contrasts dramatically with the self-possessed attitudes of Koerner's figures. What appeared to be objectivity in Koerner's image was in its own day a social statement.

The Regionalist movement was not without progressive accents. It expanded the horizons of the American Scene beyond urban enclaves to the corners of the nation previously missing from representation in its art. As historian Marcus Klein has pointed out, in the 1930s "the literary sympathizers with the masses" set out across the country to discover America in her varied and quaint regional manifestations.[53] It was also in the 1930s that government sponsorship of the arts institutionalized the liberal idea that the most appropriate sources for the creation of an authentic American art resided in "the mystic and mighty traditions of the diverse American people."[54] The writers' projects and artistic projects supported by the WPA mandated a nationwide concentration upon the unique history, customs, and scenery of individual regions. The majority of the artists engaged in this task shared with Harry Hopkins the optimistic faith that "America did have some kind of composite, democratic identity such as might be discovered by adequate research in the field."[55]

"Research in the field" for authentic American folk subjects not only induced artists to abandon their studios for expeditions to the heartland farms of their birth but also to prospect remoter corners of the country where fragments of a more primi-

12 Between 1935 and 1937 Edward Laning executed a monumental mural cycle for the federal buildings on Ellis Island relating the passage of immigrant families into the United States and their subsequent contributions to American life. Laning's *Ellis Island Arrivals* highlights two recurrent themes in the period's celebration of the common people; one, that the nation owed its strength to the solid communal virtues and industry of its humblest citizens; and two, that the immigrant populations were no longer to be viewed as aliens but instead as exemplifications of the American experience. Detail, Ellis Island mural, 1937, Fine Arts Collection, Public Buildings Service, General Services Administration, Washington, D.C.

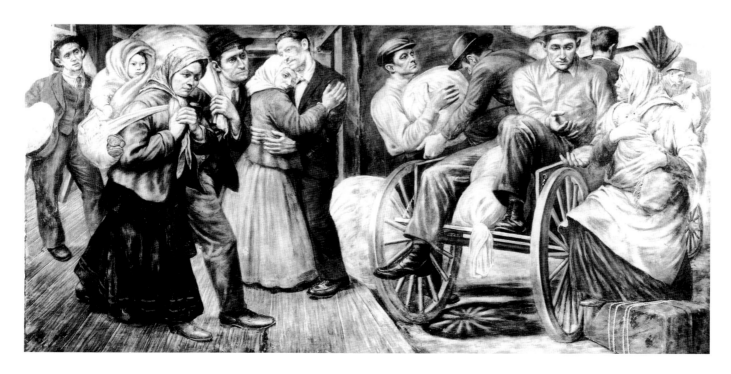

tive and exotic America survived.[56] The dusty southwestern villages of Taos and Santa Fe, New Mexico, proved to be among the locales most inspirational to artists and writers eager to peel back the layered skins of European artifice in order to expose the core of vital spirit they believed to be inherent in the simplicity and in the diversity of native cultures. John Sloan's depiction of a religious ceremony unique to the area, in *Eve of St. Francis, Santa Fe,* 1925 (page 243), recalls Bellows's tributes to the Maine shipbuilders and fishermen in its perception of the indigenous peoples as a society whose evolutionary adaptation to a land equally intense in beauty and difficulty resulted in the making of a people who experienced community on an instinctive level. For Randall Davey, like so many Anglo-European artists to come before and after him to the Southwest, the portrayal of representatives of Native American peoples such as in WAM's *Basket Dancer,* n.d. (page 121), provided evidence of America's living tradi-

tion of the primitive aesthetic, a tradition which Europeans had resort to only in ethnological museums.

Walt Kuhn's portrayal of circus and burlesque performers, exemplified by WAM's *Girl in Shako,* 1930 (page 168), and *Acrobat in White and Silver,* 1944 (page 169), paid homage to much the same cultural virtues as did the period's many depictions of Native Americans. Kuhn's theater people were not classical dramatists. They represented the working class of players—the clowns, the showgirls, the acrobats—who entertained for the masses and who lived creative but vagabond lives on the social periphery. Existing on a marginal income, living by wit and physical skills, they, like the Native American, symbolized an independence and boldness of spirit, a kind of raw, instinctive intelligence which the progressive artists associated with the American character and which qualities they believed necessary to the realization of a unique American aesthetic.

13 The Wichita artist Edmund L. Davison (1877-1944) was one of many painters attracted to the landscape and culture of the American Southwest. During the years 1922 to 1944, Davison traveled regularly between Wichita and Taos devoting time to recording contemporary life in both locales. *Street in Taos,* oil on canvas, n.d., 33⅞ x 40⅛ in., Wichita Art Museum, gift of Mr. and Mrs. H.J. Leverance.

Contemporary critics observed that Walt Kuhn identified with "types" such as the *Girl in Shako* because the artist had worked in theater and in the circus and painted from experience.[57] Commenting on Kuhn's terse economy of form in these theatrical genre portraits, critics also argued that Kuhn had achieved "an American freshness of vision" or a "Hemingway-like statement of fact" which he had applied to the great Western tradition of clown portraits reaching from Watteau through the European modernists Rouault and Picasso.[58] Although Walt Kuhn, who was one of the principal organizers of the 1913 Armory Show, openly acknowledged his debt to the formal innovations of European moderns, particularly Cézanne, the artist and his admirers believed that the combination of simplified decorative form and emotive force achieved in his best works bore the stamp of a native individualism.

The subject of the performer as a stand-in for both the private struggle of the artist-creator to achieve an authentic voice and a representative of the larger plight of the lone individual against anonymous evils grown to gargantuan proportions on a world stage appears in the late works by Yasuo Kuniyoshi from the WAM collection. In *Season Ended, 1940-45* (page 171), in the context of the vagabond existence of the circus performer, Kuniyoshi projected his own anxieties and despair about the social injustice and devastation of the Second World War into this presentation of his favorite motif, the languidly sensuous female figure.[59] With her body foreshortened, head sunken into shoulders by the composition's birds-eye view, and with her closed eyes accented by heavy shadows, the young woman portrayed by Kuniyoshi appears to have slumped into a state of depression. Kuniyoshi's mournful palette of browns and grays, combined with the abraded and scarred "skin" of color surrounding the figure, further invests the atmosphere with a weight of weary melancholy.

Executed in the artist's late style of acrid color and Surrealist allegory, the monumental image titled *Revelation,* 1949 (page 172), laid bare Kuniyoshi's sense of the war's tragic rending of humanist aspirations for the individual and for society. In this nightmare landscape of pain, weeping, and tearing of flesh, the figure of a broken puppet, half-human and half-mechanism, has been raised on a stick in the posture of crucifixion.

[56] In the 1930s so great was the emphasis upon the identification of "regionalism" with being truly "American" that Edith Halpert organized exhibitions in her Downtown Gallery to demonstrate that her stable of artists, which included those working in an abstractionist vein, such as Stuart Davis, were also American Regionalists. As Carol Troyen pointed out in her essay on Edith Halpert's contribution to the taste for modern art in America in *The Lane Collection, 20th-Century Paintings in the American Tradition* (Boston: Museum of Fine Arts, 1983), 44, Halpert mounted the exhibition *Paint America First* in 1930; in 1932 Halpert gave her presentation of a solo exhibition of the work of Marsden Hartley the regionalist title, *Pictures of New England by a New Englander;* in 1935 she presented the exhibit *14 Paintings by 14 American Contemporaries* and stressed in her press releases the "regionalist character of her artists," saying only two of them were from New York City.

[57] *Art Digest* 5 (15 November 1930), 16, quoting from an article in the *New York Herald Tribune,* observed that Kuhn painted his chorus girls and acrobats with an understanding born of experience.

[58] See *Art News* 31 (5 November 1932), 5; *Art News* 35 (30 January 1937), 18; Rosamund Frost, "Walt Kuhn, Clowns in a Great Tradition," *Art News* 42 (1 May 1943), 11.

[59] See Tom Wolf, *Yasuo Kuniyoshi's Women* (San Francisco: Pomegranate Artbooks, 1993), x-xv, for a discussion of Kuniyoshi's use of the solitary female figure, particularly the female circus performer, as the artist's alter ego, vehicle of personal expression, and symbol of primordial fecundity.

14 Ben Shahn was an influential figure among American artists who addressed their art to controversial social issues. At the beginning of his career Shahn portrayed topical events associated with the struggles of newly arrived immigrants, the poor, and the dispossessed, including the trial of Italian-born anarchists Sacco and Vanzetti, and the imprisonment of labor leader Tom Mooney. By the 1950s, however, Shahn had begun to translate his empathy for the sorrows of the common people into more abstract and generalized conceptualizations of the human condition. *Labyrinth Detail No. 1,* watercolor, 1952, 22 x 31 in., Wichita Art Museum, The Roland P. Murdock Collection, is one of a group of images in which Shahn alluded to the classical myth of Icarus as a metaphor of the irrationality of human destiny.

Ben Shahn's *The Blind Botanist,* 1954 (page 233), offers similar evidence of the artist's post-war consciousness of the fragility of American cultural ideals in the larger context of world war and holocaust. At the beginning of the 1950s Shahn had replaced his earlier exploration of the human condition in the context of the struggles of the American worker with the classical vehicles of mythology and allegory. Shahn conceived of the latter not as a betrayal of his liberal humanist sympathies, but instead as an elevation of his social concerns to a more universal level of connotation. In *The Blind Botanist,* Shahn portrayed the scientist, the protagonist of modern rationalism and progress, as Everyman. No longer confident in his powers of understanding and invention, the scientist can but tentatively grasp the mystery of nature. In an interview with Shahn conducted some six years after the painting of *The Blind Botanist,* Katharine Kuh asked Shahn to comment upon his recent series of images depicting the tragic deaths of innocent Japanese fishermen caught in the nuclear fallout from the U.S. government's tests of the hydrogen bomb in the Bikini Atoll. Shahn explained that his art had evolved from a narrow focus upon documentary explicitness to a larger meditation upon the commonality of human destiny: "When I did the Sacco and Vanzetti series and also the Mooney series, I was very careful to document my work with newspaper photographs and clippings, but with the Japanese paintings I no longer felt the need of such documentation. The radio operator on the fishing boat, who subsequently died of radiation poisoning, was a man like you and me. I now felt it was unnecessary to paint him, but to paint us. . . . I no longer felt the need to document him specifically. The terror of the beast that enters every one of the six paintings is the terror that now haunts all of us."[60]

However, Shahn's sense that possessing weapons capable of global destruction made the democratic ideal of a fraternity of mankind more urgent did not lessen the artist's pride in his national identity. When asked if he considered himself essentially an American artist, Shahn replied, "I certainly do. I think I am one of the most American artists painting today."[61]

Although realist painter Edward Hopper would not have sympathized with the liberal political causes which animated much of Shahn's art, he would have concurred with Shahn's assertion that national identity was integral to an artist's self-expression. In his "Notes On Painting" written for the catalogue of the painter's first retrospective exhibition held at the Museum of Modern Art in 1933, Hopper argued that great art emerged not from technical innovation but from the context of a nation's life and public character: "In general it can be said that a nation's art is greatest when it most reflects the character of its people."[62] He also disputed the notion that representational art had reached a dead end saying that the current direction of art toward a purely abstract notation was "sterile and without hope to those who wish to give painting a richer and more human meaning. . . ."[63]

Hopper was quick to chafe at labels and disclaimed association with any dogma. In the early 1960s when the realist movements of the 1930s and 1940s were considered passé, Hopper told his friend, art critic Brian O'Doherty, that he objected to being classed with Benton and Curry in an American Scene or Regionalist movement: "The French painters didn't talk about the 'French Scene,' or the English painters about the 'English Scene.' It always gets a rise out of me. The American quality is in a painter. He doesn't have to strive for it."[64]

Although he abhorred sentimentality and chauvinism in art, Hopper not only identified with the definition of native character advanced by the American Scene movement and the Regionalists, he energized the formulation of that ideal. In his tribute to John Sloan written in 1927 Hopper extolled Sloan's American virtues—simple visual honesty, strong personal vision, and direct contact with the life around him. Hopper explained further that Sloan had quietly and courageously worked along his own homely path despite the fact that public recognition went to the painters who "exchanged their birthright" for the easy praise earned by the exercise of superficial technical tricks mimicked from French painting.[65] Hopper believed as intensely as Henri, whose influence and vision he praised highly, in the need for the American artist to assert a muscular simplicity appropriate to his race, and to consciously disdain the cult of the aesthete.[66] What Hopper valued in his acknowledged artistic ancestors Homer, Eakins and Ryder, as well as in the work of his contemporaries Sloan and Burchfield, was their indifference to fashionable standards of taste, and the ability to exalt the raw and downright uncouth vitality of the New World.

In his own art Hopper asserted a profound identification with the commonplace and the plain. He found his subjects in the urban milieu of New York where he lived with his wife, Josephine Nivison, in a

[60] Ben Shahn, quoted in Katharine Kuh, *The Artist's Voice: Talks with Seventeen Artists* (New York: Harper & Row, 1962), 216, 218.

[61] Ben Shahn, ibid., 206.

[62] Edward Hopper, "Notes on Painting," *Edward Hopper Retrospective Exhibition* (New York: Museum of Modern Art, 1933), 17.

[63] Ibid., 18.

[64] Edward Hopper, quoted in Brian O'Doherty, *American Masters, The Voice and the Myth in Modern Art* (New York: E. P. Dutton, 1982), 12.

[65] Edward Hopper, "John Sloan and the Philadelphians," *Arts* 11, no. 4 (April 1927): 169.

[66] Ibid., 177. Hopper wrote approvingly of Sloan's artistic excursions onto the tenement rooftops and into the streets: "Out of the horde of camp-followers, imitators and publicity seekers who attach themselves to all movements in art . . . are emerging certain artists of originality and intelligence who are no longer content to be citizens of the world of art, but believe that now or in the near future American art should be weaned from its French mother. These men in their work are giving concrete expression to their belief. The 'tang of the soil' is becoming more and more evident in their paintings."

Greenwich Village apartment, along the New England coast where he and Jo kept a summer cottage, and from the passing scene glimpsed from train or car on the couple's vacation trips across the country. In each locale he deliberately sought the most mundane of vernacular structures for careful and exacting study, making virtual portraits of factories, warehouses, lighthouses, bridge overpasses, power lines, diners, gas stations, offices, storefronts, movie houses, and hotel rooms. Unlike John Sloan or Reginald Marsh, however, Hopper was uninterested in the tumult of the crowd. He frequently chose to portray times when the streets were deserted or peopled only by solitary figures. Also typical of Hopper is the view through a window of a single figure or of a couple in a sparsely furnished interior room. Very little action occurs in Hopper's paintings. Transfixed by thought or inertia, his people stare out of windows, look at their feet as they wait for the time to pass, read a magazine, idly finger the keys of a piano, or recline on the porch and gaze out at the sea. Hopper turned the examination of the lives of the people inward, focusing upon the evocation of a complex of enigmatic, poignant longings experienced by the anonymous individual in the New World of modern American culture.

Hopper wrote to Elizabeth Navas that he had gotten the inspiration for *Conference at Night,* 1949 (page 157), from something he saw on one of his fre-quent walks through the city at night.[67] Yet, as was typical of the artist, Hopper developed the scene from a composite of visual references and the careful distillation of forms into a clean solid structure. Some ideas for the painting may have come from the many illustrations of office and warehouse interiors he had executed for business journals during his years as a commercial illustrator.[68] Pictured at the back of a sparsely-furnished loft room, three individuals engage in an unexplained yet intense encounter. A balding man in shirt sleeves seated on the edge of a long work table seems to be lecturing a woman and a man, the latter in topcoat and fedora, who stand at attention. The features of the two faces in profile, especially that of the woman, exhibit sharp, almost predatory countenances. Tension issues not so much from the demeanor of the figures, however, as from the dramatic severity of the setting. The planes of walls, table tops, and window, the simple volumes of columns and ceiling beams, combine in geometric clarity and receding lines to focus the gaze of the viewer and to fix the characters in their space. A strong direct light coming from an unseen source outside the window illuminates the room in angular patterns of shadow and spotlight. Although the title implies that this is a non-event, nothing more than a simple business meeting, the scene projects a theatrical quality reminiscent of the grim urban dramas of popular cinema.[69]

67 Edward Hopper, letter to Elizabeth Navas, 28 June 1952. Navas Papers, WAM.

68 Gail Levin, *Edward Hopper as Illustrator* (New York: W.W. Norton, 1979), 17.

69 Gail Levin, *Edward Hopper, An Intimate Biography* (New York:

Alfred A. Knopf, 1995), 408, proposed the "urban melodramas now known as *film noir*" as a source for the lighting and ambience of *Conference at Night* and perhaps for other Hopper images.

70 Lloyd Goodrich, "The Painting of Edward Hopper," *Arts* 11, no. 3 (March 1927): 134-7.

71 Forbes Watson, "A Note on Edward Hopper," *Vanity Fair* 13 (February 1929): 64.

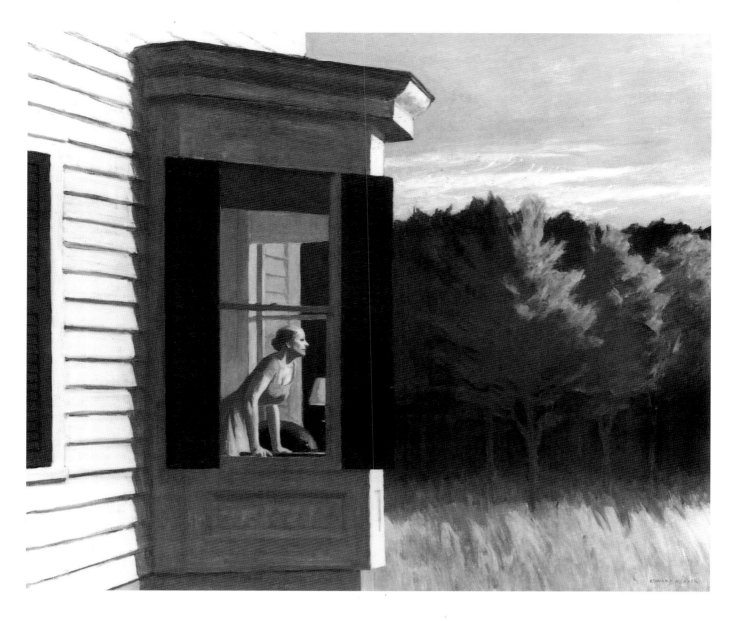

Hopper established the qualities which distinguish his style as well as the individual work of *Conference at Night*— its pedestrian subject matter, severe formal design, and emotive ambience of light— early on in his career. When he presented his first solo exhibition at the Frank K. M. Rehn Gallery in 1927, scholars and critics proclaimed Hopper a native son in the tradition of Thomas Eakins. Declaring that "Hopper belongs in the front rank of contemporary American painters," Goodrich described the artist's vision as "vigorous and eminently native," characterized by an independence so pronounced that it kept him from early acclaim and from experimentation with "fashionable modernism."

Goodrich interpreted Hopper's particular treatment of American subjects as sympathetic to "a racial [American] expression which. . . has the courage to be itself," and expressive of that "spare. . . Puritanical strain" in the culture.[70] Writing in 1929, Forbes Watson described Hopper as possessing "enough rock or iron in his constitution" to resist the seductive lure of French modernism.[71] Guy Pène du Bois, both an enthusiast of Hopper's art and one of Hopper's closest friends, proclaimed in his 1931 essay for the American Artist Series issue on Hopper published by the Whitney Museum of American Art that Hopper's stalwart masculine images would endure long after the "trivial" painters of

15 Edward Hopper cited his painting *Cape Cod Morning*, oil on canvas, 1950, 34¼ x 40⅛ in., National Museum of American Art, Smithsonian Institution, Washington, D.C., gift of the Sara Roby Foundation, as one that he liked particularly well. The image combines his favorite themes of intense and solitary looking, the sharp juxtaposition of the natural and the man-made setting, and the use of light to articulate form and feeling.

the Paris school and their American imitators had faded from memory.[72]

Where others had called Hopper's terse realism "Puritanical," making reference to the artist's literal and symbolic roots, Charles Burchfield preferred the term "classical." Nonetheless Burchfield also asserted that "Edward Hopper is an American—nowhere but in America could such an art have come into being."[73] Perhaps the thing that made Hopper most American in Burchfield's eyes was that the artist seemed so coolly himself: "But more than being American, Hopper is—just Hopper. . . . In him we have regained that sturdy American independence which Thomas Eakins gave us, but which for a time was lost."[74]

Like Homer before him, Hopper insisted, especially later in life, upon his Emersonian resourcefulness. When Katharine Kuh asked the artist what influences were strongest in his work, Hopper replied, "I've always turned to myself. I don't know if anyone has influenced me much."[75] Hopper was an original, but his originality derived its pungent flavor from the artist's cultivation of the common exemplifications of American experience. Brian O'Doherty reflected in 1974 that Hopper, probably because of his great sophistication, had tapped into powerful American myths which served both his personal voice and the larger cultural aspiration to "establish a sense of place and a confidence from which to undertake the modernist enterprise in America."[76]

As is typical of many of Hopper's images, *Sunlight on Brownstones,* 1956 (page 159), evokes a haunting sense of familiarity in the viewer. Hopper identified the actual locale of the painting as the stoop of a New York brownstone apartment building somewhere "in the West Eighties, and the [Central] Park is right there. . . . The light is largely improvised."[77] Watching him develop this image, Hopper's wife, Jo, bemoaned her husband's stubborn resistance to beauty in his manufacture of the setting and the people. When he went out to look for just the right old-fashioned brownstone she complained that "nothing around here will do—here on own st. Wash. Sq. N. with the lovely white Georgian ones, not his idea at all. Always must be the common denominator."[78] Then she despaired over his exchange of prettiness for stolid maturity in the portrayal of the female figure: "He had such an attractive young thing perched on the railing but he's now made her much too old & determined to be perching on that rail & wearing her dark hair down on her shoulders."[79]

[72] Guy Pène du Bois, *Edward Hopper,* American Artists Series (New York: Whitney Museum of American Art, 1931), 12, said that Hopper "will be shown, in any comparison of this kind, without patience for trivialities, a serious man, capable of reaching majesty; a male, if you like; certainly an Anglo-Saxon."

[73] Charles Burchfield, "Edward Hopper — Classicist," in *Edward Hopper Retrospective Exhibition* (New York: Museum of Modern Art, 1933), 16.

[74] Ibid.

[75] Edward Hopper, quoted in Katharine Kuh, *The Artist's Voice,* 135.

[76] Brian O'Doherty, *American Masters,* 46.

[77] Edward Hopper, quoted in Levin, *Hopper, An Intimate Biography,* 498.

[78] Jo Hopper, quoted in Levin, *Hopper, An Intimate Biography,* 495.

[79] Ibid., 497.

[80] Rolf Günter Renner, *Edward Hopper, Transformation of the Real,* trans. Michael Hulse (Köln: Benedikt Taschen, 1990) has elaborated upon a view held by many that Hopper's realism achieved a level of metaphorical commentary upon the myths of his culture. Renner believes that the central theme in Hopper's art is the irreconcilable and always charged tension between two equally potent American ideals of the sacred wilderness and the dynamic city.

By a process of selecting, eliminating, and solidifying of form, Hopper contrived to make something so prosaic as a city couple taking the air on their stoop feel like a moment of fate. The pair reside silently together, each lost in watchful meditation. Enveloped in a hush of weight and portent, opposing forces move into conjunction. Man and woman—each possessing a separate nature—complement and contradict each other. The world around them divides into significations of civilization and nature. Mass and light define their essence.[80] The artist formed all objects, organic and manufactured, of the same unadorned hard substance. His formal vocabulary asserted the associations of modernist imagery while his dramatic play of light and shadow probed at a volatile repository of subconscious intuitions, appetites, fears, and desires. In the couple posed upon the stoop of the brownstone apartment, Hopper presented an archetypal American Adam and Eve confronting the New World after the fall.

Many American artists who began their careers in the opening decades of this century pursued an imaginative construct of the common people as a liberating vehicle of self-expression. John Sloan and fellow participants in the Ashcan School explored the pastimes of the city's lowliest inhabitants as a means to greater spontaneity and intensity of feeling in art. The adherents of Regionalism at their worst narrowed the definition of a national aesthetic to a dogma of representational style and agrarian subject matter. However, in its more expansive embrace of popular diversity, Regionalism also forwarded the idea that a vital American vision would necessarily comprise plural sources of structure and belief. The interest of artists like Yasuo Kuniyoshi and Ben Shahn in the spiritual devastation wreaked upon individuals by chaotic social forces encouraged their investigation of intuitive and anti-rational surrealist strategies. By cultivating a personal and national myth of blunt raw character, Edward Hopper advanced his aesthetic ambition to extract the timeless moment from temporal matter. Although the images of the people which emerge from this exhibition or from the period as a whole can only offer partial truths, they provide an instructive prologue to the preoccupation of the current age with identity and cultural values.

CATALOGUE OF WORKS

MILTON AVERY (1885-1965)
Beach Blankets, 1960
Oil on canvas, 53⅜ x 71⅞ in.
Signed lower left: *Milton Avery 1960*
Gift of Marian L. Beren and S.O. Beren, 1975.64

This large painting by Milton Avery may appear at first to present nothing more that an abstract arrangement of simple shapes and flat colors. The title, however, informs us that Avery has actually depicted two blankets on an empty beach. Many of Avery's late paintings share this stark, abstract quality, but all of them remain representational in intent; Avery never abandoned nature as the source of his work.

Born in Altmar, New York, Avery moved to Connecticut with his family at a young age. He began his artistic training in 1905 at the Connecticut League of Art Students in Hartford, and later enrolled at the School of the Art Society in 1918. In 1925 Avery moved to New York to pursue a career as a painter. The influence of Henri Matisse led Avery to adopt a bold palette, simplify forms, and flatten space, while the work of John Twachtman informed the subtle tonal structure of Avery's paintings. Though Avery remained apart from the artistic groups formed by his contemporaries, Avery himself had a significant influence on his younger friends Adolph Gottlieb and Mark Rothko, who would emerge in the 1940s as leading members of the Abstract Expressionist movement.

The flow of influence would reverse itself when the mature abstract canvases of Rothko encouraged Avery to paint outsize works. Avery executed the first of these large-format canvases in the summer of 1957 in Provincetown, Massachusetts. *Beach Blankets* was painted three years later during his last summer in Provincetown. The simplicity of the painting reveals Avery's interest in capturing the essence of a subject through reduction and simplification. As Avery himself said, "I always take something out of my pictures. I strip the design to the essentials."[1]

When *Beach Blankets* was exhibited at the Grace Borgenicht Gallery in 1963, its success was recognized by a contemporary critic, who wrote: "The growth and continuing distinction of Avery's work lies in the artist's tireless search for economy and simplicity of expression. A painting called *Beach Blankets* for example, boasts two isolated shapes, one burnt-orange, one yellow painted upon a flat pink background—that is all, and yet, all is succinctly stated or (understated) and all lives in perfect clarity and unity."[2]

M.R.

1. Milton Avery quoted in Una E. Johnson, *Milton Avery: Prints and Drawings, 1930-1964* (New York: The Brooklyn Museum, n.d.), 10.

2. Unsigned, undated clipping, registrar's files, Wichita Art Museum.

GEORGE BELLOWS (1882-1925)

The Skeleton, 1916

Oil on canvas, 30⅜ x 44⅜ in.

Signed lower right: *Geo. Bellows*

Gift of the Wichita Art Museum Foundation, 1965.1

As one of a series of paintings depicting ship building at Camden, Maine, *The Skeleton* focuses on the wooden structure of a freight ship under construction. While Bellows was keenly interested in the reality of the subject at hand, he acknowledged in a letter to his mentor, Robert Henri, his reliance on imagination and memory in executing this and other paintings at Camden:

> I have done a number of pictures this summer which have not arrived in my mind from direct impressions but are creations of fancy arising out of my knowledge and experience of the facts employed. The result, while in continual danger of becoming either illustration in a bad sense or melodrama has nevertheless evolved into very rare pictures.[1]

Born in Columbus, Ohio, Bellows spent most of his early life in his native state and attended Ohio State University before leaving in his junior year. A star athlete in college, Bellows had the potential to pursue a professional baseball career, but instead chose to become an artist, moving to New York, where he studied under Robert Henri at the New York School of Art. Bellows adopted the urban realist style practiced by Henri and Henri's students John Sloan and George Luks. Critics dubbed these painters the Ashcan School because of their artistic interest in the slums, saloons, and sordid details of everyday city life. The energetic brushwork of *The Skeleton* conveys the emotional vigor that Bellows and the other Ashcan School artists brought to their work.

In 1917, Bellows expressed admiration for the ship-builder and his craft: "He is creating something splendid, to master wind and wave, something as fine and powerful as Nature's own forces. When I paint the colossal frame of the skeleton of his ship I want to put his wonder and power into my canvas, and I love to do it."[2] Unlike the other Camden works, which focus on the activity of shipbuilding itself, *The Skeleton* provides a distant view of the ship and surrounding landscape. The prominent, central placement of the ship within the land's natural formations echoes Bellows's metaphorical identification of the work of the ship-builder with the creative forces of nature. The manned rowboat in the foreground and houses in the background emphasize that the hull is a product of human craft and ingenuity as well as a source of economic vitality.

The ship under construction in *The Skeleton* was commissioned by the United States government and was intended for the war effort. While the painting offers an optimistic depiction of society's creative endeavors, it may also allude to the destructive impulses of humankind. In 1916, the U.S. involvement in World War I was mainly limited to trade with the European powers. Repeated destruction of U.S. merchant ships by German U-boats, however, led to American entry into the hostilities in 1917. The dramatic, almost foreboding atmosphere of Bellows's landscape, with its ominous sky, may refer to the ship's intended use. Even though Bellows opposed the war, he commented that he "would enlist in any army to make the world more beautiful. I would go to war for an ideal—far more easily than I could for a country. Democracy is an idea to me, is the Big Idea."[3] With an eye toward the war in Europe, George Bellows's *The Skeleton* presents a powerful depiction of the artist's democratic ideals filtered through the craft and skill of the ship-building community.

M.A.W.

1. George Bellows, letter to Robert Henri, 8 September 1916, Robert Henri Papers, Beinecke Rare Book and Manuscript Library, Yale University, quoted in Michael Quick, "Technique and Theory: The Evolution of George Bellows's Painting Style," in *The Paintings of George Bellows* (New York: Harry N. Abrams, 1992), 57.

2.George Bellows, "The Big Idea: George Bellows Talks About Patriotism For Beauty," *Touchstone* 1 (July 1917): 270.

3. Ibid., 269.

OSCAR E. BERNINGHAUS (1874-1952)

Aspens, Early Autumn, Taos, n.d.

Oil on canvas, 25¼ x 30¼ in.

Signed lower right: *O.E. Berninghaus*

Gift of Mrs. George M. Brown Estate, 1974.7

A native of St. Louis, Oscar E. Berninghaus had very little formal academic training; he began his career as a news sketch artist. At the age of sixteen, Berninghaus apprenticed as a lithographer where he developed superior drafting skills, a sensitivity to detail, and an ability to render clearly defined spaces, all of which would later inform and strengthen his painting. After completing three semesters of evening courses at the School of Fine Arts of Washington University in St. Louis, Berninghaus continued his artistic growth through self-disciplined practice.

An 1899 commission from the Denver and Rio Grande Railroad to illustrate tourism pamphlets enabled Berninghaus to travel through the areas served by the railroad. Northern New Mexico cast its spell over Berninghaus, and for the next nineteen years he would spend half of every year in Taos. In 1912 Berninghaus joined in the founding of the Taos Society of Artists, an association of six artists who recognized in the people and landscape of New Mexico a potential for a uniquely American art. In Berninghaus's view, "the canvases that come from Taos are definitely as American as anything can be."[1] Indeed, for American artists, place is as much the measure of identity as style. Like the French and American Impressionists, Berninghaus often painted outdoors, returning to the same sites repeatedly to record them in different seasons and in different light. *Aspens, Early Autumn, Taos* is a fine example of the resulting canvases.

The picture, suffused with a radiant warmth, captures the pervasive light, clear, thin air, and dramatic chiaroscuro so typical of the New Mexican landscape. A stand of aspens, united in a golden glow, is rendered in short, flickering strokes that provide an interplay of brushwork on the surface. The stark tree trunks support a shimmering canopy of foliage above, while the undulating floor of the forest below balances their relentless verticality. The elements are mildly abstracted for expressive effect, and thus the scene is as much a summation as a description. As Berninghaus commented: "The painter must first see his picture as paint—as color—as form—not as a landscape or a figure. He must see with an inner eye, then paint with feeling, not with seeing."[2]

B.J.B.

1. Quoted in Gordon E. Sanders, *Oscar E. Berninghaus, Taos, New Mexico: Master Painter of American Indians and the Frontier West* (Taos: Taos Heritage Publishing, 1985), 34.

2. Quoted in Mary Carroll Nelson, *The Legendary Artists of Taos* (New York: Watson-Guptill Publications, 1980), 41.

CHARLES E. BURCHFIELD (1893-1967)

Abandoned Coke Ovens, 1918

Born in Ashtabula Harbor, Ohio, Charles Burchfield grew up in nearby Salem, and from 1912 to 1916 studied at the Cleveland School of Art. In 1921 he moved to suburban Buffalo, New York, where he lived for the rest of his life. Stylistically and thematically, Burchfield's career went through three phases. Before 1918, he painted fantastical landscapes, drawn from childhood recollection and his imagination, visualizing the immaterial moods and sounds of nature. Rendered with calligraphic brushstrokes, the early paintings recorded Burchfield's emotional responses to nature and memory. In 1918 Burchfield began painting from direct observation, rendering realistically the people and architecture of the local landscape. Less intimate than the earlier paintings, Burchfield's middle period works were executed with a firmer, more controlled line. In 1943, Burchfield returned to his earlier concern with intensely emotional and highly personal images of nature, reworking ideas, and in some cases actual paintings, from his youth.

Painted near Burchfield's hometown of Salem, *Abandoned Coke Ovens* dates from the beginning of the artist's middle style. Burchfield recalls feeling "melancholy and depressed" during this transitional year as he awaited induction into the U.S. Army.[1] A developing awareness of "the hardness of human lives" inspired Burchfield to paint "'portraits' of individual houses" that were intended as

Abandoned Coke Ovens, 1918
Watercolor on paper, 17¼ x 26¼ in.
Signed and dated lower left: *Chas. Burchfield/1918*
Roland P. Murdock Collection, M154.58

"social or economic comments" on the changing American landscape.[2]

In *Abandoned Coke Ovens,* thin paint application and quick, scratchy brushstrokes that allow pencil markings and white paper to show through—as, for example, in the clouds and hills—give the whole scene a dry and desiccated feeling. The doleful miners' huts of *Abandoned Coke Ovens* seem anthropomorphic, with ashen complexions, wide gaping mouths, and sagging eyes underscored by heavy, black, down-turned lines. These dilapidated houses bear witness to the scorched earth and blood-red tailings in the foreground, and the "black cavities of abandoned coke-ovens [that] gleam like sinister eyes."[3] Burchfield recalled:

> There were a number of small 'ghost' settlements around Salem at that time—most of them related to coal-mining. . . . As soon as the coal ran out the whole project was abandoned, the houses and ovens left to decay. At that time, such places had for me an almost 'pre-historic' feeling as though they had been abandoned centuries ago. I was fascinated with the oven in particular, it seemed to me to resemble the head of a gigantic buzzard. . . . The peculiar plants in the foreground are. . . horse tails, the flowering phase which precedes the fern-like leaf that comes later (said by botanists to be the sole survivor of the prehistoric age of vegetation that produced coal).[4]

This botanical verism is rooted in the detailed sketches the artist made in high school of the local wildflowers and trees, yet here Burchfield employs it with rueful intentions.

D.J.W.

1. Burchfield's army service in the camouflage unit in South Carolina lasted from July 1918 until January 1919. *Charles Burchfield, His Golden Year: A Retrospective Exhibition of Watercolors, Oils and Graphics* (Tucson: University of Arizona Press, 1965), 23.

2. Ibid., 23.

3. Burchfield, from an inscription on the back of the painting, 30 April 1918.

4. Charles Burchfield, letter to Elizabeth S. Navas, 6 August 1958, registrar's files, Wichita Art Museum.

December Twilight, 1932-38

Burchfield painted *December Twilight* from his backyard in Gardenville, New York, a suburb of Buffalo. The viewer enters the foreground of the landscape and is immediately drawn through the open gate towards a lingering, fluorescent sunset. Sharp, angular forms of buildings create a jagged barrier between the viewer and the setting sun. Artificial light glows from inside a neighboring residence, evidence of human activity hidden behind drawn window shades. Above the buildings, warm natural light reflects on a heavy blanket of clouds, against which a dark church spire is outlined. The ominous sky contrasts in mood with Burchfield's evocative narrative that recounts his direct inspiration for this painting:

> I got the idea for it one Christmas Eve. My children at that time were young enough to still believe in Santa Claus—and accordingly I was out back of the studio, out of their sight, fixing the morning's Christmas-tree to its standard.
>
> It had been an unseasonably warm day, culminating in a violent thunderstorm at late afternoon, and after it had passed as I was working, I looked up and saw this strange sight in the sky, in the southwest. Something of the unusual weather, the oddity of a thunderstorm in late December, perhaps some of the feeling of Christmas, and the usual mystery of twilight combined to make this seem an unusual sight. It had a feeling to me also of some far North country such as Alaska, Labrador, or more particularly, Scandinavia (tho I have never visited these countries). I dropped everything, ran and got paper and pencil, and hastily made pencil notes.
>
> The impression was so strong that it survived all the excitement of Christmas day, and on the day following I started the painting. I have always thought of it as the "Christmas Eve" picture, but I felt "December Twilight" a more comprehensive title.[1]

Burchfield's words distinguish the romantic, spiritual nature of his artistic expression from his conventional role as a father of five, compelled to record his dramatic response to a winter storm in the middle of holiday preparations.

December Twilight, 1932-38
Watercolor on paper, 23½ x 33½ in.
Signed with monogram and dated lower left: *CB/1932-38*
Roland P. Murdock Collection, M8.39

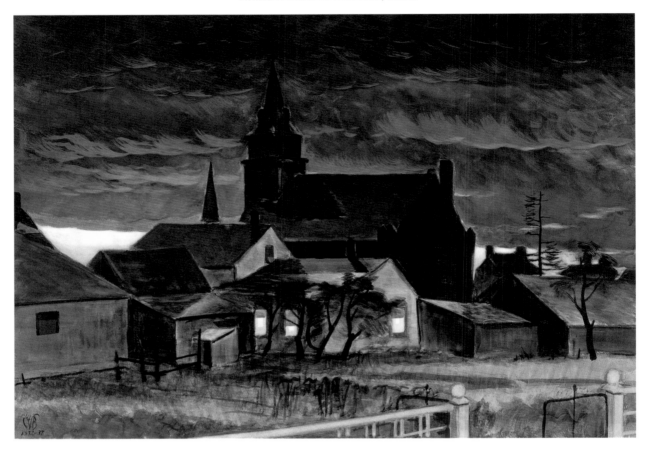

John I. H. Baur calls Burchfield a "pantheist," one who sees God everywhere, in the entirety of the natural landscape.[2] In *December Twilight*, the church spire functions not only as a symbol of the religious institution, central to the Christmas season, but also as a link between the domestic warmth of homes and the overwhelming presence of God and nature in the dramatic sky that envelopes the entire scene. It may be significant that around the time of this painting, Burchfield converted to his wife's Lutheran faith; however, most biographers agree that this visionary painter worshiped Nature, over God.

A.P.B.

1. Charles E. Burchfield, letter to Elizabeth S. Navas, 17 September 1939, registrar's files, Wichita Art Museum.

2. John I.H. Baur, *The Inlander: Life and Work of Charles Burchfield, 1893-1967* (Newark, N.J.: Associated University Presses, 1982), 257-63.

Indian Summer, 1941

Walt Whitman, one of Charles Burchfield's favorite poets, wrote his "Song at Sunset" in a voice similar to Burchfield's visual expression of reverence for nature.

Splendor of ended day floating and filling me,
Hour prophetic, hour resuming the past,
Inflating my throat, you divine average,
You earth and life till the last ray gleams I sing.

Open mouth of my soul uttering gladness,
Eyes of my soul seeing perfection,
Natural life of me faithfully praising things,
Corroborating forever the triumph of things.

O setting sun! though the time has come,
I still warble under you, if none else does,
unmitigated adoration.[1]

Burchfield's painting of the setting sun during a transitional season represents change: changing light, changing seasons, the inevitability of natural cycles. Burchfield was entering the autumn of his own life when he painted *Indian Summer* at age forty-eight. His children were growing up, preparing to leave home. American history was evolving, as the United States entered World War II. This painting does not speak directly to the future drama of war, but instead is nostalgic, reminiscent of the simple agrarian life on the farm of Burchfield's maternal grandfather.

In the foreground of Burchfield's painting, a dilapidated barbed wire fence marks a dirt road in the open countryside. In the distance, a small farm nestles into the rolling hills, almost disappearing. The farm is hidden by nature, just as the fence line is nearly obliterated by vegetation. Although the fence and farm buildings provide evidence of human habitation, there are no people in the scene. At one time, these fields were actively plowed or grazed; now they seem abandoned.

Indian Summer exhibits the more realistic style of Burchfield's middle period, 1918-43. The landscape is rendered in naturalistic hues, laid down in thin layers of watercolor. Warm strokes of yellow, orange and brown delineate plants in the foreground. With scattered touches of cool greens and pale blues, these colors, both warm and cool, echo the climatic contrasts of early autumn. The high horizon line allows the land's mass to dominate the image, while the brilliant yellow sun is restricted to a narrow, horizontal band of sky. The warmth of natural light flickers over the landscape in the day's

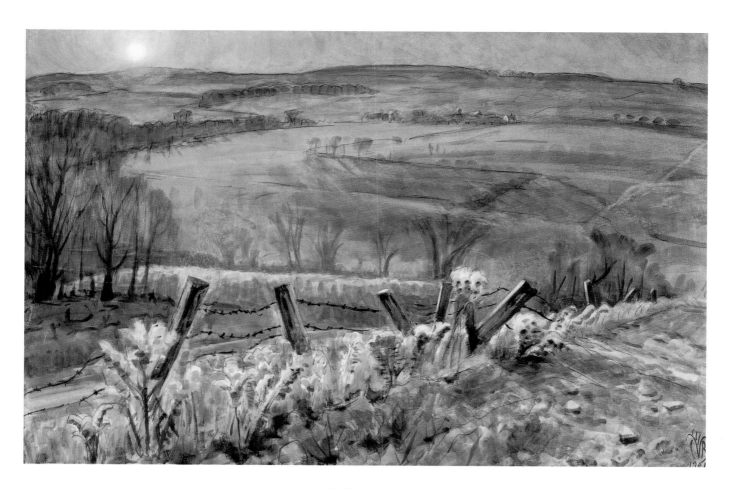

Indian Summer, 1941
Watercolor on paper, 24 x 36 in.
Signed with monogram lower right: *CEB*
John W. and Mildred L. Graves Collection, 1997.11

waning moments. Burchfield captures the transitory nature of the scene; within the hour it will be dark and completely altered.

A.P.B.

1. Walt Whitman, *Leaves of Grass* (1855; New York: Random House, 1993), 607.

Hush Before the Storm, 1947

Charles Burchfield began working in his third and final style in April of 1943—perhaps in response to his fiftieth birthday, or to the urgency of World War II—as he revived the theme and mood that captivated him in his youth: the intense emotion that he saw, felt, and heard in the natural world. This shift away from the solid, tangible forms of his more straightforwardly representational middle style, used to render urban American industry and architecture, in favor of impassioned evocations of the landscape, allowed Burchfield to explore his highly personal view of the universe.

In *Hush Before the Storm,* each tree bough, daisy petal and blade of grass seems to vibrate in anticipation of the approaching rain. Branches intersect to form pointed arches reminiscent of a Gothic cathedral, investing the painting with a religious aura. Referring to the painting, Burchfield wrote, "I had in mind doing something dark and mysterious, like a solemn Bach fugue—something to do with the dark interior of a tree on a cloudy day."[1] The fugue, a musical form in which different melodies or different parts of the same melody sound simultaneously and imitate one another in controlled but varied patterns, provides an apt metaphor for Burchfield's paint application in *Hush Before the Storm.* Quick, staccato gestures used to describe leaves and branches are answered by longer, broader brushstrokes in the grass and clouds. Thin, brushy passages of paint in the sky and foliage are complemented by thick, fluid black lines in the tree trunks and verdant leaves. Arched shapes echo each other and repeat in the forms of the flowers, bushes and branches.

According to Burchfield, *Hush Before the Storm* represents a "mid-afternoon in early July. A summer thunderstorm, whose deep rumblings have been heard in the distance for some time, is about to break. As yet there is no wind or other disturbance; instead, an ominous quiet prevails. Trees and plants, which still have the lushness usually associated with June, stand trembling, as if in fear of the violence to come. Deep mystery lurks in the black interior of the trees, and the feeling of foreboding is emphasized by the startled white daisies in the foreground."[2]

D.J.W.

1. Charles Burchfield, letter to Elizabeth S. Navas, 6 September 1950, registrar's files, Wichita Art Museum.
2. Ibid.

Winter Moonlight, 1951

Charles Burchfield's paintings belong to no single artistic movement, but instead are idiosyncratic expressions of his complex personality and romantic vision of nature. Burchfield established a personal vocabulary of symbolic imagery based on nature's elements; his individual conventions include jagged shapes denoting the wind, gothic forms in tree branches and buildings, and the beaming light of the sun or moon. In *Winter Moonlight,* the viewer's eye follows a path through receding planes in space, directed towards the luminous moon. The absence of human figures evokes aloneness, even as the viewer is surrounded by an animated nocturnal landscape. Apparitions in tree forms spark a

Hush Before the Storm, 1947
Watercolor on paper, 40 x 30 in.
Signed with monogram and dated lower right: *CEB/1941*
Roland P. Murdock Collection, M85.50

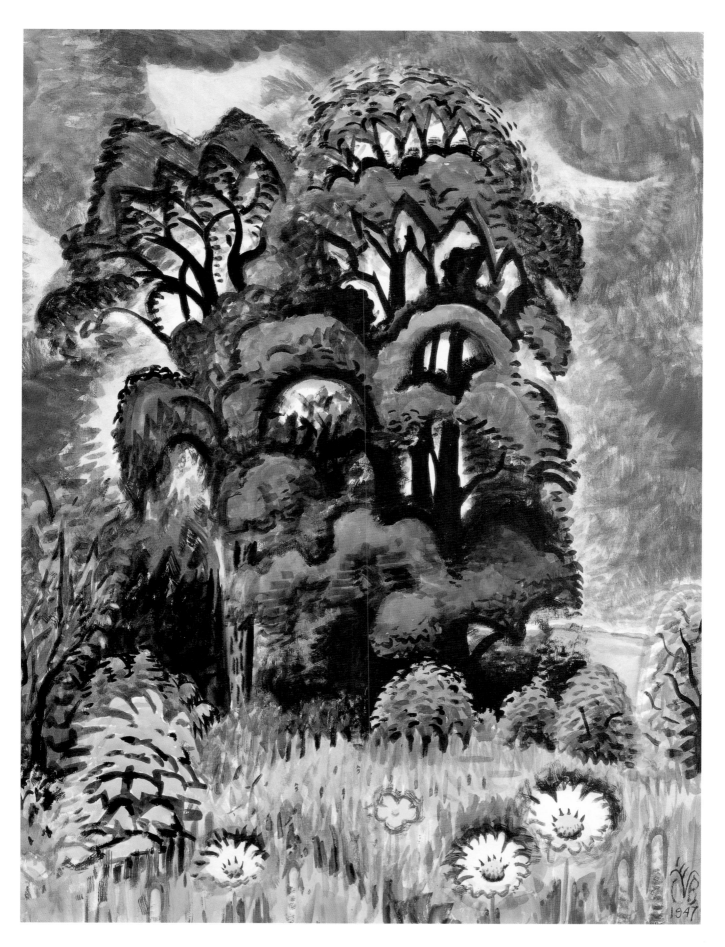

remembrance of childhood fears, fears of the changing weather and of nature, as recorded in the artist's journals.

Like many paintings from Burchfield's final artistic period (1943-67), the idea for *Winter Moonlight* began as a small sketch from the artist's self-proclaimed "Golden Year" of 1917. Burchfield wrote:

> The picture grew out of an uncompleted 1917 study—I had been out painting in the country all day, and was returning home through the woods when I was struck with the odd appearance of the moon with the ring around it. I made some pencil notes and the next day started the picture on a large scale, but never got beyond putting in the moon and a few line indications of where trees were to go. Other newer ideas demanded my attention then and it never was completed.

> My intention in taking up the subject again a couple of years ago, was to complete the 1917 picture. But as I made studies for it, I realized too much "water (or should I say water-color) had flowed under the bridge" and that I must make a totally new picture—"Winter Moonlight" is the result.

> A calm winter night in a snow-bound woods— The moon, surrounded by the large glowing ring that portends change in the weather, lights in the clean white snow-drifts with pale silvery light. Here and there tiny frost particles reflect the light in tiny stars.[1]

Calligraphic strokes of transparent paint suggest an immediate response to the natural elements; however, Burchfield was working from a decades-old memory of his personal experience in Salem, Ohio. Remembered sensations of that actual winter landscape are translated into a rapturous fantasy. Throughout his life, Burchfield was obsessed with weather, with the dramatic changing conditions of nature that are uncontrolled by man and, indeed, control man. Matthew Baigell described Burchfield as "abnormally sensitive to weather conditions even as a small child . . . [he drew] symbols of weather changes on the family calendar."[2] It seems appropriate that *Winter Moonlight,* which has often been reproduced commercially, was once employed as a calendar illustration.

Perhaps Burchfield's attachment to the watercolor medium relates to his fascination with the various forms of precipitation—the rain and ice and snow—that repeatedly saturate his landscape images. Here he expresses the frozen quiet of a snowy, moonlit woods, using limited brushstrokes and an almost monochromatic palette. The barren white paper surface represents light reflected on the virgin snow. While bare trees illustrate seasonal change and revitalization, evergreens in the lower right foreground symbolize durability and survival. The only warm colors in the landscape radiate from the pale yellow and mauve rings around the moon, emitting just enough energy to light the way, but not warm the frigid air.

A.P.B.

1. Charles E. Burchfield, letter to Elizabeth S. Navas, 29 July 1954, registrar's files, Wichita Art Museum.

2. Matthew Baigell, *Charles Burchfield* (New York: Watson-Guptill Publications, 1976), 13.

Winter Moonlight, 1951
Watercolor on paper, 40 x 33 in.
Signed with monogram lower left: *CEB*
Roland P. Murdock Collection, M120.54

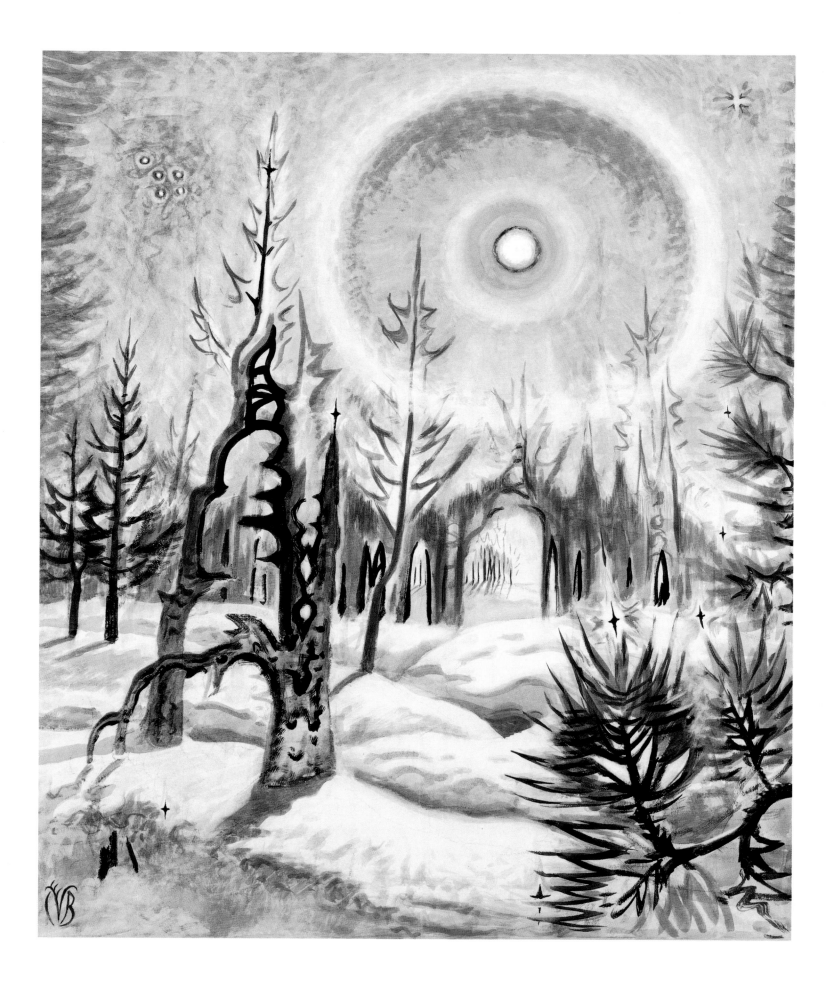

MARY CASSATT (1844-1926)
Mother and Child, ca. 1890
Oil on canvas, 35½ x 25⅜ in.
Signed lower left: *Mary Cassatt*
Roland P. Murdock Collection, M109.53

Born in Allegheny City, Pennsylvania, the daughter of a prosperous Pittsburgh businessman, Mary Cassatt was neither expected nor encouraged to pursue an artistic career. In early childhood she travelled extensively with her family, spending four years in Europe. The Cassatt family settled permanently in Philadelphia in 1858. There, at the age of seventeen, and much to her parents' dismay, Mary Cassatt enrolled at the Pennsylvania Academy of the Fine Arts and began her career as an artist. In her four years at the Academy, Cassatt grew increasingly tired of the monotonous routine of drawing from plaster casts. Determined to pursue her own course, she left for Europe, where she travelled for seven years, studying and copying the works of the Old Masters. She settled permanently in Paris in 1873.

Although Cassatt exhibited in the Paris Salon between 1872 and 1874, that institution's resistance to new artistic ideas greatly frustrated her. In 1877 she met Edgar Degas, who invited her to exhibit with the Impressionists. Cassatt, like Degas, remained committed to painting the figure, and emulated Degas's distinctive method of capturing scenes of contemporary urban life with the apparent spontaneity of a snapshot. She also learned from her study of Japanese prints to employ asymmetrical compositions, cropped forms, flattened patterns, and unconventional perspective. Cassatt integrated these influences to explore expressively one of her most celebrated themes—the bond between mother and child.

Of the numerous canvases Cassatt devoted to the mother and child relationship, the Murdock Collection's *Mother and Child* ranks among the finest. In this tranquil scene, a mother tenderly embraces her child, while the child reaches up to caress the mother's chin. The two figures, while clearly painted from actual models, ultimately transcend their specific identities to embody the abstract ideal of the intimate bond between mother and child. The brushwork and spatial conception themselves tend toward abstraction, as if to underscore the level of generality to which the image aspires. Cassatt flattens space by cropping the body of the mother, asserting the decorative pattern of her dress, and suppressing spatial recession around her; light-hued background elements, laid in rapidly with sketchy strokes, serve further to flatten the composition and emphasize the picture plane. This phenomenon is demonstrated most dramatically in the water pitcher, which not only responds to the outline of the mother's head and shoulder, but also serves to deny the space behind the figures. The primary lines of the work, established by the child's legs, the contours of the mother's skirt, and the direction of her glance, lead to the focal point, the child's head.[1] Cassatt's brushwork reinforces this compositional emphasis by treating more summarily those elements at the periphery of the composition. For example, the child's foot, audaciously simplified, dissolves into the abstract strokes of the mother's skirt. This diffuse aura surrounding the figures serves to distinguish further the parental bond as everlasting in the midst of an ephemeral material world. While Cassatt herself was childless, she seems to have understood something of that intensely private—yet universal—exchange between mothers and their children.

B.J.B.

1. Stewart Buettner, "Images of Modern Motherhood in the Art of Morisot, Cassatt, Modersohn-Becker, Kollwitz," *Woman's Art Journal* 7 (spring/summer 1987): 17.

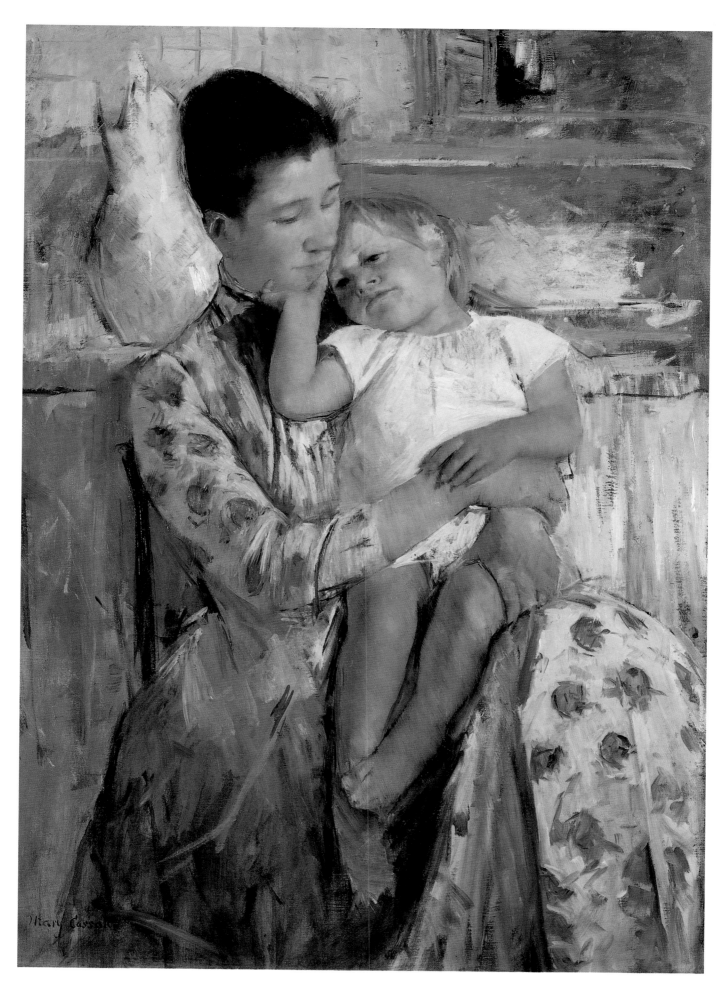

WILLIAM MERRITT CHASE (1849-1916)
Portrait of Mrs. C. (Mrs. William M. Chase),
ca. 1895
Oil on canvas, 22 x 18 in.
Signed upper left: *Wm M Chase*
Gift of Sam P. Wallingford Foundation, 1977.67

Whether in a sun-baked Italian villa, sensual Japanese interior, or the backyard of his own studio, William Merritt Chase painted life around him with confident virtuosity and a dynamic eclecticism that sparkled throughout his career. Chase was born in Williamsburg (now Nineveh), Indiana. His first teachers were local artists, upon whose urging Chase enrolled in the National Academy of Design in New York in 1869. Three years later he departed for Europe, to study at the Royal Academy in Munich, a city which in the 1870s rivaled Paris as the premier European art center. During his six years of study in Munich, augmented by sojourns in Spain and Italy, Chase assimilated the Munich School's rich, dark palette and appreciation for the Old Masters, as well as the experimental, painterly styles of James McNeill Whistler and Mariano Fortuny. Upon returning to the United States in 1878, Chase began what would become a long and prolific teaching career at the newly-formed Art Students League. As both teacher and artist, Chase stressed the appreciation of the act and history of painting as the way to true innovation and individuality. "Originality is found in the greatest composite which you can bring together," Chase said. "Take the best from everything."[1]

Chase cut down the WAM portrait from this three-quarter *Portrait of Mrs. Chase,* ca. 1895, which is preserved in a documentary photograph from the William Merritt Chase Archives of the Parrish Museum of Art, Southampton, NY, gift of Jackson Chase Storm.

Chase met Alice Gerson, his future wife, in 1880 at the home of her father, Julius Gerson, a New York arts patron. Although 17 years her senior, and a self-termed "confirmed bachelor," Chase was smitten by the precocious and charming young girl. After a six-year courtship, Chase and Gerson were married. An intelligent and radiantly beautiful woman, Alice was not only Chase's favorite model and mother of his nine children, but also, in the artist's view, his most devoted friend and best critic.[2]

The eclectic spirit of Chase's best work is apparent in the Wichita Art Museum's *Portrait of Mrs. C. (Mrs. William M. Chase)*, painted about 1895. Alice appears to wear the traditional formal costume of a Castillian Spanish noblewoman, of the kind in which she frequently dressed for the family's playful *tableaux vivants*, in which the entire family, visiting friends, and Chase's students would stage "re-enactments" of famous paintings. The rich black tones of Alice's costume and the dramatic chiaroscuro display the lingering influence of Chase's Munich School training, while the expressive realism of Velásquez is apparent in Alice's features. More contemporary are the spirited brushwork and surprising touch of bright color (in the rose in her hair), resembling the styles of Whistler and Sargent. Further adding to Chase's "composite" of Old Master and contemporary influences is the painting's close-cropped depiction of Alice in a manner derived from the engaging, immediate portraiture style of the French Impressionists. The image was actually cut down by Chase from a larger composition in the years following its completion in an attempt to "modernize" the look of the work by using this Impressionist convention.[3] Alice's steady gaze and assured pose are the focus of Chase's portrait; her slightly clouded features add an air of mystery to her mood, while her unflinching pose suggests a confident sensuality. Chase's delicious blend of straightforward portraiture and painterly display lends itself perfectly to this work's reserved celebration of both the intellect and beauty of his beloved.

M.B.

1. "Address of William M. Chase before the Buffalo Fine Arts Academy, January 28, 1890," *Studio* 5 (1 March 1890): 121-22.

2. Ronald G. Pisano, *William Merritt Chase: A Leading Spirit in American Art* (Seattle: University of Washington Press, 1983), 46.

3. Ronald G. Pisano, W. M. Chase Research Report written for

Wichita Art Museum, 16 August 1996, registrar's files, Wichita Art Museum.

RUSSELL COWLES (1887-1979)

County Fair, 1944

Oil on canvas, 28⅜ x 40½ in.

Signed lower right: *Cowles*

Roland P. Murdock Collection, M48.44

Nostalgic recollections of grand white exhibition buildings that smell of hay and friendly competition amongst farm youths vying for ruffled blue ribbons surround Russell Cowles's painting *County Fair.* Cowles returned to his Midwestern roots to present a scene drawn from pleasant memories of his childhood in rural Iowa. This celebration of agrarian life shows the influence of Regionalist painters such as Thomas Hart Benton, John Steuart Curry, and Cowles's fellow Iowan Grant Wood. The Midwestern values and nostalgia for a simpler past that these men championed permeate Cowles's interpretation of livestock judging at an annual county fair.

Cowles was born in Algona, Iowa in 1887. Despite his small town upbringing and treatment of provincial subjects, Cowles was, in both experience and training, a very cosmopolitan artist. He attended Dartmouth College, and then studied in New York at the Art Students League and the National Academy of Design. In 1915 he won the Prix de Rome and for the next five years studied at the American Academy in Rome. After returning briefly to the United States, he went back to Europe to continue his training. He studied in Paris, and then toured the globe, absorbing artistic lessons from Spain, Egypt, Greece, India, Japan, and China. Steeped in diverse styles and techniques, he returned to the United States in 1928 to forge from these influences his personal artistic vision. His style varies from abstract to representational, and his subjects from still lifes to landscapes, animals, and religious scenes.

Cowles's *County Fair* depicts dairy cattle judging in the livestock pavilion. Proud young owners parade Brown Swiss cattle past judges, while an eager audience watches in anticipation to see which animal will be proclaimed the champion. Personalities of humans and cattle alike are communicated through various postures and physical builds. It was Cowles's goal to "bring out something of the individual character of the various exhibitors and judges without destroying the sense of unity in the picture."[1] The sketches for *County Fair* were actually made at the Iowa State Fair, but Cowles wished to express the more intimate and informal character of a small county fair. He discovered that by attending the early morning preliminary judging he could capture this quality. Cowles also found the state fair's arena to be too large, and thus in his painting reduced its size to achieve a "feeling of intimacy," and "greater plastic compactness."[2] Cowles stated that the judges' table, "through its place in the composition and the strength of the light on it, becomes the focus both of the subject matter and of the plastic organization of the painting," and that "from this group interest spreads throughout the rest of the picture, being arrested for a shorter or longer time by various details."[3] One of the "details" is a solitary black man at the left of the composition who is dressed entirely in white. His presence is commanding, and he vies with the judges for our attention. Like the judges, he too receives direct light, but he looks down and out of the picture, away from the rest of the group. This man is physically and emotionally segregated by lack of physical contact, overlap, gesture, or glance. His demeaning role of cleaning up after the animals is clear, but his inclusion in the painting is not. Does his presence suggest Cowles's protest, approval, or simple acknowledgement of a harsh reality?

Overall, Cowles's *County Fair* is a positive image, fondly recalling his early life experience. He stated, "Everyone has, buried deep in him, such old memories of one sort or another, and it seems to me inevitable, if he is a painter or a writer, for instance, that they will color his later work.[4]

S.A.S.

1. Statement by Russell Cowles, 18 July 1944, registrar's files, Wichita Art Museum.
2. Ibid.
3. Ibid.
4. Russell Cowles quoted in Kraushaar Galleries, *Russell Cowles Landscape Paintings* (New York: Kraushaar Galleries, 1973), foreword.

RALSTON CRAWFORD (1906-1978)
Section of a Steel Plant, ca. 1936-37
Oil on canvas, 30⅛ x 36⅛ in.
Signed lower left: *CRAWFORD*
Gift of Mr. A. Walter Socolow, 1977.113

The only son of a ship captain, Ralston Crawford was born in 1906 in Saint Catharines, Ontario. Crawford was to spend much of his adolescence travelling the Great Lakes with his father, and later he worked as a sailor on tramp steamers to the Caribbean, Central America, and California. Crawford's formal artistic training began in 1927 at the Otis Art Institute in Los Angeles, while he supported himself as an illustrator for Disney Studios. Later that same year, Crawford moved to Philadelphia to study at the Pennsylvania Academy of the Fine Arts, where he was awarded two scholarships. Through visits to the private collection of Dr. Albert Barnes, Crawford received his first extensive exposure to modern art. Particularly influential were firmly structured works by Cézanne and Matisse that shaped Crawford's search for rigorous structure in his own painting.

Although his later work gradually evolved toward abstraction, Crawford is most frequently classified as a Precisionist. Pioneered by artists such as Charles Sheeler and Charles Demuth, the Precisionist aesthetic concentrates largely on architectonic imagery rendered in sharply-defined geometric forms. Crawford interpreted the industrial landscape in similar fashion, distilling the visual appearance to simplified, hard-edged forms deployed in a flattened space. However, this relentless simplicity did not preclude expressive overtones in his paintings. Crawford commented, "I suppose one of the reasons for the severity of some of my paintings is that I am in many respects an incurable romantic. . . I am long on feeling, and a lot of discipline—or steering of that feeling—is necessary."[1]

Section of a Steel Plant is likely part of a series Crawford completed in Coatesville, Pennsylvania between 1936-37, and it typifies Crawford's rational and expressive abstraction of a recognizable subject. For him, industrial imagery "represented the liberation of the world from poverty,"[2] and indeed the immaculate efficiency implied in this scene reinforces this utopian stance. However, Crawford does not picture industrial productivity, and the stillness echoed in this image may also be a commentary on the struggling steel industry during the years of the Great Depression. *Section of a Steel Plant* draws the viewer's attention away from the specifics of the scene, and instead offers geometric generalizations. The perpendicular balance Crawford achieves is the result of a visual interlocking of flat planes and parallel lines in this shallow-spaced, highly-structured composition. Broad expanses of simple, uninflected color delineate the pictorial elements and reinforce their crystalline clarity. The result is an ominous stillness, a union of the psychological and the abstract.

B.J.B.

1. Ralston Crawford quoted in Jack Cowart, "Recent Acquisition: Coal Elevators by Ralston Crawford," *The Saint Louis Art Museum Bulletin* 14 (January-March 1978): 14.

2. Ralston Crawford quoted in Barbara Haskell, *Ralston Crawford* (New York: Whitney Museum of American Art, 1985), 41.

JOHN STEUART CURRY (1897-1946)

Kansas Cornfield, 1933

John Steuart Curry was born in the small northeastern Kansas town of Dunavant in 1897. As a teenager he developed an interest in art, and left high school and the family farm to attend the Kansas City Art Institute. He moved on to the Art Institute of Chicago and then to a career as a successful illustrator for various publications, including the *Saturday Evening Post*. Curry aspired to become an independent artist, but felt that he lacked the proper advanced training. So in 1927 he traveled to Europe, where he was exposed to a variety of modern techniques and aesthetic theories, including Fauvism, Cubism, and Futurism. Curry rejected the modernists' tendencies toward abstraction and instead developed a more straightforward representational style in which he rendered images of Midwestern life.

During the early 1930s Curry became associated with other artists who had similar painting philosophies, most notably Thomas Hart Benton and Grant Wood. These three men comprised the heart of the Regionalist movement. The Regionalists were committed to creating scenes of their immediate surroundings, often in a search for inspiring images during the bleakest days of the Great Depression.

Kansas Cornfield is one such inspiring image. Though Curry painted it from studies of his father's fields, it is immediately apparent that this is not a simple image of typical Kansas corn. In addition to celebrating the fecundity of his native soil, Curry seems to suggest that the land has an inherent strength and dignity. The size and vertical format of the painting impart to the corn a feeling of monumentality. The stalks tower above the ground and seem capable of surrounding the viewer. They appear to possess power, even intelligence. Curry said, "I have tried to put into this painting the drama that I feel in the presence of a luxuriant [*sic*] cornfield beneath our wind-blown Kansas skies. As a child they held the same fascination for me as do the forests for those who live within them. I remember wandering through them and being overpowered by the fear of being lost in their green confines."[1]

In 1939 *Kansas Cornfield* was the first purchase made by Elizabeth S. Navas for the Roland P. Murdock Collection. At approximately the same time, Curry was finishing his work on the murals at the Kansas State Capitol in Topeka. *Kansas Cornfield* was to be the subject of a mural intended for the capitol rotunda that, due to the controversial reception of the earlier stages of the project, was unfortunately never completed.[2]

From 1936 until his death in 1946 Curry worked and taught at the Agricultural College of the University of Wisconsin as the nation's first university artist-in-residence. Though Curry was immensely popular at the time of his death, his reputation, like that of other Regionalists, went into decline with the rise of Abstract Expressionism in the later 1940s. Today, over fifty years later, Curry is once again recognized for creating the powerful images of the Midwest that had been a source of inspiration to him throughout his life.

J.A.S.

1. John Steuart Curry, letter to Elizabeth S. Navas, 30 June 1939, registrar's files, Wichita Art Museum.

2. See M. Sue Kendall, *Rethinking Regionalism: John Steuart Curry and the Kansas Mural Controversy* (Washington, D.C. and London: Smithsonian Institution Press, 1986).

Kansas Cornfield, 1933

Oil on canvas, 60⅜ x 38½ in.
Signed and dated lower left: *JOHN STEUART CURRY/1933*
Roland P. Murdock Collection, M1.39

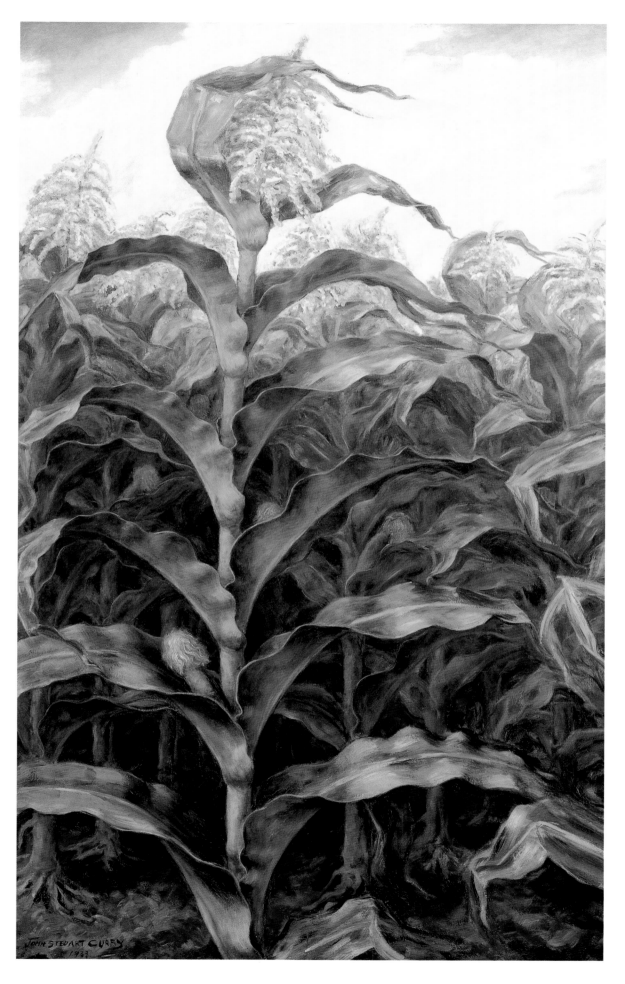

Father and Mother, 1933

Oil on canvas, 18⅛ x 24⅛ in.

Signed and dated lower right: *FATHER AND MOTH-
ER/JOHN STEUART CURRY/JULY 1933*

Extended loan, Wichita Public Schools, EL1974.3

Father and Mother, 1933

After his painting *Baptism in Kansas* brought John Steuart Curry fame as an American Scene painter in 1928, the artist traveled from Connecticut to the Midwest every summer to gather imagery for his art until he moved to Wisconsin in 1936. In July 1933 Curry met Grant Wood for the first time at Wood's art colony in Stone City, Iowa, where the two Regionalists donned crisp matching overalls and posed for publicity photographs. While visiting his parents on their farm near Dunavant, Kansas, dur-

ing the same month, Curry drew studies for his large *Kansas Cornfield* and painted the modest-sized *Father and Mother.*

In this double portrait Thomas Smith Curry and Margaret Steuart Curry sit in rocking chairs turned towards each other. Smith Curry's simple rocker is wood; Margaret Curry's more elaborate one is curvilinear wicker. Frontally positioned, Smith Curry glances out of the corners of his eyes to the left. The more diagonal angle of Margaret Curry's chair places her in a three-quarter view, and she gazes straightforwardly in the same direction as her husband. Windows behind each figure form

separate backdrops of sunshine diffused by gauzy curtains; light also enters the room from an unseen source at the left, toward which the figures look. Margaret Curry's blouse and dress shine softly in the room's gentle illumination, while Smith Curry's sturdy overalls, although touched by light, remain stolidly dark. In offering subtle indications of the differences between his parents, such as Margaret Curry's serenity and Smith Curry's uneasiness, the artist makes observations about not only his parents' relationship to each other, but also his own relationship with each of them. Curry's mother encouraged her son's decision to pursue a career in art. A college graduate, as was her husband, Margaret Curry was disappointed that John was not interested in school, but she supported his artistic ambitions. Smith Curry did not oppose an art career for his son, but he was less comfortable with the idea than his wife was.

Curry's small image of his parents is similar to *Portrait of Father and Mother,* painted in 1929 during Curry's first return visit to Kansas.[1] In this earlier version a window between the two figures sitting in their rockers draws the viewer's attention to a farm scene, encouraged by the father's gaze in that direction. The central window in the earlier version may be the unseen light source in the later painting. With its shift in composition, the focus of the 1933 painting is not the land but the two figures themselves, as both father and mother and husband and wife.

Between the painting of these two artworks Curry's life went through momentous changes. In July 1932, amidst troubles which included marital separation and alcoholism, Curry's, wife Clara Derrick Curry, died of heart disease.[2] In 1933 Curry met Kathleen Gould, who became his second wife in 1934 and helped him return to happiness and productivity.[3] Considering its strategic position in Curry's life, this domestic view of his parents' imperfect but stable union may have functioned for the artist as both an image of comforting familiarity and a symbol of the complexities of marriage.

J.C.

1. Reproduced in Laurence E. Schmeckebier, *John Steuart Curry's Pageant of America* (New York: American Artists Group, 1943), 173.

2. M. Sue Kendall, *Rethinking Regionalism: John Steuart Curry and the Kansas Mural Controversy* (Washington, D.C. and London: Smithsonian Institution Press, 1986), 33.

3. Ibid., 34.

ALLAN D'ARCANGELO (b. 1930)

Landscape, 1965

Acrylic on canvas, 86⅜ x 68¼ in.

Inscribed on reverse of canvas: *D'Arcangelo/NYC/1965*

Gift of Mr. and Mrs. Samuel Dorsky, 1976.5

Allan D'Arcangelo has described *Landscape* as "part of a group of my early works visually commenting on the American landscape as it is embedded in our memory."[1] Successfully combining Pop art's interest in American vernacular imagery with the minimalist aesthetics of hard-edge painting, D'Arcangelo's picture transforms the common experience of highway driving into a bold abstraction. D'Arcangelo renders the road as a taut, flat field of black, stretching across the entire lateral surface of the picture. Bisecting the road is a bright white median strip that rises from the base of the canvas and narrows gradually to a point a few inches from its top. There, the highway meets the horizon, defined by the crisp outlines of black foliage silhouetted against a thin blue band of sky.

D'Arcangelo's emphatic horizon line and perfect one-point perspective create a strong illusion of spatial recession, which is simultaneously denied by the picture's flat, unmodulated paint surface. Lawrence Alloway observes that D'Arcangelo's "paint surface itself has a kind of blankness, a finish that involves the spectator neither in admiring high finish nor in awareness of sensuous surface. It is, maybe, the analogue of the unnoticed but pervasive newness of highway engineering, of smooth surfaces. . . and clear enameled signs."[2] D'Arcangelo suppresses all detail, and avoids atmospheric perspective by painting both foreground and background with uniform hardness. "The effect," writes Alloway, "is somewhere between a streamlined tunnel, pulling us in, and a flat wall. . . His vista is as unelaborated, and unsupported by auxiliary spatial cues, as a rudimentary perception diagram. His perspective is like the raw material for perceptual judgment."[3]

Born in Buffalo, New York, D'Arcangelo earned an undergraduate degree in history from the University of Buffalo in 1953 before moving to New York City that same year. In New York he studied art privately from 1955-56 under Boris Lurie. He then enrolled at Mexico City College from 1957-59, where he studied with John Golding and Fernando Belain. From 1963-68 D'Arcangelo was an instructor at the School of Visual Arts in New York. In 1973, he was appointed professor of art at Brooklyn College, and, from 1983 on, served concurrently as graduate instructor at the School of Visual Arts. He also has held a number of visiting artist positions at art schools around the United States.

D.C.

1. Allan D'Arcangelo, letter to the author, 12 August 1996. Gallery labels on the back of the painting indicate that it has also been exhibited under the title *Block #1*, but, according to D'Arcangelo, the proper title is *Landscape*.

2. Lawrence Alloway, "Hi-way Culture: Man at the Wheel," *Arts Magazine* 41, no. 4 (February 1967): 32.

3. Ibid., 33.

RANDALL DAVEY (1887-1964)
Basket Dancer, n.d.
Oil on canvas, 24⅛ x 20¼ in.
Signed lower center: *Randall Davey*
Burneta Adair Endowment Fund, 1991.23

Randall Davey, born in 1887 in East Orange, New Jersey, initially studied architecture at Cornell University from 1904 to 1908. In the same year that he left Cornell with an "Honorable Dismissal," he enrolled in Robert Henri's classes at the New York School of Art. The young Davey impressed his instructor to such a degree that Henri hired him as his teaching assistant and took him on a trip to Spain in 1912. Upon returning to the United States, Davey began to exhibit his work regularly, participating in the Armory Show of 1913 and National Academy of Design annuals thereafter.

Davey developed a lasting friendship with former Henri student John Sloan in the 1910s, and the two frequently painted in the same locales. For example, both men painted at Gloucester, Massachusetts in 1916 and again in 1919. During the latter Gloucester sojourn, Davey, having grown tired of the coastal scene, decided to travel to Santa Fe, and convinced Sloan to accompany him. Both artists were captivated by the New Mexican environment, and came to spend much of the rest of their lives in Santa Fe. Sloan worked there every summer but two until his death in 1951. Davey became a permanent resident, though to support himself he did accept out-of-state teaching positions on several occasions, joining the faculty of the Art Institute of Chicago in 1919, the Kansas City Art Institute from 1921-24, and the Broadmoor Art Academy in Colorado Springs from 1924-31. Later, he taught at the University of New Mexico in Albuquerque from 1945-56.

Davey probably executed *Basket Dancer* during the first decade of his residence in Santa Fe, as suggested by the vibrant colors and loose brushwork of the painting, which are common to the artist's style of the 1920s. Emphasizing the head and upper torso in a manner similar to portraits by Davey's teacher, Henri, the picture focuses on a single Puebloan, identified as a basket dancer through his spruce collar and gourd rattle. Such ceremonial dress would rarely be worn outside of the Basket Dance, but Davey has detached his sitter from the ritual performance, and presents him as an independent and unique individual.

Davey probably witnessed the Basket Dance when segments of it were performed regularly in Santa Fe during the 1920s. Traditionally held during the winter months of December or January to ensure agricultural fertility for the coming year, the Basket Dance is usually sponsored by the women's societies of the Pueblos, though both women and men participate in the ceremony. Although San Ildefonso and Santa Clara Pueblos perform the dance the most frequently, the headdress of Davey's dancer does not possess the yucca stalks or squash blossoms characteristic of those respective Pueblos, but consists entirely of feathers. The exact tribal affiliation of the dancer has yet to be determined, but the headdress might originate from the Tesuque or Taos Pueblos.

Davey's interest in the Pueblos often extended past artistic treatment; for instance, he joined Sloan in political action when government legislation, proposed by Bureau of Indian Affairs director Edmund Burke, threatened to ban Native-American dances and other traditional religious practices on several occasions throughout the 1920s.[1] Davey was also instrumental in creating the Artists' and Writers' Protest Petition against the Bursum Bill of 1922, which nearly stripped both land and water rights from the Pueblos.[2] In this context, Davey's presentation of the Basket Dancer as a proud individual, nobly carrying on an ancient ritual tradition, may be seen as a manifestation of the artist's own political support for the sovereignty of Native-American religious expression.

M.A.W.

1. John Collier, *From Every Zenith: A Memoir* (Denver: Sage Books, 1963), 137.

2. Edna Robertson and Sarah Nestor, *Artists of the Canyons and Caminos: Santa Fe, the Early Years* (Santa Fe: Peregrine Smith, Inc., 1976), 81-82.

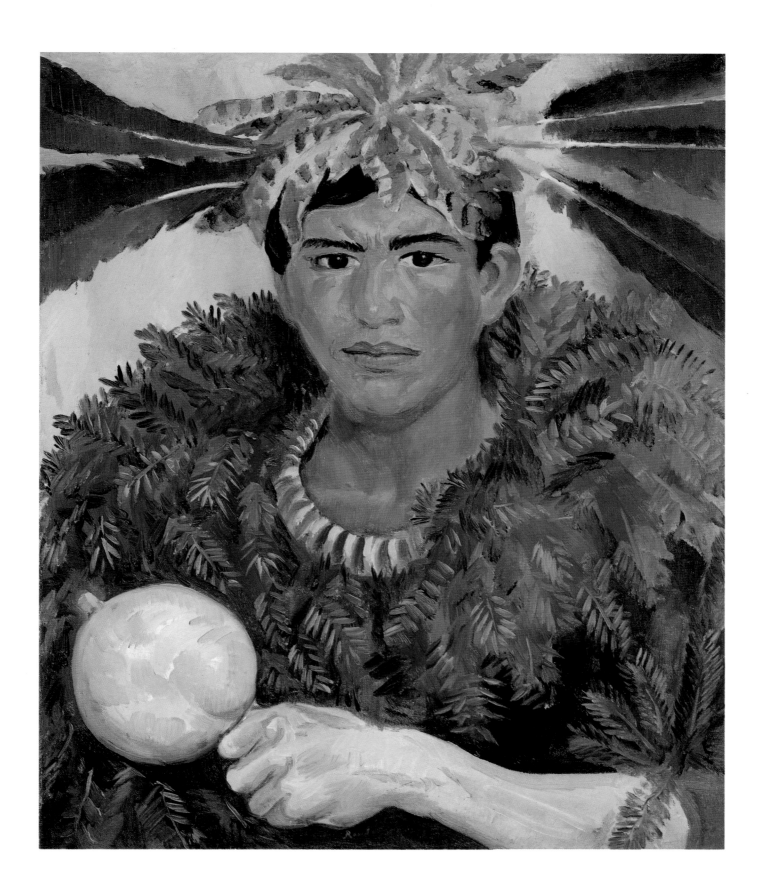

STUART DAVIS (1892-1964)
Bass Rocks #1, 1939
Oil on canvas, 33⅛ x 43¼ in.
Signed and dated lower right: *Stuart Davis 1939*
Roland P. Murdock Collection, M49.44

In Stuart Davis's *Bass Rocks #1,* the brilliant white of light reflecting off water serves as the matrix for bright, irregular shapes of color and intensely-hued line. The angular solids and bouncy lines mingle and separate across the canvas, forming an unpredictable pattern that buzzes with energy. This upbeat abstraction is a fine example of the personal brand of modernism that Stuart Davis developed over a long and varied career.

Davis inherited his artistic vocation at his birth in Philadelphia; his mother was a sculptor, and his father the art editor of the *Philadelphia Press.* In 1909, at the age of 17, Davis left high school to study art with Robert Henri in New York City. He exhibited five watercolors at the 1913 Armory Show, a landmark exhibition that exposed the young artist to European modernism for the first time. Over the next several years Davis studied and emulated the work of such artists as van Gogh, Seurat, Picasso, Miró and Léger. During a visit to Paris in 1928-29, Davis recorded his impressions of the city's urban architecture in a simplified linear style. In the 1930s Davis worked for the Federal Art Project of the WPA, and was active in the Artists Union and the American Artists Congress.

Bass Rocks #1 was painted amidst a frenzy of activity in 1939: that year the artist completed a WPA-commissioned mural for radio station WNYC and the gigantic History of Communications mural for the New York World's Fair. Faced with hardship at the close of his WPA tenure that same year, Davis turned to easel painting for his livelihood: "Having no money I did the conventional thing—I hired myself a studio and devoted myself to painting. I felt it was 'now or never.' I made *Bass Rocks.*"[1]

The painting can be interpreted as a respite from Davis' other 1939 projects. While images of civilization dominate his other work of this time, here the artist uses nature as a starting point towards a completely abstract composition. The painting is based on a 1938 drawing of the Bass Rocks, located on the Atlantic coast of Cape Ann, Massachusetts, where Davis frequently worked.[2] In the drawing, a bank of rocks juts forward on the left side of the composition and across the foreground, while a beach and hillside in the distance are seen in the upper right corner. In the finished painting, all representational references have been eliminated, and natural forms have been distilled into abstract lines and planes of color.

Nevertheless, Davis felt that *Bass Rocks #1,* far from being an impersonal formal exercise, was imbued with his personal experience of the site. In a letter to Elizabeth S. Navas, he reflected:

Naturally it was not my purpose to reproduce the optical appearance of this scene. What I wanted to do was to make a picture that would recall my exhilaration in contemplating it. . . . What is sought is the subjective event, that is to say, what was felt and experienced at the time and place. . . . [One] reacts to it in relation to the mood he brings to it, his general state of mind in relation to a specific place. . . . In the case of 'Bass Rocks', the brilliance of light, the dynamics of the rock formations, the entirely different dynamics of the sea, etc., were transmuted into an analogous [*sic*] dynamics of spaces and color. In this way the pleasure which I felt at that time and place is given objective permanence, and becomes the means of evoking it again at will.[3]

J.C.

1. Stuart Davis quoted in James Johnson Sweeney, *Stuart Davis* (New York: The Museum of Modern Art, 1945), 30.

2. Reproduced in Karen Wilkin and Lewis Kachur, *The Drawings of Stuart Davis: The Amazing Continuity* (New York: The American Federation of Arts in association with Harry N. Abrams, 1992), 75.

3. Stuart Davis, letter to Elizabeth S. Navas, 16 August 1944, registrar's files, Wichita Art Museum.

CHARLES DEMUTH (1883-1935)
Rise of the Prism, 1919
Tempera on paper, 19¼ x 15¾ in.
Signed and dated lower left: *C. Demuth/1919*
Roland P. Murdock Collection, M63.46

Rise of the Prism belongs to a small series of tempera landscapes on which Demuth, up to that point primarily a watercolorist, embarked in 1919. In its application of Cubist and Futurist formal elements to a representational subject, the painting typifies what came to be known as Demuth's Precisionist style. While Precisionism was neither an organized movement nor a formal artistic theory, it was a clearly defined impulse in American art between the World Wars that centered on the representation of architectural and industrial subjects in a clean, geometrically ordered style. Through the formal vocabulary of Precisionism Demuth sought to render the crisp geometry of architecture and its relationship to the organic environment in which it stands. In *Rise of the Prism,* his experimentation with the more opaque medium of tempera allowed for a heightened definition of the architecture's solidity without surrendering the subtle tonal gradations and shimmering qualities of sunlight that he captured with excellent effect in his watercolors.

Painted in the legendary artists' resort of Provincetown, Massachusetts, the landscape is presented from a curiously high vantage point, looking down upon a shore-front building nestled between the trees of a sloping forest. The tall ship masts in the foreground divide the composition into thirds and bracket the prismatic arrangement of rays into which Demuth compresses the landscape. The rich crimson rooftop of the enigmatic "Pew & Co." building—is it a mill, or perhaps a Provincetown general store?—forms a weighty base for the lush green trees whose airy bunches of leaves spring up toward the sky. As if the scene were recorded through a shimmering crystal kaleidoscope, Demuth communicates the sparkling light and cloud-like forests of New England through analytical planes that echo those of the man-made objects existing within this natural environment.

Demuth's artistic career was shaped by his wide travels and eclectic interests. His art education began in 1900 at the Drexel Institute in Philadelphia, and continued later at the Pennsylvania Academy of the Fine Arts. From 1912-14, Demuth studied in Paris, and through his participation in the avant-garde salon of Gertrude Stein became immersed in contemporary French modernism, particularly Cubism and Fauvism. Upon returning to the United States, Demuth gravitated toward American modernist circles, where he exchanged ideas with American Cubists, Dadaists, and, most importantly, members of Alfred Stieglitz's 291 gallery. While best known for his Precisionist landscapes and Dada-inspired "poster portraits," the wealth of diverse creative individuals and influences Demuth encountered fed the variety and constant experimentation of his other work. His fruit and flower still lifes, painted sporadically throughout his career, reflect his disciplined training and fully manifest his skills as a realist. On the other hand, Demuth's passionate expressiveness and sly sense of humor infuse the sensual homoerotic watercolors of his late career. The Wichita Art Museum's *Rise of the Prism* shows the delight in which the artist applied his eclectic influences and unique vision to the American landscape, representing just one of the many facets of Demuth's stellar career.

M.B.

ARTHUR G. DOVE (1880-1946)

Forms Against the Sun, ca. 1926

Arthur Dove was born in Canindaigua, New York, in 1880. Newton Weatherly, an amateur artist and naturalist who lived near the Doves, often took young Arthur on his painting excursions. Dove also joined his neighbor on many hunting and fishing trips to upstate New York. It would be difficult to overestimate the significance of these experiences for the future artist.

Dove studied pre-law for one year before switching majors and studying illustration at Cornell University with Charles Wellington Furlong. He graduated in 1903 and quickly found work as a freelance illustrator in New York City. After working for almost five years, Dove used his savings to take an eighteen-month sojourn to Paris. There, he discovered the work of Cézanne, Matisse, and the Fauves. Galvanized by what he saw in Europe, the artist returned to New York with renewed ambition and an armful of paintings. He soon found a powerful ally and lifelong friend in photographer, gallery owner, and art world luminary Alfred Stieglitz. Stieglitz, impressed with Dove's paintings, included his work in a show titled "Younger American Artists" in 1910. Not long after, Dove made the transition from capable imitator to inspired innovator. Six oil panels Dove painted in 1910 or 1911, now known as *Abstraction No. 1* through *No. 6,* rank among the first examples of native non-objective painting in America. This group, also referred to as *Nature Symbolized,* suggests the direction of Dove's art for the rest of his life.

Dove probably painted *Forms Against the Sun* around 1926.[1] Like many of Dove's best-known works, the subjects of this painting straddle the line between familiarity and non-objectivity. One way to appreciate Dove's unique vision is to examine his ideas regarding the natural world. Like Ralph Waldo Emerson and Henry David Thoreau, Dove believed that every object possessed an essence or spirit. Dove also held that an object's spirit is not fully revealed in its outer physical form. Instead of slavishly reproducing the familiar, outward forms of a tree, for example, Dove suggested its spirit through shapes and colors which correlated only slightly, if at all, with its outward appearance. Hence, the sinuous stalks that rise and writhe on either side of *Forms Against the Sun* gain power through suggestion, not scientific accuracy.

The interrelationship of all living things was another tenet of pantheistic philosophy to which Dove subscribed. The manner in which the organic forms and warm hues overlap and fuse into one another seems to suggest the delicate balance of life. Concentric circles, which Dove called both "force lines" and "growth lines,"[2] radiate from the sun and suggest its generative power. The force lines also unify the composition by overlapping and bisecting the mysterious organic shapes. The juxtaposition of these forms and colors refracts kaleidoscopically and translates into paint the mutual dependence of all living things.

M.W.

1. When purchased for the museum, the painting was dated ca. 1915, but Ann Lee Morgan, *Arthur Dove: Life and Work, With a Catalogue Raisonné* (Newark: University of Delaware Press, 1984), 147, makes a persuasive argument for the later date on stylistic and technical grounds.

2. Barbara Haskell, *Arthur Dove* (Boston: New York Graphic Society, 1974), 24.

Forms Against the Sun, ca. 1926
Oil on metal, 29 x 21 in.
Roland P. Murdock Collection, M76.48

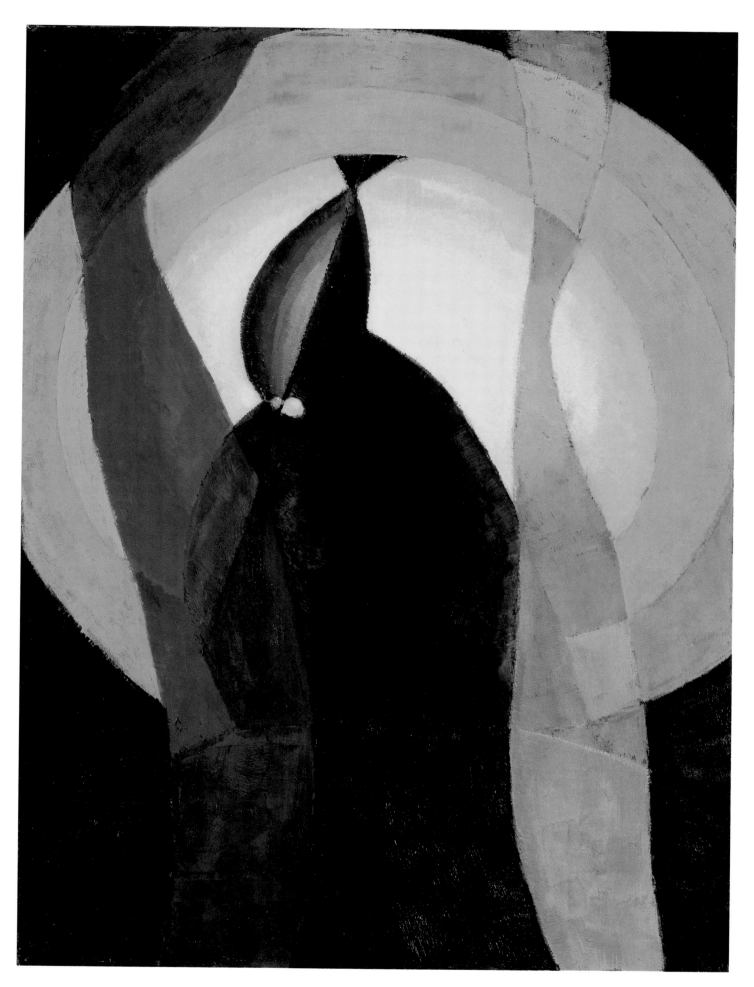

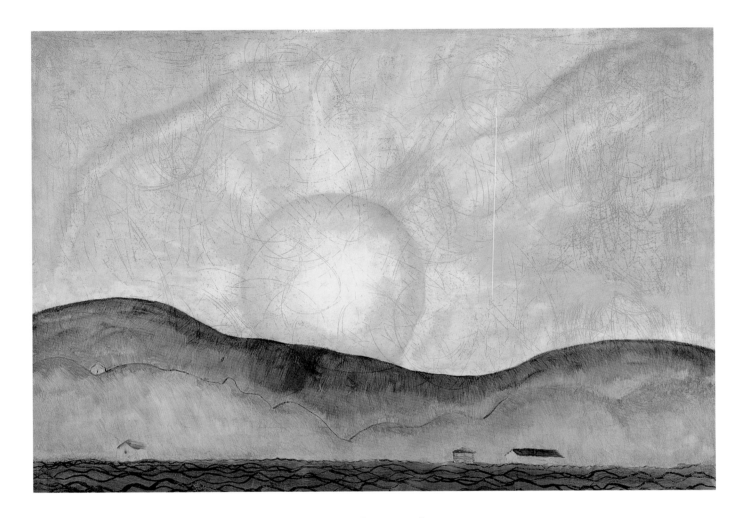

Sunrise in Northport Harbor, 1929

Oil on metal, 20 x 28 in.

Signed lower right: *Dove*

Roland P. Murdock Collection, M151.57

Sunrise in Northport Harbor, 1929

In 1921, Arthur Dove left his wife to live with Helen "Reds" Torr, a fellow artist he met through mutual friends in Westport, Connecticut. That year, Dove and Torr took residence on a houseboat moored off of upper Manhattan. Late in 1922, Dove bought a forty-two foot yawl, the Mona, which became their residence for many years to come. The couple moved to a mooring on the north shore of Long Island in the summer of 1924. Despite their tiny living space (which also served as their studio), the demanding upkeep of the Mona, and the pressures of illustrating (Dove still relied on illustration work for his primary source of income), Dove managed to continue painting.

It seems likely that Dove fashioned the subject of *Sunrise in Northport Harbor*[1] after the glorious sunrises he must have witnessed from the Mona. The couple were still living on their yawl when Dove completed the painting in 1929. Indeed, the waves in the immediate foreground suggest that the viewer looks back toward the shore from a point on the water. The entire painting is suffused by a sense of child-like wonder. The homes, dwarfed by the sun, appear to be mere dollhouses. The nervous black lines of the water, echoed in the profiles of the surrounding hills, recall the erratic crayon lines of a child's scribblings. The components of the painting are unified by the palette of warm yellows, blues, and greens that glow with life.

The swelling sun slightly left of the center of the painting commands the viewer's attention by virtue of its sheer size. The sun was a source of endless interest and inspiration for Dove, as *Forms Against the Sun* and *High Noon,* the two other paintings by Dove in the Wichita collection, attest. Unlike the other two works, *Sunrise in Northport Harbor* is more realistic in style. Only the colossal orange and yellow orb, which rises majestically over the hills, suggests that the scene has been filtered through Dove's imagination.

Sunrise in Northport Harbor was painted in 1929, three years after Dove sold his first painting to Duncan Phillips, an affluent New York collector. Starting in 1930, Phillips began supporting Dove on a regular basis by sending him fifty dollars a month in exchange for his first choice of Dove's annual new work. Phillips's patronage continued until Dove's death in 1946. Phillips, who at one point only collected conservative American Impressionist paintings, credited Dove with changing his feelings about modern art:

> My own discovery of Dove about 1922 was important to my evolution as a critic and collector. At that time I still had the writer's attraction to painters whose special qualities could be interpreted and perhaps even recreated in words. Fascinated from the first glimpse by Dove's unique vision I found that I was being drawn to an artist because his appeal was exclusively visual.[2]

Through his patronage and friendship, Phillips provided Dove with the moral and financial support that the artist would increasingly rely on in the later years of his life.

M.W.

1. The painting was first exhibited under the title *Sunrise at Northport [No. 2].* See Ann Lee Morgan, *Arthur Dove: Life and Work, With a Catalogue Raisonné* (Newark: University of Delaware Press, 1984), 174.

2. Duncan Phillips quoted in Sasha Newman, *Arthur Dove and Duncan Phillips: Artist and Patron* (New York: George Braziller, 1981), 31.

High Noon, 1944

Dove's late work evidences a departure from his earlier style, a departure animated by his probing of spiritual meaning in the relationship between cosmos, light, and life. His late works, like *High Noon,* composed of hard-edged geometric shapes, take on an iconic quality, heightened by his use of brilliant primary and secondary hues. By probing into the outward nature of the universe through the physical laws that govern its chaos, Dove was actually engaged in an inward journey to attain peace with his own moment in that universe—a moment which was coming to pass.

By 1941, Dove's health had greatly deteriorated, his body ravaged by kidney disease and two strokes. Due to his physical condition, he became increasingly isolated from his circle of New York associates, which revolved around Alfred Stieglitz and his gallery An American Place. Despite his declining health, Dove's diaries reveal an alert mind actively engaged in artistic questions of form, color, and space. Fascinated by contemporary theories regarding the fourth dimension and its relation to time and shape, Dove included extensive explanations of the fourth dimension in his diary. Working prodigiously, he began translating these theories from the written word into a visual language by using abstract form to communicate abstract mathematical theory—the fourth dimension could be visualized by its continuously varying sections which lie in three dimensional space.

Shifting shapes and luminous solids in *High Noon* embody a notion of continuously rotating time, as explained by the fourth dimension, where time is a coordinant point in which an event occurs. The mesmerizing yellow of the toothed diamond, in which the sun's orb is encapsulated, suggests a cross-section of a whirling solid. The sun viewed through this vibrating field suggests the transparency of all solids in this next dimension, while illustrating Dove's personal understanding of the sun as a celestial body formed of layered gases through which light escapes. Vividly colored, abstract forms at the bottom of the canvas exist within a space that is subsumed within a dark blue void contained by a larger green, interior geometry. Read intuitively, these bold forms suggest growing organic forms thriving on cosmic energy. Through the saturated color and iconic shapes of *High Noon,* Dove breathes drama into the intellectual experience of the physical mysteries of the universe.

D.L.D.

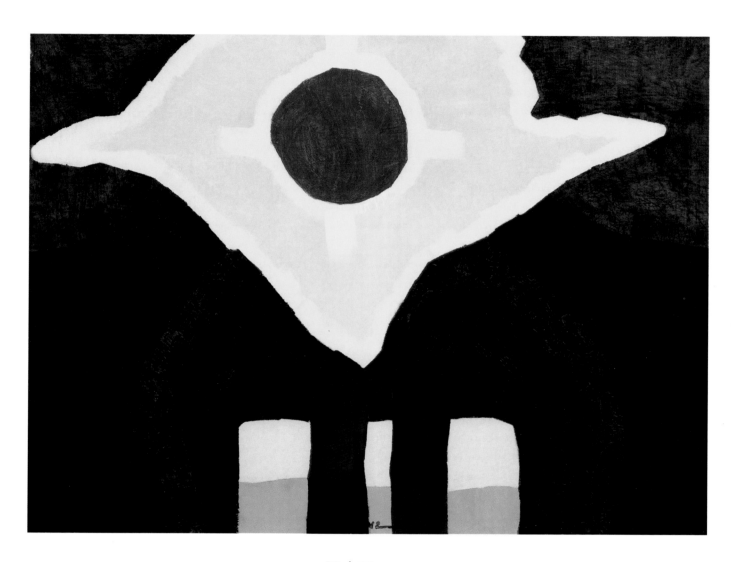

High Noon, 1944

Oil and wax on canvas, 27⅛ x 36¼ in.

Signed lower center: *Dove*

Roland P. Murdock Collection, M105.52

GUY PÈNE DU BOIS (1884-1958)
Fog, Amagansett, 1938
Oil on canvas, 25 x 30⅛ in.
Signed and dated lower left: *Guy Pene du Bois '38*
Roland P. Murdock Collection, M13.40

Guy Pène du Bois was the painter of the same fashionable and decadent society that F. Scott Fitzgerald immortalized in prose. Stylized, elegant and superficial, du Bois's wealthy subjects were seen through the eyes of an artist who, like Fitzgerald, knew the life of leisure. Born in Brooklyn into a transplanted Creole family, du Bois was named after his father's literary friend Guy de Maupassant. In 1899, he enrolled at the New York School of Art, where he began his studies under William Merritt Chase. Although he adopted Chase's loose brushwork, du Bois found less attractive his teacher's aesthetic philosophy of art for art's sake. Subsequent study at the New York School under Robert Henri convinced the young artist to paint the life he saw around him. Du Bois's conviction that "art is not a question of art but of life"[1] became the foundation of the voluminous art criticism he would later write for numerous New York publications.

Aside from two extended stays in France from 1905-6 and 1924-29, du Bois based his career in New York, where, as a painter, critic and teacher, he enjoyed a cosmopolitan life. He spent many of his summers in Connecticut, either amid the lively artistic and literary circles of Westport, where "work was an effort made between parties,"[2] or in Stonington at the Guy Pène du Bois Summer School.

During the summer of 1938 du Bois taught at a summer art school at Amagansett on Long Island, where he painted *Fog, Amagansett.* He later recalled:

> It was painted from notes and memory . . . toward the end of the summer. I had spent most of the summer doing sketches on The Beach and was full of information about it. The picture was done very easily and rapidly and is, I think, one of the most fluent ones I have done in recent years.[3]

Despite the carefully structured composition, the painting has no central narrative. Figures in the background are barely distinguishable through the afternoon haze, while the three in the foreground, united in their glance out to sea, ultimately remain isolated and self-absorbed. With his back turned to the others, the foremost man strides toward the viewer. Generalized in form and features and lacking a clear narrative function, this man signifies not an individual but a social class. Sleek, elegant, and refined, he seems to epitomize the life of leisure.

M.P.G.

1. Guy Pène du Bois quoted in Betsy Fahlman, *Guy Pène du Bois: Artist About Town* (Washington, D.C.: Corcoran Gallery of Art, 1980), 6.

2. Guy Pène du Bois quoted in ibid., 23.

3. Guy Pène du Bois, letter to Elizabeth S. Navas, 2 April 1940, registrar's files, Wichita Art Museum.

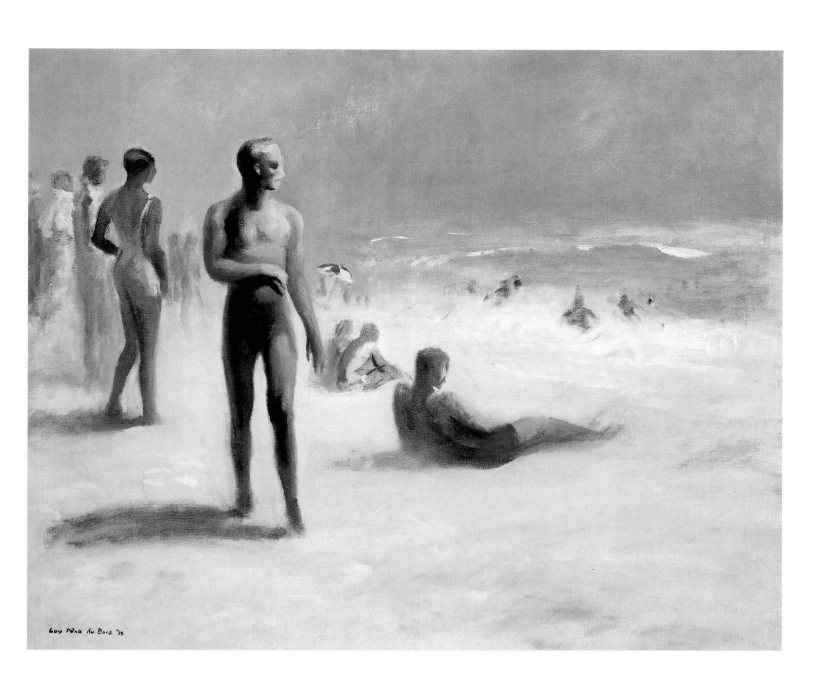

THOMAS EAKINS (1844-1916)

Starting Out After Rail, 1874

Meticulous perspective and precise reflections characterize Thomas Eakins's depiction of sails and sea in his painting *Starting Out After Rail.* Eakins approached painting with the eye of a scientist and discovered his personal aesthetic in clinical objectivity. He stated:

> There is so much beauty in reflections that it is generally worth while to try and get them right. Everyone must have noticed on the sides of boats and wharves or rocks, when the sun is shining and the water in motion, never-ending processions of bright points and lines. . . . These points and lines are the reflections of the sun from the concave parts of the waves acting towards the sun as concave mirrors, focussing his rays now here, now there, according to the shifting concavities.[1]

Eakins was born in Philadelphia in 1844. His scientific interest manifested itself early on, and became a major factor in his artistic training when he enrolled in anatomy classes at Jefferson Medical College in order to augment his concurrent studies at the Pennsylvania Academy of the Fine Arts. He went to Paris in 1866 and studied with the painters Jean-Léon Gérôme and Léon Bonnat, and the sculptor Augustin-Alexandre Dumont. Of Eakins's teachers, Gérôme was most influential, emphasizing the importance of precise draftsmanship, and reinforcing his student's interests in perspective and scientific exactitude. Eakins returned to Philadelphia in 1870, making the city his permanent home. In Philadelphia, Eakins became an important teacher in his own right at the Pennsylvania Academy of the Fine Arts.

Starting Out After Rail depicts two men setting out across the Delaware River to the New Jersey marshes in order to hunt the aquatic game bird. Eakins knew the two men in the painting and identified the picture as *Harry Young, of Moyamensing, and Sam Helhower, "The Pusher," Going Rail Shooting.*[2] Eakins was himself a rail hunter, and it seems fitting that the artist traded the picture with James C. Wignall, a Philadelphia boat builder, who accepted it as payment for a boat. Because Eakins was well acquainted with the sport of rail hunting, and strived toward exacting artistic realism, every detail is precisely rendered. Eakins depicts everything from the stitching on the sail to the double-barreled shotgun held fast on the inside of the boat with an amazing technical facility and literalness difficult to achieve with watercolor. Even the artist's signature on the spray cover at the stern of the boat is rendered in perfect perspective.

Eakins painted two other versions of this composition, both in oil. One painting (Museum of Fine Arts, Boston) bears the same title, and is nearly identical to the watercolor. The other, simply titled *Sailing* (Philadelphia Museum of Art), depicts the same scene but is more generalized, and eliminates details such as the push pole, shotgun, and rigging. *Starting Out After Rail* is also related to several other of Eakins's aquatic sporting pictures of the same period, notably his Schuylkill River sculling subjects.

S.A.S.

1. Quoted in Lloyd Goodrich, *Thomas Eakins: His Life and Work* (New York: Whitney Museum of American Art, 1933), 47.

2. Exhibition catalogue of the *Seventh Annual Exhibition of the American Society of Painters in Water Colors in New York,* 1874, cited by Donelson F. Hoopes, *Eakins Watercolors* (New York: Watson-Guptill Publications, 1971), 28.

Billy Smith, 1898

Thomas Eakins's *Billy Smith* marvelously exemplifies both the virtuoso realist style and intense psychological portraiture for which the artist is best known. Although executed as an oil study for a larger canvas, entitled *Between Rounds* (1899, Philadelphia Museum of Art), the painting, like most of Eakins' smaller studies, stands on its own as a sensitively-rendered, finished portrait. The sitter, south Philadelphia boxer "Turkey Point" Billy Smith, received the portrait from Eakins as a gift, and kept it until late in his life, when it was purchased by the Wichita Art Museum. When asked to comment on his involve-

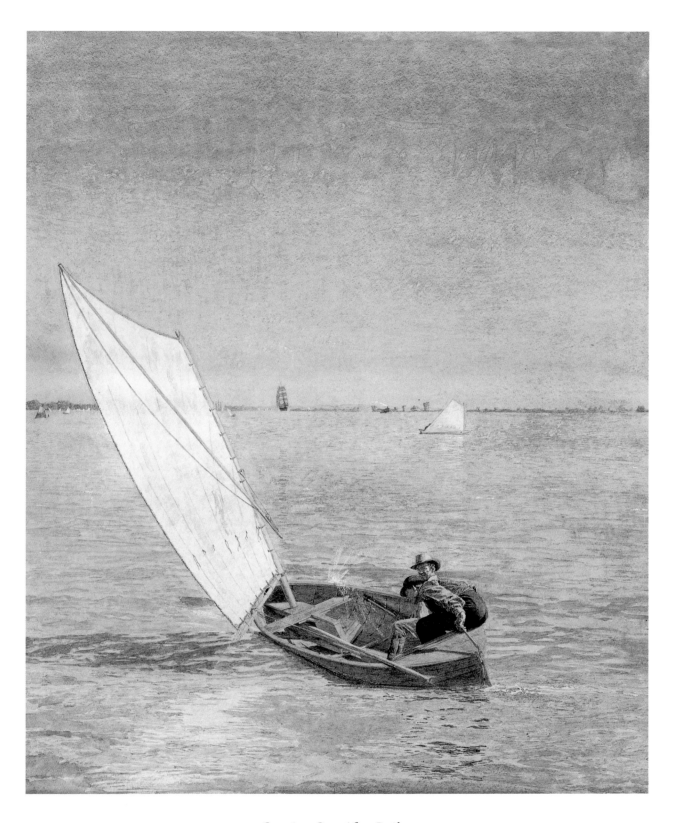

Starting Out After Rail, 1874

Watercolor on paper, 25 x 20 in.

Signed and dated on spray cover at stern of boat: *Eakins '74*

Roland P. Murdock Collection, M26.41

ment in the painting and his friendship with Eakins, Smith gave a simple response that conveyed the high esteem in which he held Eakins both as a man and an artist:

> It was 1898, when Mr. Eakins came to a Boxing Club, to get a modle [*sic*] for his first fight picture, titled Between Rounds. He choose [*sic*] me. . . Mr. Eakins, to Me was a Gentleman and an Artist, and a Realist of Realists. In his work he would not add or subtract. I recall. . . I noticed a dark smear across my upper lip, I asked Mr. Eakins what it was, He said it was my mustache, I wanted it of [*sic*], He said it was there, and there it stayed. You can see that he was a Realist.[1]

The influence of the Spanish realists Velázquez and Ribera on Eakins's work, strengthened by Eakins's formal training in anatomy and medical illustration, is perceptible in his sensual and unflinchingly honest handling of Smith's figure. The skill with which Eakins renders Smith's physical attributes—the powerful forearms reaching toward the ropes, the strong bone structure of the face, the grayish-yellow skin pallor that the indoor sport induces—is uncompromising in its naturalism. Even more striking is how accurately Eakins conveys the essence of the fighter in a moment of trance-like concentration, capturing an aspect of the psychology of the brutally physical sport.

Eakins painted WAM's portrait of *Billy Smith* as a study for the large fight scene of *Between Rounds,* 1899, oil on canvas, 50¼ x 40 in., Philadelphia Museum of Art, Pennsylvania.

Smith's eyes peer out from under the shade of his brow with a mixture of determination and fear, and the muscles of his neck and shoulders strain with tension. The painting's smoky palette and dramatic chiaroscuro further convey both the anxiety of the pugilist preparing for battle and the musty excitement and mystery surrounding the prizefight. The tension and anxiety of this portrait seem connected to the outcome of the real match upon which this study, and its subsequent painting, was based: the semi-windup at the Philadelphia Arena, on 22 April 1898, which Smith lost to fellow featherweight Tim Callahan.

After posing for *Between Rounds* and *Salutat* (1898, Museum of Art, Carnegie Institute, Pittsburgh), another of Eakins's large boxing pictures, Billy Smith became a companion and a comfort to Eakins until the artist's death in 1916. When the elderly Eakins could no longer move around his house in the months before his death, Smith relieved his pain with therapeutic massages and moved the artist from room to room when his legs failed him. As Smith's reflections on his portrait attest to the esteem in which he held Eakins, so the painting itself seems to manifest the equally high regard in which the artist held the fighter. As art historian Britt Steen Beedenbender has written about this striking portrait: "The study of Billy Smith is a celebration of humanity and a reminder of the heroism within all men."[2]

M.B.

1. William Smith, letter to Maynard Walker Galleries, New York, 15 August 1940, registrar's files, Wichita Art Museum.

2. John Wilmerding, ed., *Thomas Eakins* (Washington, D.C.: Smithsonian Institution Press, 1993), 135.

Billy Smith, 1898
Oil on canvas, 21⅛ x 17¼ in.
Inscribed and dated lower right: *BILLY SMITH/FROM HIS FRIEND/ THOMAS EAKINS/1898*
Roland P. Murdock Collection, M16.40

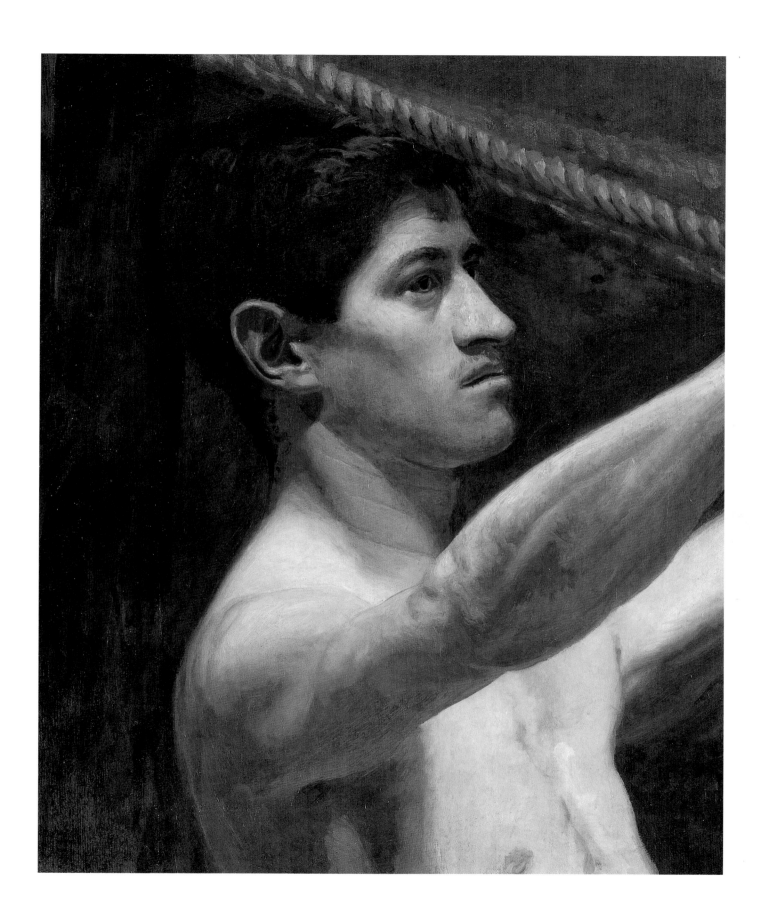

Mrs. Mary Hallock Greenewalt, 1903

Today, Thomas Eakins takes his place among the greatest names in American art, but in his own lifetime his art suffered rejection by the social and artistic establishment of his native Philadelphia. Eakins's outspoken nature and forward-looking opinions took a toll on his reputation. He received bitter criticism for his unconventional teaching methods and was forced to resign from the Pennsylvania Academy of the Fine Arts in 1886 after an infamous incident in which he fully disrobed a male model in front of a class that included female students. The human figure was always central to Eakins's work, and after resigning from teaching he largely limited himself to portraiture. Eakins did not flatter sitters in the elegant manner of John Singer Sargent, nor endow them with the dashing charm seen in the portraits of William Merritt Chase. Instead Eakins portrayed his subjects with penetrating realism, constantly striving to plumb their psychological character. The frank nature of Eakins's work did not endear him to potential clients, as is proved by the fact that of the 246 portraits he is known to have painted only twenty-five were commissioned by the sitters. Many of Eakins's subjects were friends or people he admired and would ask to pose for him. Often he would give the completed painting to the sitter with the inscription TO MY FRIEND.[1] Eakins inscribed the portrait of Mary Hallock Greenewalt with her name in Latin on the back of the canvas. This was an honor he usually reserved for male subjects; such an indication of his admiration for the sitter only appears on one other portrait of a woman.

Mary Hallock Greenewalt was internationally known for her interpretations of Chopin, and was also a pioneer of color-light effects used in conjunction with musical performances. A Philadelphian, Greenewalt was likely an acquaintance of Eakins and his wife, Susan MacDowell Eakins. Mrs. Eakins was herself an accomplished amateur pianist and, with her husband, kept friendships with many musicians. The Greenewalt painting is one of eleven portraits of musicians produced by Thomas Eakins.

Eakins's portrait of thirty-two-year-old Greenewalt captures both the beauty and the intelligence of the subject, who gazes directly out at us, commanding our attention. She is dressed in a pale violet silk evening gown as if ready to perform a recital. Her strong, expressive hands, lightly resting together in her lap, are upturned to show the palms and underside of the fingers. The form of her head is modeled in a subdued light, with a shadow falling on left side of her face. Her strong neck and shoulders are more strongly illuminated. The whole composition is set against a dark ground, which is modulated only to suggest the back of the chair on which Greenewalt sits.

The precise rendering of Greenewalt's face and body provides clear evidence of Eakins's complete understanding of human anatomy, gained through years of dissection classes. Around the time he painted the Greenewalt portrait, Eakins also was actively studying the body not only in drawing and painting but also in sculpture. This work in three dimensions may have contributed to Eakins's achievement of a highly sculptural rendition of Greenewalt in her painted portrait, and it is significant to note that he also made a small bronze relief portrait of her in 1905.[2] The location of the bronze is unknown today, but the oil portrait pleased Greenewalt greatly. She kept it in her possession until very late in her life, when it entered the Wichita collection.

M.R.

1. Lloyd Goodrich, *Thomas Eakins* (Cambridge, Mass.: Harvard University Press, 1982), 2:80.

2. Ibid., 126.

Mrs. Mary Hallock Greenewalt, 1903
Oil on canvas, 36⅛ x 24⅛ in.
Signed and dated upper right: *EAKINS/1903*
Roland P. Murdock Collection, M61.45

HARRY GOTTLIEB (1895-1992)

Dixie Cups, 1936-37

Oil on canvas, 24⅛ x 41 in.

Signed lower right: *Harry Gottlieb*

Gift of Friends of the Wichita Art Museum, Inc., 1982.42

Born in Romania in 1895, Harry Gottlieb immigrated with his family to Minneapolis, Minnesota in 1906. At the age of twenty, he began his artistic training at the Minneapolis Institute of Art. Three years later he moved to the artists' colony at Woodstock, New York. A Guggenheim fellowship awarded in 1931 allowed him to travel to Europe. After his year abroad, Gottlieb returned to Woodstock, but moved shortly thereafter to New York City to immerse himself in the cosmopolitan atmosphere he felt necessary to the growth of his work.

In New York Gottlieb joined other artists in the economic hardship brought about by the Great Depression. Seeking avenues toward employment, he optimistically joined the Artists Union in 1933, which led to his employment by the Public Works of Art Project, and its successor, the Federal Art Project. During this time, Gottlieb took up the mission of promoting the political aims of the

Artists Union, and in 1936 was elected president of that body. As the Federal Art Project came to a close in 1939, Gottlieb struggled to preserve the partnership between government and working American artists. His vision of enduring economic support for artists failed to materialize, however, and by 1942, the art project had been reduced to a minor department within the War Services Division.

Under the auspices of the Federal Art Project, Gottlieb produced numerous portrayals of the American worker, of which *Dixie Cups* is a characteristic example. In *Dixie Cups,* kettles of molten metal clash against frigid air and the resultant steam is borne away by a brisk wind. Steel workers carefully attend to the task at hand as the green flag waves the production line forward. Clearly, it is the force of men that moves the production of steel, and for Gottlieb, the strength of the industry relied upon the strength of the American worker in his acts of everyday heroism.

D.L.D.

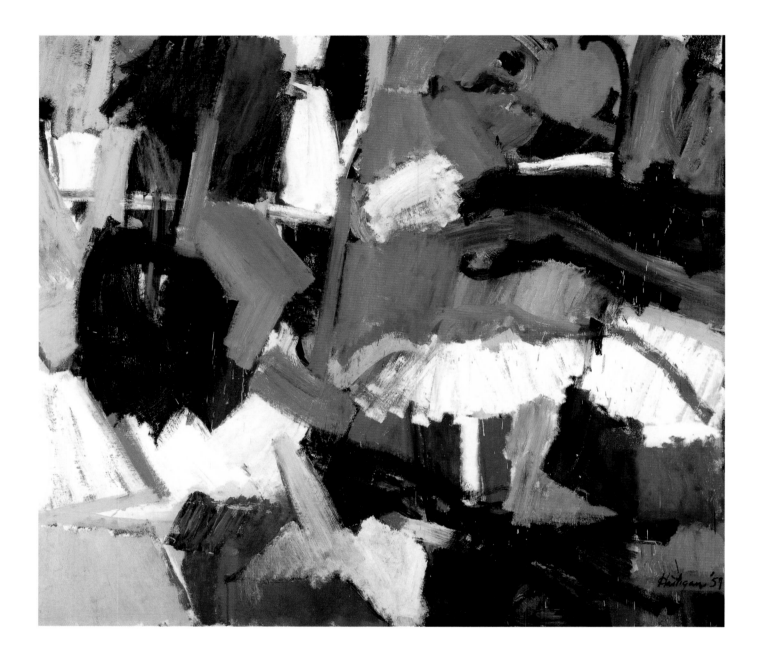

GRACE HARTIGAN (b. 1922)

East River Drive, 1957

Oil on canvas, 70½ x 79½ in.

Signed and dated lower right: *Hartigan '57*

Robert and Betty Foulston Fund, 1989.21

Born in Newark, New Jersey, Grace Hartigan was raised in nearby Bayonne. She took her first drawing and painting classes soon after high school and supported herself with various jobs, including modeling for Hans Hofmann's painting classes. Her early art was representational, and influenced by the bold colors and simplified forms of Matisse. After moving to New York City in 1945, she encountered Jackson Pollock's drip paintings, and was inspired to paint abstractions herself.

Unlike Pollock, however, Hartigan continued to refer to the environment around her, even while working in an abstract mode. "I had found that my best work had some roots in the visual world," she later recalled. "I just had to throw in something of the life around me, even if it was just fragments, little memories . . ."[1] Hartigan was attracted not only to places typically considered beautiful, such as the peaceful countryside depicted in *New England, October* (1957, Albright-Knox Art Gallery), but also to places and things often considered unpleasant or even ugly, such as a crowded street or a busy expressway. She stated, "Our highways are fantastic . . . most of all I like to work directly from American sources and phenomena."[2]

Many of Hartigan's paintings of the mid-fifties, including *East River Drive,* were inspired by her urban surroundings. While living in an old garment building in New York City's Lower East Side from 1950-60, she absorbed the rhythms of the city from her studio window and by taking walks around the neighborhood. The paintings she created, such as *Grand Street Brides* (1954, Whitney Museum of American Art), *City Life* (1956, Nelson A. Rockefeller Collection), and *East River Drive* differed greatly from works by preceding artists who were inspired by the city and the Lower East Side. Whereas the early

twentieth-century Ashcan School artists such as George Luks painted genre scenes focusing on the people of the Lower East Side, Hartigan painted her personal responses to the neighborhood and its constant activity.

Hartigan produced works that included fragments of the visible world and others that were completely abstract, such as *East River Drive.* In this painting, rather than depicting the expressway cars and street signs she saw on her walks to the East River Drive (which borders the East River and spans the east side of Manhattan), Hartigan represented her own reactions to the busy highway with energetic brushwork and bold colors. Jagged brushstrokes of bright blues, oranges, and yellows collide and bounce off each other, forming a jazz-like rhythm. Splatters of paint evoke the animated pace of the freeway and urban life. Brushy patches of white pigment abruptly interrupt the scene as would blaring car horns. In *East River Drive,* one can almost sense the proliferation of cars, traffic, and superhighways that increased the pace of New York City street life during the fifties.

With evident pleasure, Hartigan transformed the ordinary expressway into something extraordinary. The artist stated: "I have found my subject, it concerns that which is vulgar and vital in American modern life, and the possibilities of its transcendence into the beautiful. I do not wish to describe my subject matter or to reflect upon it—I want to distill it until I have its essence."[3]

S.S.

1. Grace Hartigan, quoted in Cindy Nemser, *Art Talk* (New York: Charles Scribner's Sons, 1975), 156-57.

2. Grace Hartigan, quoted in Lee Nordness, ed., *Art USA Now* (New York: Viking Press, 1963), 356.

3. Grace Hartigan, quoted in Dorothy C. Miller, ed., *Twelve Americans* (New York: The Museum of Modern Art, 1956), 53.

MARSDEN HARTLEY (1877-1943)
End of the Hurricane, 1938
Oil on composition board, 22 x 28 in.
Inscribed on verso: *End of the Hurricane/Sept 1938/Lanes Island,*
Vinalhaven
Roland P. Murdock Collection, M20.41

At the age of sixteen, Marsden Hartley left his home state of Maine to join his father and stepmother in Cleveland, Ohio, where in 1898 he entered the Cleveland School of Art. By the following year, he was studying in New York, first at the Chase School and later at the National Academy of Design. Although Hartley's paintings did not take on a strong abstract character until 1911, the mysticism so prominent throughout his life, in both his paintings and poetry, took hold early through readings of the transcendentalist authors Emerson and Thoreau.

Hartley's life was one of constant movement and chronic illness and depression. He was a lonely and introverted man, always dependent upon others for financial support. His most important benefactor was Alfred Stieglitz, who in 1909 held Hartley's first one-man exhibition and who also supported Hartley's first trip to Europe. From 1912-15 the artist lived primarily in Berlin, painting abstractions based on military and mystical subject matter. After the advent of World War I forced him to leave Germany, Hartley spent the next two decades wandering Europe and America. During this period, Hartley abandoned abstraction for a more representational yet highly personal and symbolic style.

Although illness and financial troubles continued to plague Hartley in his later years, he was able to find some happiness during the summers of 1935-36 while staying with the family of Francis Mason in Nova Scotia. Hartley grew particularly fond of the two Mason boys, Alty and Donny. The tragic drowning of the two brothers during a fierce gale in the summer of 1936 left Hartley emotionally devastated.

Following the loss of his friends, Hartley meditated on their deaths through numerous paintings and poems. *End of the Hurricane,* probably painted in Maine during the summer of 1938, suggests the emotional pain Hartley continued to feel two years after the tragic event. As the title indicates, the initial storm has ended, but the violent churnings of the ocean continue to batter the jagged and weather-worn rocks, just as memories of the sea continued to trouble the artist himself. Coastal rocks and crashing waves alternate, cutting across the picture surface in four powerful diagonals. For the mystic Hartley, rocks and waves become the actors in a human drama. In the spirit of Winslow Homer's late coastal scenes of Maine, the battle between two essential components of nature—earth and water—seems to signify humanity in perpetual conflict with the elements.

M.P.G.

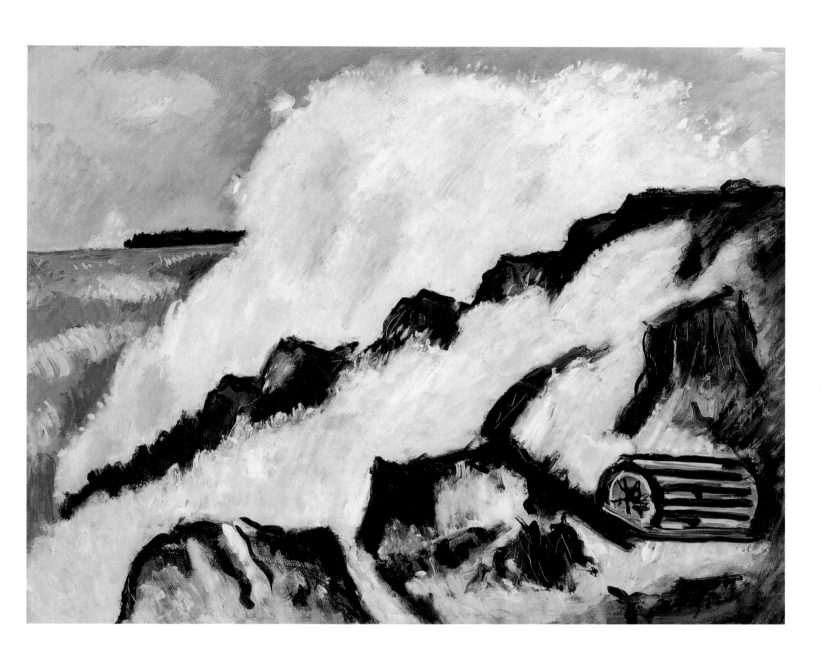

CHILDE HASSAM (1859-1935)

The Birches, 1891

Frederick Childe Hassam, born in Dorchester, Massachusetts, was one of the most famous and successful proponents of American Impressionism. After modest local success as an illustrator and exhibiting watercolorist, Hassam moved to Paris in 1886 to study at the Académie Julian. The rigorous academic discipline served him well, and his facility in painting developed rapidly. It was, however, Hassam's encounter with French Impressionism that most radically shaped his work during his three years in Paris; the Impressionists' interest in light and color reinforced similar qualities of Hassam's early work, and he quickly assimilated their techniques. But, remaining true to his intense academic training in life-drawing and his experience as a professional illustrator, Hassam did not go as far as his French contemporaries did in abandoning firm drawing nor in dissolving solid form into patches of pure color.

Returning to the United States in 1889, having captured the bronze medal from that year's Paris Exposition, Hassam settled in New York, where his work met with critical and popular acclaim. Late Victorian culture was at its height on the Eastern seaboard. The splendor of New York's genteel urban streets, as well as the fresh landscapes of New England and the glittering Atlantic seacoast, provided Hassam with attractive subjects to capture with his new-found, exciting brand of Impressionism.

Despite the popularity of Hassam's work among both collectors and exhibition juries, many leading academic painters were still hostile toward the more experimental American Impressionists. Hassam's steadfast support of his fellow American Impressionists led him to resign from the Society of American Artists in 1897, when that body rejected a landscape by John Twachtman. In protest of the increasingly conservative officials, juries, and exhibitions of the Society, Hassam, along with Twachtman and Julian Alden Weir, formed an independent organization of Impressionist and Tonalist painters that became known as "The Ten," after the group's first 1898 exhibition, the Show of Ten American Painters. Hassam was by far the closest adherent of The Ten to the French Impressionist Style, whose limits he explored continuously throughout his career, until his death in 1935.

Hassam's pastel drawing, *The Birches,* of 1891, comes from the decade generally acknowledged as the artist's greatest period of innovation. Fresh from Paris, Hassam undertook his American work in the 1890s with a masterful knowledge of Impressionist principles, animated by the excitement with which he approached his subjects armed with these new techniques. In *The Birches,* Hassam seems to have devoured this peaceful landscape with a sense of awe, in quick, yet assured strokes of pastel pigment laid down to capture the bright, shifting effects of sunlight on the trees and their reflections in the glittering blue water. Typical of Hassam's work of the 1890s, the pastel displays a strong realist commitment to solid representation of forms, as in the water-side trees and grassy landscape. However, the overall blond palette and the expert, short-stroked mixing of pastel pigments—used to render the bushy trees' leaves and to communicate the magical swirling of color and light in the water—originate in the artist's knowledge of French Impressionist technique. In *The Birches,* one finds the delight with which Hassam applied the still-fresh tenets of Impressionism to his early work.

M.B.

The Birches, 1891
Pastel on board, 22 x 18 in.
Signed and dated lower left: *Childe Hassam 1891*
John W. and Mildred L. Graves Collection, 1993.1

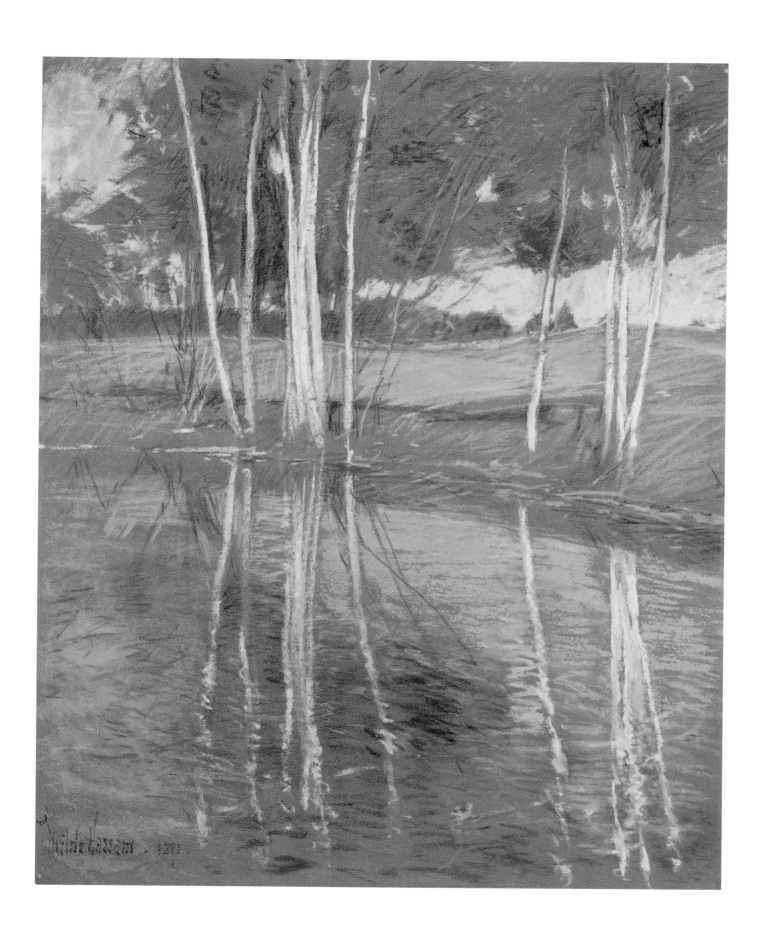

A crescent with its glory just begun,
A spark from the great central fires sublime,
A crescent that shall orb into a sun,
And burn in splendor through the mists of time.

CELIA THAXTER, from a sonnet on Childe Hassam, 1890
By courtesy of the Trustees of the Boston Public Library

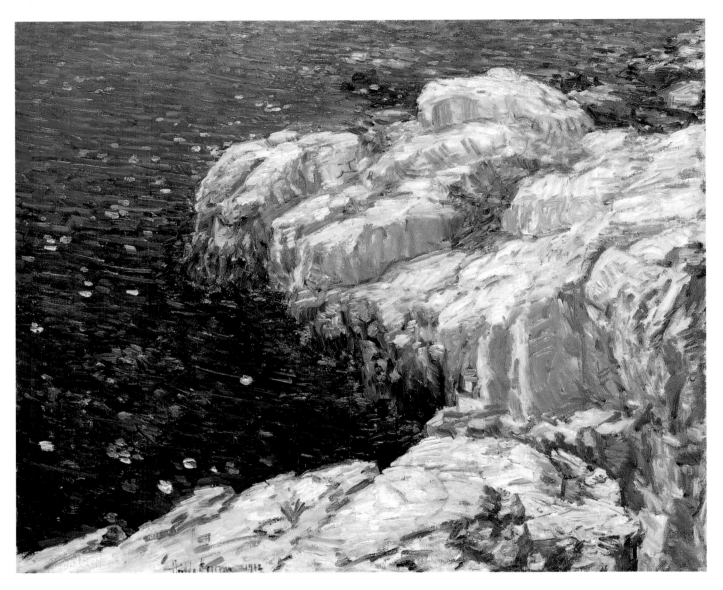

Jelly Fish, 1912
Oil on canvas, 20¼ x 24¼ in.
Signed and dated left of lower center: *Childe Hassam 1912*
John W. and Mildred L. Graves Collection, 1986.50

Jelly Fish, 1912

New England poet and journalist Celia Thaxter (1835-94) first became acquainted with Childe Hassam around 1884, when she briefly studied painting under him in Boston. In addition to her books of poetry and prose, well-known among Victorian New England *literati,* Thaxter and her family owned Appledore House, on the Isles of Shoals off the coasts of Maine and New Hamsphire, where artists, writers, and musicians spent summers amidst the rocky terrain and in Thaxter's celebrated flower garden. Soon after meeting Thaxter, Hassam and his wife, Maud, began spending summers at the resort. Hassam found Thaxter's pantheistic odes to the island and her graceful, quick-witted presence as fascinating as she had found his lyrical Impressionist paintings, and the two became very close friends. Although twenty-four years older than Hassam, Thaxter became the artist's muse; her painterly poems and lush gardens inspired Hassam to paint radiant studies of Thaxter—charming in her parlor and contemplative in her garden—as well as to illustrate many of her writings. His most famous efforts in this genre were his watercolors of Appledore flora for Thaxter's book, *An Island Garden* (1894). Hassam's inspiration at the Isles of Shoals did not stop, however, at the gates of Appledore House. The artist spent nearly every summer from 1886 to 1916 painting the majestic lighthouses, shimmering sea sunsets and delicate wildflowers of the islands, creating a series that many critics consider the most personal and revealing of the changing aesthetic concerns of Hassam's career.

After Thaxter's death in 1894, Hassam's focus on the Isles of Shoals turned from the gentle depictions of fragrant flower patches and sunlit Appledore interiors to the harsh waves and imposing granite coasts of the islands. As if in mourning for his dear friend, he began depicting the melancholy, even cruel nature of the weather-beaten terrain. His post-1895 paintings of the region seemed to reflect Thaxter's account of Appledore's rocky foundations in *Among the Isles of Shoals:* ". . . very sad they look, stern, bleak and uncompromising, yet they are enchanted islands."[1]

Painted in 1912, *Jelly Fish* presents the viewer with the sublime contradictions that seemed to endear the Isles of Shoals to both the painter and his muse. Craggy white rocks seem to rise like an impenetrable force from the impossibly dense, electric blue waters painted in thick, cropped strokes. However, even the fierce stone foundation cannot keep the luminosity of life away from its intimidating form. A single yellow flower pokes its way through the rock, defying the barren aspect of the rocky coast. And fluttering magically in the sea water, a shoal of jellyfish flock around the islands whose name is taken from their very formation. Hassam's *Jelly Fish* seems to be a bittersweet paean to both the inspiration Celia Thaxter gave him on the island, and an illustration for a breathtaking passage from Thaxter's *Among the Isles of Shoals.*[2]

> Sometimes in a pool of crystal water one comes upon (a baby sculpin) unawares—a fairy creature, the color of a blush-rose, striped and freaked and pied with silver and gleaming green, hanging in the almost invisible water as a bird in the air.[3]

M.B.

1. Celia Thaxter, *Among the Isles of Shoals* (Boston: 1873), 13.

2. David Park Curry, *Childe Hassam: An Island Garden Revisited* (Denver: Denver Art Museum in association with W. W. Norton, 1990), 181.

3. Thaxter, 86.

ROBERT HENRI (1865-1929)

Eva Green, 1907

Oil on canvas, 24⅛ x 20¼ in.

Signed and dated lower left: *Robert Henri/Dec 25 1907*

Roland P. Murdock Collection, M59.45

Robert Henri was born Robert Henry Cozad on 24 June 1865, in Cincinnati, Ohio. He spent much of his childhood in Cozad, Nebraska, a town founded by his father. In 1882, after Robert's father shot and killed a man, the Cozad family fled to the East Coast and changed their names in an attempt to disguise their true identities. In 1886 Henri enrolled in the Pennsylvania Academy of the Fine Arts, where he learned to draw by copying plaster casts of ancient statuary and studying the nude figure. Two years later he traveled to Paris, where he studied at the Académie Julian and the École des Beaux-Arts, and came under the influence of the Barbizon School and the Impressionists. Henri returned to Philadelphia in 1891 and taught there until 1895 when he returned to Paris. During this and subsequent visits to Europe, Henri traveled widely and studied the works of Frans Hals, Velázquez, Goya, and Manet, which would greatly influence his maturing style.

In Philadelphia Henri became the artistic leader of a group that included John Sloan, Everett Shinn, William Glackens, and George Luks, all of them illustrators for the *Philadelphia Press.* Henri encouraged his students to apply their journalistic skills to the development of personal artistic styles that could capture the vitality of the modern world around them. Henri and his students all moved to New York City around 1900, where they began to paint the poor inhabitants and lower class neighborhoods of the inner city, earning for themselves the name of the Ashcan School. The Ashcan artists' embrace of the everyday world of the American city and rejection of academic painting traditions alienated them from the leading art societies of the day. Henri struggled to gain exposure for his and the others' art by organizing independent, non-juried exhibitions such as the famous exhibition of

"The Eight" at the Macbeth Gallery in 1908 and the Exhibition of Independent Artists in 1910. Henri even participated, for a time, in the organization of the landmark 1913 Armory Show, which introduced European modern art to the American public. In the aftermath of that exhibition, Henri's influence declined: compared to modernist abstraction, his commitment to realism seemed old-fashioned. He did, however, continue to teach and paint until his death in 1929.

After his move to New York, Henri dedicated himself primarily to portraiture. *Eva Green* is one of his finest portraits of children, whom he saw as embodiments of uncorrupted vitality. Painted on Christmas Day in 1907, this portrait was completed after Henri returned from a trip to Holland. While there he had been deeply impressed by the works of Rembrandt and Frans Hals, whom he emulated by using broad brushstokes, abundant pigment, earth tones, and dark backgrounds.[1]

Henri's notes about *Eva Green* record a "tamoshanter hat Blue coat, blue ribbon showing and reddish ribbon sticking out from back of hair."[2] Not mentioned in the notes but quite significant is the fact that Eva Green is an African American child, depicted by Henri in an autonomous role usually reserved for white youths. Henri's interest in representing people of different races was a manifestation of the deeply-felt democratic view of humanity that animated his portrait painting throughout his lifetime.

J.A.S.

1. Valerie Ann Leeds, *My People: The Portraits of Robert Henri,* exhibition catalogue (Orlando, Fla.: Orlando Museum of Art, 1994), 25.

2. Henri's Record Book, collection of Janet Le Clair, quoted in ibid., 26.

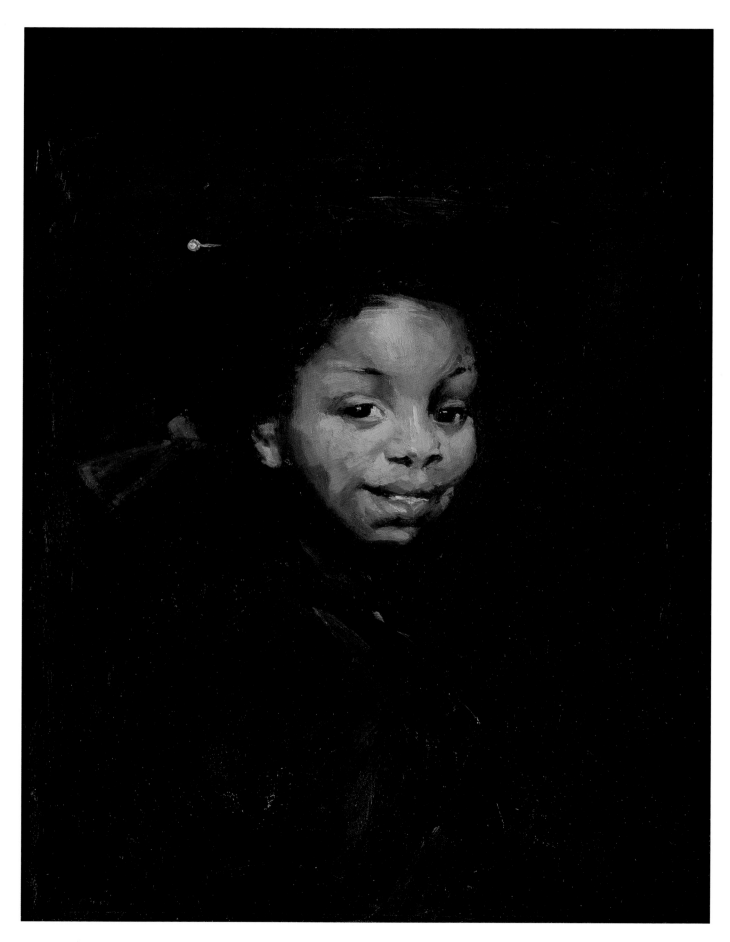

WINSLOW HOMER (1836-1910)
In the Mowing, 1874
Oil on canvas, 15¾ x 23 in.
Signed and dated lower right: *Homer /1874*
Roland P. Murdock Collection, M127.54

Knee-deep in a meadow sprinkled with daisies, three boys stop and turn towards their father who is calling them home. The sun is setting, and it is time for supper; an afternoon filled with childhood games has come to an end. The three are presumably brothers, and the youngest clutches his older brother's hand so as not to trip in the tall grass. Silhouetted against the landscape, they assume an heroic presence that is a timeless expression of brotherhood.

Representations of childhood, particularly images of school children and farm youths, frequently appear in Winslow Homer's paintings of the 1870s. *In the Mowing* could be interpreted as one of the most personal of this genre, as it seems based on a memory from the artist's own youth. Homer was the second of three male children. His older brother, Charles, was two when Winslow was born; his younger brother, Arthur, was born five years later. The gaps in age between the Homer boys correspond with the ages of the three youths presented in the painting, and it is easy to imagine them as the three Homer boys returning home.

The idyllic spirit of simple childhood experience seems rooted in Homer's early days in rural Cambridge, Massachusetts. Winslow was six when his family moved to Cambridge, which was at the time a suburban village bordered by rural landscape. The Homer boys loved the country, and seized every opportunity to play and explore in the countryside surrounding their town. In an early article on Homer, George William Sheldon described the artist's boyhood in Cambridge. "He has a great liking for country life—a liking which he thinks had its origin in the meadows, ponds, fishing, and beautiful surroundings of that suburban place. To this day there is no recreation that Mr. Homer prefers to an excursion into the country."[1]

When Homer was nineteen he left Cambridge to apprentice at a Boston lithography firm. Homer thus began his career as an illustrator, working most notably for *Harper's Weekly* in New York. During the Civil War, Homer did many illustrations of soldiers and their activities for *Harper's,* and worked up several of these sketches into paintings. Later in the 1860s, Homer began to depict in both graphic media and oils subjects such as vacationers and croquet players. Concurrently, Homer also began to paint pictures of country children doing chores, attending school, and playing games. *In the Mowing* is an example of this genre.

Although much loved today, Homer's rural scenes did not please every member of his contemporary audience. Even the most severe critics, however, admitted the appeal of these paintings. As Henry James observed in 1875:

> We frankly confess that we detest his subjects—his barren plank fences, his glaring, bald blue skies, his big, dreary, vacant lot of meadows, his freckled straight-haired Yankee urchins. . . . He has chosen the least pictorial features of the least pictorial range of scenery and civilization; he has resolutely treated them as if they were pictorial, as if they were every inch as good as Capri or Tangiers; and to reward his audacity, he has incontestably succeeded.[2]

In the Mowing exemplifies the type of picture that James describes, and it too rises above its seemingly humble subject. It is an image ablaze with color and light, that is at once personal and universal. While the image is likely rooted in a memory specific to Homer, it is capable of transcending particulars to become a nostalgic meditation on childhood.

S.A.S.

1. George William Sheldon, *Art Journal,* 1878, quoted in Lloyd Goodrich, *Winslow Homer* (New York: Published for the Whitney Museum of American Art by the Macmillan Company, 1945), 3.

2. Henry James, *The Galaxy,* July 1875, quoted in Albert Ten Eyck Gardner, *Winslow Homer, American Artist: His World and His Work* (New York: Bramhall House, 1961), 195.

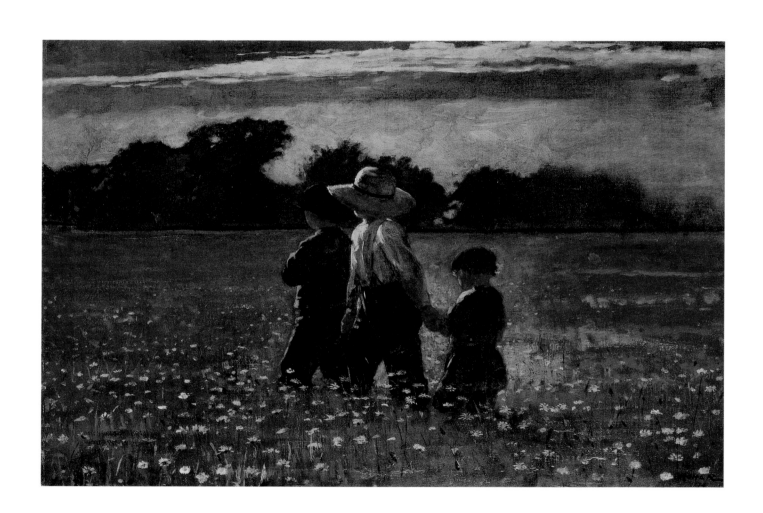

EDWARD HOPPER (1882-1967)

Adam's House, 1928

Born in Nyack, New York in 1882, Edward Hopper moved to New York City in 1900 where he studied painting at the New York School of Art from 1900 to 1906 under Willam Merritt Chase, Kenneth Hayes Miller, and Robert Henri. Hopper rounded out his artistic education with three trips to Paris between 1906 and 1910. Unable to support himself as a painter early in his career, Hopper earned his livelihood as a commercial illustrator in New York City from 1906 to 1925, while working on his own time to realize his independent artistic ends. He worked mostly in oil until 1915, and from 1915 to 1923 devoted much of his effort to etching. In 1923 he took up watercolor, which became, with oil, his major medium.

To escape the sweltering heat of New York City, Hopper spent most of his summers after 1912 along the New England coast, working in Ogunquit and Monhegan Island in Maine, and in Gloucester, Massachusetts. After 1930 he and his wife summered regularly in South Truro, Massachusetts. In these New England locations, Hopper painted ships, lighthouses, and small town streets in a spare, descriptive style. He executed his oils in the studio but painted his watercolors out-of-doors directly from the motif, typically completing them in a single session. He disliked being observed while he painted his watercolors, and after 1927, preferred to work from the back seat of his car so as to avoid being the spectacle that an artist with easel and brush inevitably presented to passers-by. In the Gloucester street scene *Adam's House,* passers-by are in fact notably absent. The street appears vacant and anonymous, a generic New England corner. But the title suggests that it is a specific place and that Hopper was familiar with the house and its inhabitants; it was indeed an actual house, still standing decades later when it was photographed by the art historian Gail Levin.[1]

To render *Adam's House,* Hopper, in his usual manner, first lightly sketched in the street scene in pencil onto toothed watercolor paper. Over this brief sketch he then applied loose washes before proceeding to develop areas of greater detail. Finer detail like shutter slats and telephone wires were dryly brushed in with deft strokes at the last. Forms appear in high relief beneath the summer sun with long shadows stretching from behind fire hydrant, utility pole, and neighboring houses. The utility pole and wires stand in marked contrast to the New England clapboard and picket fence, hinting at an underlying tension between traditional and modern values. The watercolor thus speaks subtly of Hopper's fascination with the alienating aspects of modernization and its transforming effect on the New England of the past.

D.L.D.

1. For the photograph, see Gail Levin, *Hopper's Places* (New York: Alfred A. Knopf, 1985), 66.

5 A.M., 1937

By 1937, Edward Hopper had achieved critical success in the American art world. The Metropolitan Museum, the Whitney Museum, and the Museum of Modern Art acquired examples of his work in the early 1930s, and other major American museums followed their lead. Critics and collectors praised Hopper's stylistic "authenticity" and his commitment to a range of subject matter characterized by Lloyd Goodrich as "the physical face of America."[1] The artist found inspiration in what he termed "our native architecture with its hideous beauty" and similar subjects that successfully communicated "the tang of the soil."[2] For Hopper, these architectural subjects proved essential to any "honest delineation of the American scene."[3]

Adam's House, 1928
Watercolor on paper, 16 x 25 in.
Signed lower right: *Edward Hopper/Gloucester*
Roland P. Murdock Collection, M122.54

5 A.M., 1937
Oil on canvas, 25⅛ X 36⅛ in.
Signed lower right: *EDWARD HOPPER*
Roland P. Murdock Collection, M4.39

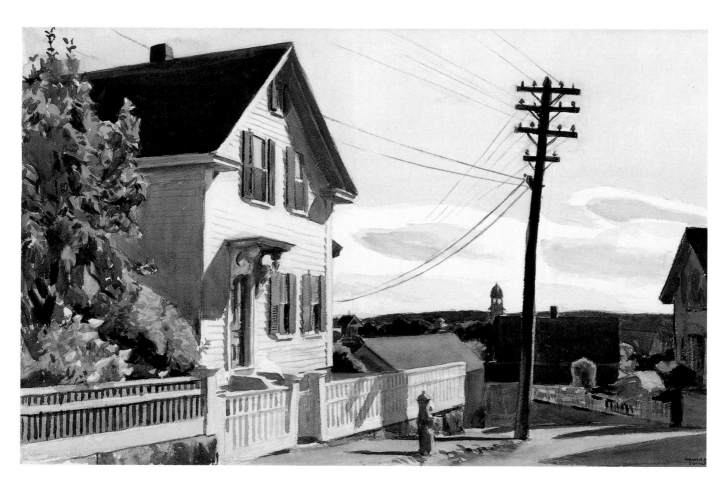

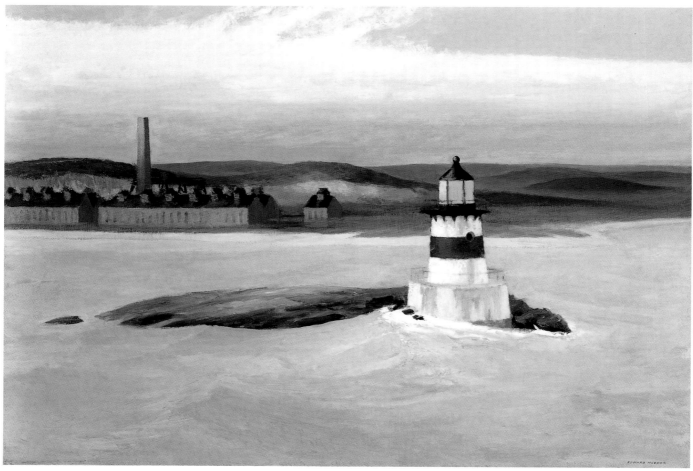

In *5 A.M.,* Hopper combines his interest in the architectural landscape of the United States and his boyhood fascination with the sea. Lighthouses appear commonly in the artist's work, but more often seen from below than from the elevated vantage point of *5 A.M.* For example, Hopper places the viewer below the structure in *Lighthouse at Two Lights* (1929, Metropolitan Museum of Art), so that the towering subject alone commands the viewer's attention. The Wichita painting, on the other hand, allows the viewer to survey the environment: the surrounding waters, the nearby shore, and the seemingly inactive factory. The title's reference to the early morning hour suggests a possible reason for the lack of human activity at the factory, yet is is equally possible that the business has vacated this location.

Critic Ernest Brace found Hopper's architecture to be "unequivocal in its reality so that the impression takes its place as a mood inherent in the scene . . ."[4] Hopper's architectural subjects often symbolize the psychological state of their inhabitants, emphasizing qualities of loneliness and withdrawal. Painter and critic Guy Pène du Bois described Hopper's buildings as "haunted."[5]

Hopper wrote of the scene of *5 A.M.* as "an attempted synthesis of an entrance to a harbor on the New England coast. The lighthouse is a not very actual rendition of one near Staten Island in New York harbor."[6] Others have maintained that Hopper actually depicted the lighthouse and Plymouth Cordage Works at Saquish Head near Duxbury and Plymouth, Massachusetts.[7] Regardless of the painting's specific source or sources, Hopper seems to have wanted above all else for it to convey a specific mood. In depictions of American architecture such as the ordinary lighthouse and factory, Hopper invests the banal vernacular landscape of the 1930s with a sense of mystery.

M.A.W.

1. Andrew Hemingway, "To 'Personalize the Rainpipe': The Critical Mythology of Edward Hopper," *Prospects* 17 (1992): 383, and Lloyd Goodrich, *Edward Hopper* (New York: Harry N. Abrams, 1971), 99.

2. Edward Hopper, "Charles Burchfield: American," *Arts* 14, no. 1 (July 1928): 7, and "John Sloan and the Philadelphians," *Arts* 11, no. 4 (April 1927): 177.

3. Hopper, "Charles Burchfield: American," 7.

4. Ernest Brace, "Edward Hopper," *Magazine of Art* 30, no. 5 (May 1937): 274.

5. Guy Pène du Bois, "The American Paintings of Edward Hopper," *Creative Art* 8, no. 3 (March 1931): 190-91.

6. Edward Hopper, letter to Elizabeth S. Navas, 12 July 1939, registrar's files, Wichita Art Museum.

7. Documentation in registrar's files, Wichita Art Museum.

Conference at Night, 1949

Unable initially to make a living as a painter, Edward Hopper began his artistic career as an illustrator for trade journals and popular magazines. The financial success of his 1924 show of watercolors at New York's Frank K.M. Rehn Gallery finally freed him to concentrate solely on painting. Hopper indirectly acknowledged the lasting influence of his illustration work on his later painting when he admitted that "in every artist's development the germ of the later work is always found in the earlier."[1] Indeed, prototypes for *Conference at Night* can be found in the office interiors Hopper illustrated in *System, the Magazine of Business* in the 1910s.[2]

In *Conference at Night,* a diagonal wedge of artificial light cuts through the window at the right to illuminate a sparsely furnished office. A balding man sitting on a table gestures to a standing man and woman. His casual posture and rolled-up shirt sleeves set him in contrast to the man and woman he is addressing. The woman's stance is rigid, her dress formal. Her wide-eyed gaze seems fixed on a point beyond the man who speaks to her. The man next to her wears an overcoat and hat, suggesting he has either just arrived or is on his way out. Cast in shadow, hands in trouser pockets, the standing man is set off from the other two figures who seem coupled by the garish white glare highlighting their heads and open-palmed hands. Glancing in on the scene without access to the conversation, we find ourselves voyeurs of this mysterious episode.

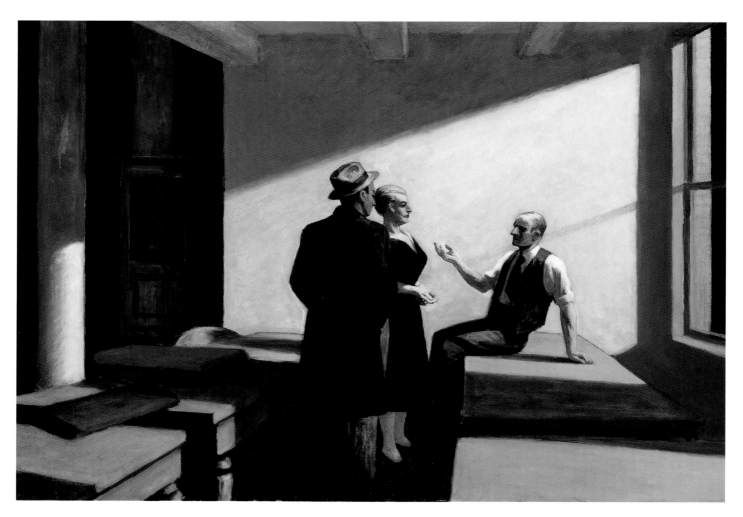

Conference at Night, 1949

Oil on canvas, 28⅞ x 40⅛ in.

Signed lower left: *Edward Hopper*

Roland P. Murdock Collection, M100.52

Hopper was deliberately evasive about the meaning of *Conference at Night*. In a written commentary on the painting, he said, "the idea of a loft or business building with the artificial light of the street coming into the room at night [was] suggested by things I had seen on Broadway in walking there at night. The attempt to give a concrete expression to a very amorphous impression is the insurmountable difficulty in painting."[3] Hopper's wife, Jo Nivison, who after their marriage modeled for all the female figures in her husband's paintings, and recorded fictional details about many of them, added, "Deborah is blond, a queen in her own right. . . . Sammy," who sits on the table, is "better looking than here in drawing."[4] This playful characterization does little to clarify the story, yet it provides a model for the viewer to narrate the unset-

tling scene. Unresolved, disturbing, voyeuristic, alienating, *Conference at Night* exemplifies the enigmatic side of Edward Hopper's art.

D.J.W.

1. Edward Hopper, "Edward Hopper Objects," [letter from Hopper to the editor, Nathaniel Pousette-Dart], *The Art of Today* 6 (February 1935): 11, cited in Gail Levin, *Edward Hopper as Illustrator* (New York: W.W. Norton and Company, in association with the Whitney Museum of American Art, 1979), 1.

2. Levin, 17.

3. Edward Hopper, letter to Elizabeth S. Navas, 28 June 1952, registrar's files, Wichita Art Museum.

4. Edward Hopper Record Book III, 29, in Gail Levin, *Edward Hopper: An Intimate Biography* (New York: Alfred A. Knopf, 1995), 408-9.

Sunlight on Brownstones, 1956

"Maybe I am not very human," Edward Hopper mused in 1946. "What I wanted to do was to paint sunlight on the side of a house."[1] Hopper pursued this modest aspiration with renewed vigor during the last decades of his career, suggested by the title of *Sunlight on Brownstones* as well as *Morning Sun* (1952), *Second Story Sunlight* (1960), and *Sun in an Empty Room* (1963).

In the left half of *Sunlight on Brownstones,* a smartly dressed couple lounge on the stoop of a brownstone apartment. They appear locked into place by the strict rhythm of vertical lines formed by the windows, doorways and railings. To the right, the green trees of an undeveloped grove seem to retreat from the advancing tide of civilization. Hopper's brushstrokes underscore this implied dissonance: on the right side of the painting, the trees are formed by loose, fluid brushstrokes that counteract the meticulously painted, rigidly architectonic forms on the left. Gail Levin has suggested that the composition for *Sunlight on Brownstones* shares a striking similarity to Rembrandt's etching *The Good Samaritan,* which also depicts two figures standing in a doorway of a building that recedes into space in a similar fashion.[2] In her diary entry for 10 February 1956, Hopper's wife, Jo, noted that her husband "hasn't started his new canvas yet [*Sunlight on Brownstones*], goes over his sketches, gazes at book of Rembrandt reproductions, reads this & that."[3]

The couple on the stoop appear to gaze upon something beyond the painting's right edge, begging the question of their interest. The answer appears to lie outside the painting's frame, both literal and temporal. Like a movie still, *Sunlight on Brownstones* seems to have been removed from a larger narrative.[4] Hopper frustrates any attempt to create a cohesive account from the clues left in the painting. On one occasion, Jo Hopper suggested that a female figure at a window in another painting was checking the weather. Her suggestion earned her a stern rebuke from the artist: "You're making it Norman Rockwell. From my point of view she's just looking out the window."[5]

Hopper's stringent aversion to narrative and anecdote first manifested itself, ironically, when the artist worked as an illustrator and commercial artist from 1906-24. His editors' demands for dramatic illustrations clashed with Hopper's commitment to a less theatrical approach. "I was always interested in architecture," the artist once remarked, "but the editors wanted people waving their arms."[6] Far from gesticulating wildly, the man and woman in *Sunlight on Brownstones* do not gesture or even interact at all. Instead, they seem to look expectantly toward the sun, as if searching for an answer to an unspoken question.

M.W.

1. Original notation in the Lloyd Goodrich papers, dated 20 April 1946, quoted in Matthew Baigell, "The Silent Witness of Edward Hopper," *Arts* 49 (September 1974): 33.

2. Gail Levin, *Edward Hopper: An Intimate Biography* (New York: Alfred A. Knopf, 1995), 496.

3. Jo Hopper diary entry for 10 February 1956, quoted in Levin, 496.

4. Robert Hobbs, *Edward Hopper* (New York: Harry N. Abrams, 1987), 16.

5. Hopper, quoted in "Gold for Gold," *Time* 65, 30 May 1955, 72.

6. Hopper, quoted in Hobbs, 79.

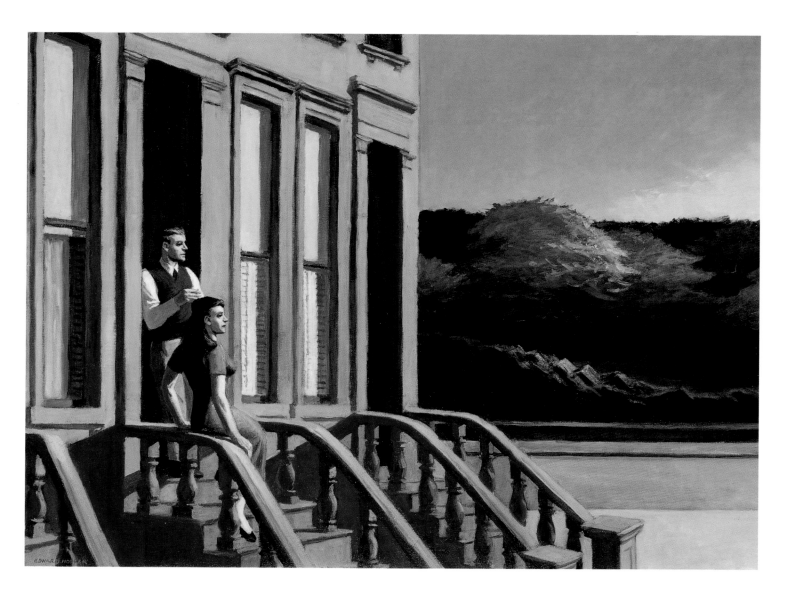

Sunlight on Brownstones, 1956

Oil on canvas, 30⅛ x 40⅛ in.

Signed lower left: *Edward Hopper*

Roland P. Murdock Collection, M148.57

RAYMOND JONSON (1891-1982)
White Mesa-1922, 1922
Oil on canvas, 25⅛ x 33¼ in.
Signed with monogram and dated lower right: *1922*
Gift of Merleyn and Don Calvin, 1977.109

In New Mexico, Raymond Jonson found a permanent artistic and spiritual home. An invigorating four-month vacation in Santa Fe during the summer of 1922 inspired Jonson to flee Chicago, where he had been living since 1909. Jonson found the southwestern landscape more conducive than Chicago's cold urban ambiance to his search for a higher and more perfect order of existence which ultimately would transform the style and substance of his art. *White Mesa-1922* marks the beginning of a transitional period in Jonson's art that moves away from a representational mode of expression to an abstract one, culminating a decade later in non-objective painting.

Although *White Mesa* remains rooted in the artist's observation of the natural world, variations in brushwork and color point to Jonson's interest in modernist ideas. Devoid of any human presence, the painting appears emblematic of a more ancient and unadulterated time and place. The white walls and corbelled top of the mesa loom triumphantly over the chromatically-charged desert landscape. Jonson uses heavy outlines to demarcate the geological variations of the rocks, creating a geometric pattern that reveals the landscape's structural essence. This effect is enhanced by the juxtaposition of complementary colors that imparts greater luminosity to the painting. In a 1923 diary entry Jonson wrote: "In expressing my idea of this country I struggled especially to obtain a unity—a unity of all the means used [such] as form, design, color, rhythm, and line."[1]

Jonson's fascination with the compositional elements of painting developed out of his formal artistic training. Born in Chariton, Iowa in 1891, he studied at the Portland Museum Art School, the Chicago Academy of Fine Arts and the Art Institute of Chicago. But more important to Jonson's development was his work at the Chicago Little Theatre, designing sets, lights and costumes. Working with this short-lived experimental theatre in the mid-1910s provided Jonson an arena in which to create ideal environments through the manipulation of color and light.

At an early age Jonson understood that art did not have to imitate reality. When the New York Armory Show travelled to Chicago in 1913, Jonson was favorably impressed by the works by European modernists, unlike other Chicago art students who demonstrated their disdain of modernism by burning Matisse in effigy. Jonson never adopted the stylistic models of the Post-Impressionists, Fauvists, Cubists and Futurists; instead he learned the tenets of modernism from theory and principle. Although *White Mesa* recalls most poignantly Cézanne's landscapes of southern France, by the early 1920s Jonson's own aesthetic theories paralleled those espoused by Wassily Kandinsky. Only in Jonson's later abstract and non-objective works, however, did he achieve an art that communicates inner feeling solely through form.

Jonson promoted his belief in the spiritual value of art throughout his lifetime, conveying it to students and the general public in New Mexico and elsewhere through his organizing of artists' groups, exhibitions and teaching.

K.A.M.

1. Raymond Jonson, *Diary,* 9 January 1923, Jonson Gallery archives, University of New Mexico, Albuquerque, quoted in Ed Garman, *The Art of Raymond Jonson, Painter* (Albuquerque: University of New Mexico Press, 1976), 68.

JOHN KANE (1860-1934)
Turtle Creek Valley, No. 2, 1932
Oil on canvas, 34⅛ x 44⅛ in.
Signed and dated lower left: *JOHN KANE, 1932*
Roland P. Murdock Collection, M74.48

John Kane exhibited his first painting at the Carnegie International Exhibition of 1927, at the age of sixty-seven. From that time until his death in 1934, he gained increasing acclaim as one of America's great self-taught artists. Prior to this late recognition, however, Kane had made his living as a laborer, from the age of nine when he began working in a Scottish shale mine to the age of sixty-nine, when he held his last job as a house painter in Pittsburgh. Kane was pleased that he was able to commit himself fully to his art during his final years, but he never lost his working-class perspective. "I have lived too long the life of the poor," he once said, "to attach undue importance to the honors of the art world."[1]

Born in West Calder, Scotland, Kane immigrated to Pennsylvania at the age of eighteen. He moved from town to town throughout Pennsylvania, Ohio, and the South; he worked in coal mines, in steel mills, on railroads, and in many other jobs, staying in each place as long as there was work to be found. He was married in 1897, but separated from his wife in 1904, shortly after his only son died in infancy. Kane saw little of his family for the next twenty-five years. It was during this long period of separation that he began to paint seriously. Kane was in his forties when he made his first painting, after learning to mix colors while painting freight cars in Pittsburgh. Soon he was devoting all his free hours to his art.

During his last years, as his fame was growing, Kane often painted the industrial landscape of East Pittsburgh, the subject of *Turtle Creek Valley, No. 2.* Since Kane had never attended art school, he never learned to apply the rules of linear perspective to his landscapes. Instead, the artist pieced together *Turtle Creek Valley, No. 2* as one might build a house, carefully balancing each element of the painting within a unifying architectural structure. A web-like network of roads and railroad tracks becomes a framework that unites foreground and background. The movement that takes place upon this framework maintains the overall balance: the train on the left has its complement in the train on the right, which travels in the opposite direction; and this pattern is repeated with the two cars and with the trolley and horse-drawn cart.

But before Kane began painting the landscape of East Pittsburgh with his brush, he had spent a lifetime building it with his hands. He built roads and bridges and worked in factories like those pictured in *Turtle Creek Valley, No. 2*; and the first time he painted a train, it was with a gallon-bucket of paint and a six-inch brush. The roads, trains, bridges, and factories that were so much a part of Kane's life naturally found their way into his art. "Why shouldn't I want to set them down," he once said, "when they are, to some extent, children of my labors."[2]

M.P.G.

1. *Sky Hooks, The Autobiography of John Kane* (Philadelphia: J.B. Lippincott Company, 1938), 154.

2. Ibid., 181.

HENRY KOERNER (1915-1991)
Pond, 1949
Gouache on paper board, 13¾ x 17½ in.
Roland P. Murdock Collection, M84.50

Henry Koerner was born in Vienna, Austria, and began working as an illustrator at an early age. The rise of the Nazis led Koerner to flee his homeland in 1938. After a year in Italy, he immigrated to Brooklyn, New York. From 1943-47, Koerner designed posters for the Office of War Information and served as a courtroom artist at the Nuremburg Trials. It was during this return to Germany and Austria after World War II that Koerner learned that his father, mother and brother were among the Jews killed in the Holocaust. This traumatic discovery marked the decisive moment when Koerner moved beyond commercial illustration to express his personal emotions in paint.

Koerner returned to Brooklyn in 1947, and then moved to Pittsburgh, Pennsylvania in 1952. Isolated from the New York art scene, Koerner developed a unique style, sometimes integrating the complex, fantastic aspects of Magic Realism, and at other times working in a vein close to Social Realism, as seen in *Pond*. Described by his son as "relentlessly prolific," Koerner worked in the Renaissance tradition of repeated studies made directly from nature.[1] He also revered the Old Masters, and covered his studio with reproductions of the work of Giotto, whom Koerner called "my greatest teacher."[2] Koerner won the prestigious Gold Medal at the Pennsylvania Academy Annual Exhibition in 1949, while continuing to work as an illustrator, best known for his *Time* magazine covers in the 1950s and 1960s. And although he had little formal training himself, Koerner taught at several art schools, including the Art Institute of Pittsburgh.

Pond began as a sketch from a summer trip to Chattanooga, Tennessee. We sense that the artist worked from direct observation, yet the forms are simplified and the design is tightly controlled. The influence of Cézanne seems visible in the structuring of three-dimensional forms in space. An atmosphere of static calm is created through the careful balancing and arrangement of the physical masses of people and the landscape.

The painting shows four African American adults fishing in a small pond, nestled in a landscape of rolling hills. The sun is high and bright, necessitating protection from the heat and glare. The subjects' clothing—overalls on the men and simple dresses on the women—reveals their working-class status. Both couples are intent on their activity, with all eyes focused on the multiple fishing lines in the water. They are anonymous, clustered together in the center of the composition, their bodies enveloped by the natural environment. The setting is quiet, except for the slight rustling of grass in a breeze and the panting noises of the five puppies on the shore.

Throughout his career, Koerner was concerned with issues of race. When he came to America, he was surprised at the segregation in the South.[3] In *Pond*, he embeds a restrained social commentary on the economic situation of African Americans in 1949 within the simply picturesque landscape of Tennessee.

A.P.B.

1. Professor Joseph Koerner, interview with the author, 19 April 1995.

2. Henry Koerner quoted in "Storyteller," *Time*, 27 March 1950, 61.

3. Professor Joseph Koerner, interview with the author, 19 April 1995.

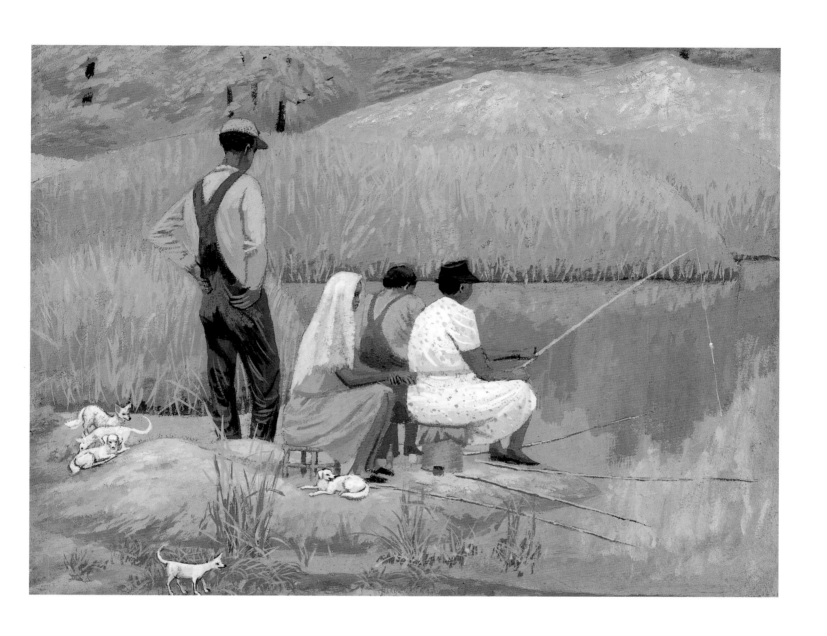

WALT KUHN (1877-1949)

Girl in Shako, 1930

Walt Kuhn left his native Brooklyn in 1901 to pursue a European artistic training in Paris and Munich. Two years later he returned to New York, where he financed his painting career by drawing cartoons for various magazines and newspapers. A founding member of the Association of American Painters and Sculptors, Kuhn was instrumental in the group's organization of the groundbreaking Armory Show of 1913. He spent the following years absorbing the show's modernist lessons, with particular attention to the works of the Post-Impressionists and Fauves. By the early 1920s, however, Kuhn had begun to employ simple colors and spare compositions in a frankly representational style that would for the rest of his career characterize his still-lifes and landscapes, in addition to his trademark circus and show-business subjects.

Girl in Shako of 1930 is a typical Kuhn portrayal of a female stage performer. The artist captures the exaggerated color contrasts of the stage in the woman's bright make-up and in the gold trim and crimson plume of her shako, all of which stand in garish opposition to the cooler whites and blues of the figure and background. In the following years, Kuhn continued to experiment with a palette that employed the colors of show business. He wrote in 1935 about his use of "arbitrary color," the artist's own term for the deliberate pursuit of the gaudy look of the stage.[1]

The iconic, frontal pose and deadpan expression lend to the subject an eerie presence. Rejecting the traditional conventions of portraiture, Kuhn saw his sitter less as a unique individual than as a means toward a pictorial end. "Each painting," wrote his wife, Vera:

> was a specific problem, sometimes tossed about in his mind for a year or more. During this time, before actual painting began, the idea became more simplified and clarified. The costume for a specific idea was often on hand, complete, before

the model was picked. It was a matter of having the right girl or man for that particular idea appear at the studio.[2]

Girl in Shako is one of many paintings in which Kuhn posed female performers in shakos he designed and made himself.

In contrast to his unfailingly sensitive treatment of male performers, such as Acrobat in White and Silver, Kuhn's females often appear generic and lifeless, functioning primarily as props for exotic costumes. While Kuhn's attitude toward gender roles awaits further examination, the artist's own statement that his "paintings are intended for men and for virile women"[3] suggests that maintaining a manly self-image was important to this painter.

M.P.G.

1. Philip Rhys Adams, *Walt Kuhn, Painter: His Life and Work* (Columbus, Ohio: Ohio State University Press, 1978), 161.

2. Vera Kuhn, letter to Elizabeth S. Navas, 14 June 1952, registrar's files, Wichita Art Museum.

3. Walt Kuhn quoted in Adams, 169.

Acrobat in White and Silver, 1944

Walt Kuhn loved Show-Business, the world of the circus, the theater and the nightclub. Its performers were his models and his friends. He inspired them with tales of his art experiences, they in turn gave of themselves so that his paintings might breathe the spirit of the sawdust and the stage. It was a mutual understanding between kindred souls.[1]

While perhaps overly romantic, Vera Kuhn's paean to her husband does underscore those themes—the circus and the stage—that characterize much of Walt Kuhn's work. Kuhn's mother, while raising her son in Brooklyn, passed on to the young artist her passion for vaudeville and variety shows. In 1922, when he found he could not support himself solely through painting, Kuhn returned to his childhood enthusiasm; for the next few years, he worked successfully designing, writing, and directing for vaudeville and the circus.

In 1925, after a nearly fatal ulcer forced him to reassess his life goals, Kuhn again began to paint seriously, redirecting his love for show business into what he saw as a more enduring form. Taking as his models the professionals of the stage and circus, he began to paint portraits of individual performers. Although his fascination with the circus and stage is often compared to that of Toulouse-Lautrec and Degas, Kuhn's acrobats and clowns seem closer in spirit to Picasso's melancholy circus performers. Almost without exception, Kuhn depicted the individual performer at rest, not as an embodiment of the excitement and vitality of show business but rather as a metaphor of some larger reality.

Kuhn first portrayed Frank Landy, the model for *Acrobat in White and Silver*, in *Trio* (Colorado Springs Fine Arts Center) of 1937. In the Wichita painting Landy is seen seven years later, as a circus veteran wearied by the tedium of show business. With typical economy of statement, Kuhn has stripped the picture to its essentials through the nearly monochromatic palette, the abstract background, and the simplified body that has been reduced to only the necessary contours. All the emphasis falls on Landy's face, distinctive in its strongly modeled features and penetrating blue eyes. Here, in contrast to his *Girl in Shako,* Kuhn looks beneath the mask of performance to reveal the individual. "Interesting fellow," Kuhn said of his model, ". . . had ideas besides being an acrobat."[2]

M.P.G.

1. Vera Kuhn, letter to Elizabeth S. Navas, 14 June 1952, registrar's files, Wichita Art Museum.

2. Walt Kuhn, statement in registrar's files, Wichita Art Museum.

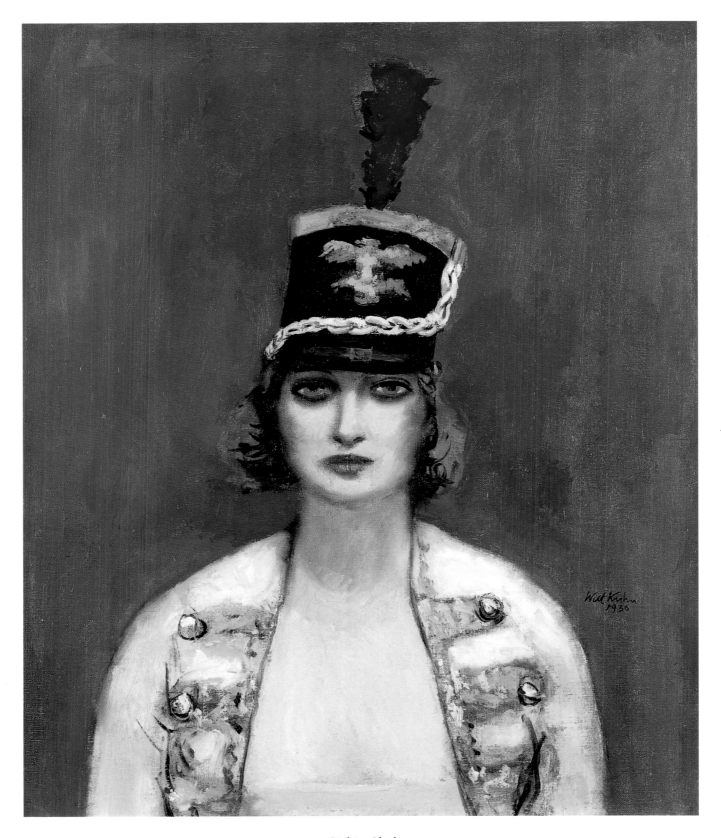

Girl in Shako, 1930

Oil on canvas, 30⅛ x 25 in.

Signed and dated to right of woman's left shoulder: *Walt Kuhn/1930*

Roland P. Murdock Collection, M102.52

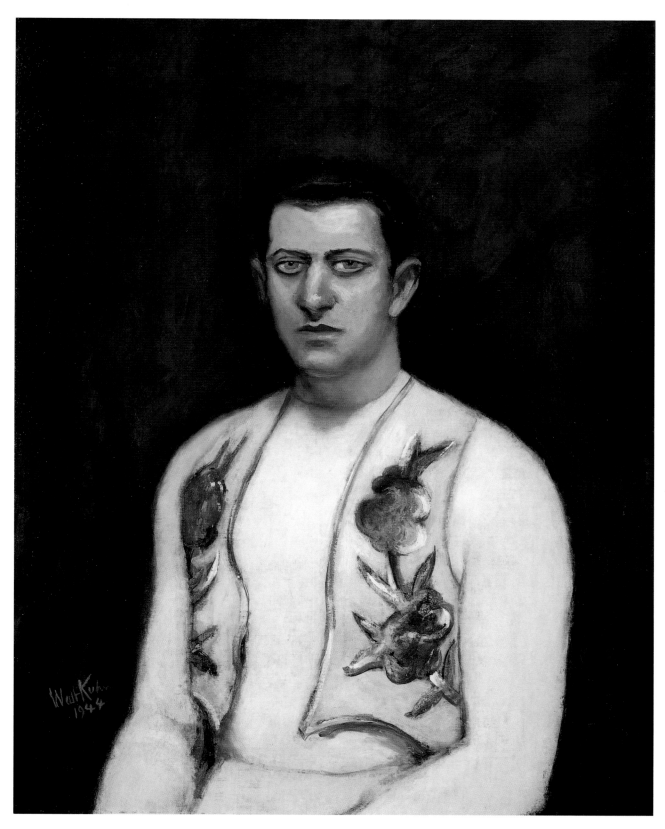

Acrobat in White and Silver, 1944

Oil on canvas, 30⅛ x 25⅛ in.

Signed and dated lower left: *Walt Kuhn/1944*

Roland P. Murdock Collection, M67.46

YASUO KUNIYOSHI (1889-1953)

Season Ended, 1940-45

The subtle ambiguities of *Season Ended* convey the emotional and psychological tensions that Yasuo Kuniyoshi felt as a Japanese-American artist in the United States during World War II. In this picture, a sensuous woman in clinging garments leans towards the viewer in a languorous pose. Our sense of intimacy with the lone figure is heightened by her isolation in the ambiguous landscape. Muted earth tones unify the figure and ground. The space is defined in more Eastern than Western terms, established through the relationship of major forms within the composition rather than the use of linear perspective.[1]

Season Ended shares with Kuniyoshi's paintings of women, done from the late 1920s until the early 1940s, a melancholic tone, heightened by the wartime era. Although the woman's costume and drum are reminiscent of Kuniyoshi's early paintings of circus performers, this image defies literal interpretation as a circus painting. It is easier to imagine the drum sounding a slow military cadence than the active beat of a circus rhythm. The title, *Season Ended,* could relate to the end of a circus season or, more likely, to the end of the war, since this painting was completed in 1945. There is a marked contrast between the dreamy representation of a curvaceous woman and the harsh reality of the newspaper headline that spells out "Nazis." The psychological tone of this painting is not merely sentimental, but is solemn and symbolic; Kuniyoshi does not glorify or celebrate the war's end, but evokes an introspective lamentation.

Born in Okayama, Japan, Kuniyoshi immigrated to Seattle in 1906 at the age of seventeen. He studied at the Los Angeles School of Art and Design from 1907-10, and then moved to New York, where he studied at the National Academy of Design, the Robert Henri School, and the Independent School, while working odd jobs to support himself. From 1916-20, Kuniyoshi studied with Kenneth Hayes Miller at the Art Students League. There the shy artist finally developed a circle of friends, including Walt Kuhn, Reginald Marsh, and Niles Spencer. During the 1920s Kuniyoshi traveled to Italy and France, and in 1931 he attended the opening of his first retrospective in Japan. In the mid-1930s he worked for the Graphics Division of the Federal Art Project of the WPA. Kuniyoshi was an influential teacher at the Art Students League from 1933 and at the New School for Social Research from 1936, continuing in both positions until his death in 1953.

The five years spanning the creation of *Season Ended* were filled with many difficulties for Kuniyoshi, who considered himself American although he was never able to attain citizenship. After the 7 December 1941 bombing of Pearl Harbor, Kuniyoshi's legal status went from being a legal alien to an enemy alien; only his outspoken stance against Japanese atrocities kept him out of the Japanese internment camps in the United States. Even as his legal rights were being challenged, however, Kuniyoshi was achieving critical and commercial success. In 1944, he received numerous prizes and awards, including the prestigious first prize at the Carnegie International. Four years later, Kuniyoshi was honored with the first one-man exhibition ever given to a living artist by the Whitney Museum of American Art.

A. P. B.

1. Lloyd Goodrich, *Yasuo Kuniyoshi Retrospective Exhibition* (New York: Whitney Museum of American Art, 1948), 16.

Season Ended, 1940-45
Oil on canvas, 40¼ x 29⅜ in.
Signed and dated upper right: *Kuniyoshi/1940-45*
Roland P. Murdock Collection, M145.57

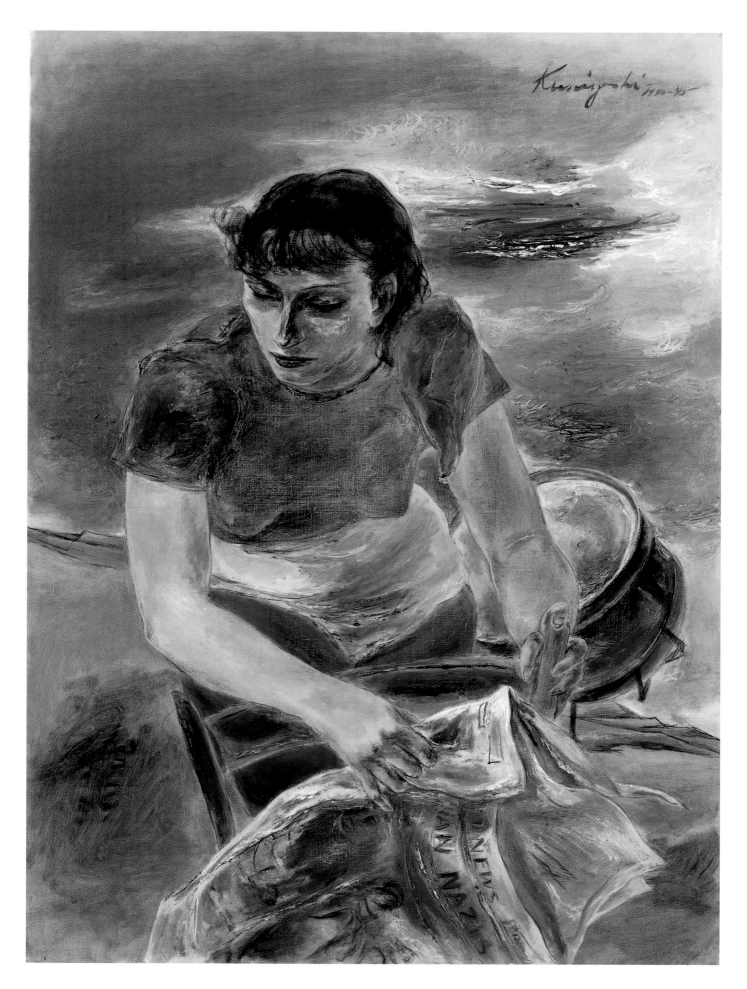

Revelation, 1949

In Yasuo Kuniyoshi's *Revelation,* transparent layers of paint combine with a fractured composition of disturbing figures to amplify the shifting space of an image that is theatrical, even shocking. Tension arises when a superficially cheerful palette is used to picture strange figures of uncertain, perhaps sinister, meaning. None of these figures interact; they do not even represent living humans. The female form on the left is a ghostly half-figure, grimacing and contorted. The torn anatomical chart at the right is a studio prop. So, too, is the lifeless wooden mannequin that replaces the sensual women of Kuniyoshi's earlier works. This broken mannequin is arranged like a crucifix, central and iconic in the composition, yet precariously balanced and disquieting.

The smiling mask worn by this central figure is a particularly enigmatic motif. The use of masks in many of Kuniyoshi's late paintings is intriguing: Was the artist being playful or was he hiding something? The mask in *Revelation* may be a Japanese Noh theater mask, given to Kuniyoshi by his student, Paul Jenkins.[1] The inclusion of this Japanese artifact in the picture may represent the interrelationship between Kuniyoshi's ethnicity and contemporary American society. This was the age of nationalism and anti-communism that followed World War II and escalated during the McCarthy era. Foreign-born individuals, as well as political liberals, often were suspected of being "un-American" and were targeted for investigation by government committees. The environment of fear and concealment that pervaded American life was symbolized through Kuniyoshi's inclusion of masks in works like *Revelation.*

Kuniyoshi had a long history of involvement with leftist political groups. He was on the executive committee of the American Artists Congress from 1937-40, was president of An American Group from 1939-44, and was the first president of Artist's Equity from 1947-50. His paintings in the controversial *Advancing American Art* exhibition, organized by the U.S. State Department in 1946, were widely criticized in the American press, and Kuniyoshi was labeled a communist. However, Kuniyoshi was widely accepted by his peers and museum curators as a leader in modern American painting. He was one of four painters to represent the United States at the 26th Venice Biennale in 1952, and *Revelation* was included in the *Landmarks in American Art* exhibition in 1953.[2]

Kuniyoshi's works invite multiple interpretations. His colleague and friend Ben Shahn wrote that Kuniyoshi's paintings had "a certain quality—I suppose you would call it metaphoric, an extended and beyond meaning, never spelled out, always elusive, but inviting the observer of a picture to wonder, so no picture is ever a closed statement, a finality, but is rather a haunting and undisclosed world in itself."[3] Ultimately, the "revelation" can only occur through the interaction between the viewer and the painting.

A.P.B.

1. Paul Jenkins, in *Yasuo Kuniyoshi, 1889-1953: A Retrospective Exhibition* (Austin, Tex.: University Art Museum, 1975), 47.

2. *Landmarks in American Art, 1670-1950* (New York: Wildenstein and Company, 1953), ill. no. 61.

3. Ben Shahn, foreword to *Yasuo Kuniyoshi: Retrospective Exhibition* (Boston: Boston University Art Gallery, 1961), n.p.

Revelation, 1949

Oil on canvas, 70 x 46⅜ in.

Signed lower right: *Kuniyoshi*

Roland P. Murdock Collection, M80.49

Quiet Pool, ca. 1952

Shrouded in the psychological aftermath of the Second World War, Yasuo Kuniyoshi's late drawings meditate on states of loneliness, lifelessness, and destruction. Images ranging from severed fish heads and grotesque insects to desolate, menacing landscapes suggest the depth of Kuniyoshi's despondency. The gravity and despair of this disturbing imagery is made more poignant by the knowledge that at this time Kuniyoshi was struggling against terminal illness. In *Quiet Pool,* Kuniyoshi projects his feelings of dissonance and melancholy into the form of an imaginary landscape.

Kuniyoshi executed *Quiet Pool* in the medium of Sumi ink on paper. Although this technique is reminiscent of Japanese Zen brush drawings, Kuniyoshi's work lacks the spontaneity of Zen. This and other late drawings were so elaborately constructed that they are more correctly termed "ink paintings." Kuniyoshi wrote of his process:

> I purposely destroy what I have created and re-do it over and over again. In other words that which comes easily I distrust. When I have condensed and simplified sufficiently I know then that I have something more than reality.[1]

Quiet Pool is among the most understated and least disturbing of Kuniyoshi's late drawings. The lugubrious black washes obscure detail initially, but closer examination reveals energetic pen hatching and subtle tonal variations. The flattened space of the drab, improbable landscape contrasted against the stark, featureless sky contribute further to this dissonant arrangement. A predatory dragonfly, the sole inhabitant of this ominous scene, hovers above the water at the upper right, its form echoed at the lower left in the plant at pool's edge. The life that is sustained and even nurtured by the quiet pool is offset by the desolation of the surrounding landscape. Vertical extensions of a leafless tree, silhouetted against the vacant sky, evoke associations with mortality, thus perpetuating this dialogue of contrasts between life and death, black and white, substance and nothingness. The curious juxtaposition of life and death in this and other late ink drawings perhaps reflects Kuniyoshi's awareness of his own physical decay, as he looked into the distance of his own mind and there recognized his mortality. Indeed Kuniyoshi's late drawings "evoke a complexity of feeling and experience that transcends simple polarities of mood, and in their mastery they present a worthy finale to Kuniyoshi's career."[2]

B.J.B.

1. Yasuo Kuniyoshi, "East to West," *Magazine of Art* 33, no. 2 (February 1940): 80.

2. Tom Wolf, "The Late Drawings of Yasuo Kuniyoshi," *Drawing* 8, no. 5 (January-February 1992): 103.

Quiet Pool, ca. 1952
Ink on paper, 22⅜ x 28½ in.
Signed lower right: *Kuniyoshi*
Roland P. Murdock Collection, M126.54

VINCENT LA GAMBINA

VINCENT LA GAMBINA (1909–1994)

Forty Second Street, New York City, 1938

Vincent La Gambina was born in Agrigento, Sicily, and came to New York in 1920 at age eleven. The young immigrant was orphaned shortly after and was left homeless. Eventually he was able to support himself as an artist; he made his first sale at fifteen, while still a student at the Leonardo Da Vinci Art School, to New York Mayor Fiorello La Guardia. La Gambina also studied at the National Academy of Design.

During the Depression he was employed by the teaching, easel, and mural divisions of the Federal Art Project of the WPA. After serving in the army, he studied on the GI Bill at the Art Students League with Sidney Dickinson, Frank DuMond, and Ivan Olinsky. In the 1940s he taught at his own Washington Square Art School.

Forty Second Street, New York City depicts midtown Manhattan looking west from Fifth Avenue down Forty-Second Street.[1] On the far left side of the picture, the striated surface pierced with windows represents the north wall of the New York Public Library. The lush greenery beyond it indicates Bryant Park, a large public area that had been

Forty Second Street, New York City, 1938
Oil on canvas, 18⅛ x 25⅛ in.
Signed and dated lower right: *Vincent La Gambina/1938*
Gift of the artist, 1988.21

redesigned in 1934. Forty-second Street, a dramatic diagonal tunnel of receding space bathed in golden afternoon sunlight, dominates the composition, and strongly contrasts with the shady left side of the painting. The light emanates from the unseen open space of the park and flows over the uppermost branches of the dark green trees on its way to the north side of the street. A particularly luminous triangular patch at the edge of the street parries the larger triangular shape created by the one-point perspective. The sidewalks bustle with colorful figures, but are not overly crowded on this warm summer day; pedestrians crossing the street, most women, stroll bare-armed. Four American flags and a blue banner displayed on the buildings, along with the light traffic in the street, may indicate that this is a Fourth of July holiday scene.

The artist's point of view is slightly above street level, undoubtedly from an elevated terrace that runs across the east-facing front of the library and extends beyond the library wall seen in the painting. A photograph by Berenice Abbott taken from the northeast side of the same intersection shows the terrace and also the newspaper kiosk that is located in the foreground of La Gambina's painting, as well as the library wall and the park.[2] Abbott's photograph, entitled *Tempo of the City,* was taken on 6 September 1938, the same year that La Gambina painted this canvas. Abbott was photographing a series of views of New York City for the Federal Art Project when she created this image, so it seems possible that La Gambina's work may have been done at the time that he was working for the easel division of the same program. Rather than the massed humanity of Abbott's photograph, La Gambina offers the viewer a relaxed, spacious perspective of the city on a beautiful day.

<div align="right">J.C.</div>

1. My thanks to Dr. John Pultz for identifying the location of this scene.

2. Reproduced in Berenice Abbott, *New York in the Thirties* (New York: Dover Publications, Inc., 1973), plate 62.

Coal Mine Disaster, 1941

In La Gambina's *Coal Mine Disaster,* the horror of a contemporary catastrophe is ennobled by the visual language of the Old Masters. Against the backdrop of timbers in the gloom, three groups of miners struggle towards safety. Coal car tracks, curving forward from background to foreground and returning to the distance, link the groups and underscore their movement from right to left, from the darkness of the mine's depths to the light of its entrance.

On the right, only barely discernible in the deep shadow of the shaft, three miners carry the motionless body of a man whose ashen color and lolling head imply that he is dead. On the left, a miner aids a limping comrade who has recovered enough to move, under his own power, towards the brightness of the entrance. The central group, then, suspended in a pool of light in the darkness, teeters between life and death. Two men carry the injured miner, one staggering under the weight of the victim's bare torso and the other grasping his legs; a third man turns back to the group and raises the lamp that illuminates the scene. The wounded man's eyes are closed and his mouth gapes as if gasping for breath, while the mouth of the left rescuer is also open, as if shouting in fear. Neither gone from life nor safely in the world, the central figure and his rescuers are frozen at a decisive moment in time.

The dramatically rendered central group of *Coal Mine Disaster* can be compared with scenes of the burial of Christ from earlier art historical periods; Raphael's *Entombment of Christ,* for example, although not compositionally identical, is similar enough to have served as a prototype for La Gambina's painting.[1] The American artist's interpretation of the subject in the style of the Old Masters was undoubtedly the result of his academic training at the Leonardo Da Vinci School of Art and the National Academy of Design, and perhaps even owes something to his Italian heritage.

In this modern history painting, La Gambina depicts a very timely subject. In 1941, the year of *Coal Mine Disaster,* widespread strikes by the

United Mine Workers Association resulted in some instances of violence and even murder. The seemingly endless negotiations between miners and mine owners were chronicled in the *New York Times* on a daily basis throughout 1941, indicating the country's concern about its industrial stability as the threat of war loomed. La Gambina's opinion about these events is not known, but as an artist who had worked under the WPA and amidst the leftist atmosphere of the Artists Union, it is possi-

ble that his painting indicates his political support for the worker. Without doubt, however, his work sympathetically captures the pathos of the disaster and the heroism of those engaged in the rescue.

J.C.

1. The Raphael is reproduced in Leopold D. and Helen S. Ettlinger, *Raphael* (Oxford: Phaidon, 1987), 69.

Coal Mine Disaster, 1941 (above, and facing page, detail)
Oil on canvas, 30⅛ x 40⅛ in.
Signed and dated lower right: *Vincent La Gambina/1941*
Gift of the artist, 1988.18

EDWARD LANING (1906-1981)
Camp Meeting, 1937
Oil on canvas, 33 x 48 in.
Signed lower left: *Laning*
Gift of Friends of the Wichita Art Museum, Inc., 1981.10

The headline of a discarded flyer in the lower left of Edward Laning's *Camp Meeting* reveals the theme for this late-summer revival meeting: "The Scarlet Sin. Adultery!" A banner identifies the location of the service as Petersburg, Illinois, Laning's hometown. Laning grew up in central Illinois where both of his grandfathers were actively involved in populist politics. Laning studied at the Art Institute of Chicago for two summers before attending New York's Art Students League from 1926 until 1931. At the League, Laning developed a close friendship with teacher Kenneth Hayes Miller, traveling to Europe with him in 1931, and substituting for him when Miller took a year-long leave of absence.

Laning served on the board of the John Reed Club's art school in the early 1930s. In that decade he also executed mural commissions at Ellis Island and the New York Public Library for the Federal Art Project of the Works Progress Administration. During World War II, Laning traveled abroad as a *Life Magazine* artist-correspondent before accepting a five year appointment as the head of the Department of Painting and Drawing of the Kansas City Art Institute. From the 1950s until the mid-1970s Laning taught at the Art Students League, while he continued to execute mural commissions. When Laning died in 1981 he left unfinished a New York Public Library mural project.[1]

Camp Meeting takes place under an open-air tabernacle, where writhing, gesticulating figures cry out in religious ecstasy or sob uncontrollably. In the foreground, a couple sits on a bench stoically watching the frenetic scene. This calm couple and the detached group of onlookers gathered in the background contrast sharply with the repenting, hysterical crowd. The viewer is led into the scene through the couple, a device that gives the painting a voyeuristic feeling.

At the center of the composition, a man in a brown suit and a similarly aged woman wearing a clinging white dress tied with a red ribbon throw their arms into the air, lost in fervent worship. The woman faints into the embrace of a young man whose shirt has come untucked. Laning suggests the hypocrisy of these worshippers who seek redemption through religious ecstasy that approximates the very sexual ecstasy for which they repent.

Moths that swarm around a lamp hanging from the rafters mimic the frenzied revivalists, who, like the insects, are attracted to a light that may singe them. The lamp may also be a reference to a famous 1937 mural that Laning was no doubt familiar with: Picasso's *Guernica,* an elegy to a bombed Spanish village. In *Guernica,* as in *Camp Meeting,* a light bulb hanging left of center illuminates the frantic scene. The poses of the figures in *Camp Meeting* are similar to the outstretched arms and gaping mouths that signal the atrocities of the Spanish Civil War. *Camp Meeting,* as well as being an ironic portrayal of rural American religious revivals, may be Laning's homage to the Spaniard whose anti-fascist sentiments he shared.

D.J.W.

1. Howard E. Wooden, *Edward Laning: American Realist, 1906-1981: A Retrospective Exhibition* (Wichita: Wichita Art Museum, 1982), 5-25.

JACOB LAWRENCE (b. 1917)

Concert, 1950

Gouache on paper, 22 x 30 in.

Signed and dated lower right: *Jacob Lawrence/1950*

Roland P. Murdock Collection, M91.51

Born in Atlantic City, New Jersey in 1917, Jacob Lawrence began his art training in New York City in the 1930s at the College Art Association, the Harlem Art Workshop, and the American Artists School before joining the easel section of the Federal Art Project of the Works Progress Administration in 1938. During World War II, Lawrence served in the United States Coast Guard. His successful painting career would earn Lawrence many exhibitions, awards, commissions, and teaching positions on the East Coast before he moved, in 1971, to the West Coast. In Seattle, where he still lives and paints, Lawrence taught at the University of Washington until his retirement in 1983.

Famous for painting series dealing with such subjects as the Northern migration of Southern African Americans, the civil rights movement, and World War II, as well as for biographical sequences on Harriet Tubman, Frederick Douglass, John Brown, and others, Lawrence used the series format to explore the complexity of the African-American experience. "As a boy in Harlem," Lawrence recalled, "I heard a lot of talk about black heroes. . . . I began to do paintings about them, but I found I couldn't pack everything into one picture. So I developed the idea of doing works in series."[1]

Belonging to an eleven-part series Lawrence painted during a nine-month voluntary hospitalization at the Hillside Hospital, a psychiatric institution in Queens, *Concert* is unusual for its depiction of an entirely white group of people. Unlike Lawrence's more historical or biographical series, the Hillside Hospital pictures relate more openly to his personal experiences. According to his doctor at the hospital

These paintings do not come from his temporary illness. As they always have—and is true for most real artists—the paintings express the healthiest part of his personality, the part that is in close touch with both the inner depths of his own feeling and with the outer world.[2]

Lawrence himself characterized the experience positively, recalling, "I gained a lot: The most important thing was that I was able to delve into my personality and nature. . . . I think it was one of the most important periods of my life."[3]

In *Concert,* a woman in a light blue gown stands on a stage before an audience, her back to the viewer. The angularity of the shapes, the seemingly random shading of figures, the cool blue of the performer's dress that recedes against the warmer browns and yellows of the stage—all these formal elements combine to flatten out the composition and bring the crowd and the performer together. The artist, and by extension, the viewer, occupies the space behind the performer, as if he, too, were on stage. Lawrence seems to enmesh viewer with artist, concert-goer with singer. Underscoring these confused performative roles is the way the audience members on either side of the singer nervously glance askance at the people on the other side of the theater, and perhaps not at the stage at all.

D. J. W.

1. Quoted in Grace Glueck, "Sharing Success Pleases Jacob Lawrence," *New York Times,* 3 June 1974, 38 (L).

2. Aline B. Louchheim, "An Artist Reports on the Troubled Mind," *New York Times Magazine,* 15 October 1950, 15. See also Ellen Harkins Wheat, *Jacob Lawrence, American Painter,* (Seattle and London: University of Washington Press, 1986), 102.

3. *New York Post,* 26 March 1961. Cited in Wheat, 102.

ERNEST LAWSON (1873-1939)

Green and Gold, n.d.

In *Green and Gold*, thick areas of impasto contrast with nearly unworked sections of canvas to echo an uneven terrain. This coarse surface treatment seems appropriate for an artist who almost exclusively painted landscapes. The scrubbing of Lawson's brush literally imitates the scrub vegetation, spindly trees are interpreted through long threads of paint, and rocks are created through solid swipes of the palette knife.

Lawson is often considered an American Impressionist and *Green and Gold* exhibits Impressionistic influence in both its brushwork and its quality of light. The hills and meadows blush with the warmth of golden sun and the reflective pond glows with luminous color. The painting's hues are primarily blue-greens and yellows and shadows are given value through a deep violet rather than black. Like the Impressionists, Lawson preferred to paint outdoors, and based his landscapes on dedicated studies of nature's changing light and seasons. Lawson stated, "Movement in nature is my creed as a landscapist and light and air are my delight."[1]

Categorizing Lawson as an Impressionist, however, does not adequately describe his eclectic style, which in fact drew on numerous influences. Lawson was born in 1873 in Halifax, Nova Scotia, and spent much of his youth with an aunt and uncle in Ontario. The Canadian landscape left a lasting impression on him and he returned to Canada many times throughout his life. In 1888 he moved to join his parents in Kansas City, Missouri, where he studied at the Kansas City Art Institute with Ella Holman, the woman he would later marry. In 1892 Lawson went to study with John Twachtman and J. Alden Weir at their school in Cos Cob, Connecticut, and through these artists he was exposed to Impressionism. These men also introduced Lawson to Tonalism, and the title of this painting, *Green and Gold,* reflects Tonalist sensibilities as well as an interest in the aestheticism of Whistler. In 1893, Lawson went to France to study

at the Académie Julian, and it was in France that he met and was influenced by the Impressionist Alfred Sisley. Cézanne's paintings were also important to Lawson's development and helped to precipitate a greater solidity in his work. Many of Lawson's landscapes, including *Green and Gold,* bear a compositional relationship to Cézanne's paintings of Mont Sainte-Victoire.

Lawson's most famous association was with the group of painters known as "The Eight." Through his friend William Glackens, Lawson came to know Robert Henri, Arthur B. Davies, Maurice Prendergast, John Sloan, George Luks, and Everett Shinn, and was included as one of The Eight in their famous 1908 exhibition. Lawson was the only pure landscapist among them, and his paintings were rather out of character with the rest of the group. For the most part, Lawson was not interested in the urban realism that preoccupied many of the group's other members. He concerned himself less with narrative and rhetoric and more with color, mood, and the physical process of painting.

S.A.S.

1. Quoted in Henry and Sidney Berry-Hill, *Ernest Lawson: American Impressionist 1873-1939* (Leigh-On-Sea, England: F. Lewis Publishers, Limited, 1968), 22.

Colorado, ca. 1927

In 1927 Lawson accepted a position as a painting instructor at the Broadmoor Art Academy in Colorado Springs, Colorado. During his three-year tenure in the state, the Colorado landscape served as the subject of many of his canvases. The rugged terrain dominated by the Rocky Mountains influenced Lawson, and compelled him to change his palette and technique to suit his subject. His colors became darker in response to the deep browns and blues of the mountains, and he applied his paint with greater bravura and thickness in order to capture their density and bulk. Pike's Peak, Royal Gorge, the Garden of the Gods, and the gold mining of Cripple Creek were just some of the well-known Colorado subjects that Lawson depicted. The present example does not

Green and Gold, n.d.

Oil on canvas, 25¼ x 30¼ in.

Signed lower left: *E. Lawson*

John W. and Mildred L. Graves Collection, 1991.20

feature a well-known landmark but nevertheless represents an indigenous scene with rocky bluffs, winding rivers, and evergreens. While in Colorado, Lawson helped plan an exhibition of his Colorado subjects at the Ferargil Galleries in New York with his friend and dealer Newlin Price. It was Price's idea to promote the works as "Intimate Notes of Colorado."[1]

The tenebrous terrain of the Rockies may not have been the only impetus behind the darkening of Lawson's palette, for Lawson's somber colors would seem to reflect a despondency of mood that increasingly plagued him. In 1926 Lawson's youngest daughter died, and shortly afterwards his wife and surviving daughter moved to France; they would remain apart from Lawson for the rest of his life. The artist was also plagued by constant financial woes, and tried to escape his problems through alcohol. His letters reveal a discouragement that might also be read in his paintings. Lawson himself stated, "Color with me has always been a matter of emotion and of late years, I have let myself go and painted things as I have felt them."[2]

A bright note for Lawson at this time was that his Colorado canvases met with critical success. One painting, *Gold Mining, Cripple Creek,* was even awarded the Saltus Gold Medal by the National Academy in 1930. Critics in both the United States and Canada praised his mountain landscapes, approving of Lawson's darker palette and thicker surface impasto. Critic James Gibbons Huneker was one of the most eloquent. "Lawson's palette of crushed jewels had become richer and truer," he said, "and his paintings had much of the fabric of dreams."[3]

S.A.S.

1. Henry and Sidney Berry-Hill, *Ernest Lawson: American Impressionist 1873-1939* (Leigh-On-Sea, England: F. Lewis Publishers, Limited, 1968), 43.

2. Ibid., 33.

3. Ibid., 44.

Colorado, ca. 1927

Oil on canvas, 18 x 22 in.

Signed lower left: *E. Lawson*

John W. and Mildred L. Graves Collection, 1997.12

JACK LEVINE (b. 1915)
Medicine Show IV, 1958
Oil on canvas, 35⅜ x 40¼ in.
Signed lower left: *J. Levine*
Roland P. Murdock Collection, M157.59

Jack Levine was born in an immigrant neighborhood of Boston's South End. As a child, he attended art classes at the Boston Museum of Fine Arts. By the age of twelve Levine had met Dr. Denman Ross, an art professor at Harvard University, who helped to further his painting career. The rich street life and colorful characters of Levine's Boston neighborhood were also sources of inspiration. By his eighteenth birthday Levine had exhibited drawings at Harvard's Fogg Art Museum, worked for the Federal Art Project of the WPA, had his first one-man show at New York's Downtown Gallery, and sold paintings to both the Metropolitan Museum of Art and the Museum of Modern Art. The biting satire of Levine's *The Feast of Pure Reason* (1937, Museum of Modern Art, New York), a visual diatribe against corruption, brought him instant national recognition and marked the beginning of a career that has spanned over six decades.

Levine again attacks corruption and deception through satiric means in *Medicine Show IV.* It is the last in a series of medicine show paintings that treat the theme of the huckster performing his fraudulent operations on a gullible crowd. The charlatan poses center-stage with arms outstretched, radiating confidence in the benefits of his "medicine." Members of the captivated crowd count their money in anticipation of purchasing a bottle of this suspect elixir. A shadow hides the mountebank's eyes so that the crowd is unable to gauge his sincerity. Surrounding the man are several scantily-clad women who ornament the stage and help to boost sales. According to one critic:

Levine is mocking power, this time a power far more widely distributed and far more widely given conscious obedience than the usual subjects of his research. The power in question is sex itself. Despite the presence of that commercialized sex we think of as peculiarly American in *Medicine Show* and the burlesque pictures, the subject goes deeper than that. It is sex in its aspect of "human bondage," that power for liberation and fulfillment so often used, on a domestic or personal scale, to create and maintain a tyranny over the mind of man.[1]

Levine depicts this theatrical event with gusto. Just as the performance mystifies the believing crowd, the viewer is seduced by the jewel-like paint quality and dazzled by a lively arrangement of caricatures accented by shimmering silver tonalities reminiscent of Tintoretto or late Titian. Levine combines detailed highlights with quickly-rendered blurry areas of paint that emphasize the fast pace of this urban spectacle. These out-of-focus areas operate as visual metaphors for the questionable nature of the subject. They may also imply a sense of memory or nostalgia.

"I've always tried to make some point about charlatans," Levine said, "in this case, a medicine show, or in some other case, somebody doing card tricks, or pulling a rabbit out of a hat. I've always been trying to make a kind of indictment of mysticism and people being fooled, people being gulled."[2] With Levine's old Boston neighborhood as a backdrop, *Medicine Show IV* is also suggestive of an earlier era. "I think that in fact what I succeeded in doing in *Medicine Show,*" said Levine, "is expressing a certain nostalgia. There's a city background which is really South Boston. . . and all this could have happened around 1935, when I was very young."[3]

S.H.

1. Frank Getlein, *Jack Levine* (New York: Harry N. Abrams, 1966), 24-25.

2. Jack Levine, *Jack Levine* (New York: Chameleon, 1989), 70.

3. Ibid.

GEORGE LUKS (1867-1933)
Mike McTeague, 1921
Oil on canvas, 20⅛ x 16 in.
Signed lower left: *George Luks*
Roland P. Murdock Collection, M2.39

George Luks was born in Williamsport, Pennsylvania in 1867. From 1885 to 1895 he studied at the Pennsylvania Academy of the Fine Arts and the Dusseldorf Academy, and also painted in London and Paris. Most meaningful, however, for the development of his artistic style and vision was his first-hand exposure, while in Europe, to the work of Frans Hals and Francisco Goya. On returning to the United States, Luks began a career as a newspaper illustrator and cartoonist, first in Philadelphia and then in New York from 1896 on. This experience fostered Luks's talent for seizing instantaneously upon the essentials of a subject and recording them in a direct and accurate manner. In 1908 Luks exhibited at the Macbeth Gallery as a member of "The Eight," out of which later emerged the larger Ashcan School under the leadership of Robert Henri. The Ashcan School artists stood in opposition to the conservative attitudes and values of the genteel art establishment, and devoted themselves to the depiction of working-class subjects in urban environments.

Inspired by Hals, Luks often returned to scenes of youth and childhood, choosing for his subjects local children from his working-class neighborhood. In characteristic fashion, he pictures *Mike McTeague* against a dark and simply handled background, which serves to direct attention to the boy's brightly-lit face. While Luks usually portrayed conventional types such as the laughing child, *Mike McTeague* is recorded in a sullen pout—an unexpected mood for an artist to capture in a portrait of a child, but an entirely natural one nonetheless.

Also surprising is the picture's intense palette. The strong hues and subtle variation of the orange and yellow pigments are enhanced by the deep claret tones in the background. Luks's use of vigorous color reflects the lessons of his teacher and friend Robert Henri. The jaunty orange smock and hat worn by *Mike McTeague* provide a strong contrast to his serious demeanor. Ultimately, the energetic brushwork and vivid palette serve to communicate the vitality and spirit of the sitter underneath the pouting exterior.

M.R.

JOHN MARIN (1870-1953)

Sunset, Casco Bay, 1919

John Marin drew inspiration for distinctive watercolors like *Sunset, Casco Bay* from the Maine landscape. Born in Rutherford, New Jersey, Marin began a career as an architect in the early 1890s before deciding to study art, first at the Pennsylvania Academy of the Fine Arts from 1899-1901, then at the Art Students League in New York City from 1902-03. From 1905-10, Marin travelled extensively in Europe, where he produced etchings and painted watercolors. He returned to New York City and, in 1914, began to spend his summers in Maine along the Atlantic coast. This seasonal hiatus from the syncopations of modern life in New York City, the subject of his watercolors from 1912-14, proved pivotal to Marin's refinement of subject matter and style. In Maine, Marin explored transient effects of light on the sea and landscape. His imagination was endlessly stimulated by the kaleidoscopic colors, variegated forms, and passing atmospheric conditions.

Working on the Maine coast in the summer of 1919, Marin executed two versions of *Sunset,*

Sunset, Casco Bay, 1919
Watercolor on paper, 16 x 19¼ in.
Signed and dated lower right: *Marin 19*
Roland P. Murdock Collection, M147.57

Casco Bay. One of them he kept while the other, now in Wichita, was owned by Georgia O'Keeffe.[1] In the Wichita watercolor, the sun bursts into a radiant spectrum of color—greens, blue-violets and reddish orange washes. These vivid notes of color, originating in the sunburst, are recapitulated throughout the composition. The vibrant, pulsing red that defines the orb of the sun spreads through both the sky and the foreground shore, where it blends in a rich wash heightened by orange and yellow. Green, in both sun ray and sea water, appears in multiple registers of the composition and ultimately defines the coniferous tree line before the expanse of water. Water catches the sun's hues as reddish-orange highlights in dappled waves. Sensuous blue-violet fingers reach down to touch the earth, their pigment dragged by the brush in long, wet strokes. Black lines, dryly brushed, delineate forms and zones of pure color. The bay, spread out beneath an elevated vantage point, offers a dramatic panorama before the sunset's brilliance.

Marin links the planes of sky and land, not only by his use of color, but in his summary treatment of foreground elements. Near the center of the composition a lone tree rises from the foreground. Its skeletal form, executed in brisk, dry strokes of black, reaches up into the sky to meet the pulsating rhythms of color. Equally abbreviated is the arm of a distant shore, sketched in to create only an abstract sense of the land rather than a concrete presence. Despite such use of broad washes and sketchy strokes, Marin also includes the specific in his translation of light setting over cove. In the immediate foreground, he articulates individual blades of grass with dry strokes laid over wash. In these contrasts between the general and the specific, Marin creates a parallel tension to heighten the friction between flattened foreground and suggested spatial recession into the background plane. Such tensions reveal Marin's interest in modern abstraction; yet, his subject matter and style remain the artist's own highly personal expression.

D.L.D

1. Cf. cat. nos. 19.39 and 19.40 in Sheldon Reich, *John Marin, Part II: Catalogue Raisonné* (Tucson: University of

Arizona Press, 1970), 473-74. On p. 474 see also cat. no. 19.41, *Sunset, Maine Coast* (Columbus Museum of Art), from the same year, which features a similar composition albeit with the sun sinking below the horizon and casting its rays up into the sky rather than down onto the sea, as it does in the two versions of *Sunset, Casco Bay.*

Region, Trinity Church, N.Y.C., 1926-36

By the time Marin painted *Region, Trinity Church, N.Y.C.,* he was dividing his year between homes in New Jersey and Maine. Marin's residence in Weehawken, New Jersey was just across the Hudson River from New York, the metropolis that provided inspiration to the artist throughout his life. Marin apparently chose to live in the quiet suburbs rather than the city itself so that his experience of urban activity would be heightened through the repeated process of entering and leaving Manhattan. During his visits to the city Marin habitually recorded his impressions on paper, and often returned to the same subject numerous times. He first depicted Trinity Church, for example, in an etching of 1915. The date "26-36" that appears on *Region, Trinity Church, N.Y.C.,* indicates that Marin worked on this particular watercolor over the span of a decade.[1]

Departing from the looser, more spontaneous compositions of the 1910s such as *Sunset, Casco Bay,* Marin developed in the 1920s a tighter, more rigorously structured style, as seen in *Region, Trinity Church, N.Y.C.* As the title suggests, Marin does not focus in this work on the church in isolation but also takes in the wider cityscape that surrounds it. Indeed, Trinity Church, identified by its steeple soaring into the top right of the composition, is almost lost amidst the cacophony of lines. In the lower register of the composition, Marin idiosyncratically encloses the forms of pedestrians and an automobile within drawn frames that play off the edge of the rectangular paper itself. By dividing and framing the composition in this way, Marin denies the restriction of the physical frame and increases the dynamic tension within the painting. The linear strength of the composition is intensified by Marin's subtle use of graphite lines throughout the work, which he chose to leave

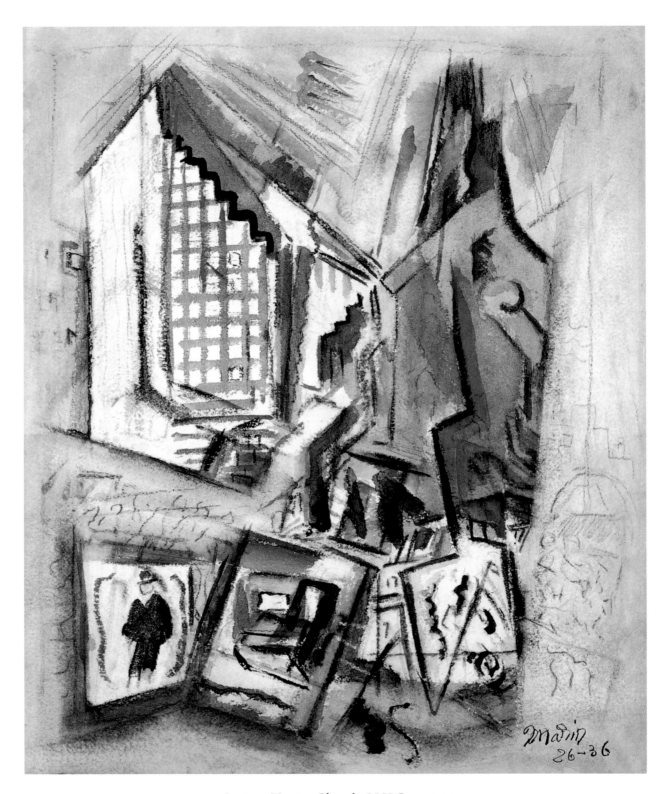

Region, Trinity Church, N.Y.C., 1926-36
Watercolor on paper, 24½ x 19½ in.
Signed and dated lower right: *Marin/26-36*
Roland P. Murdock Collection, M97.52

Cape Split, 1939-42
Watercolor on paper, 22 x 28 in.
Signed and dated lower right: *Marin/39-42*
Roland P. Murdock Collection, M136.55

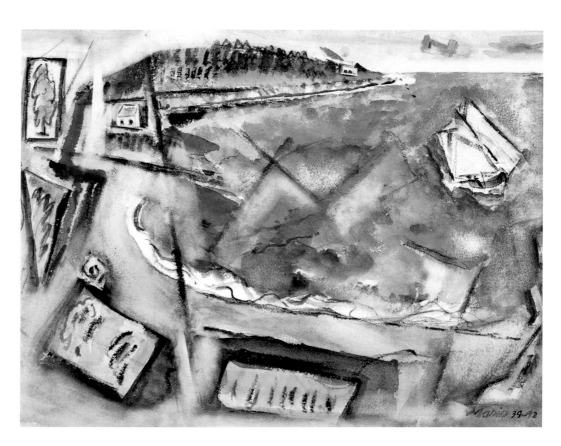

unpainted on the right-
hand side of the com-
position. The lingering
influence on Marin of
the cubist compositions
he had seen at the
Armory Show is evi-
denced in the flattening
of forms and emphasis
on planes, while the
probable influence of
Italian Futurism is felt
in Marin's dynamic use
of line. The force of the
work is amplified by
the gesture and rhythm
with which Marin typi-
cally endowed his many
watercolor composi-
tions.

In a 1951 letter,
Marin wrote of this
work as follows:

> As for this particular picture titled—Region
> Trinity Church New York—it came into being
> together with five other variations—as the result of
> my wanderings there abouts—these seeings—
> transposed into—symbol seeings—not losing
> the—core—of my seeing—Rythm [*sic*] through-
> out was looked for—ballance [*sic*] and construc-
> tion—a playing part with part—movements of
> juxtaposition object—certain objects framed as it
> were to bear attention to themselves—each object
> taking its place. The whole—I repeat—to be a bal-
> lanced [*sic*] construction.[2]

M.R.

1. Ruth Fine, *John Marin* (New York: Abbeville Press, 1990), 148.

2. John Marin, undated letter to Elizabeth S. Navas, 1951, registrar's files, Wichita Art Museum.

Cape Split, 1939-42

In 1933 John Marin spent his first summer at Cape Split, Maine, whose breathtaking scenery would inspire his land and seascapes over the next several years. One year later, after purchasing a seaside cottage with an impressive view of the cape and Pleasant Bay, Marin wrote, "Here the sea is so damned insistent that houses and land things won't appear much in my pictures."[1] True to his word, Marin painted numerous images of the open sea in all its many moods. However, he also gave indications of human presence in his depictions of Cape Split's wide-spanning cove, through his inclusion of loosely-drawn boats and seaside architecture.

Cape Split typifies Marin's use, in his Maine landscapes, of simplified, geometric structures. Boxy, Cubist-inspired forms along the left and

lower margins represent beach houses. Marin also uses framing devices, particularly around the tree in the upper left, that help impose structure and highlight certain aspects of the composition. The treatment of the sails, while echoing the geometric frames and houses, may indicate a day of rough sailing for the boat. Finally, the ocean, with its energetic marks and uneven cerulean washes, extends nearly to the top of the picture, perhaps indicating Marin's penchant for depicting the sea in a particular mood.

The broad contour of the shore safely contains the surging, dynamic ocean. Beginning with the continuous line of houses, the composition leads the eye on a sweeping clockwise loop around the painting, ending in the center of the bright blue cove. The excited sea and gusty wind, although possibly hazardous to the sailboat, do not pose a threat to the safely-nestled beach cottages or the arboreal landscape on the horizon. Marin activates the entire landscape with his rugged mark-making and brilliant coloring, portraying a vigorous ride for the lone sailboat, while at the same time celebrating the vibrance of the Maine coastline.

S.H.

1. John Marin, letter to Alfred Stieglitz, 10 September 1936, quoted in Ruth Fine, *John Marin* (New York: Abbeville Press, 1990), 229.

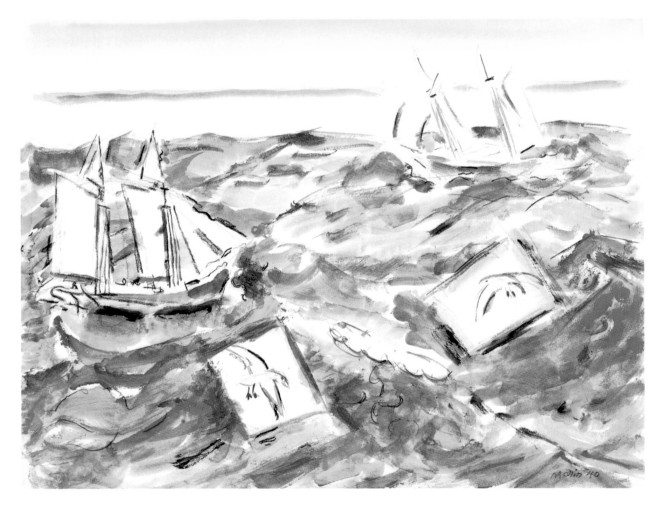

Boats and Gulls, 1940

Watercolor on paper, 18¼ x 23¼ in.

Signed and dated lower right: *Marin/40*

Roland P. Murdock Collection, M75.48

Boats and Gulls, 1940

Whether in the form of a placid harbor, a peacefully flowing river, or a powerfully churning ocean, water is continually present in the work of John Marin. In his maturity, Marin expressed his love of water not only in his art but also in his life, spending several months each year on the Maine coast. In 1914 the artist purchased a small, uninhabitable piece of land in northern Maine which he proudly named "Marin Island." In the 1920s Marin spent many of his summers in the Stonington-Deer Island area of Maine, on Penobscot Bay. In 1933 Marin visited Cape Split, Maine for the first time. He returned the following summer with his family and bought a cottage there. Cape Split differed significantly from other Maine locations Marin had inhabited. The sparsely-populated land was rugged, isolated, and accessible only via difficult dirt roads. Marin thrived in this challenging environment and responded to it in his painting. He spent every summer on Cape Split until his death in 1952.

Boats and Gulls, originally entitled Cape Split, Maine, was first exhibited in December 1940 at Alfred Stieglitz's gallery An American Place. Marin employed quick, thin dashes of black pigment on white paper to form a high horizon and the outlines of two ships and two birds. The curious, boxlike shapes around the gulls are a common motif in Marin's art, appearing frequently in his work in various forms. Marin often used lines of paint or graphite as a framing device around an entire composition, as in Region, Trinity Church, N.Y.C. of 1926-36. He also commonly framed sections of seemingly empty space, as in The Fog Lifts of 1949. He included individual forms such as the birds of Boats and Gulls inside areas of negative space, possibly to create a sense of depth in the painting or to suggest a series of movements across the paper.

In Boats and Gulls, the areas around the enclosed birds are painted with cool greens and browns, laid down with vigorous strokes that describe a tumultuous sea. A contemporary reviewer observed that "no one surpasses [Marin] in turning the sea inside out and hence in suggesting its restlessness."[1] But in Boats and Gulls the heaving ocean seems to have strangely little effect on the boxed-in birds or the boats that calmly settle in between its cresting and crashing waves.

J.A.S.

1. J.W.L., "Marin and Other Marines: Three Exhibitions," Art News 39 (21-28 December 1940): 11.

The Fog Lifts, 1949

Near the end of his life Marin created some of his most lively, celebratory images of the Maine coast. He was seventy-nine when he painted The Fog Lifts, a picture that, in the words of one critic, "synthesizes all of Marin into oil."[1] Painting on canvas after many years of working in watercolor, Marin successfully translated the subtle and transparent qualities of watercolor into oil. He renders the scene with expressive strokes, combining thick and thin layers of paint, often revealing areas of exposed canvas.

The jagged rocks along the bottom are executed in Marin's highly personal calligraphic style. Above them float flat, geometric forms of fog, abstracted by Marin into white rectangles. This work captures the brief period during which fog disperses from the coastal areas in late morning, opening onto a view of the horizon. A silvery Maine mist lingers while hints of sunlight begin to diffuse through the atmosphere and illuminate the scene. White hovering blocks of paint dominate and activate the composition, appearing to advance and recede. The abstract pattern they create indicates not only the gradual lifting of the fog, but also the rhythmically shifting land and sea.

Marin's composition is not confined to the canvas but spills over onto the frame, also painted by the artist. Patches of white haze seem to drift out of the two-dimensional picture plane and onto the frame, extending the field of vision into three dimensions. "If I were younger," Marin said, "I would plunge into sculptures, but my frame-making will have to satisfy my sculptural urges."[2]

S.H.

The Fog Lifts, 1949
Oil on canvas, 22 x 28 in.
Signed and dated lower right: *Marin 49*
Roland P. Murdock Collection, M143.57

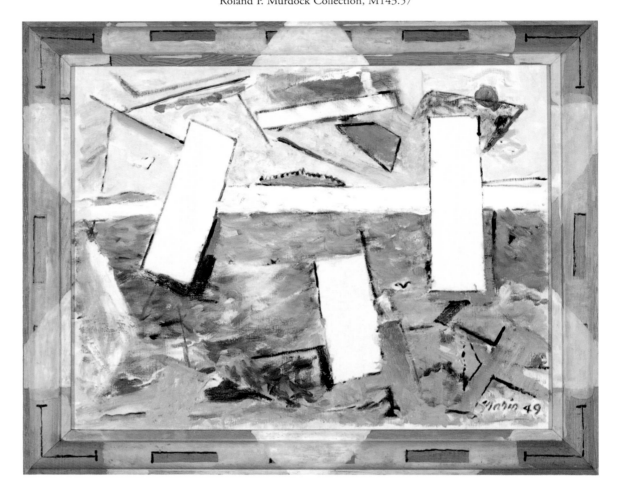

1. Frederick Wight, "John Marin—Frontiersman," in *John Marin Memorial Exhibition* (Los Angeles: Art Galleries, University of California, 1955).

2. John Marin quoted in Ruth Fine, *John Marin* (New York: Abbeville Press, 1990), 207.

Tunk Mountains, 1952

Marin painted *Tunk Mountains* near the end of a long and successful career. In 1950 the artist was awarded honorary Doctor of Fine Arts degrees from both Yale University and the University of Maine. The same year Marin was also honored with a retrospective exhibition at the Venice Biennale, in the company of the younger American artists Willem de Kooning, Arshile Gorky and Jackson Pollock. It

seems appropriate for Marin to have been shown with these Abstract Expressionists, since even though his work never abandoned references to nature, its gestural freedom predicted the spontaneous brushwork of the younger painters. The liberated quality of Marin's late work suggests that painting had become almost second nature to him. "As for painting—I've given that up—" Marin wrote in 1943, "I just tie a brush to my fingers and let that old silly brush do the painting."[1]

Marin did not seriously pursue oil painting until the 1930s. At this time he enthusiastically explored the rich impasto surface easily attained in oils, and so different from the flatter texture of his usual working medium of watercolor. Bold surface texture, combined with calligraphic line and rhythmic composition, characterize *Tunk Mountains.*

Tunk Mountains, 1952
Oil on canvas, 22⅛ x 28¼ in.
Signed and dated lower right: *Marin 52*
Roland P. Murdock collection, M114.53

The subject, a mountain range in Maine, was one Marin painted on numerous occasions during the 1940s and 1950s.

For the Wichita painting Marin used a commercially primed canvas, to which he applied a putty-colored base layer of paint. Over this base, he set down the strong black lines of the composition, which seem to push out of the canvas towards the viewer. These calligraphic black marks dominate the painting, framing and defining forms, and establishing a zig-zag sensation of compositional movement. Complementing the motion of the lines are thick dabs of blue, green and red pigment.

Painted a year before Marin's death, the lively *Tunk Mountains* exemplifies the artist's optimistic attitude towards life. Marin's own words express his positive outlook most clearly in his response to the existential angst driving the work of many of the younger generation of artists:

> Shakespeare didn't give us tragedies only; he gave us comedies as well. I'd like the modern artists to think about that —there's room in life for both and I'd like to see them restore the balance and give us something a little cheerful. The sun is still shining and there's a lot of color in the world. Let's see some of it on canvas.[2]

M.R.

1. John Marin, letter to Alfred Stieglitz, 29 September 1943, quoted in Sheldon Reich, *John Marin, Part 1: A Stylistic Analysis* (Tucson: University of Arizona Press, 1970), 236.

2. John Marin quoted in "Noted Artist Abhors All 'isms' except 'Real'ism in Art", *Palisadian,* December 1947, in Ruth Fine, *John Marin* (New York: Abbeville Press, 1990), 282.

Sandwiches, 1938
Egg tempera on presdwood, 23½ x 30 in.
Signed and dated lower right: *Reginald Marsh/1938*
Roland P. Murdock Collection, M7.39

REGINALD MARSH (1898-1954)

Sandwiches, 1938

A shabbily-clothed man rummages through a trash can, a man and woman passionately embrace behind a wooden partition, and three semi-nude figures saunter out of the water. These self-contained vignettes, uneasily conjoined in the painting *Sandwiches,* attest to the ambiguities and inconsistencies of life that Reginald Marsh observed and constantly recorded in his art. In *Sandwiches,* Marsh distills the energy of urban living to its most basic elements and to the participants' fundamental needs: food, sex and leisure.

Arranged along an emphatic diagonal from left to right, the three scenes recede through fore-, middle- and background according to a spatially-reinforced social hierarchy. The anecdotal title *Sandwiches* accentuates the dominant compositional feature—the socially and racially isolated figure of the black man, absorbed in his search for food. Marsh stated that "the subject was from an observation made one night at sundown in midsummer 1938 on the Coney Island Beach." The artist later discussed the subject with his model Walter Broe, a formerly homeless person, who speculated that the black man was "probably scavenging the tin can for sandwiches."[1] In addition to explaining the genesis of the title, this statement reveals the degree to

which Marsh distanced himself from his observed subjects, and in this instance relied on another's experience to elucidate what he saw.

Indeed, the artist, born in Paris in 1898 and raised in affluent suburbs of New York and New Jersey, was of a higher class than those who figured so prominently in his work. After graduating from Yale University in 1920, Marsh moved to New York City, where he worked as a free-lance illustrator for newspapers and magazines ranging from *Esquire* to *The New Masses.* During this time he began studying at the Art Students League (ASL) under John Sloan, George Luks and Kenneth Hayes Miller. After traveling to Paris in 1925-26, Marsh returned to take classes with Miller at the ASL, pursuing painting more seriously while continuing to work in a broad range of media. From 1935 to 1954, Marsh himself taught at the ASL.

Marsh considered himself foremost a draftsman, and his predilection for linear and transparent mediums led him to start experimenting with egg tempera in 1929. Although traditionally regarded as a labor-intensive and opaque medium, tempera, unlike oil, dried quickly and could be easily thinned. Marsh exploited these qualities, giving his work the impression of spontaneity while carefully building up the painting surface through the application of numerous layers of pigment.

In *Sandwiches,* the complexity of Marsh's experimental painting style matches that of his subject matter. Over a ground of white casein, Marsh loosely paints with a dark palette of browns, blues and grays. In some areas the veils of color are rubbed or scratched away to indicate highlights. Heavy brown outlines emphasize the contours of the representational elements and intensify their shadows. The coarse rendering and gloomy mood of the painting create a psychological tension; the subjects seem suspended in an oppressive air that denies them a past or future. For Marsh, the detached observer, what merits description is only the present.

K.A.M.

1. Reginald Marsh, letter to Elizabeth S. Navas, 12 September 1939, registrar's files, Wichita Art Museum.

Red Curtain, 1947

Though the settings change, the subject of Reginald Marsh's art is nearly always the people of New York City. Whether at the beach or an amusement park, on a subway platform or in the tenement districts, Marsh loved to paint the milling crowds that filled every borough of the thriving metropolis. Marsh would wander the streets of the city in search of engaging vignettes, and was never without paper and ink to capture a quick impression. He also set up a telescope in his studio so he could observe the people below and immediately record their images. Marsh worked rapidly to seize the vitality of the city's inhabitants, in small sketches that served as studies for full-sized etchings, drawings and paintings.

During the early part of his career, Marsh worked as an illustrator for a number of New York newspapers and magazines. From 1922 to 1925, he produced a daily cartoon review of vaudeville and burlesque shows for the *New York Daily News.* To prepare these reviews, Marsh attended the shows and sketched the performances. His drawings were published in the newspaper along with ratings of the acts.[1] Marsh continued to haunt vaudeville and burlesque theaters for the rest of his life, and depicted them often in his art. *Red Curtain,* which pictures a burlesque dancer performing on stage, is a typical example.

Marsh's teacher, Kenneth Hayes Miller, once told him: "You are a painter of the body. Sex is your theme."[2] Sex is indisputably the theme of *Red Curtain.* The dancer on the stage, with her curvy form, ample bosom and pale flesh, embodies Marsh's ideal of feminine allure. Because Marsh very rarely engaged nude models to pose for him in his studio, this woman could well have been a dancer he observed at an actual burlesque theater. But he has transformed her into a ripe, fleshy figure in the style of Rubens, whom Marsh cited as an influence, and her powerful physical presence dominates the composition.

The dancer's blond hair and faded blue and red veils stand in visual contrast to the bold primary coloring of the curtain, column, and architec-

Red Curtain, 1947

Tempera on paper, 27¼ x 40¾ in.

Signed and dated lower right: *Reginald Marsh/1947*

Gift of the Estate of Felicia Meyer Marsh, 1979.16

ture above the crowd. The crowd itself is painted in neutral hues, but the faces of the men in the audience do register a colorful variety of responses to the show. Some are obviously excited by the spectacle and gaze lustfully at the buxom dancer on the stage. One young man blatantly gapes at her, evidently having never seen or imagined such sights. Others stare at the floor in apparent boredom. As a group, these men represent the variety of types who regularly visited the dance halls. But Marsh draws each of them with distinctive facial features and a unique expression, and, given the artist's proclivity for sketching people in public, it is not unreasonable to assume that these are caricatural portraits of men actually present at one of the theaters Marsh himself frequented.

J.A.S.

1. Marilyn Cohen, *Reginald Marsh's New York: Paintings, Drawings, Prints and Photographs* (New York: Whitney Museum of American Art, 1983), 3.

2. Quoted in Reginald Marsh, "Kenneth Hayes Miller," *Magazine of Art* 45 (April 1952): 171.

Untitled (Cityscape), 1950

For over thirty years Reginald Marsh was captivated by the many facets of New York City's urban landscape. Although best known for his depictions of the diverse inhabitants who animated the city, Marsh also deftly captured its busy maritime life and awe-inspiring skyline. The artist filled his notebooks with sketches of the New York harbor, studying the bustling movement of the tugboats, barges and ocean liners that trans-

ported both people and goods from shore to shore. Throughout the 1920s and 1930s Marsh translated his observations into a broad variety of media: etchings, engravings, watercolors, tempera and oil paintings. Although finished works in their own right, many of these served a preparatory role in Marsh's designs for his 1937 mural decoration of the rotunda of the U.S. Custom House in New York.

In 1950 when Marsh executed this untitled ink and charcoal drawing, he returned to a familiar subject, but with a fresh formal and conceptual approach. In the 1940s Marsh conjoined his predilection for graphic and black and white

media in his large-scale experiments with Chinese ink on paper. By dissolving charcoal sticks in water Marsh could produce a variety of ink tonalities that were easily manipulated and, in their monochromy, lent themselves to the artist's urban subject matter.

Whereas Marsh's earlier panoramic views of Manhattan from Governor's Island or Brooklyn served as a backdrop to the harbor's activities, in his drawing of 1950 the skyline itself dominates. Marsh places the viewer on a cluttered pier looking over East River to the city beyond. The use of dark ink clearly establishes a projecting foreground space and adds to the dirty, viscous urban atmos-

Untitled (Cityscape), 1950
Ink wash and charcoal on paper, 22½ x 30¹¹⁄₁₆ in.
Signed and dated lower right: *22 Oct. 1950/Reginald Marsh*
Gift of the Estate of Felicia Meyer Marsh, 1979.20

phere. Wet daubs and dashes of ink demarcate the waterway that fills the compressed middle ground area. Two boats act as intermediaries connecting the two shores and above them rise skyscrapers, creating a dense, almost impenetrable wall. Broad areas of pale, gray ink give form to the architecture and indicate shadows while areas left white create the impression of three-dimensionality and specify a strong light striking the south side of the buildings. To accentuate and individualize the architecture Marsh added a variety of charcoal lines. In the buildings these lines run horizontally, thereby counteracting the vertical thrust of the buildings themselves.

Although the inhabitants of the city are not visible, their movement is implied in the animation of the man-made buildings and boats. In the sky, clouds, haze and puffs of smoke rendered with extra layers of ink wash and agitated charcoal lines act as surrogates for the absent human figures and attest to the activity below.

K.A.M.

The Bowery, 1952-53

In *The Bowery* Marsh captures on paper the lives and living conditions of the residents of New York City's "Skid Row." The scene is set on a street corner located under a bridge or subway platform, but the buildings lack any real substance and seem to be on the verge of dematerializing. The people on the street are more solidly drawn than the architecture and most occupy the foreground of the picture. Worn and disheveled, they are obviously poor and many are probably homeless. Several stand around idly. One man, holding a bottle, seems to be laughing and talking to himself. Another lies slumped against a building, perhaps in an alcoholic stupor. Marsh focuses here on the lowest of the low, literally and figuratively beneath the city that passes above their heads.

In his art Marsh would often depict loud, chaotic, urban crowds in which bodies press together on busy streets and subway platforms. But the figures in *The Bowery* do not touch; each person exists in a separate space and does not interact with anyone else. These people do not even appear to have any desire to communicate with each other. Several of them seem to be merging with the surrounding architecture: in the center of the image one man's body takes the *S* shape of the mechanical box on which he leans, while another figure, with his hands in his pockets, stands as rigidly as the pole behind him. Marsh perhaps suggests that these people are as much a part of the environment as the buildings that surround them every day and are easy for the more fortunate city dwellers to walk past or ignore. For example, the one fashionably dressed person in the scene, the woman on the left, hardly glances back at the vagrants as she strides across the street.

Marsh has been aptly described as the "American Daumier."[1] Like Daumier and many other nineteenth-century European journalistic illustrators who were an inspiration to him, Marsh was a sharp-eyed observer of the human foibles he saw around him, and occasionally would include subtle political commentary in his work. In *The Bowery,* such commentary is made through the inclusion of the *Daily Mirror* that lies on the sidewalk. Its main headline declares: "Soviets in Fear of Revolt—U.S." Smaller headlines read "State Dept. Explains Jewish Purge" and "Report HST Will Spare Rosenbergs." The Cold War worries of the United States government reported by the newspaper are, of course, completely irrelevant to the daily lives of the Bowery derelicts. Marsh juxtaposes newspaper announcements of Cold War political anxiety with an image of the harsh realities of slum life, and asks us to decide which problem is more immediately pressing.

J.A.S.

1. W. Benton, "American Daumier," *Saturday Review*, 24 December 1955, pp. 8-9.

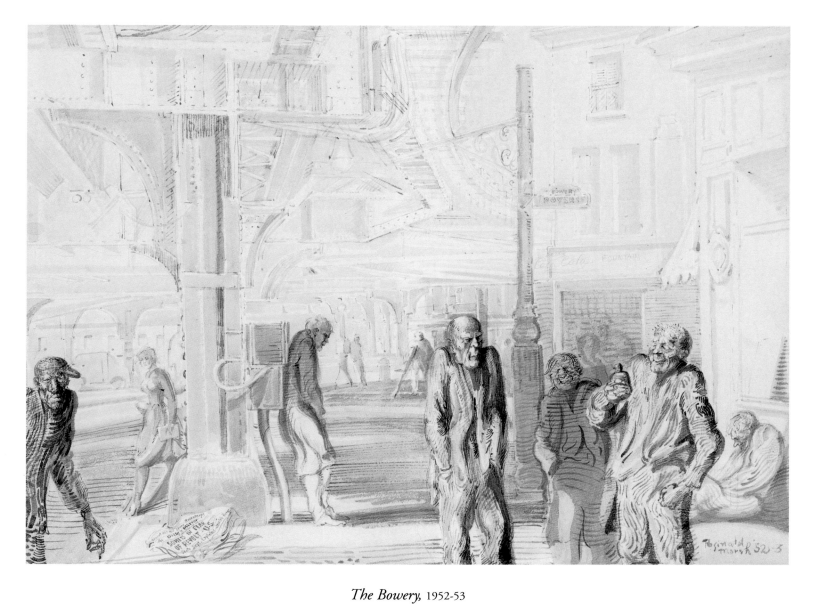

The Bowery, 1952-53

Chinese ink on paper, 22½ x 30¾ in.

Signed and dated lower right: *Reginald Marsh '52-3*

Roland P. Murdock Collection, M152.58

PAUL R. MELTSNER (1905-1966)
Martha Graham Dance Class, ca. 1939
Oil on canvas, 28 x 36⅛ in.
Signed lower left: *PAUL MELTSNER*
Gift of Virginia and George Ablah, 1981.9

Born in New York City, Paul Meltsner studied at the National Academy of Design and was a member of the Society of Independent Artists. In the 1920s and early 1930s, he produced still-lifes, rural views, and paintings of labor and industrial life. Later in the decade, Meltsner shifted his energies to portraying Broadway celebrities such as Carmen Miranda, Lynn Fontanne, and Gertrude Lawrence. His favorite subject was Martha Graham, whom Meltsner painted on at least three occasions.[1]

Martha Graham was a pioneer in the art of modern dance. Rejecting the balletic forms and decorative theatricality of traditional dance, she shocked her audiences with harsh, angular movements and stark costumes and sets. Graham sought to distinguish American dance from the European tradition, and often explored specifically American themes such as westward expansion and the pioneer spirit. Not surprisingly, Graham was recognized internationally as the most influential American dancer and choreographer of the 1930s and 1940s.

Meltsner's *Martha Graham Dance Class* celebrates Graham's pioneering role in the modern dance movement. Graham occupies a dominant, vertical position in the foreground. Strongly lit and wearing a sleek, brightly-colored garment, Graham stands apart from a group of students in the dark background. She strikes a characteristic pose, with arms stretched overhead in a bent, angular position.

Meltsner's portraits of Martha Graham garnered considerable critical attention, and they were exhibited in significant exhibitions such as the Golden Gate International Exposition of 1939, the Corcoran Biennial Exhibition of 1939, and the Pennsylvania Academy of the Fine Arts Annual Exhibition of 1941. Interestingly, in 1940, an American collector presented one of the Graham portraits to the National Museum of Argentina as a good will gesture on behalf of the United States.[2]

In the 1940s and 1950s, Meltsner produced urban scenes in a looser, more painterly style. During this period, Meltsner was also instrumental in raising money for war bonds through the sale of his pictures. Meltsner eventually settled in Woodstock, New York, where he died in 1966.

L.D.

1. "Paul Meltsner Turns His Eyes to Broadway," *Art Digest* 14 (1 March 1940): 7.

2. "Buenos Aires: Gift of a Meltsner Canvas," *Art News* 39 (7 December 1940): 14.

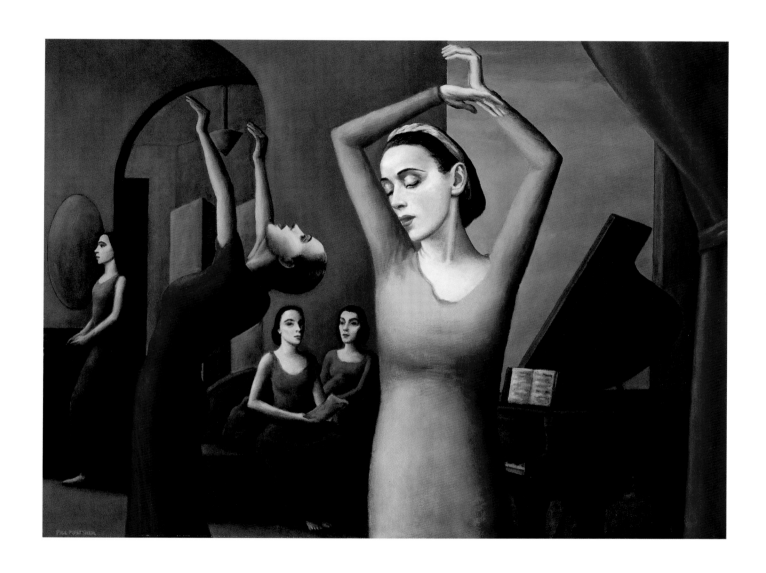

WILLARD LEROY METCALF (1858-1925)
Old Willows in Spring, 1923
Oil on canvas, 26¼ x 29⅛ in.
Signed lower left: *W.L. METCALF*
John W. and Mildred L. Graves Collection, 1988.15

Declining health did not keep Willard Metcalf from interpreting the changing seasons of the New England landscape that he had known so intimately for so long. During the last five years of his life, Chester, Vermont became Metcalf's favorite picturesque locale. The year before he painted *Old Willows in Spring,* Metcalf wrote his daughter: "I shall once more pack up my things to go to Vermont—up to Chester—for I want to paint the springtime up there—with the beautiful hills and dancing, singing brooks. . . . Oh, I love the springtime—it is so full of promise and makes me feel always as though youth had returned, not only to all nature, but to me as well."[1]

Born in Lowell, Massachusetts, in 1858, Metcalf lived and worked in the Northeast almost his entire life. Apprenticed first to a wood engraver and then to the Boston landscape painter George Loring Brown, Metcalf learned to render precise, solid forms and create well-balanced compositions. Unable to afford a trip abroad, in 1881 he traveled instead to the Southwest to illustrate stories for *Harper's* and *Century* magazines. By 1883 he had saved enough to study at the Académie Julian in Paris but he also sketched and painted in the French countryside, working for a time in Giverny where he met Monet in the mid-1880s. In this environment Metcalf, like other American painters such as Theodore Robinson, absorbed the tenets of French Impressionism. Returning to the United States in 1889, Metcalf established a studio in New York but spent most of his time painting in rural New England in his newly acquired impressionist style. Metcalf joined with other American Impressionists and Tonalists in 1897 to form a group called Ten American Painters. Their annual exhibitions provided the principal forum for Metcalf's work for the next two decades.

Although occasionally Metcalf painted scenes of New York City life, he won acclaim for his depictions of idyllic country retreats, particularly after 1903 when his brushwork and palette grew more vibrant. The 1923 painting *Old Willows in Spring* typifies his later work. Three wiry, intertwined trees dominate the composition, their dark and gnarled trunks contrasting the tendril-like branches that erupt with budding green leaves. Pastoral motifs punctuate the vernal landscape—a fisherman rests in the foreground next to the winding stream, cows graze on a hill in the middle ground, and an old white farmhouse lies nestled in the valley background. A feeling of tranquility permeates the scene, augmented by the painting's square format—a Metcalf convention that heightens the sense of stability and changelessness. Unlike many Impressionists who used a high-keyed palette and flickering brushstroke to dissolve form, Metcalf never strayed from a more descriptive rendition of nature and of a specific place. The harmonious colors and idiosyncratic application of paint—narrow and broken in the foreground, smooth and glassy in the stream and sky—clarify rather than obscure the subject. Unequivocally nostalgic, Metcalf's painting attests to the endurance of American Impressionism well into the twentieth century.

K.A.M.

1. Willard Metcalf, letter to daughter Rosalind, 6 August 1922, collection of Rosalind Metcalf Harris, cited in Elizabeth de Veer, *Sunlight and Shadow: The Life and Art of Willard L. Metcalf* (New York: Abbeville Press, 1987), 141.

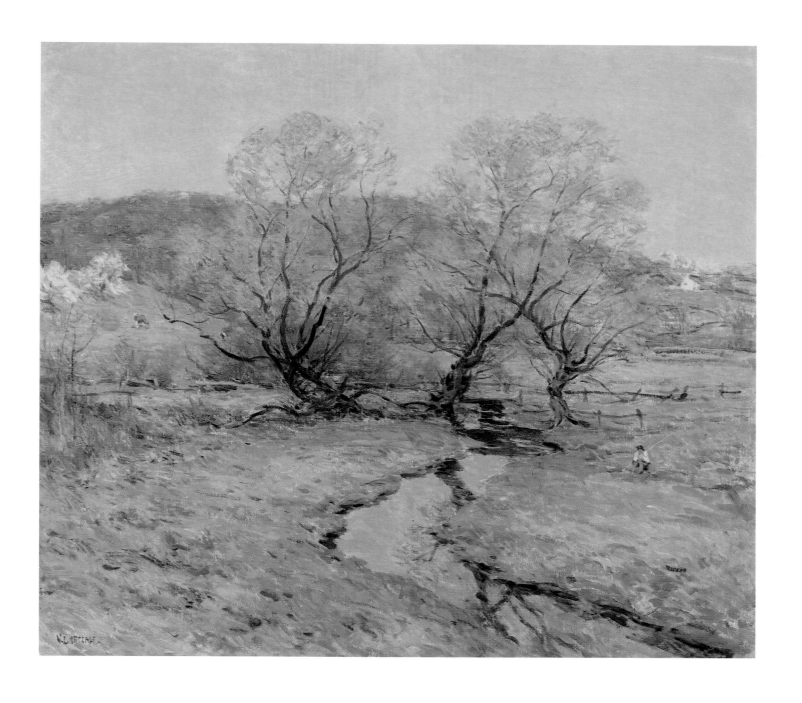

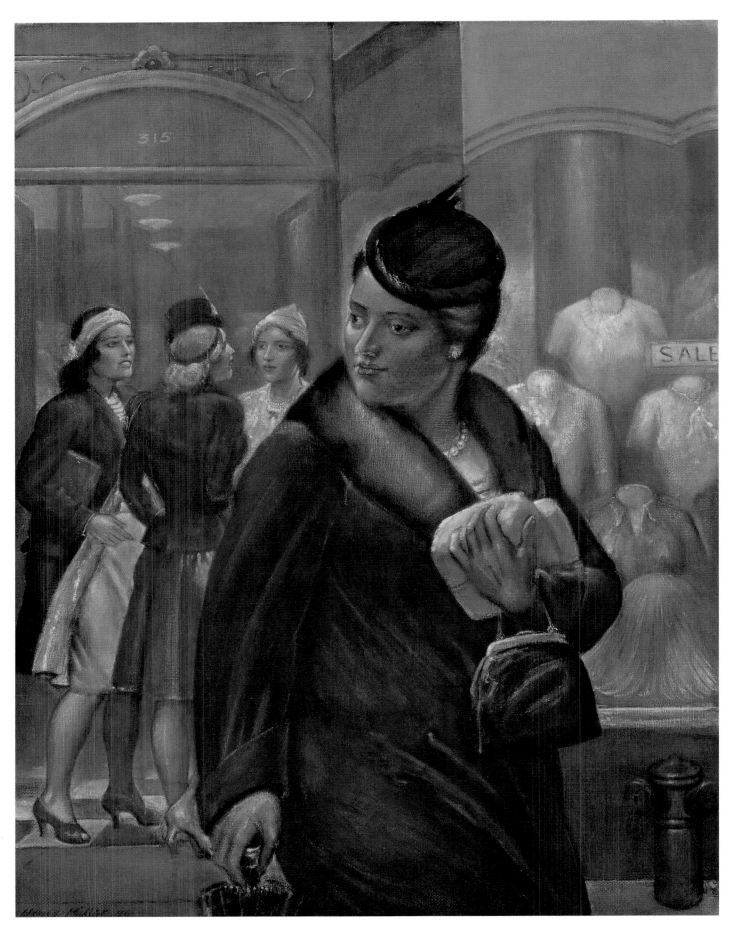

KENNETH HAYES MILLER (1876-1952)
Show Window #2, 1938

Oil on canvas, 27½ x 21⅛ in.

Signed lower left: *Hayes Miller*

Gift of Friends of the Wichita Art Museum, Inc., 1980.67

Kenneth Hayes Miller painted *Show Window #2* at the height of his reputation as an important artist and teacher. Born in Oneida, New York, Miller first studied and then taught at both the Art Students League and the New York School of Art. Over the course of four decades Miller influenced generations of American artists; his most prominent students included George Bellows, Edward Hopper, Yasuo Kuniyoshi, Edward Laning, Reginald Marsh and Isabel Bishop.

Miller's figurative style and distinctly American subject matter appealed to art critics and patrons, many of whom shared the artist's disapproval of European modernism. Miller began painting the New York urban scene in the 1920s, observing from his studio along Fourteenth Street the bustling daily activities of the Union Square district. He focused in particular on women searching for bargains in this lower- to middle-class commercial area known for its numerous retail stores.

Miller did not profess in his paintings to offer commentary on the socio-economic conditions of Union Square, but instead claimed to be primarily concerned with formal issues. Miller's clean, carefully composed street scenes and volumetric figures recall classical precedents; in fact, the American artist self-consciously adopted the conventions of Old Masters such as Raphael, Titian, Rubens and Rembrandt. Miller differentiated shapes through his controlled brushwork and use of dark outlines, which were in turn reinforced by a repetition of rounded inner contours.

Although Miller's own statements about his work emphasized a preoccupation with structure and sculptural form, his images of women shopping can be understood in the context of a burgeoning female-oriented consumer culture. The matronly shopper in the foreground of *Show Window #2,* already clutching a number of packages to her bosom, eagerly looks over her right shoulder as if yet another item has caught her attention. Behind her converse three younger women, who in number and pose recall the mythic Three Graces, a motif that Miller frequently employed. Their youthful female forms counterbalance a window display of buxom torsos. Miller's selective use of bright, high-keyed color draws attention to the sale blouses in the vitrine, as well as to the young women's clothing and their heavily made-up faces. Like the mass-produced items they wear, these models of feminine beauty are at once signs of modernity, urbanism and sexuality. By conjoining both traditional and modern images of women, Miller creates a reassuring image for the Depression era. By partaking in a domestic leisure activity, these women, in the words of one recent scholar, "implied that financial stability would re-emerge, consumption would continue, and society would prosper."[1]

K.A.M.

1. Ellen Wiley Todd, *The "New Woman" Revised: Painting and Gender Politics on Fourteenth Street* (Berkeley: University of California Press, 1993), 167.

JOHN NOBLE (1874-1934)
Provincetown Winter, ca. 1920-21
Oil on canvas, 40½ x 50¼ in.
Signed lower right: *John Noble*
Gift of Allan Ames Noble, John Noble, Esq., and Mrs. Beverly
Noble, 1987.39

John Noble was born in Wichita, Kansas, the son of prosperous first-generation settlers from England. He studied art in Cincinnati from 1893-95 while supporting himself as a commercial photographer. Like many American artists around the turn of the century, Noble made the pilgrimage to Europe for training, studying under Jean-Paul Laurens at the Académie Julian in Paris. After experiencing artistic success in France and England, Noble returned to the United States in 1919 with his French wife, Amelia, and settled in Provincetown, Massachusetts. The site of a lively summer artists' colony, Provincetown provided a vital, bohemian atmosphere for the repatriated Noble. Most painters spent the daylight hours working from nature, and enjoyed evening companionship with the other artists, writers, actors and playwrights who gathered in the town. Noble cut a colorful figure in Provincetown, playing off his frontier origins to style himself as a swaggering cowboy. In 1920 Noble founded and served as the first director of the Provincetown Art Association. He led the funding campaign for the renovation of a house into an art museum to host annual summer exhibitions by the association's members. The Nobles lived year-round at Provincetown until the autumn of 1922, when they moved to New York.

Although many Provincetown artists painted harbor scenes, this example is unusual in depicting the port in winter, a season during which most artists abandoned the area due to its harsh climate. The vibrant colors and bravura strokes of Noble's seascape capture the vivacity and difficulty of life along the northeastern coast. The variety of textures adds visual interest to the painting's surface, from thin areas of paint to thick impasto applied with a palette knife. According to Noble's own notes, the harbor was painted from "pilgrim mon-

ument," a stone tower that was the geographic high point of the area.[1] This unique vantage point allowed an elevated, expansive view. The painting's composition is built of progressive spatial layers, from the crowded fishing village, to the sailboats and pier, to the expanse of open water and sky. Cool shades of blue and green dominate the scene, with deep purple representing shadows. It is dawn, and most of the windows are still dark. The fluorescent orange glow of a lantern is the first indication of life and warmth in the village, as fishermen rise to begin their difficult labor. They are awakened by a brilliant yellow sun, which contrasts with the chilled ocean atmosphere. *Provincetown Winter* won the W.A. Clarke prize at the Corcoran Gallery in Washington in 1923. The following year, Noble was elected to the National Academy of Design.

This seascape is full of color and romantic nostalgia, echoing Noble's own comparison between the land of his native Kansas and the sea he loved so well: "There's not much difference between the prairie and the ocean—that is, the prairie I used to know. I began to feel that the vastness, the bulk, the overwhelming power of the prairie is the same in its immensity as the sea—only the sea is changeless, and the plains, as I knew, were passing."[2]

A.P.B.

1. Note in Noble's handwriting in registrar's files, Wichita Art Museum. I am grateful to Dwight Burnham, Professor Emeritus, University of Kansas, for verifying the location of this site in Provincetown.

2. John Noble quoted in Madeleine Aaron, "The Prairie and the Sea," *I Cover the Bookfront* (December 1943).

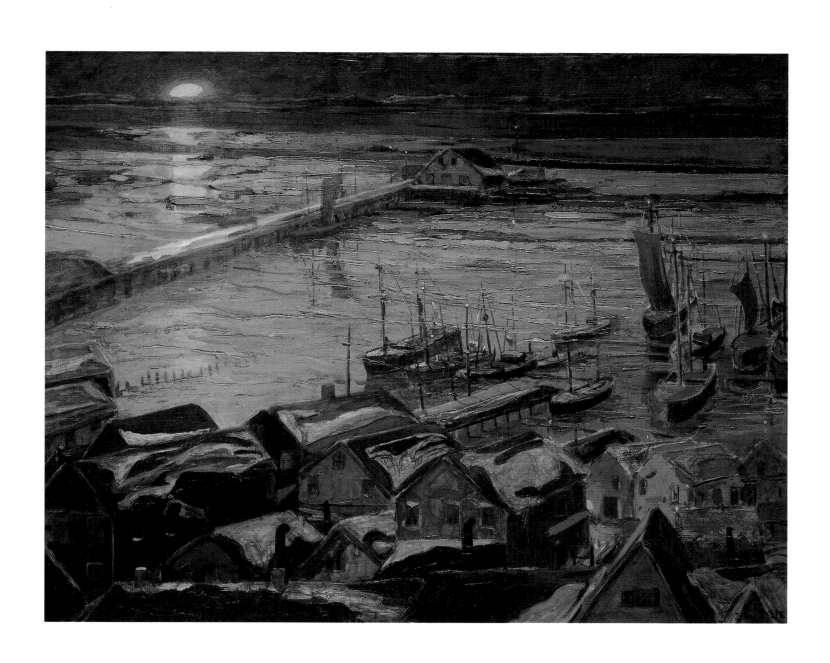

GEORGIA O'KEEFFE (1887-1986)

East River No. 1, 1926

Oil on linen, 12⅛ x 32⅛ in.

Signed and dated on verso on stretcher:

Georgia O'Keeffe/East River No. 1 - 1926

Gift of the Friends of the Wichita Art Museum, Inc., 1979.35

Georgia O'Keeffe was born on her family's farm near Sun Prairie, Wisconsin. After studying at the Art Institute of Chicago in 1905-6, she enrolled at the Art Students League in New York in 1907, where she studied under William Merritt Chase. When her father's financial difficulties forced her to withdraw from classes, O'Keeffe subsisted as a commercial illustrator and then as an art teacher. In 1914, she returned to school at Columbia University Teacher's College to study with Arthur Wesley Dow, who encouraged O'Keeffe to begin her first series of abstractions in 1915. The following year, her work was shown to Alfred Stieglitz, photographer and owner of the 291 Gallery. Stieglitz took great interest in her work and offered her financial support as well as exhibitions at 291 and at his later galleries, the Intimate Gallery and An American Place. O'Keeffe and Stieglitz married in 1924 and continued both a working and personal relationship until the latter's death in 1946. Following Stieglitz's death, O'Keeffe moved permanently to New Mexico, where she painted her well-known interpretations of the surrounding landscape and its distinctive motifs, such as desert flowers and cattle bones.

East River No. 1 dates to the period following O'Keeffe and Stieglitz's move onto the twenty-eighth floor of the Shelton Hotel in Manhattan.[1] The Wichita painting is one of a series of five canvases depicting "the expansive, grayed industrial districts of Queens stretching like a valley of ashes beyond the East River to the smoky horizon."[2] In *East River No. 1,* O'Keeffe's vantage point from the modern skyscraper creates a unique, panoramic view of the city that differs markedly from the scenes she painted at street level looking up at the tall buildings. For the artist, this elevated view offered artistic inspiration: "I realize it's unusual for an artist to work way up near the roof of a big hotel in the heart of the roaring city, but I think that's just what the artist of today needs for stimulus. He has to have a place where he can behold the city as a unit before his eyes."[3]

The implied distance of the city in relation to the perimeters of the painting contrasts to the intimate close-up views of O'Keeffe's better known floral imagery. This compressed space suggests that the artist might have been looking at the cityscape below through a telephoto lens.[4] Comparisons between *East River No. 1* and Stieglitz's similar views of the cityscape also allude to the photographic aspect of this painting, but it should be noted that Stieglitz was not photographing the city at the same time O'Keeffe painted these canvases.[5] The gray tonalities of the painting reinforce the connection to black-and-white photography, although O'Keeffe preferred a limited range of tones rather than the stark contrasts normally associated with photography of this period.

As one of the first American artists to live in a skyscraper, O'Keeffe faced the challenge of painting New York City: "I had never lived so high before and was so excited that I began talking about trying to paint New York. Of course, I was told that it was an impossible idea—even the men hadn't done too well with it."[6] However, critics praised her paintings of Manhattan following their first exhibition in 1926. *East River No. 1* appeared at the Intimate Gallery the following year, once again to critical acclaim. O'Keeffe recalled, "No one ever objected to my painting New York after that."[7]

M.A.W.

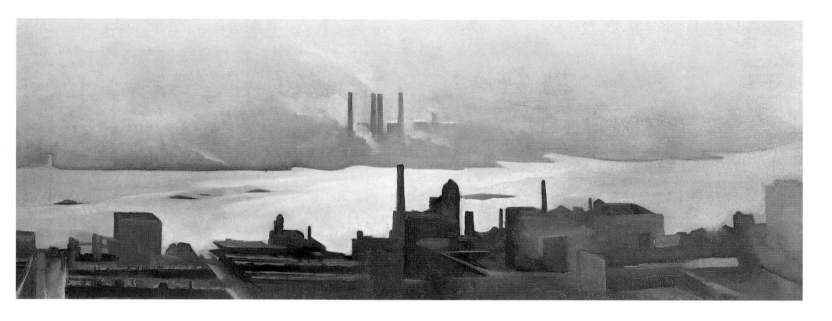

1. Anna C. Chave notes that O'Keeffe and Stieglitz initially lived on the twenty-eighth floor before moving to the thirtieth floor in January of 1928. Chave, "Who Will Paint New York? 'The World's New Art Center' and the Skyscraper Paintings of Georgia O'Keeffe," in Christopher Merrill and Ellen Bradbury, eds., *From the Faraway Nearby: Georgia O'Keeffe as Icon* (Reading, Mass.: Addison-Wesley Publishing Company, 1992), 74.

2. Charles C. Eldredge, *Georgia O'Keeffe: American and Modern* (New Haven and London: Yale University Press, 1993), 189.

3. O'Keeffe quoted in B. Vladimir Berman, "She painted the Lily . . .," *New York Evening Graphic,* 12 May 1928, p. 287, cited in Chave, 72.

4. Sarah Whitaker Peters, *Becoming O'Keeffe* (New York: Abbeville Press, 1991), 289.

5. Chave, 76, notes that O'Keeffe disliked sharing subjects with Stieglitz; once Stieglitz resumed photographing the city O'Keeffe turned to other subjects in her paintings.

6. Georgia O'Keeffe, *Georgia O'Keeffe* (New York: Viking Press, 1976), n.p.

7. Ibid.

August Threshing, Iowa, 1932
Gum emulsion tempera on canvas mounted on presdwood, 16 x 20 in.
Signed and dated on verso on stretcher: *August Threshing, Iowa/William C. Palmer—-32*
Gift of Friends of the Wichita Art Museum, Inc., 1983.24

WILLIAM C. PALMER (1906-1987)

August Threshing, Iowa, 1932

William Palmer was born in Des Moines, Iowa. Between 1924 and 1926, he studied in New York City at the Art Students League with Kenneth Hayes Miller, Boardman Robinson, and Thomas Hart Benton. In 1928 Palmer studied fresco painting in Fontainebleau, France, and toured the major museums of France, England, Belgium, and Holland.

Following his return to the United States, Palmer spent several summers in his hometown of Des Moines, where he sketched the local land-scape. To Palmer, the Iowa landscape bore favorable comparison to the landscapes immortalized by earlier Northern European painters: "I found the paintings of Vermeer, Ruisdale [sic] and Turner of great interest and when I returned to Iowa in the summer the spacious skies and flat landscape around Des Moines and the State Capitol remind-ed me of the church towers of English and Dutch paintings."[1] By 1930 Palmer had moved to New York City, where he began to paint landscape scenes based on his Iowa sketches. *August Threshing, Iowa* and *Southeast Bottoms, Des Moines* were painted in New York and exhibited in Palmer's first one-artist show in that city in 1932. William Palmer was among a group of American

Southeast Bottoms, Des Moines, 1932

Tempera on linen, mounted on panel, 30 x 40⅛ in.

Gift of the artist, 1985.18

artists working in the 1930s who rejected European modernism in favor of realistic representations of American life. Like fellow Regionalist painters Grant Wood, John Steuart Curry, and his former instructor Thomas Hart Benton, Palmer generally painted optimistic views of the rural Midwestern landscape. Agricultural images, such as threshing wheat, appear frequently in the works of Palmer, Benton, and Joe Jones, another Missouri Regionalist. In *August Threshing, Iowa,* a group of Iowa farmers gathers around a large threshing machine as it separates grain kernels into a wagon at right while spewing the remaining chaff onto a growing mound at left. Undulating, rhythmic lines and shimmering, golden light convey an aura of prosperity and warmth. The sky is animated by swirling clouds, and the earth swells with plenitude.

Critics wrote appreciatively of Palmer's Iowa landscapes. In the words of one, "He paints the Iowan scene with style and individuality. . . . He delights in wide expanses of rolling country that melt into skies filled with drifting, swirling clouds."[2] During the late 1930s Palmer gained even greater recognition for a series of murals he produced for the Federal Art Project of the WPA. Between 1941 and 1973, Palmer served as director of the Munson-Williams-Proctor Institute School of Art in Utica, New York. Although Palmer later experimented with more abstract styles, he continued to be inspired by observations of local scenery until his death in 1987.

L.D.

1. William C. Palmer, letter to Howard E. Wooden, 12 June 1985, registrar's files, Wichita Art Museum.

2. "Around the Galleries," *Art News* 31 (14 January 1933): 6.

Southeast Bottoms, Des Moines, 1932

Although Palmer studied in New York City and Europe, he returned to Iowa often and painted numerous images of the regional landscape. Growing up in Des Moines, he had frequently enjoyed visits to the State Capitol and its surroundings. As he recalled fondly, "Climbing up to the very top of the Capitol on a shakey [*sic*] cat walk to look out over the city and surrounding plains was thrill beyound [*sic*] discription [*sic*] and probably developed in me my feeling for space and distance."[1]

The painting *Southeast Bottoms, Des Moines* manifests Palmer's lingering affection for the Capitol building as well as his "feeling for space and distance." The picture presents a long view over the fertile fields of Des Moines, with the State Capitol perched on a hilltop at the right, and a group of industrial buildings at the left.

The image expresses Palmer's dismay at the deleterious effects of industrialization on Des Moines and its environs. The dignified State House and fertile farmlands seem threatened by encroaching industrial development. A large factory complex belches thick gray smoke from a multitude of smokestacks. In the extreme left corner, a dying tree stretches its scrawny branches along the line of smoke. Above, turbulent clouds push the smoke towards the Capitol.

Palmer explained the impetus for this painting: "In the summer when I would return to Des Moines to visit my family I was disturbed by the lack of respect for the Capitol setting. . . ."[2] He therefore painted *Southeast Bottoms, Des Moines* as a "protest of neglect" and a call to action.

L.D.

1. William C. Palmer, letter to Howard E. Wooden, 12 June 1985, registrar's files, Wichita Art Museum.

2. Ibid.

HORACE PIPPIN (1888-1946)
West Chester, Pennsylvania, 1942
Oil on canvas 29½ x 36 in.
Signed lower right: *H. PiPPiN*
Roland P. Murdock Collection, M51.44

"I paint things exactly the way they are," Horace Pippin explained to a colleague while painting West Chester, Pennsylvania. "I don't do what these white guys do. I don't go around here making up a whole lot of stuff. I paint it exactly the way it is and exactly the way I see it."[1] A self-taught artist who completed his first picture at the age of forty-three, Pippin painted, in a bold, direct style, what he knew and observed. Pippin employed tightly-controlled brushstrokes and simplified forms to render his highly personal visions, such as this view of brick rowhouses along a street in his hometown.

Born in West Chester, Pennsylvania, Pippin spent most of his childhood in New York State. After completing the eighth grade he went to work, supporting himself with jobs as a porter, mover, and iron molder before enlisting in the U.S. Army in 1917. His African American regiment was sent to France and soon after, Pippin was wounded in the right shoulder, leaving his arm permanently damaged. Upon his honorable discharge in 1920, Pippin married and moved back to West Chester, where he supplemented his disability pension by working as a handyman and delivering laundry that his wife took in.

Pippin's earliest extant works are six drawings that he made during his military service. For years his crippled right arm prevented him from drawing, but in the mid-1920s he started burning images on wood panels using a hot iron poker. Later he began adding oil paint and worked on fabric, overcoming his disability by using his left hand to prop up his right forearm. Pippin's paintings and wood panels depicting his war experiences and childhood memories were largely unknown beyond his immediate family and friends until 1937. Although the exact circumstances surrounding his "discovery" are debated, during that year the art critic and Chester County resident

Christian Brinton saw Pippin's work and arranged for his first one-man show at the West Chester Community Center.[2] Pippin's national debut came just a year later when four of his paintings were included in the Museum of Modern Art's exhibition *Masters of Popular Painting.*

Pippin's works are relatively small and painstakingly rendered with little, narrow strokes. In *West Chester, Pennsylvania,* Pippin pays particular attention to the central motifs and leaves other areas of the canvas less detailed. A broad field of gray indicates the vacant street in the foreground, interrupted by an open foundation in the lower left corner. The rest of the painting erupts with bright colors; the dilapidated red brick building is seemingly protected by a lush green tree that literally unites the earth with the cerulean sky above.

Signs of human habitation dot the painting: laundry hangs on a clothesline, a cart sets on the grass, a bicycle leans on the white fence, and old furniture clutters doorways and sidewalks. But an unsettling quietude pervades the painting, accentuated by the inclusion of a lone white man sitting under the tree canopy.

Recent scholarship has identified the location depicted by Pippin as a building near South Adams Street in an African American neighborhood.[3] Pippin, however, chose not to insert a black individual into the scene, thereby denying the viewer's stereotyped expectation of what racial "type" should be living in the area. Pippin seems more interested in affirming the everyday experiences of ordinary people—a subject that, in the end, is colorblind.

K.A.M.

1. Horace Pippin quoted by Edward Loper, interview with Marina Pacini, 12 May 1989, Edward Loper Papers, Archives of American Art, Smithsonian Institution, 34-35, cited in Judith E. Stein, et al., *I Tell My Heart: The Art of Horace Pippin* (Philadelphia: Pennsylvania Academy of the Fine Arts, 1993), 16.

2. Stein, 5.

3. Ibid., 87.

EDWARD HENRY POTTHAST (1857-1927)

The Bathers, ca. 1915-20

Oil on canvas, 24⅛ x 30⅛ in.

Signed lower left: *E Potthast*

John W. and Mildred L. Graves Collection, 1985.1

Born in Cincinnati, Ohio, Edward Potthast began working as a lithographer at the age of sixteen and continued to support himself as a freelance lithographer throughout much of his life. His formal art training commenced with evening classes at the McMicken School of Design in 1870. Between 1882 and 1889 Potthast studied painting in Europe, and combined in his work of that time the deep brown tonalities of the Munich School and the hazy rural tradition of the Barbizon School. Potthast soon discovered the French Impressionists and adopted their dissolution of form, flickering, spontaneous brushwork and interest in the fleeting everyday world.

Potthast's impressionist-inspired style was ideal for the rendition of radiant seashore scenes like *The Bathers.* Potthast made such scenes his specialty, committing himself to them so strongly that many critics dismissed him as a narrow, limited painter. However, as one contemporary commented, "when a man paints a theme as well as Potthast paints seashore subjects we forgive him for sticking to it to the exclusion of other subjects."[1]

The Bathers evokes the sunny, carefree atmosphere of middle-class urbanites vacationing on the seaside. An informally arranged group of figures is shown wading in the shallow waters off the beach. The children, with eyes closed and arms outstretched, moving blindly through the water, play a game of Marco Polo, while adults observe and converse. Behind them the mounting surf breaks into billowy white waves, their force conveyed through heavy impasto. Viewed at close range, Potthast's palette of greens, blues, and mauve would seem almost arbitrary, but from a distance these disparate shades blend effectively. The yellow highlights of the waves, coupled with the bright reds of the bathers' caps, sustain a visual momentum across the surface of the composition. Potthast submerged the identities of individual figures into an almost tangible evocation of sparkling water and sun-drenched bodies in the open air.

B.J.B.

1. Unidentified critic quoted in Arlene Jacobowitz, *Edward Henry Potthast, 1857 to 1927* (New York: Chapellier Galleries, 1969), 7.

As Ships Go Sailing By, ca. 1910-13

Oil on wood panel, 15¼ x 19½ in.

Signed lower center: *Prendergast*

On the verso: oil sketch (beach scene), ca. 1907-10

Roland P. Murdock Collection, M9.39

MAURICE BRAZIL PRENDERGAST

(1859-1924)

As Ships Go Sailing By, ca. 1910-13

In the early 1910s Maurice Prendergast painted several beach scenes depicting large crowds of promenading figures in their vibrant dresses, pastel swimming suits, and brightly colored riding togs. The title of *As Ships Go Sailing By* draws attention to the water traffic, yet the sail boats and two-masted ship, small in scale and relegated to the background, are subordinate to the figures on the beach. The narrative emphasizes their leisurely activities, which range from horse riding to sailing.

Born in Newfoundland, Prendergast grew up in Boston and, save for a number of trips abroad, remained in New England for most of his life. At the age of fourteen, Prendergast left school to take an apprenticeship under a commercial painter. Once he was himself established as a commercial artist he traveled to Europe in 1886 with his brother Charles. This first trip was brief, but five years later Prendergast returned to Paris and enrolled in the Académie Julian, where he studied for three years while sketching everyday Parisian life. During

this time the artist explored a variety of modern artistic movements, and assimilated influences from James McNeill Whistler, Edouard Manet, and Georges Seurat.

Despite changes in style over the course of his career, Prendergast consistently depicted scenes of outdoor leisure, like the one seen in *As Ships Go Sailing By*. Prendergast traveled extensively between Europe and the United States in the late 1900s and early 1910s; however, the site depicted in this painting is indeterminate. The Wichita painting may have been executed after his return to the United States in 1911 following a year-long sojourn in Paris, where he had been studying the work of Cézanne and Matisse.[1] Whether the exact location is an American or French coast is unimportant; the artist's subject suggests an idyllic world similar to those imagined both by European Post-Impressionists Seurat, Signac, and Matisse as well as American artists of the Boston School like Edmund C. Tarbell and Frank W. Benson.

Within the generalized landscape setting, the unification of color and light to establish the forms of *As Ships Go Sailing By* constitutes Prendergast's major impulse. Beginning with base tones, the artist successively layered brighter colors toward an eventual harmony. He subordinated line and emphasized the inherent energy of the mosaic-like daubs and scumbling. In fact, line only appears as traces of a base color peering through subsequent, brighter layers of paint or as an insignificant outline on the fragmentary figures.

Ellen Glavin has noted that Prendergast used color and light as key elements or "syntax" in determining the composition of his paintings.[2] The artist ordered his composition according to chosen color harmonies, and in *As Ships Go Sailing By* Prendergast structured the composition along levels of contrasting tonalities. The beach area consists largely of vertical forms in warm colors in contrast to the horizontal field of blue that defines the ocean. Above, the sky fades from a flaxen yellow at the horizon to an azure blue liberally accented with greens in the upper atmosphere. The play of tones continues within these levels; for instance, in the center of the painting a violet figure is paired with an orange one.

M.A.W.

1. Although *As Ships Go Sailing By* was dated 1917 when acquired by the Wichita Art Museum, scholars have recently proposed an earlier date of ca. 1910-1913 due to the similarity between the Wichita painting and the canvases Prendergast exhibited at the Armory Show. Cf. Carol Clark, Nancy Mowll Mathews, and Gwendolyn Owens, *Maurice Brazil Prendergast, Charles Prendergast: A Catalogue Raisonné* (Williamstown, Mass: Williams College Museum of Art and Prestel-Verlag, 1990), cat.299.

2. Ellen Glavin, "Color as Syntax," in *Maurice Prendergast* (College Park: University of Maryland Art Gallery, 1976), 166-68.

Prendergast typically reworked his images and painted on the reverse of panels/canvases. This sketch of a group of figures on a beach appears on the verso of *As Ships Go Sailing By*.

The Holiday, ca. 1918-23

In the years following the Armory Show, Prendergast moved from depictions of contemporary leisure like *As Ships Go Sailing By* to renditions of mythical subjects. These paintings, featuring large female figures and animals situated within wooden groves and parks, often alluded to classical sources, while simultaneously recalling slightly earlier prototypes like Auguste Renoir's voluptuous bathers and Arthur B. Davies's lyrical dancers. Prendergast eventually combined the classical muses and allegorical swans of these post-Armory Show works with his earlier leisure scenes. In the works like *The Holiday* that followed Prendergast's integration of these two distinct subjects, the artist transformed the classical figures into contemporary women, and transported them from imagined, exotic locales to modern seaside parks.

The Holiday no longer depicts classical goddesses but modern women clothed in summer finery, who have gathered at a park bench, accompanied by a small domestic animal that has replaced the allegorical beasts of the earlier paintings. Even though *The Holiday* replaces mythological attributes with contemporary motifs, the painting retains an idyllic quality. The static depiction of the figures and the solitude of their location conveys a feeling of tranquility, reinforced by the suggestion of leisure in the title. The figure on the left prepares to bite into an apple taken from the tree above her, possibly a reference to paradise and the Garden of Eden.

Prendergast ordered the forms of *The Holiday* through conventions of composition and color common to his paintings of this period. For example, he placed the figures in a circular arrangement, continually returning the viewer's attention to the immediate area of the park bench. In addition, the figures and trees provide a vertical counterpoint to the strong horizontal slats of the park bench and the body of water in the background. Prendergast's use of color emphasizes the figures as well. The pastels of the dresses and parasols contrast with the deeper greens and blues of the flora and water. Dark outlines separate the figures from the dense brocade of paint that might otherwise obscure their forms.

As with many of Prendergast's late works, *The Holiday* remained in the artist's studio after his death. The thick paint application and indeterminacy of several forms suggest that Prendergast may still have been working on this painting at the time of his death. The artist's fondness for color harmonies led him to rework tirelessly a single canvas, often obscuring the original design. As Nancy Mowll Mathews has observed, "The late idyllic paintings, with their visible signs of Prendergast's ceaseless attempt to improve his art, reveal an essential feature of Prendergast as an artist. . . . Even when he restricted himself to a single idyllic message of peace and harmony late in his life, he worked to improve the expression in each one even if it meant dispensing with what went on before."[1]

M.A.W.

1. Nancy Mowll Mathews, *Maurice Prendergast* (Munich: Prestel-Verlag in association with Williams College Museum of Art, 1990), 38.

The Holiday, ca. 1918-23
Oil on canvas, 32 x 39½ in.
Signed lower left: *Prendergast*
Roland P. Murdock Collection, M121.54

ALBERT PINKHAM RYDER (1847-1917)

Moonlight on the Sea, ca. 1880-90

Oil on wood panel, cradled, 11⅜ x 15¾ in.

Signed lower right of center: *A. P. Ryder*

Roland P. Murdock Collection, M72.47

Albert Pinkham Ryder was born in the whaling city of New Bedford, Massachusetts. He grew up in close proximity to New Bedford's thriving commercial districts and wharves, from which fishermen embarked on long and perilous whaling journeys. Little is known about Ryder's upbringing except that, like most of his contemporaries, he received only a grammar school education. He would have found, however, in New Bedford an abundance of cultural resources, established in part by the wealthy patrons of the whaling industry. New Bedford was also the home of a small community of artists including William Allen Wall, William Bradford, and Albert Bierstadt, an artist under whom the young Ryder may have considered studying. In the late 1860s Ryder moved to New York City and enrolled at the National Academy of Design, where he received his only formal art training.

While seeming at first to be a dark picture, *Moonlight on the Sea* gradually reveals its glowing luminosity, achieved through the layering of a variety of glazes and pigments. Ryder employed a wide range of technical methods and worked with several different media; he was known, for example, to apply coats of varnish to still-wet canvases. Such procedures contributed to the luminous effects of Ryder's paintings and endowed them with a sense of individual personality. Unfortunately, however, they also led to the further darkening of many of his canvases and extensive cracking of their surfaces.

Ryder is most noted as a painter of moonlit seascapes that combine extreme darkness with radiant luminosity. In *Moonlight on the Sea,* Ryder demonstrates his expertise at rendering softly contoured silhouettes that balance, rather than dominate the background. The masses of clouds move unyieldingly across the picture, to the relentless cadence of the waves. Similarly, the boat may symbolize the heroic, strong-willed mariner as he journeys across the water. The boat looks as if it is traveling on the brink between heaven and earth, entirely reliant on the forces of nature.

Ryder's New Bedford upbringing doubtless underpins his moonlit seascapes. Lloyd Goodrich observed that Ryder never forgot the ocean's "vastness, its eternal rhythmic flow, the majesty of its skies, its loneliness and terror, and its profound peace. In his frequent concept of a lone boat sailing moonlit waters he gives us the sea as it lives in the mind, an image of infinity and eternity, amid which the boat seems a symbol of man's journey through the unknown."[1]

S.H.

1. Lloyd Goodrich, *Albert Pinkham Ryder* (New York: George Braziller, 1959), 19.

BIRGER SANDZÉN (1871-1954)
Twilight: Cottonwood Grove and Pond, 1922
Oil on canvas, 36 x 48 in.
Signed lower left: *Birger Sandzén/1922*
Gift of the Estate of Dr. and Mrs. Ernest Seydell, 1965.11

Birger Sandzén's *Twilight: Cottonwood Grove and Pond* displays the shimmering color of a Kansas landscape at day's end. Skipping across the pond rimmed with rushes, the waning but still powerful solar rays illuminate a dense stand of cottonwoods. The tree trunks gleam like pewter, while the sun-facing leaves pale against the darkness of the lower, denser boughs that are screened from the light. Beyond, the low hills stretch beneath an iridescent bank of cumulus clouds that hovers like an elongated halo behind the clustered treetops. The pale pinks of the cloud formation shimmer on the water's surface, forming a spatial echo of color from far to near and, on the surface of the canvas, from top to bottom. Sparkling foreground pool, lush grove of trees in the middle ground, and lustrous faraway hills and sky differ in intensity of color, but are unified by the golden wash of twilight.

Sandzén employs a diverse palette in *Twilight: Cottonwood Grove and Pond,* incorporating unexpected hues like blood red, magenta, olive, and powder pink into the predictable landscape colors of greens and blues. Discretely juxtaposed on the canvas, the colors blend in the viewer's eye into the brilliance of the scene. Sandzén's brushstroke is thick and forceful but, surprisingly, was not the result of impulsive instinct: he was a cautious and methodical painter who did numerous preparatory sketches for a painting. In painting, Sandzén wielded his large brushes close to the canvas, not at arm's length, and with precision, not spontaneity.

Birger Sandzén was born in 1871 in Blidsberg, Sweden. After graduating from the Skara School he studied with the well-known Swedish painter Anders Zorn, whose approach to art, influenced by the Impressionists, stressed light, color, and textural brushwork. In 1894 Sandzén spent six months in Paris studying with the painter Edmond-François Aman-Jean, whose stylistic affinities with the Neo-Impressionist Georges Seurat also influenced the young Swede. Inspired by the book *I Sverige,* by Dr. Carl Swensson, the president of Bethany College in Lindsborg, Kansas, Sandzén wrote to the author and asked for a position, and Swensson responded with an invitation to join the faculty. Sandzén arrived in Kansas in the fall of 1894. He taught at Bethany College for fifty-two years.

In his new home, Sandzén's skills in languages, writing, and music, as well as in art, made him a highly respected member of the Bethany faculty and a venerated citizen of Kansas. Over time his painting went through a series of stylistic changes that were rooted in European sources but primarily came from his personal response to the landscape and light which differed greatly from those of his native land. Throughout his life he painted mostly landscapes of the prairie he found so inspiring, with a few still-lifes and portraits. He traveled extensively over the plains and also painted in the Rocky Mountains and the Southwest.

Twilight: Cottonwood Grove and Pond, executed in 1922, dates from a decade that critics have described as an apex in Sandzén's career. Its rough yet welcoming portrayal of the landscape, however, is characteristic of the love of nature that pervades all his work.

J.C.

ZOLTAN SEPESHY (1898-1974)
Farm Land, 1938
Watercolor on paper, 17¼ x 21½ in.
Signed lower left: *Z. Sepeshy*
Roland P. Murdock Collection, M17.41

Zoltan Sepeshy was born in 1898 in Kassa, Hungary. After graduating from high school, he attended the Royal Academy of Art in Budapest, where he earned Master's degrees in art and art education. Sepeshy continued his studies in Vienna and Paris and traveled extensively in Germany and Italy.

In 1921 Sepeshy immigrated to the United States. After several months in New York he moved to Detroit to live with his uncle. There, because he spoke no English, Sepeshy was forced to earn a living working in lumberyards and sweeping barbershop floors. Eventually he found work at an advertising agency and an outdoor sign company where he could put to use his artistic training. During this time he also painted pictures which he sold to members of Detroit's Hungarian community. The patronage of these countrymen enabled Sepeshy to earn enough money to travel west to New Mexico. During the early months of 1922 he lived in Taos and associated with such artists as Ernest Blumenschein, Walter Ufer, and John Sloan.

Soon after Sepeshy returned to Detroit in late 1922 his work began to attract the admiration of art critics. He won first prize in an exhibition of Michigan artists and gained national exposure through a favorable review in the *Christian Science Monitor.* The local art community quickly noticed Sepeshy's success and soon he was in demand as a painter and teacher. In 1926 Sepeshy was appointed painting instructor at the newly founded Detroit Society of Arts and Crafts. In 1930 he accepted a position as instructor at the Cranbrook Academy of Art in Bloomfield Hills, Michigan, nineteen miles north of Detroit. He became Cranbrook's resident-artist in 1933 and in 1947 its director. In 1959 he was given the title of president, which he held until his retirement in 1966. Sepeshy died in Royal Oak, Michigan in 1974.

Sepeshy's art defies easy classification. He painted still lifes, portraits, and landscapes, with the latter depicting rural, urban and imaginary scenery. Though his style is predominantly realistic, his oeuvre also includes many works in which the subjects have been distorted and abstracted. Sepeshy assimilated influences from a wide variety of modern artists, including Cézanne, Picasso, Hopper, Benton, Wood, and Dalí. Sepeshy purposely worked in different styles and challenged the idea that an artist needed to belong to one specific group. Instead he contended that "art arises from the common needs and aspirations of all men and that compartmentalization is a hindrance to its growth."[1]

In *Farm Land* Sepeshy depicts a verdant agrarian landscape in which traces of human presence are suggested by a road in the foreground that leads to a cultivated field and an orchard. Space rises steeply to a high horizon while a row of vegetation delineates the foreground. Sepeshy employs a broad variety of watercolor techniques to define different areas of the painting. Earth colors dominate, expressing the fertility and abundance of the land. Given the fact that Sepeshy often drew direct inspiration from other artists, *Farm Land* may be interpreted as his approving acknowledgement of the accomplishments of Regionalists like Benton and Wood, who, in their work of the 1930s, also celebrated agricultural life in the Midwest.

J.A.S.

1. Sepeshy quoted in Laurence Schmeckebier, *Zoltan Sepeshy: Forty Years of His Work* (Syracuse: The School of Art, Syracuse University, 1966), 33.

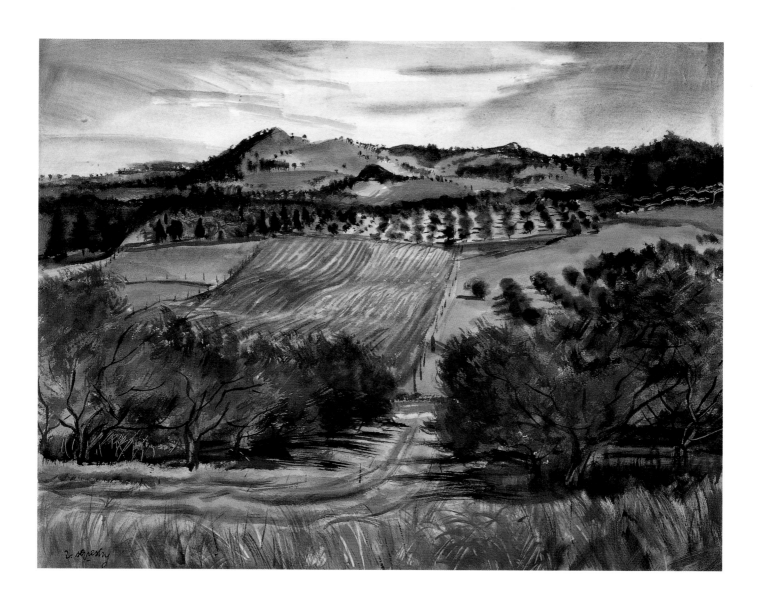

BEN SHAHN (1898-1969)

The Blind Botanist, 1954

Tempera on masonite, 52 x 31 in.

Signed lower center: *Ben Shahn*

Roland P. Murdock Collection, M137.55

Born in Kovno, Lithuania, in 1898, Ben Shahn immigrated to Brooklyn in 1906. After working as a lithographer's apprentice, Shahn studied biology at New York University, but he eventually returned to his childhood interest in art through studies at the City College of New York and the National Academy of Design. Shahn's 1932 exhibition of paintings about the controversial Sacco and Vanzetti trial established his reputation as a politically-engaged artist. During the Depression he worked for the Farm Security Administration as a painter and photographer documenting rural life. Shahn designed posters for the Office of War Information during World War II, and created graphics for the Political Action Committee of the Congress of Industrial Organizations. After the war Shahn exhibited internationally, and was well-known as an advocate for human rights.

The Blind Botanist of 1954 portrays an elderly, sightless, black-suited man seated in a wiry red chair and grasping a thorny green vine. The painting dates from the post-war period when Shahn's work shifted from social realism, which addressed specific issues, to "personal realism," which was both universal and ambiguous in its content.[1] In answer to a query about *The Blind Botanist*'s meaning, Shahn stated: "My own concern was to express a curious quality of irrational hope that man seems to carry around with him, and . . . to suggest the unpredictable miraculous vocations which he pursues."[2]

When Shahn returned to the same image in graphic work in the early 1960s, he included on two prints a quotation from Robert Hooke's *Micrographia* of 1664:

So many are the links, upon which the true philosophy depends, of which if one be loose or weak, the whole chain is in danger of being dissolved; it is to begin with the Hands and Eyes, and proceed on through the memory; to be continued by the reason; nor is it to stop there, but to come to the Hands and Eyes again . . .[3]

These cautionary words are taken from Hooke's book on the wonders of the microscope, an important work in the burgeoning scientific climate of the seventeenth century, which Shahn had probably come to know through his study of biology. Shahn was deeply concerned about contemporary experimentation; he was active in the peace movement, and made posters advocating the banning of nuclear testing. On 1 March of 1954, the year *The Blind Botanist* was painted, the United States detonated a hydrogen bomb with catastrophic results: the crew of a nearby Japanese ship suffered deadly radiation poisoning. In the early 1960s, at the same time as his return to the blind botanist imagery, Shahn created illustrations for an article in *Harper's* magazine about this appalling event. In *The Blind Botanist,* the image of the oblivious scientist whose huge hands support the threatening specimen serves as a visual echo of Hooke's admonition for prudence in scientific experimentation.

The Blind Botanist, engaging in its simplicity, is a mysteriously potent work by the artist, who said, "If the sense of the painting is fugitive, that is as I have wanted it; I hope that the explanation itself will not be too fugitive, but still a little so."[4]

J.C.

1. Ben Shahn, *The Shape of Content* (Cambridge, Mass.: Harvard University Press, 1957), 40.

2. Ben Shahn, letter to Elizabeth S. Navas, 7 March 1955, registrar's files, Wichita Art Museum.

3. For Shahn's prints of the blind botanist theme, see Kenneth W. Prescott, *The Complete Graphic Works of Ben Shahn* (New York: Quadrangle, 1973), 47-52. Shahn's exact rendition of the quote from Hooke is cited on p. 48.

4. Shahn to Navas, 7 March 1955.

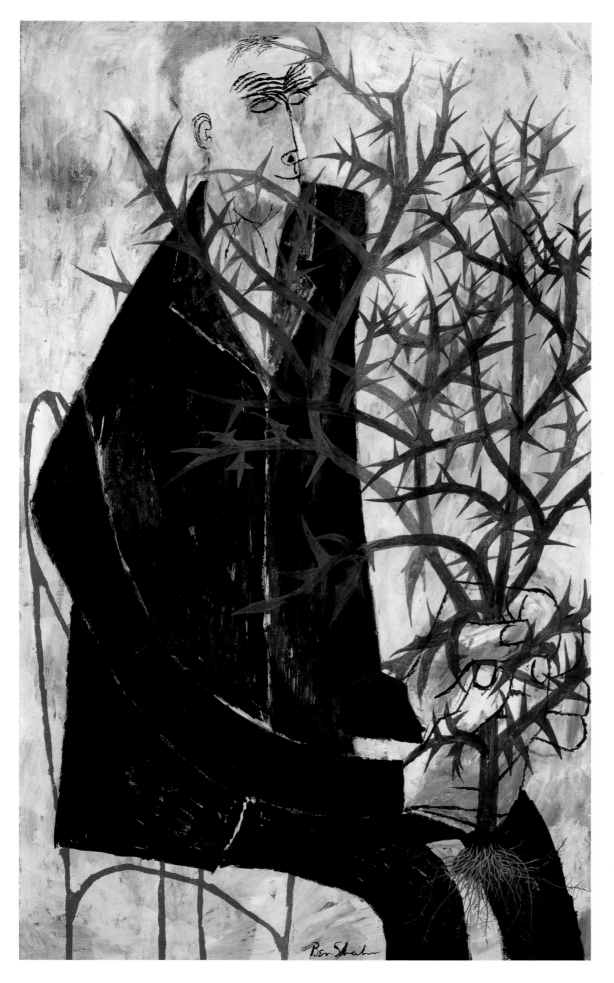

CHARLES SHEELER (1883-1965)

Skyline, 1950

Oil on canvas, 24⅛ x 40⅛ in.

Signed and dated lower right: *Sheeler - 1950*

Roland P. Murdock Collection, M104.52

Whether he was painting skyscrapers, collecting Shaker furniture, or designing flatware, Charles Sheeler always sought clarity of design and simplicity of form. This Precisionist aesthetic developed in Sheeler's art during the 1910s, when he was working in the most progressive artistic circles of New York. Sheeler had by this time moved well beyond his academic training at the Pennsylvania Academy of the Fine Arts in his native Philadelphia, where from 1903-6 he had learned to paint in the fluid, impressionistic style of his teacher William Merritt Chase.

In contrast to Chase's emphasis on palpable brushwork, Sheeler came to believe in the removal of "the method of painting as far as possible from being an obstacle in the way of consideration of the content of the picture."[1] In photography, Sheeler found an alternative means of expressing his artistic convictions. In addition to providing him with lucrative commercial opportunities, photography proved to be an ideal medium for exploring objective forms while concealing Sheeler's artistic presence.

In his paintings as well as in his photographs, Sheeler never forgot that he was working in two dimensions. In this respect, the Cubists who exhibited at the 1913 Armory Show had a profound influence on the artist, providing him with a method for reconciling three-dimensional forms with a two-dimensional surface. For the duration of Sheeler's career, the abstract and the realistic existed side by side in his work, in accordance with his belief that "pictures realistically conceived might have an underlying abstract structure."[2]

Skyline is part of a series of paintings from the early 1950s in which Sheeler returned to a theme he had explored thirty years earlier. In both series, Sheeler first recorded New York skyscrapers in photographs, which he then transposed into simplified and more abstract views in his paintings. In *Skyline,* the objective content has become inseparable from the formal, two-dimensional structure of the canvas. The shadows of the buildings, for example, suggest a recession into space, but they also defy that recession by acting independently, flattening space even as they create it. Sheeler's foremost artistic concerns find expression in *Skyline:* the artist's presence is lost behind the meticulous construction and unblended colors; forms have been reduced to two-dimensional abstractions; yet all is grounded in an actual (and originally even photographic) view of New York.

M.P.G.

1. Charles Sheeler quoted in *Charles Sheeler: Paintings, Drawings, Photographs* (New York: The Museum of Modern Art, 1939), 10.

2. Ibid.

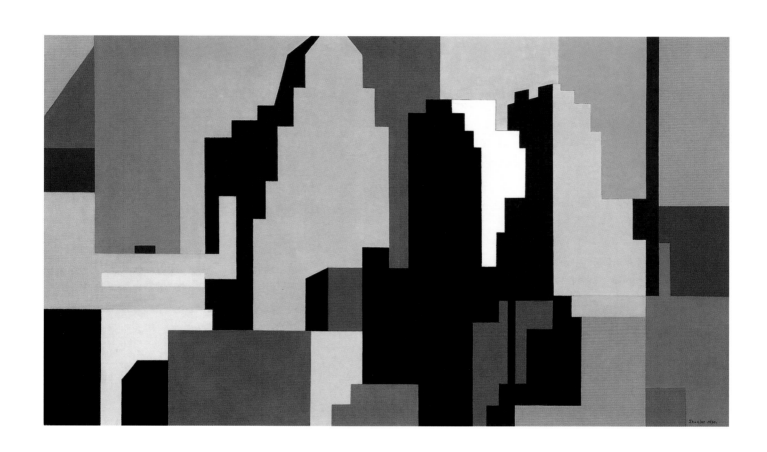

EVERETT SHINN (1876-1953)
The Monologist, 1910
Pastel on paper, 8¼ x 11¾ in.
Signed and dated lower right: *Everett Shinn/1910*
Roland P. Murdock Collection, M22.41

One of the founding members of The Eight, a group of artists who rebelled against the conservative artistic establishment in America during the early 20th century, Everett Shinn is best known for his depictions of theatrical subjects. Born in Woodstown, New Jersey, Shinn studied industrial design before deciding to become an artist. In Philadelphia from 1893 to 1897, Shinn met future members of The Eight William Glackens, George Luks, John Sloan and Robert Henri, while he studied at the Pennsylvania Academy of the Fine Arts and worked as an illustrator for the *Philadelphia Press.* In 1897 Shinn moved to New York, where his varied career would include working in pastel and oil, painting murals, decorating furniture, illustrating magazines, designing movie sets, and writing, performing and producing vaudeville shows. Shinn's interest in the stage dated to his student days in Philadelphia, where he performed plays in Henri's studio. In New York, Shinn built a small playhouse in his home that could accommodate an audience of fifty-five. There, Shinn wrote, directed, produced, and designed sets for comic dramas.

Shinn's experience covering the modern scene as a newspaper and magazine illustrator taught him to regard the city as a worthy subject for his paintings and pastels. This interest in the crowded streets and such urban entertainments as the ballet and the theater is akin to that of the French Impressionists Edgar Degas and Jean-Louis Forain, whom Shinn and his circle of friends in Philadelphia had long admired for their lively illustrations of contemporary Parisian life. A trip to Europe in 1900 provided him with first-hand knowledge of the works of these and other French Impressionists; sketches and studies from Paris and London supplied Shinn with a reserve of subjects he would continue to draw upon long after he had returned to New York.

The influence of Degas and Forain is suggested in *The Monologist*'s theatrical subject, surprising viewpoint, asymmetrical composition, and pastel medium, though the thick, juicy surface of Shinn's picture contrasts with the characteristic dustiness of pastel. Shinn's performer appears in comic costume, with too-short pants that reveal his bare ankles, and casual, slipper-like shoes that clash with his more formal tails and top hat. He props himself up with a chair in one hand and an umbrella in the other as he addresses the audience. A bold yellow band at the edge of the stage cleaves the canvas and separates the vaudeville entertainer from his audience and the piano player at lower right. Shinn renders the crowd with quick, simple gestures. Facial features are limited to black smudges in the front row that define eyebrows, lips, and chins, while, beyond the front row, faces appear only as a blur of swirling ovals.

D.J.W.

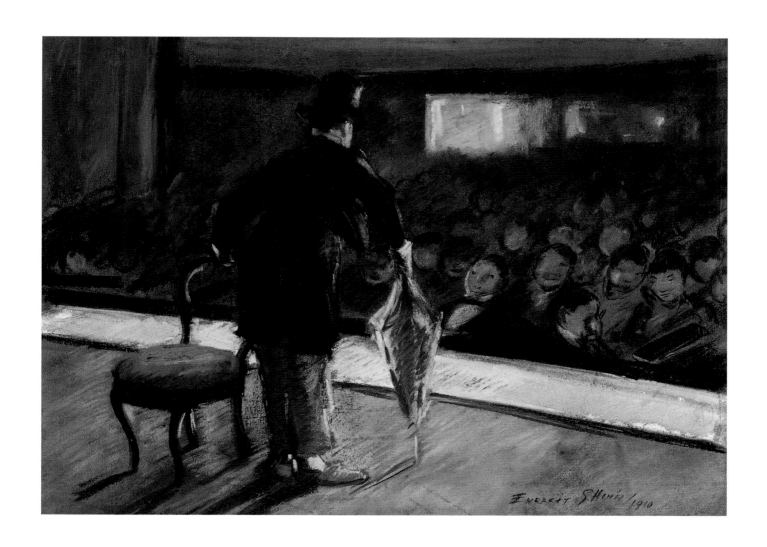

Hudson Sky, 1908
Oil on canvas, 26⅛ x 32⅛ in.
Signed and dated lower left: *John Sloan - 1908*
Roland P. Murdock Collection, M5.39

JOHN SLOAN (1871-1951)

Hudson Sky, 1908

Born in Lockhaven, Pennsylvania, John Sloan moved at an early age to Philadelphia, where he spent most of his early life. A self-taught illustrator and letterer, Sloan attempted a career as a freelance artist before the need for a more stable source of income led him to join the staff of the *Philadelphia Inquirer* in 1892. In 1895

Sloan moved to the *Philadelphia Press,* where he developed friendships with fellow staff illustrators William Glackens, George Luks, and Everett Shinn. In addition, Sloan enrolled in night classes under Thomas Anschutz at the Pennsylvania Academy of the Fine Arts, where he also met Robert Henri.

In 1904 Sloan, secure in his accomplishments and reputation as an illustrator, followed his *Press* colleagues to New York City, where he once again sought work as a freelance artist. Sloan found the

New York cityscape and its inhabitants to be ideal subjects for his oil paintings, watercolors, and etchings. While these works were critically successful, the artist was continually disappointed by the slow sales of his new work. His peers at the National Academy of Design disparaged his work as well; selection committees at Academy exhibitions often hung his paintings in high corners or rejected them altogether. Following Henri in a boycott of the National Academy exhibition of 1907, Sloan and his Philadelphia colleagues, joined by Arthur B. Davies, Ernest Lawson, and Maurice Prendergast, held an independent exhibition at the Macbeth Galleries in February of 1908. Sloan played a major role in the organization of this exhibition of the group the critics dubbed "The Eight."

In June of 1908, Sloan left New York for Coytesville, New Jersey. There, working on nine-by-eleven-inch canvases, he painted a series of landscapes on the Palisades. These were the first landscapes Sloan had painted outdoors in eighteen years. Most of them can be described as oil sketches of the atmospheric conditions prevailing over the Hudson River and distant Manhattan. In his diary entry of 16 June, Sloan wrote: "This morning the weather was clear, the sky filled with big clouds. I made a first sketch from the top of the Palisades looking down at an apron of ground."[1] Sloan wrote three days later that "The cliffs below and New York across the river are limitless in the interesting effects of light and haze."[2] *Hudson Sky* was likely worked up from the oil sketch Sloan describes in his diary.

The large cloud formation and the cool blue of the sky dominate the painting. As the orthogonals of the cloud banks recede, a large wall of rock on the left bridges the division between the sky, the horizon line of the landscape, and the river, compositionally unifying the blues of the sky and water with the earth tones of the land. Sloan also echoes this unification through the steam of a distant ship across the river. Except for the receding clouds and the minimal use of atmospheric perspective, the artist seems unconcerned with establishing depth in his landscape, which reads as a flat surface. This surface flatness is accentuated by the activity of Sloan's brushwork, particularly vibrant in the foliage of the Palisades. Thus, the painting maintains a delicate balance between the suggestion of illusionistic space and the indication of the artist's painterly performance. *Hudson Sky* and the other Palisades landscapes, in their inclination toward flatness and their emphasis on bold brushwork, predict the same qualities that are more pronounced in Sloan's later, better-known Gloucester landscapes.

M.A.W.

1. John Sloan, 16 June 1908, in Bruce St. John, ed., *John Sloan's New York Scene: From the Diaries, Notes, and Correspondence 1906 - 1913* (New York: Harper & Row, 1965), 226.

2. Sloan, 19 June 1908, ibid., 227.

Indians on Broadway, 1914

Only a year after losing his job at the *Philadelphia Press* in 1903, John Sloan moved to New York City, where the demand for illustrators had lured many of his friends several years before. Soon after his arrival, Sloan found work as a freelance illustrator for several magazines, including *Collier's* and *The Century*. Freelance work was not steady, however, so Sloan, armed with his portfolio, began making the rounds of local publishers. It was during these trips that Sloan apparently discovered the people, places, and daily foibles of New York for the first time. This "everyday world" of New York, as Sloan called it, captivated the artist and quickly became his favorite subject of study.[1]

Sloan's interest in the "noble commonplace of nature"[2] took a political turn in 1908 when one of his friends introduced him to socialism. Although he had once defiantly announced that "I am not a Democrat, I am of no party," Sloan was soon preaching the ideals of socialism to anyone who might listen.[3] "I tried to convert him to Socialism," Sloan later wrote of an encounter with a truck driver, "but he is of the contented sort. Has a little home of his own, etc. No revolt in him."[4]

From 1912 to 1916, Sloan contributed to and served on the editorial board of *The Masses,* a magazine supportive of socialist ideals. Working for *The Masses* liberated him from the stifling restrictions of commercial interests that dictated his work as a freelance illustrator. *Indians on Broadway,* which appeared in *The Masses* in July, 1914, is not the heavy-handed propaganda of a proselytizing socialist, however, but a witty and satirical portrait of New York life. The drawing was inspired by an event Sloan witnessed during one of his strolls through the city, which he describes in his diary on 29 January 1907: "Coming back met Kirby and went to Durand-Ruel Galleries to see Monet's several fine things. Foolishly, brazenly, modernly dressed women laughing at the costumes of squaws who pass Fifth Avenue corner of 34th Street. The squaws seemed the more rationally rigged."[5]

In Sloan's drawing, a procession of Native Americans passes through a crowd of New Yorkers who have gathered to watch the parade. The subject of the spectacle, however, is nearly obscured by the conspicuously fashionable spectators who crowd around the Native Americans in a claustrophobic phalanx. The hats of the two women in the center of the painting appear to sprout strange appendages and contrast with the Native Americans' regal headgear. On the right side of the drawing, a boy holds his hand to his mouth, mocking the Native Americans' war whoop in a clichéd gesture. Drawn in profile, the Native Americans possess an air of stoicism and dignity—qualities conspicuously absent in the stylish crowd. Subtle but hardly tame, Sloan's pithy send-up of New York's *haute culture* is a fine example of his powers as a satirist and a self-described "spectator of life."[6]

M. W.

1. John Sloan quoted in Helen Farr Sloan, ed., *John Sloan: New York Etchings (1905-1949)* (New York: Dover Publications, Inc., 1978), viii.

2. Ibid., xi.

3. John Sloan quoted in Whitney Museum of Art, *John Sloan, 1871-1951* (New York: Plantin Press, 1952), 41.

4. Ibid.

5. Bruce St. John, ed., *John Sloan's New York Scene: From the Diaries, Notes, and Correspondence 1906-1913* (New York: Harper & Row, 1965), 101.

6. John Sloan quoted in Helen Farr Sloan, ix.

Eve of St. Francis, Santa Fe, 1925

In 1919 John Sloan, at the urging of his close friend Robert Henri, made his first trip to Santa Fe, New Mexico. Upon his arrival he was enthralled by the Pueblo Indian, Hispanic and Anglo populations and by the beauty of the Southwestern landscape. The following year Sloan established a home and studio in Santa Fe where he resided most summers until his death in 1951.

Like many other Anglo-European artists associated with the Santa Fe and Taos art colonies, Sloan found a compelling subject in the unique religious customs of the local people. He depicted Roman Catholic ceremonies and, in particular, holy-day processions. Commenting upon *Eve of St. Francis, Santa Fe,* Sloan noted that the "eve of the patron saint's day is marked by a beautiful night procession leaving the cathedral in the background."[1] The occasion to which Sloan refers is not the official Feast day of St. Francis of Assisi on 4 October, but rather, a less common celebration honoring St. Francis on the eve of 2 August. Early Spanish settlers brought the tradition to New Mexico, while the Penitentes or flagellant brotherhood—an outgrowth of the Third Order of St.

Indians on Broadway, 1914
Crayon, pen and ink on paper, 21¼ x 14⅞ in.
Signed and dated lower left: *John Sloan 1914*
Roland P. Murdock Collection, M107.52

Francis—oversaw its continuation in the area.[2]

The principal ceremony that Sloan depicts in *Eve of St. Francis, Santa Fe* consists of an outdoor procession that starts from the church's main entrance and winds around the grounds. Groups of female worshippers move along in two single files while reciting prayers and singing hymns. The crucifix heads the procession, whose course is highlighted at intervals with bonfires. The bonfires eerily animate the architecture against the dark blue-black sky. Shades of blues and pinks reflect off the windows and highlight the textures of the Romanesque-Byzantine style Cathedral of St. Francis and the adobe walls of the adjacent rectory.

Although spatially the buildings occupy a greater portion of the canvas, the participants' activity remains the focal point of the scene. Sloan's selective use of bright and pure color individualizes the women and children in the foreground, underscoring their variety in age, dress, and degrees of piety. The conservative older women wear black fringed shawls while the younger majority sport stylish coats and hats. A young girl dressed in orange looks directly out and engages the viewer, as if acknowledging the sense of spectacle that permeates the scene. Due to her youth, she, like the uninitiated spectator, does not fully participate in the religious rite. The space that separates this child from the devout woman who bows her head and grasps her rosary beads at the head of the procession might symbolize the possibility that traditional beliefs and practices could wane with the passing of the older generations.

Although Sloan's picture should not be viewed as an explicit social commentary, the painter did have a genuine concern for the perpetuation of local customs in the Santa Fe area, whose ethnic and cultural richness Sloan championed in his life as well as in his art.

K.A.M.

1. John Sloan, *Gist of Art* (New York: American Artists Group, Inc., 1939), 279.

2. Henning Cohen and Tristram Potter Coffin, eds., *The Folklore of American Holidays* (Detroit: Gale Research Company, 1988), 255-56.

Eve of St. Francis, Santa Fe, 1925

Oil on canvas, 30⅛ x 40⅛ in.

Signed lower left: *John Sloan*

Roland P. Murdock Collection, M83.50

LAWRENCE BEALL SMITH (1909-1995)
Ring Around the Chimney, 1939
Oil on canvas, 25⅛ x 30⅛ in.
Signed and dated lower right: *LAWRENCE BEALL SMITH '39*
Gift of the Friends of the Wichita Art Museum, Inc., 1981.20

Lawrence Beall Smith was born in Washington, D.C. He studied at the University of Chicago and at the School of the Art Institute of Chicago. In the early 1930s Smith moved to Boston and continued his studies at the Boston School of Fine Arts. Smith lived in Boston until the 1950s when he moved to Cross River, New York, north of New York City. There he worked primarily as a book illustrator.

Smith's *Ring Around the Chimney* pictures the impact of industrialization on lower class urban life in the United States. Smith depicts the billowing smoke from the city's industrial sprawl as the backdrop for an intimate human incident that takes place on a tenement rooftop. The sooty upsurge from the city clearly contrasts the clean laundered clothes that an anonymous woman hangs on a line while talking with a friend. The rooftop setting is dominated by a wide brick chimney that provides a domestic bulwark against the encroachments of the industrial world. The two women direct their attention to a small, plump toddler who plays a game around the chimney. By focusing on this playful incident, Smith evokes a positive sense of community within the harsh urban environment.

Smith was far from alone in recording lower class urban life during the years of the Great Depression. But in contrast to the less optimistic paintings of contemporary Social Realist artists such as Ben Shahn and Raphael Soyer, Smith's picture celebrates the strength of the human spirit in the face of hardship. Through its positive portrayal of an everyday incident of lower class urban life, Smith's painting testifies to the lingering influence of the Ashcan School in later American painting.

M.R.

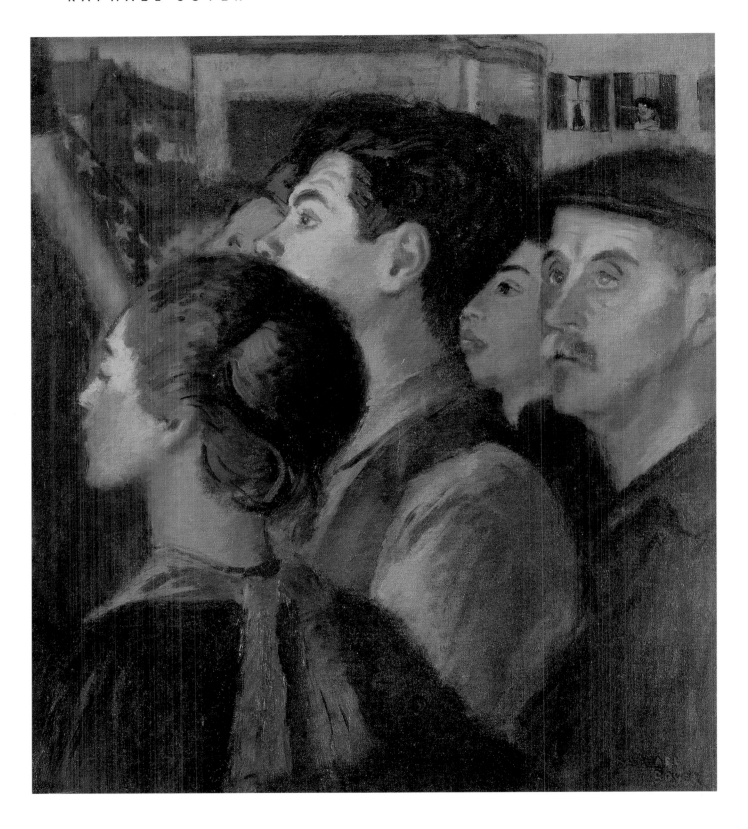

RAPHAEL SOYER (1899-1987)
The Crowd, 1932
Oil on canvas, 25⅝ x 22¾ in.
Signed lower right: *RAPHAEL SOYER*
Gift of KAKE-TV in honor of Martin Umansky, 1982.6

Raphael Soyer's *The Crowd* is a fragment of a larger composition entitled *Union Square* that originally depicted a street orator speaking at a neighborhood rally. The full painting was damaged and Soyer chose to preserve this segment of listeners. Neighbors and acquaintances of Soyer modeled for the four most prominent figures in the composition. Soyer described them as "an art student whose name I have forgotten. . . Danny Cohen, a talented artist who died at the age of 24. . . Sylvia, a dancer. . . and the super of the building where my studio was."[1]

Raphael Soyer was born in Tombov, Russia in 1899. As a young boy, he immigrated to the United States with his family, and grew up in various lower class neighborhoods in New York City. Along with his brothers Isaac and Moses, Raphael began several years of formal training at the National Academy of Design in 1919. He also studied at the Art Students League in 1920-21 under Guy Pène Du Bois, who ultimately encouraged Soyer to work independently. "As soon as I left the Academy," Soyer wrote in 1946, "I made a conscious effort to forget everything I had learned there. . . . I really started from the beginning again and painted in a frank and almost naive manner subjects of ordinary interest that were part of my immediate life."[2] For the next several years he worked primarily at home, where he painted portraits of his family and cityscapes of his Bronx neighborhood. Soyer had his first one-man show at the Daniel Gallery in 1929. This show was well-received, as were Soyer's exhibitions throughout the subsequent decade of the Great Depression. Though the Depression had little financial effect on Soyer, it did mark the onset of his involvement in the John Reed Club, a left-wing organization whose artist members staged demonstrations and created social protest murals. Soyer's activism in the John Reed Club reaffirmed his strong identification with the plight of the unemployed and underprivileged.

Despite his radical political beliefs, *The Crowd* is, according to Soyer, one of only two paintings he created under the direct influence of the John Reed Club.[3] Very few of Soyer's works, in fact, deliver political propaganda. Rather, Soyer delighted in the portrayal of the underprivileged and the changing spectacle of the streets—themes of homelessness, unemployment, and poverty in the context of urban life. No stranger to the hardships of city life, Soyer identified with human suffering and held great admiration for the human character.

In *The Crowd,* the younger audience members look with hope and anticipation in the direction of the stage. By contrast, the older man appears weary, as if he has heard these same words before. This painterly work is suffused with a glow that conveys a hint of optimism and animates the otherwise drab palette of oranges and browns. Neither a critical nor a satirical portrayal, *The Crowd* typifies Soyer's familiarity with urban subjects and his commitment to exploring the human condition.

S.H.

1. Raphael Soyer, undated letter to Howard E. Wooden, 1982, registrar's files, Wichita Art Museum.

2. Raphael Soyer, *Raphael Soyer* (New York: American Artists Group, 1946), 1.

3. Ellen Wiley Todd, *The "New Woman" Revised: Painting and Gender Politics on Fourteenth Street* (Berkeley: University of California Press, 1993), 127.

NILES SPENCER (1893-1952)

Signal at Highland, ca. 1940

Oil on canvas, 30⅛ x 24¼ in.

Signed lower left: *NILES SPENCER*

Roland P. Murdock Collection, M23.41

Niles Spencer was born in Pawtucket, Rhode Island. After graduating from the Rhode Island School of Design in 1915, Spencer continued his studies under Hamilton Easter Field at the Perkins Cove Art Colony in Ogunquit, Maine. Field's eclectic curriculum, which embraced native folk arts as well as the art of the European avant-garde, had a profound effect on Spencer's own art. The flattened, simplified forms of the colonial American limners and the sparse, unadorned beauty of Shaker furniture became a model of aesthetic simplicity and rigor that Spencer emulated in his own reductive canvases.

Spencer was also influenced by the work of Cézanne, which he saw in New York in the winter of 1915-16. Spencer's recollection of a winter scene that inspired one of his early paintings clearly recalls the spirit of Cézanne's own work: "the contact with the winter scene. . . when the underlying structure of the whole landscape stood out so clearly, affected the whole direction of my work."[1] In *Signal at Highland,* Spencer's interest in simplification and structure are manifest in the manner in which the building, the fence and even the path resolve themselves into a matrix of horizontal and vertical lines.

Like the work of the Precisionists, with whom he is most often associated, Spencer's oeuvre primarily consists of urban and industrial landscapes occupied by skyscrapers, factories, smokestacks and storage tanks. The lonely signal tower in *Signal at Highland,* however, belongs to a smaller group of paintings by Spencer that address the rural New England landscape. The subject of the painting is most likely a wireless radio station that once stood adjacent to the Highland Lighthouse on the Cape Cod peninsula near Truro.[2] Spencer has not made a literal representation of the site, however, but has translated the subject into his own pictorial language. What is remarkable about *Signal at Highland* is the mysterious and melancholic mood that pervades the painting. In several areas of the composition, Spencer supplants the clinical brushwork and unmodulated colors characteristic of Precisionism with looser paint handling and a more brooding palette. Hence, the heavy gray clouds that occupy more than half of the picture, rendered in a loose, painterly manner, counteract the hard geometric forms and flat colors of the building in the center of the painting.

Painted on the eve of World War II, the ominous clouds and dark palette may symbolize the bleak mood of the country at the beginning of the war. Read in this manner, the signal tower appears to be a stalwart sentinel or outpost on the front lines of the Eastern seaboard. The nature of the signal referred to in the title remains unclear, however, lending the painting another degree of mystery.

M. W.

1. Niles Spencer, statement in *Museum in Action, Presenting the Museum's Activities* (Newark, N.J.: The Newark Museum, 1944), l35.

2. Joan Hopkins Coughlin, letter to the author, 18 April 1995.

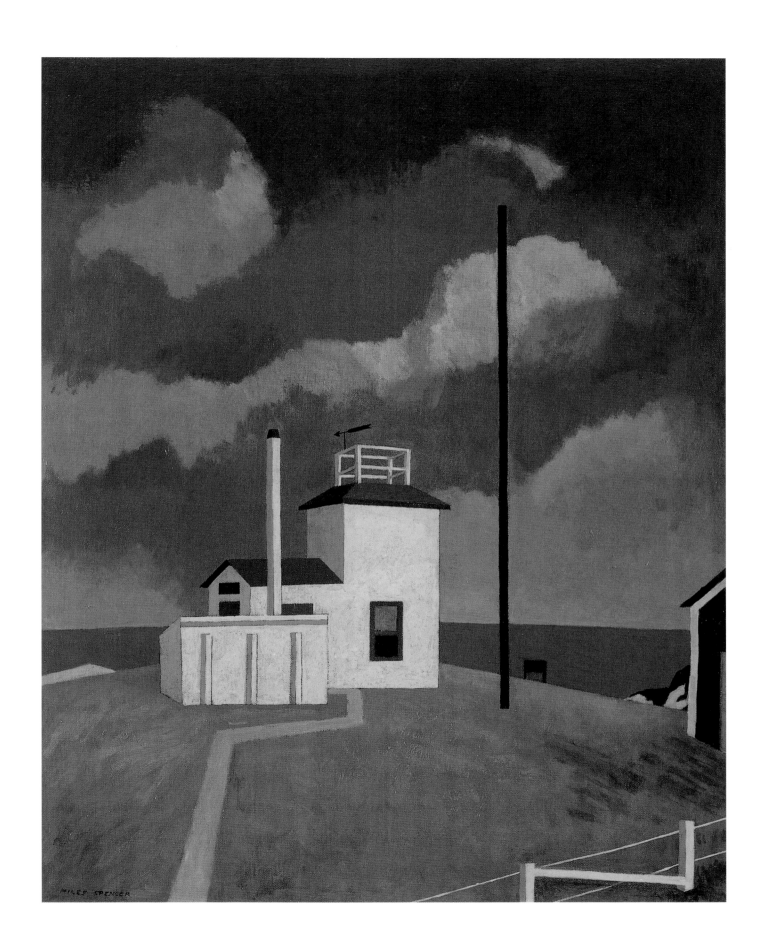

MARK TOBEY (1890-1976)

Golden Gardens, 1956

Tempera on paper on panel, 35¼ x 44¾ in.

Signed and dated lower right: *Tobey/56*

Roland P. Murdock Collection, M159.60

Like the steady tempo of a metronome underlying a musical score, Mark Tobey creates a rhythmic pattern within his composition through vertical columns of yellow-white pigment. These vaporous swipes of the brush have no clear referent, and could be based on the measures of music, the slats of a white picket fence, or the pallid trunks of trees. The bottom third of the painting functions as a foreground to this abstract scene, while small swatches of paint shift and float, flickering in the golden light like autumn leaves. Do they represent the foliage of some Arcadian glen, the matted grasses and flowers that grow up around small white fences, or are these notes in Tobey's musical score?

Golden Gardens physically embodies the artist's ideas, beliefs, and values, which were not as easily expressed through representational means. Tobey has been called the "Northwest Mystic," and the "Sage of Seattle,"[1] in part because he chose Seattle as his home, but also because he was a spiritual practitioner of the Baha'i World Faith. Baha'i is a Persian religion that strives for universality and emphasizes the oneness of humanity. It attempts to reconcile the doctrines of the major world religions into a universal faith. Quoting Bahá'u'lláh, the prophet and founder of Baha'i, Tobey declared, "The East and West will embrace as long-lost lovers."[2] In his paintings these two aesthetic styles do exactly that. Both Chinese and Japanese calligraphy were very influential for Tobey's painting, and he was first introduced to these forms in 1923 through his mentor Teng Kwei, a Chinese calligrapher. After experiencing this centuries-old aesthetic, Tobey stated, "I need only take one step backward into the past, and the tree in front of my studio in Seattle is all rhythm, lifting, springing upward!"[3] Following this turning point, and especially after his 1934 travels to the Far East, Tobey's forms evolved from solidity and stasis to shifting, changing entities emphasizing process over subject. This is especially true of his famous calligraphic "white writing" paintings, but *Golden Gardens* also reveals a grounding in Asian aesthetic traditions. "The tree," wrote Tobey, "is no more a solid in the earth, breaking into lesser solids bathed in chiaroscuro."[4]

Tobey was born in the small Midwestern town of Centerville, Wisconsin. As an artist he was mostly self-taught, although he did attend Saturday classes at the Art Institute of Chicago in 1906. Tobey is often compared to the Abstract Expressionists, notably Jackson Pollock, but his geographic base in Seattle, slightly earlier maturity, and the greater delicacy of his art, separates him from these New York painters. Scholars have even gone so far as to identify him as the leader of a "Pacific School" of painting and for much of his life he was a teacher, although no formal school or movement arose around him as such a label would suggest.

In addition to painting and teaching Tobey composed music and poetry. He played the piano and wrote several musical compositions. It is tempting to read *Golden Gardens* as an abstracted sheet of music complete with staffs, measures, and notes. Tobey's poetic skills also influenced his paintings and are manifest in his lyrically evocative titles. A title like *Golden Gardens* is aesthetic and descriptive, yet remains ambiguous. It allows the painting to at once represent the misty landscape of Seattle, the visual realization of music, or a tranquil Japanese garden, thus creating a universal image consistent with the spiritual lessons of Baha'i.

S.A.S.

1. William C. Seitz, "Tobey's World View," in *Mark Tobey: Art and Belief* (Oxford: George Ronald, Publisher, 1984), 15.

2. Ibid.

3. Quoted in Wieland Schmied, *Tobey,* trans. Margaret L. Kaplan (New York: Harry N. Abrams, Inc., 1966), 12.

4. Quoted in Arthur L. Dahl, "Mark Tobey, 1890-1976," in *Mark Tobey: Art and Belief,* 5.

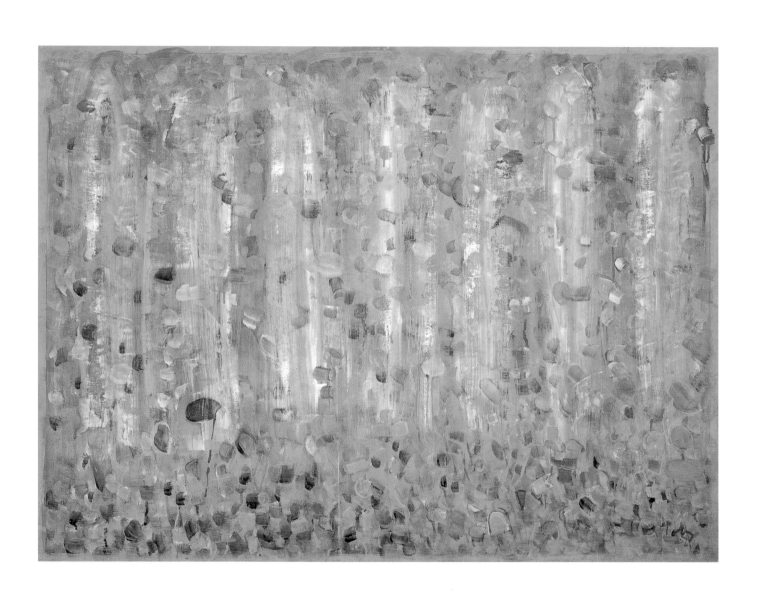

JOHN H. TWACHTMAN (1853-1902)

Falls in January, ca. 1895

Oil on canvas, 25 x 30⅛ in.

Signed lower right: *J. H. Twachtman -*

Roland P. Murdock Collection, M44.43

Never is nature more lively than when it is snowing. Everything is so quiet and the whole earth seems wrapped in a mantle. . . . all nature is hushed to silence.[1]

Written in 1891, John Twachtman's words capture the mood he evokes visually in his many snow-scenes of rural Connecticut. Twachtman painted *Falls in January* at his farm in Greenwich, taking as his subject a small cascade in Horseneck Brook, a stream that flowed through the artist's property and which he painted often, under a variety of seasonal conditions.

In *Falls in January,* thick impastos suggest an accumulation of snow and ice, while linear brushstrokes imitate falling and swirling water. But even as the brushwork suggests nature, its assertive physical presence exposes Twachtman's artifice. And even though we can almost hear the quiet trickle of a brook encased in snow and ice, we are also drawn to the painting's abstract design. The artist has focused so closely upon the waterfall that we find it difficult to establish a foothold within this natural scene; and so strongly are we attracted to the surface patterns that our eyes are constantly brought back to the flat plane of the canvas. The result is a tension between an illusion of nature in three dimensions and the two-dimensional patterns of the painting's design. This tension is the hallmark of Twachtman's mature style.

Twachtman's early works bear little stylistic resemblance to *Falls in January.* After a period of local art instruction in his hometown of Cincinnati, he enrolled at the Royal Academy of Fine Arts in Munich in 1875. Under the tutelage of Frank Duveneck, Twachtman adopted the vigorous brushwork and dark tones of the Munich school. During a period of study in Paris from 1883-85, he developed a more subtle handling of paint and a broader color range. On his return to America, Twachtman settled in Greenwich, Connecticut, where his style continued to evolve, becoming increasingly personal and abstract. While his reputation today rests primarily on his paintings, Twachtman was also an influential teacher and was instrumental in founding the group of American Impressionists and Tonalists known as "The Ten."

Before his death at the age of forty-nine, Twachtman helped to bring a new intimacy to American landscape painting. His modest, evocative canvases stand in marked contrast to the spectacular mountainous panoramas by painters of the previous generation such as Albert Bierstadt and Thomas Moran. Childe Hassam, an admirer of Twachtman's genius for evoking the essence of nature through simple and unassuming means, praised the artist for painting "Truths well told, interestingly told, just as a few words well chosen will tell a truth that a thousand cannot!"[2]

M.P.G.

1. John Twachtman, letter to J. Alden Weir, 16 December 1891, quoted in Richard Boyle, *John Twachtman* (New York: Watson-Guptill, 1979), 21.

2. Childe Hassam, et al., "John H. Twachtman: An Estimation," *North American Review* 176, no. 557 (April 1903): 556.

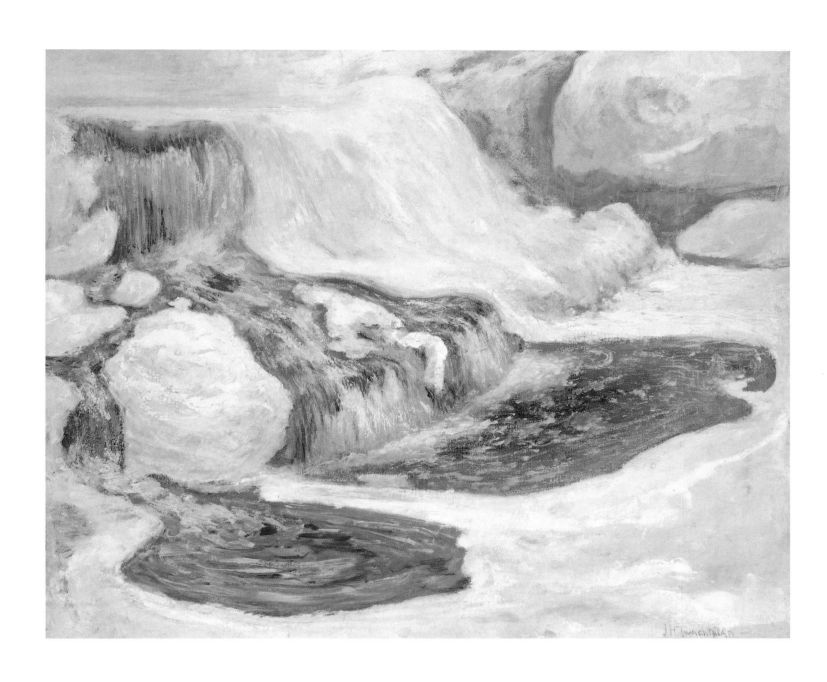

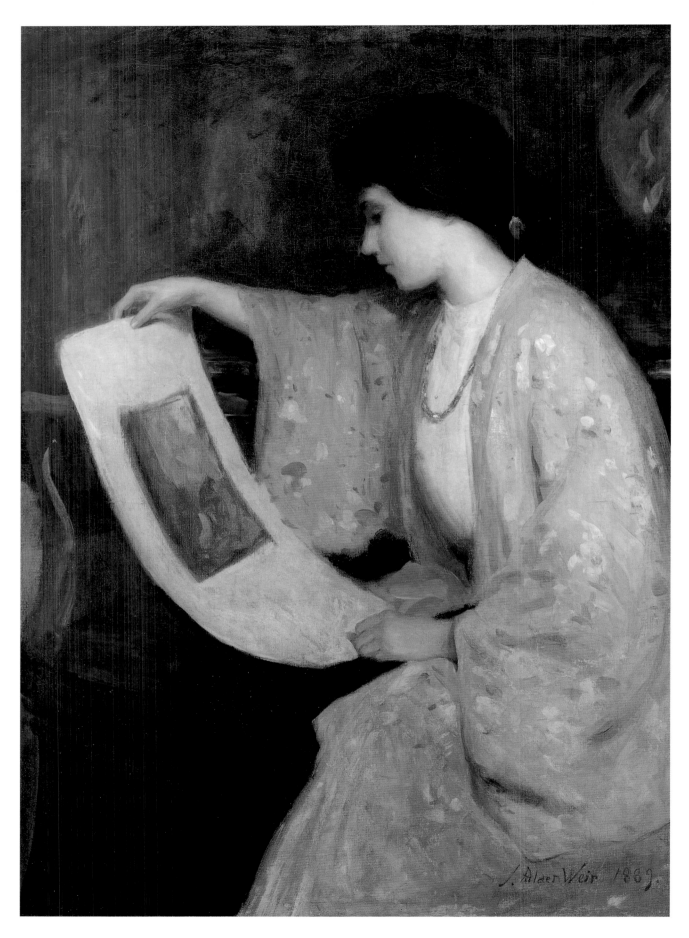

JULIAN ALDEN WEIR (1852-1919)

The Connoisseur, 1889

Oil on canvas, 42¼ x 30⅜ in.

Signed and dated lower right: *J. Alden Weir 1889*

Gift of Friends of the Wichita Art Museum, Inc., and dedicated
to Elizabeth S. Navas, 1978.91

Julian Alden Weir, one of the central figures of American Impressionism, was born at West Point, New York, the son of Robert Weir, a drawing teacher and professor at the U.S. Military Academy at West Point. The youngest of sixteen children, Weir received his first art training from his father. Showing early promise, Weir began attending winter classes at the National Academy of Design starting in 1870-71.[1] In 1873, financed by a generous stipend from his godmother, Mrs. Bradford Alden, Weir traveled to Paris, where he studied under Jean Léon Gérôme, the great French academic painter, at the École des Beaux-Arts. Returning to New York in 1877 armed with the technical skills and confidence inspired by four years in Paris, Weir supported himself by painting portraits and teaching art classes at the Cooper Union Women's Art School and the Art Students League.

Weir painted *The Connoisseur* in 1889 during a transitional period within his stylistic development when he began to apply the lessons of the Impressionists to his own work.[2] During this period, his paint application loosened up, his lines softened, and his palette lightened. In *The Connoisseur,* Weir's debt to the Impressionists is especially evident in the light blue robe, wherein the loosely applied brushstrokes suggest a remarkable degree of translucency and delicacy. The woman's face and hands, by comparison, are more firmly modeled and show Weir's reluctance to abandon altogether the tenets of his academic training.

During the late 1880s Weir painted several variations on the theme of the contemplative woman, of which *The Connoisseur* is one fine example. Within the conspicuous display of beautiful objects, including the print, vase, and lavish robe, the woman appears as just one more beautiful object in an arrangement of precious treasures. Weir was himself an eclectic collector and connoisseur. He often advised major American collectors such as Erwin Davis and, when abroad, even occasionally made purchases on their behalf.[3] Weir also began avidly collecting Japanese prints in the 1890s, the same decade in which the popularity of Japanese art and culture reached its zenith in America. Although *The Connoisseur* was painted several years before Weir began experimenting with Eastern stylistic conventions such as asymmetrical compositions and flattened space, the kimono-like robe is one of the earliest signs of his budding interest in Japanese art and culture.

M.W.

1. Accounts of Weir's studies at the National Academy of Design vary; see Dorothy Weir Young, *The Life and Letters of J. Alden Weir* (New York: Yale University Press, 1960), 13, and Doreen Bolger Burke, *J. Alden Weir, An American Impressionist* (Newark: University of Delaware Press, 1983), 33, 36.

2. Burke, 112.

3. Matthew Baigell, *Dictionary of American Art* (New York: Harper & Row, 1982), 372.

GUY CARLETON WIGGINS (1883-1962)
Looking Down Fifth Avenue, ca. 1947
Oil on canvas, 30¼ x 25⅛ in.
Signed lower right: *Guy Wiggins NA*
John W. and Mildred L. Graves Collection, 1996.21

The son of artist Carleton Wiggins, Guy Wiggins was born in Brooklyn, New York. Although he attended grammar school in England, Wiggins returned to New York to study at the National Academy of Design under William Merritt Chase. By the time he was twenty, the precocious young artist was represented in the permanent collection of the Metropolitan Museum of Art, and numerous awards were to follow.

Adopting the loose brushwork and vibrant palette of his teacher, Wiggins learned from the start to paint as an impressionist; and he continued to do so long past the heyday of American Impressionism. For most of his career, Wiggins divided his time between New York City and Connecticut, where in 1920 he bought a farm near the art colony at Old Lyme. Among the colony's more famous painters was Childe Hassam, whose rosy views of urban life influenced Wiggins's own cityscapes. In 1937, the artist relocated to Essex, Connecticut, where he opened the Guy Wiggins Art School.

Wiggins's alternation between New York and rural Connecticut was a typical pattern among the American Impressionists, for whom the country and the city were central artistic themes. In painting these subjects, they opted for picturesque views over the presentation of less palatable social realities. The countryside became for them a pastoral retreat—both in their art and in their art colonies—while they chose to depict the city as a decidedly pleasant, bourgeois environment.

Wiggins's *Looking Down Fifth Avenue* is typical of such cityscapes. There is no sense of urban alienation here, as a soft white blanket conceals the cold asphalt and concrete of the city. There is nothing ominous about these skyscrapers, nearly hidden behind a veil of gently falling snow. But Wiggins's New York offers more than just wintry urban reverie: rippling American flags add a patriotic flair, while amidst all the hustle and bustle of the city, the steeple of Fifth Avenue's First Presbyterian Church reminds us of less worldly concerns. In *Looking Down Fifth Avenue* and in many similar canvases, Wiggins made his patrons feel good about city life; they returned the favor in their eagerness to purchase his snow scenes. Whenever he was in need of a little cash, Wiggins claimed he could always "brush up a little snow."[1]

M.P.G.

1. Guy Wiggins quoted in Adrienne L. Walt, "Guy Wiggins: American Impressionist," *American Art Review* 4, no. 3 (December 1977): 103.

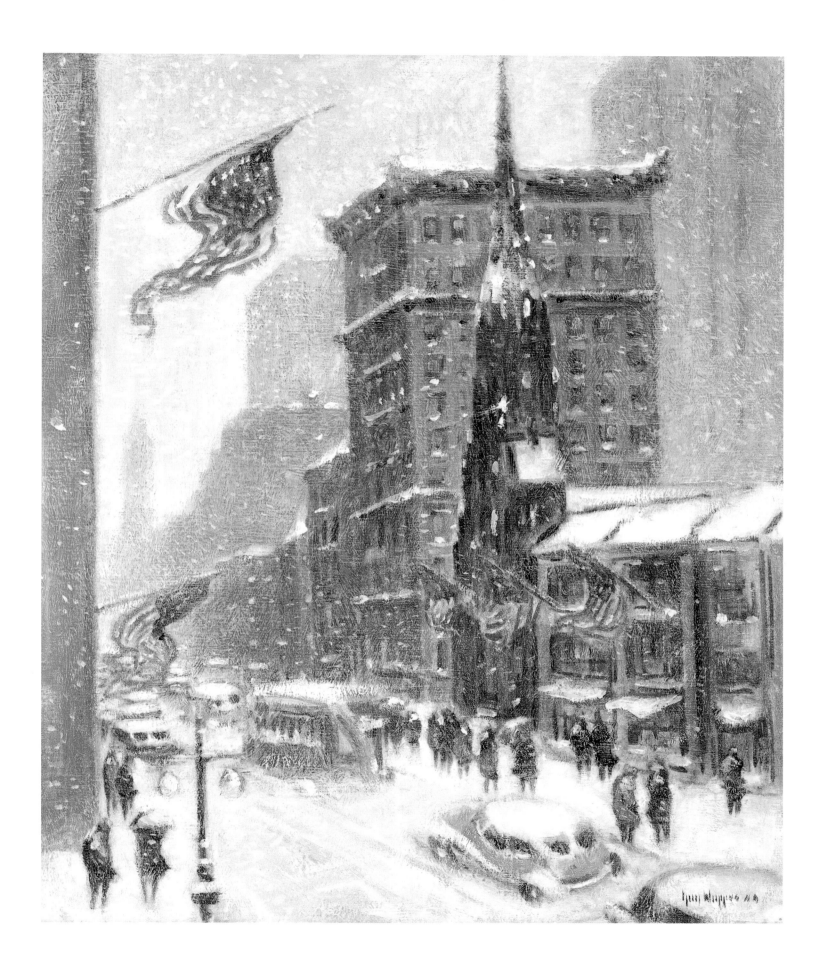

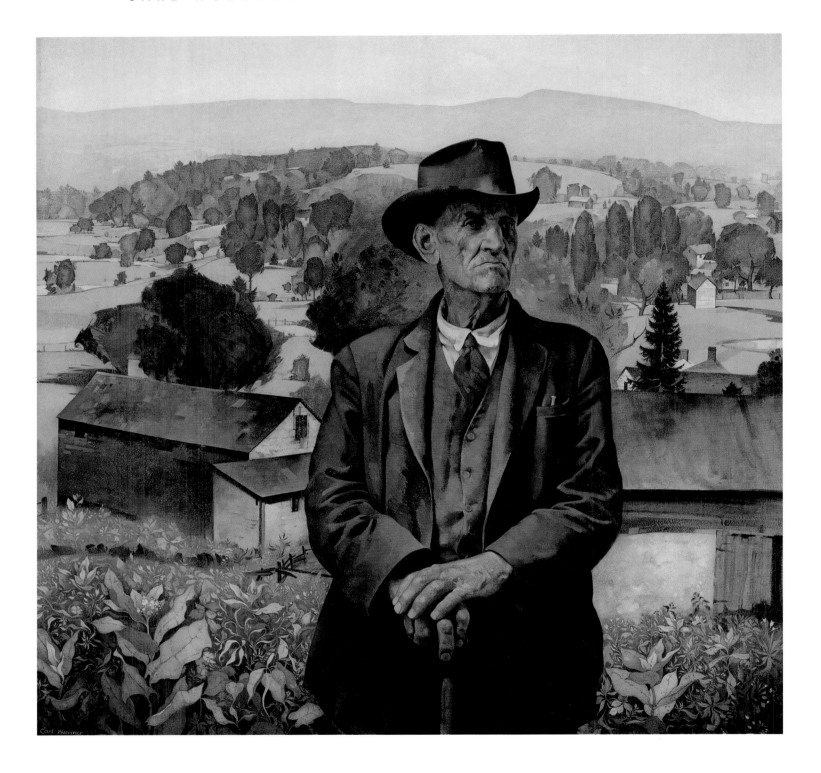

CARL WUERMER (1900-1983)
American Farmer, 1930
Oil on canvas, 36¼ x 36¼ in.
Signed lower left: *Carl Wuermer*
Gift of Friends of the Wichita Art Museum, Inc., 1987.6

Carl Wuermer's captivating image of an *American Farmer,* painted in 1930, stands both as a portrait of an individual farmer and as a symbol of the common American farmer of the period. The model for the farmer was a Mr. Hommel, whom Wuermer represented standing before the sunlit hills of the Schutis farm in Woodstock, New York.[1] The farmer's deeply wrinkled face, shaded gaze and softly stern expression convey a sense of the wisdom that comes with age. Likewise, his firmly-rooted frame, balanced steadily over his wooden cane, adds an air of nobility to his bearing. The dignified presence of this man before the wooded fields and rolling hills speaks silently of his pride in his past—of both happy achievements and sorrowful struggles in toiling the land. From his gnarled, calloused hands to the rich, earthy tones in which he is clothed, Wuermer's *American Farmer* seems to embody the spirit of the land.

But the farm now lies behind him, and his eyes peer out with uncertainty into the distance of a less assured future. By 1930 the Great Depression had begun, and this farmer's ambiguous gaze seems to point toward the unknown future with both worry and determination.[2] In this respect, Wuermer's figure stands as a symbol of every American farmer of the 1930s whose economic future in the land was at stake. In addition to the generic title of this portrait, the schism between Wuermer's representation of the figure and its background landscape contributes to the symbolic nature of *American Farmer.* The farmer appears almost as a cut-out figure standing before a previously-painted backdrop. He seems to stand before rather than within the landscape. The marked, Byzantine-like detachment of the figure from its environment effectively seals off the farmer from the land before which he proudly stands. Is Wuermer placing this individual before a nostalgic representation of a farm now obliterated by the Depression, or is this a premonition of misfortune to come? The uncertain destiny of the land with which the farmer seems to identify is inherent in the painting; it is a destiny that this man seems ready to accept with both work-worn weariness and an unwavering air of dignity. Wuermer's *American Farmer* begs association with every American farmer of the Great Depression—fearful, yet steadfast in his identification with and dependence upon the bounty of his soil in this tragic era of the nation's history.

Born in Munich, Germany in 1900, Wuermer immigrated to the United States in 1915 and became a citizen shortly thereafter. After studying at the Art Institute of Chicago from 1920-24, he traveled to New York to study at the Art Students League and then settled in Woodstock, where he lived until his death in 1983. The rural atmosphere of upstate New York provided the artist with inspiration throughout his life, in what one critic called "infinitely patient and peaceful studies of Woodstock town and country,"[3] of which the Wichita Art Museum's *American Farmer* is a poignant example.

M.B.

1. Howard E. Wooden, *Collected Essays on 101 Art Works from the Permanent Collections of the Wichita Art Museum* (Wichita: Wichita Art Museum, 1988), 100.

2. Ibid.

3. "Fifty-Seventh Street in Review," *Art Digest* 21 (1 March 1947): 22.

N . C . WYETH (1882-1945)

The Homesteader, 1930

Oil on canvas, 36¼ x 40⅛ in.

Signed lower right: *N.C. WYETH*

Gift of Paul Ross Charitable Foundation, 1981.45

Born in 1882, Newell Convers Wyeth was raised on a farm outside Needham, Massachusetts. Images of the American West in the work of George Catlin and Frederic Remington captivated Wyeth as a youth, and he spent hours on end drawing Native Americans, frontiersmen, and settlers. In 1902 Wyeth had already begun to develop his drawing skills in a few art classes and was accepted into the Howard Pyle School of Art in Chadds Ford, Pennsylvania and Wilmington, Delaware. Pyle, one of the period's leading illustrators, stated, "I regard magazine and book illustration as a ground from which to produce painters." Through Pyle, Wyeth developed into an oil painter whose work was widely reproduced.

In 1903, after studying under Pyle for only a few months, Wyeth's first published illustration, a bucking bronco with rider, appeared on the cover of the *Saturday Evening Post.* His work soon began to appear regularly in periodicals such as *Harper's Weekly, Success,* and *Scribner's Magazine.* Wyeth visited the American West for the first time in 1904, where he recorded the region's unique qualities of light, sun-baked colors, and brilliant cloud formations.

Wyeth painted *The Homesteader* as the principal full-color illustration for a story by Wilbur Daniel Steele entitled "Green Vigil: A Saga of the West."[1] The female figure represents Ivy, the main character, described by Steele as "strong and young, not above twenty-eight, with the shoulders and hands of a country girl, the dull, pretty face and large-calved legs of a Tom-show dancer, and the brain of a child."[2] In *The Homesteader,* Ivy stands atop a hill where she has buried her recently deceased husband. Looking out at the viewer, she drapes her arm around a cottonwood pole that marks her husband's burial plot. According to the story, this pole has magically transformed itself into a sapling. As a visitor to the site remarks, "That's cottonwood for you. . . . Cottonwood beats all for the will to grab a root most anywhere and go on living."[3] Ivy towers above the land, framed by a mass of dark clouds that opens to a bluer, clearer sky. She is heroically depicted as a strong, self-sufficient homesteader who stands firm even in the midst of adversity.

Rather than merely depicting a scene from the story, Wyeth's literary illustrations enhance the text as a whole. In paintings like *The Homesteader,* he reveres the Western American landscape and the figures who settled it.

S.H.

1. Published in *Ladies Home Journal,* September 1930.

2. Ibid., 3.

3. Ibid., 79.

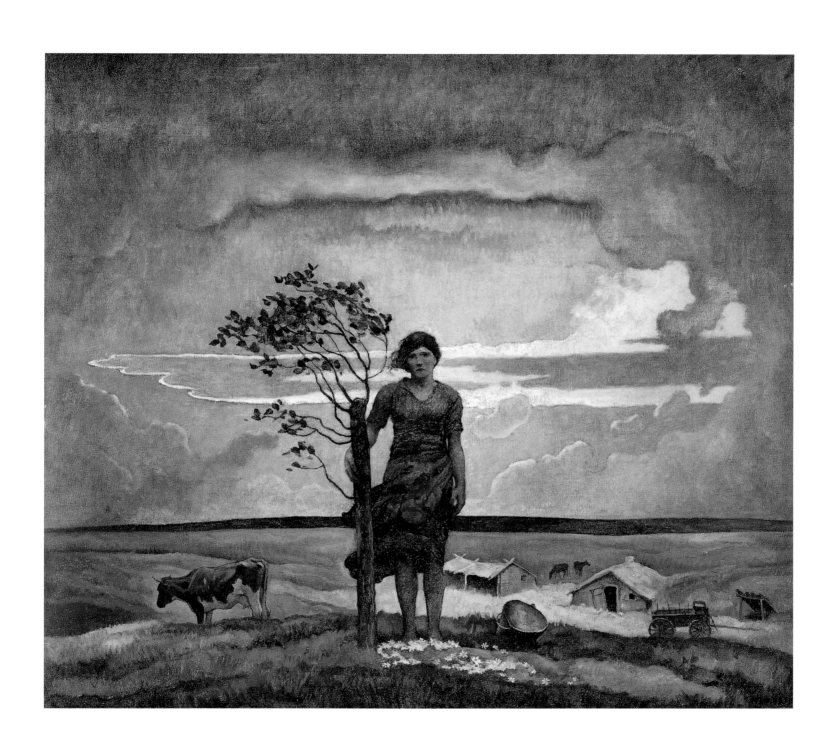